ABOUT THE AUTHOR

MICHAEL ADAMS is the reviews editor of the Australian edition of *Empire* magazine and a frequent contributor to *Men's Style, Rolling Stone,* and RottenTomatoes.com. He writes the "Bad Movies We Love" column for Movieline.com and the "Schlock & Awe" column for TheWrap.com and is the author of *Shining Lights*, a book profiling Oscar winners. He lives in Sydney, Australia, with his partner, Clare, and their daughter, Ava. Those who saw his cameo as "Stoned Hippy" in the Z-grade classic *Bloodlust* won't be looking forward to his zombie "acting" in *Survival Of The Dead*.

SHOWGIRLS, Teen Wolves, and ASTRO ZOMBIES

MICHAEL ADAMS

itbooks

AN IMPRINT OF HARPERCOLLINS PUBLISHERS

SHOWGIRLS,

Teen Wolves,

and

ASTRO ZOMBIES

A Film Critic's Year-Long Quest to
Find the Worst Movie Ever Made

*it***books**

HarperCollins books may be purchased for educational, business, or sales
promotional use. For information please write: Special Markets
Department, HarpcrCollins Publishers, 10 East 53rd Street, New York,
NY 10022.

FIRST EDITION

Designed by Paula Russell Szafranski

Printed on acid-free paper

Library of Congress Cataloging-in-Publication Data is available upon
request.

ISBN 978-0-06-180629-2

10 11 12 13 14 OV/RRD 10 9 8 7 6 5 4 3 2 1

For Clare and Ava, always

CONTENTS

CONTENTS

FOREWORD

I met Michael Adams when he came to interview me for a retrospective of my zombie films. We quickly bonded over our desire to drink our lunch and find somewhere we could smoke in peace. That turned out to be my hotel room, where, over more drinks, we talked about everything non-undead related, from the travesty of the Bush-Rumsfeld years to the declining state of the news media. And then, as the beer and spirits flowed and the air got thicker with smoke, he told me about the book he was writing—the same book you hold in your hands today—that would recount his year of watching, from night to dawn to day, the worst goddamned movies he could get his grubby little paws on.

If I hadn't fully appreciated him before, I now gave him all the credit in the world for giving the time of day to obscure films that most disregarded but some, like me, thought of as seminal. Someone, maybe it was Pauline Kael, once wrote that "we all love good movies but a true cinephile is someone who

totally digs talking about the worst movies they've seen." And on that note...

"What's the worst movie *you've* ever seen?" my new drinking buddy asked me.

"*Robot Monster*," I shot back, describing that fantastic folly of an apocalypse epic whose lead villain is a man in a gorilla suit wearing a diving helmet ... in 3-D, no less.

Michael and I laughed long and loud at the shared recollection of this truly bizarre piece of sci-fi silliness. But what really surprised me was how much he knew about the film and the personalities behind it and what became of them. It's this humor and affection that makes *Showgirls, Teen Wolves, and Astro Zombies* such a fun and informative piece of pop film criticism, as well as an engaging memoir of what it's like to work a couple jobs, raise a kid, and devote every nook and cranny of your spare time to obsessive Z-grade movie watching and research.

While I'm glad he watched them so we don't have to, the book is enough to make me want to head out to the video store, or jump onto Netflix, and track down *Frankenstein Island* or *For Y'ur Height Only* or *Road House* or ... maybe ... just maybe ... *The Black Gestapo.*

After that first meeting, Michael and I stayed in touch and he even came to Toronto to be a zombie in my latest film. I thought his interpretation of a dead man was a pretty good one, snarly and steeped in tradition.

After a few takes my script supervisor leaned over and whispered in my ear, "That guy, your Australian buddy ... don't you think he's doing ... a bit too much?"

"No," I replied. "He's doing it just right. Just ... cheesy enough."

I look forward to the day that Michael and I are able to watch the flick together. When he sees himself, he might turn

to me and say, "Jesus, what I did there *was* really cheesy."

To which, I will say, "Yes, it was. But isn't cheesiness what we are here to celebrate?"

We met by chance. We've become friends. I'd rather spend an evening talking about cheesy cinema with this guy than just about anything else. And as you read this book, I hope you will form the same attachment to him that I did. You're in good hands. Enjoy. Don't overanalyze. Just enjoy.

George A. Romero

INTRODUCTION

BAD MOVIE BINGO

It's just about to hit midnight on New Year's Eve and my pulse is pounding because the ball is about to drop. I'm not in Times Square, watching the big orb descend, surrounded by a million screaming New Yorkers. I'm in my living room in Sydney, cranking a toy bingo machine, while my better half, Clare, and a few close friends count down the last seconds of the year. "Ten! Nine! Eight! . . ."

I catch their bemused glances. I know it's ridiculous, being this excited . . . about little white numbered spheres. Then again, the rattling cage of balls *is* going to decide how I spend the next twelve months. It's a common notion—what you do on New Year's Eve is what'll you do for the following year—but for once it's true. For the next 365 days I'm going to watch one bad film a day to discover what is the worst movie ever made— and I'll view the schlock in the order dictated by the bingo machine. "Seven! Six! . . ."

I've joined in the countdown chant now, keenly aware that

part of my challenge is to *not* let my newfound obsession take over my life and relationships—at least, not completely. "Five! Four! . . ." That said, a little ball's in the scoop and is about to drop into the tray! My number's nearly up. "Three! Two! . . ."

One—one month, that's how far I need to rewind to explain how this madness started.

It was December 1, a Friday, just after lunch at the Sydney office of *Empire*, the world's leading movie magazine. In the line of duty as reviews editor, I'd just watched *Material Girls*. For those who've not had the displeasure, it's an egregious wannabe comedy starring pop-music moppets Hilary and Haylie Duff as cosmetic heiresses who fall on hard times and are forced to suffer hideous indignities—like, you know, mingling with minorities and using public transport. Ninety-seven eye-gouging minutes later, I steamed back to my desk, ready to vent in my review.

But even fulmination needs fact-checking—you've got to spell the names right when you sully them—so I pulled up the *Material Girls* page on the Internet Movie Database (IMDb), the world's most-visited film reference site. What I saw took the vim out of my venom. At that moment, with an average rating of 1.7 out of 10, the Duff sisters' flick occupied the number 1 spot—*bottom ranking*—on the IMDb's user-voted chart of the one hundred worst movies *ever* made.

Don't get me wrong. *Material Girls* had been an affront to everything right and decent in our world. The script was originally a vehicle for the Olsen twins—and *they* turned it down. But seeing it at number 1 on this chart made it seem like an underdog. Was it bad? Sure! Terrible? You betcha! The *worst* movie *ever*? Not a chance.

In my decades as a cinephile and years as a critic, I'd risked retinal burnout on far more heinous crimes against cinema. *Material Girls* wasn't a patch on Hulk Hogan's yuletide

yawnfest *Santa with Muscles*. Or on Adam Sandler's beyond-moronic *Going Overboard*, Mariah Carey's entirely without luster *Glitter*, or the all-thumbs video-game adaptations *House of the Dead* and *Alone in the Dark* from German director Uwe Boll.

Looking down the IMDb's Bottom 100 list, I knew it was unlikely that the Duffs' far-from-right stuff could really be lamer than legendary crapfests I'd never gotten around to seeing, cult atrocities like *Manos: The Hands of Fate* and *The Beast of Yucca Flats*, or more recent film flatulence, such as *Leonard Part 6* and *It's Pat*. For that matter, where was *Plan 9 from Outer Space* on the chart? Ed Wood's legendary howler—by default "the worst movie ever made" since pronounced such in Harry and Michael Medved's 1980 book *The Golden Turkey Awards*—wasn't in the Bottom 100 at all.

That night—with Clare having a girls' night out and our fourteen-month-old daughter, Ava, tucked up in her crib—I'd planned to polish a sci-fi screenplay I'd written. But rather than buff the pages that'd land me that elusive seven-figure sale, I sat with a few beers, unable to shake the question: What *really* is the worst movie ever made?

When it comes to great films there's no shortage of "best" announcements, from the annual critics' top ten lists and the Golden Globes, Oscars, and BAFTAs that follow through to more permanent pantheons decreed by the American and British Film Institutes and publications like *Sight & Sound, Film Comment*, and *Empire*. But the other end of the cinematic scale doesn't get nearly as much attention.

It ought to, I thought, as I cracked open another brew. If only because truly, madly, and deeply bad movies are, in their own way, as rare as the works of genius bestowed on us by Kurosawa, Hitchcock, Renoir, Scorsese, and Spielberg. The more I pondered the question, the more it seemed possible that

one poor fool, working methodically and passionately over a set time and using the same criteria, might be able to decide whether *Evil Brain from Outer Space* was more mindless than *Baby Geniuses*, whether *Invasion of the Neptune Men* was a scarier sigh-fi monstrosity than scientology-fi fest *Battlefield Earth*. Such a movie martyr might suffer to know definitively what deserved a lower mark out of not ten but one hundred, *Plan 9* or *Another 9 ½ Weeks*? Eventually, enough "compare and contrast" might make it feasible for that cine-idiot to decide the worst movie ever made.

No prizes for guessing who I considered for this mission. *Material Girls* had sparked the fire and the beers weren't putting it out. There was no escaping that I *wanted* to do this. But was *I* the man for the job?

That I wasn't a cultist, I reasoned, was in my favor. I had no desire to convince myself or anyone else that a Z-grade 1960s biker flick was the ne plus ultra of undiluted rebel cinema or that a 1990s straight-to-video slasher was actually a cunning social critique.

That said, I'd seen my share of movies so bad they were actually perversely entertaining—and appreciated that they could even be thought provoking, if only because you were made to wonder *how* they'd ever been made. When I was a kid, I'd stay up late to catch Creature Feature screenings of *The Giant Claw*, *The Navy vs. the Night Monsters*, or *Squirm*, and a few years later stoner friends and I would venture to inner-city grind houses to giggle through the likes of *Glen or Glenda* or *Robot Monster*. After school, when I got a shit-kicking job with a film distributor, one of my responsibilities was quality control evaluations on the video transfers of cheapie acquisitions like *Girls School Screamers*, *Igor and the Lunatics*, and *Roller Blade*.

In the years since, I'd also glimpsed the other side of the

silver screen. *Empire* had taken me to the sets of movies that turned out bad. While I'd like to report the people behind Paris Hilton vehicle *House of Wax* were cretins or crackheads, they weren't. I'm neither, either—but that didn't stop *my* first and only produced screenplay for a TV thriller series called *Two Twisted* from getting critically dumped on as "cornball and cliché" by Sydney's leading newspaper. Then there was that time I took on a supporting role in a horror film that I thought was going to be seriously kick-ass but that quickly became considered one of the worst Australian films ever made. As they say, no one sets out to make a bad movie.

Sitting in the backyard on beer number four, I decided my experience made me as suited as anyone to a worst-movie quest. But I also sensed this was a Eureka! moment unlikely to survive the harsh light of day. So, to ensure I couldn't change my mind, I got up, logged on to Amazon and started buying up bad movies on VHS and DVD. Within half an hour, I'd ordered dozens and spent hundreds of dollars I didn't really have.

It was a weird, giddy feeling, paying good money for movies most people would pay *not* to see. I fought hard to banish visions of Clare, Ava, and I forced to live on donated gruel in some dripping halfway house thanks to my spending spree. But now firmly in the grip of my obsession, I kept on clicking that Buy button. *The Incredible Melting Man* for $10.48! *Hercules in New York* for $9.98! *Orgy of the Dead* for $13.46!

I spent $750 in under an hour. I was now committed. Catching my breath, I wondered whether I ought to *be* committed. The least I could do, before I continued bankrupting myself, was decide how I was going to work this thing. Initially, I thought I might spend a month watching bad movies but, looking at it closer, it was clear this would have to be a marathon, not a sprint.

The IMDb's Bottom 100 was but a starting point. I'd also

have to seek out legendary flops, critical failures, cult curios, video-age obscurities, and the very worst films to disgrace the annual anti-Oscars, the Golden Raspberry Awards, a.k.a. the Razzies. I'd ask aficionados for their worst-ever recommendations. I'd keep abreast of new turkeys being hatched in cinemas. Obviously, there'd be *hundreds* of movies to consider. With January 1, 2007, one month away, it suddenly made sense that the New Year should become my annus horribilis of cinema. To keep the pressure on, my goal would be to average at least one bad movie a day.

Midnight came and went as I worked out other rules of engagement. Any feature-length movie that was—or had been—commercially available would be eligible. I ruled out porn, made-for-TV efforts, and foreign films that hadn't penetrated the English-speaking world because, well, I had to draw the line somewhere. Painful though it might be, I'd rewatch any genuinely deserving flick I'd already seen so I wouldn't be comparing dusty recollections of *Robot Monster* or *Can't Stop the Music* to fresh viewings of *Track of the Moon Beast* and *The Garbage Pail Kids Movie*. Each picture would be viewed in its entirety—no fast-forwarding. And where possible, I'd ask the antigeniuses responsible what in the *hell* they were thinking.

When Clare came home, I told her the plan.

"How many beers have you had?" she asked, not unreasonably.

"Five," I said. I'd forgotten to open the last one in my six-pack. A troubling sign of true obsession.

To my surprise, Clare said it sounded like an interesting, funny project.

"You think you'll want to watch 'em with me?" I asked a little too eagerly. "I mean, when we met, you *did* say you were a 'movie whore.'"

Clare did say that—meaning she was happy to watch any sort of film—early in our courtship. She lied.

"Not a chance, buddy."

I quietly held out hope I could entice her to share some of them.

Over December, my ordering frenzy continued. I clocked up hundreds of titles, battered my Visa way into the red. The Amazon and eBay packages started arriving—a trickle at first, then a tidal wave of discs and tapes. I trembled at the enormity of the task. I assiduously didn't keep track of expenditure. It was just too daunting.

I spent hours and days pondering exactly what constitutes a bad movie. Faltering acting, deadly dialogue, insane plots, po-faced themes, flat direction, dyslexic editing, out-of-focus camera work, cardboard sets, threadbare costumes, cheapo special effects, and clunky music—they all have their place. And I'd rank them each out of 10 or 20 toward a total of 100. I've pretty much divided it up into a score out of 10 each for acting, direction, script, theme/ideas, cinematography, music, and more general scores, from 20, for production value and general enjoyment. It wouldn't be an exact science, it ain't even Z-grade rocket science. Even more amorphously, it'd also come down to how a movie failed to meet its *own* ambitions, be they miniscule, modest, or magnificent. In fairness, though, I'd also have to consider any flickers of entertainment or elucidation that saved a production from total damnation. My biggest challenge would be in differentiating what's so-bad-it's-good, what's so-very-bad-it's-bad, and, ultimately, what's so-very-very-bad-it's-the-worst.

All that was left as the New Year approached was to work out in what order I'd watch my movies. The idea of a list arranged chronologically or alphabetically or by genre was just too wearisome to contemplate and a sure recipe for giving up.

It needed to be broken down into bite-sized chunks. But how? Then—bingo!—the idea struck. Bingo! I'd divide the movies into groups based on genres, subjects, directors, and stars, assign each group a number, and let the random forces of the universe decide what I'd watch and when. With a quick scurry around eBay I found a toy bingo machine for ten dollars.

I put movies into categories. Pictures about asses and related anal matters got the number 1 in honor of a movie called *Anus Magillicutty*—self-proclaimed "worst movie ever made"—being the first disc that arrived in my mailbox. Other groupings included bad superhero epics, diabolical kiddie flicks, stinky sequels, terrible teenage tales, blaxploitation bungles, star vehicles for the likes of Bo Derek, Pia Zadora, John Travolta, and Madonna. As December 31 loomed, I couldn't wait to get started.

And now New Year's Eve is here. At least for one more second.

"One!"

"Happy New Year!" we all shout.

Once we're done with the kissing and pretending to know the lyrics to "Auld Lang Syne," I pick up the little white bingo ball that's popped out of Bad Movie Bingo.

It's the number 11. I consult my index of categories. And the loser is . . .

JANUARY

It was horrible . . . utterly horrible . . . and fascinating.
—Richard Burton as Father Philip Lamont,
Exorcist II: The Heretic

ESZTERHAS OF PAIN

I've seen some of the movies on my list, but there's only one
I've watched five times and that's 1995's *Showgirls*. I take it as
a good omen that Bad Movie Bingo selects it as my baptism of
dire.

So enamored of it was I back in 1999 that I made a pilgrim-
age to the Stardust Hotel in Las Vegas where the film is set.
There I saw *Enter the Night*, a legendary titty revue, and
laughed my ass off, which didn't endear me to the middle-aged
couples sharing my booth. They treated the skates-and-se-
quins spectacle—ninety minutes of gyrations in G-strings for
$19.95, inclusive of all-you-can-eat-Mexican and two marga-
ritas in souvenir cups—with the reverence usually reserved
for $500 seats at a Three Tenors concert.

Showgirls takes us behind the scenes of spectaculars like
Enter the Night, being the journey of Nomi Malone, a crack
whore who hitches into Vegas to claw and screw her way to the
top, only to discover she's really hit bottom.

"I worry that you've watched this five—now *six*—times," Clare says as she walks through the lounge room, trailed by Ava, whose eyes are, happily, averted from the writhing top-less women in bondage gear on the screen. "It's like porn."

I'm prepared for this.

"I'm as likely to get turned on by this as I am to laugh at *Two and a Half Men*," I reply. And it's true: An erection while doubled over with laughter isn't scientifically feasible.

Part of the hysterical appeal of *Showgirls* is that it's all so po-faced, from our antiheroine's name being a phonetic koan— "Know me, I'm alone"—to the always-insane dialogue that peaks with the achingly sensitive, "It must be weird, not having anybody come on you." Joe Eszterhas was Hollywood's highest-paid screenwriter until he killed his career with this collaboration with his *Basic Instinct* director, Paul Ver-hoeven.

I do feel a little sorry for Elizabeth Berkley, who, as Nomi, is a nude doe in the spotlights. But it's doubtful anyone could've done better with the role—even Charlize Theron, who missed out on the part. And Berkley wouldn't even have taken Nomi if Jennifer Aniston hadn't beaten *her* out for Rachel in *Friends*. In an alternative universe, Theron doesn't have her *Monster* Oscar and it's Berkley who's America's Sweetheart. In our world, she'll always be remembered for bronco riding Kyle MacLachlan's sleazy Stardust manager in a neon-lit pool.

Scenes like that are so transcendentally funny I suspected this was a satire, like Verhoeven's *Starship Troopers*. Ver-hoeven set me straight a few years back when I interviewed him for a career retrospective *Empire* feature. "*Showgirls* was not supposed to be a comedy," the director corrected me in his staccato Dutch accent. "It was an attempt to show the pit of filth which Vegas is, to portray that in the most blatant terms!"

Showgirls was a blatant failure and scooped the Razzies, awards Verhoeven accepted personally. Until then, he and Eszterhas had planned a *sequel*. "Yah, it was going to be called *Bimbos!*" Verhoeven chortled. "It was going to be Nomi in Los Angeles."

The mind boggles. But thinking about this, I wonder if *Showgirls* has *any* veracity. Akke Levin is the gal to tell me. She starred in *Enter the Night* and was promoted as a "Showgirl for the 21st Century" on the tails of jetliners, just like Nomi. Unlike Nomi, Akke didn't ride the freeway into town— or out of it. Born in Holland, she danced at Paris's famous Crazy Horse revue and became its media darling because she spoke five languages and was studying law. She signed on for *Enter the Night* and moved to Vegas just as *Showgirls* hit. "All the strippers started calling themselves showgirls," she told me with a sigh when I called her. "If I said I was a showgirl, people'd say, 'Oh, you're a *pole dancer.*'"

I asked Akke if any of the film was true to life. She said she didn't do drugs and her boss was openly gay so there was no inference she'd slept her way to the top. What *Showgirls* nailed was the utter bitchiness.

"Did you think you might get a stiletto in the back on the stairs?" I asked excitedly. In the film, Nomi takes the top job by literally toppling her mentor backstage.

"At least that would've been more honest," Akke laughed. "I'll never forget someone I thought was my friend telling me, 'Who do you think you are? Why should you be on the billboards? Why are you getting interviews? You've got nothing to say. You're a *nobody.*'"

Joe Eszterhas was close to nobody by the time his next movie, the 1997 satire *An Alan Smithee Film: Burn Hollywood Burn*, limped into release. Whereas *Showgirls* rates a 45/100 on the scale I've devised, this is an annoying, stupid

mockumentary about director Alan Smithee trying to take his name off action movie *Trio* and discovering he can't because the official pseudonym for such cases is . . . Alan Smithee! Chalk this 24/100 effort as the most protracted in-joke ever. The irony is that Eszterhas's clashes with veteran director Arthur Hiller meant the latter took his name off the project, really making it an Alan Smithee film.

The sliver of interest in this movie is the small role of Michelle, who provides a glimpse into where Eszterhas might've taken Nomi in *Bimbos*. We're told she used to be a Vegas showgirl but is now the in-house whore to cameoing Hollywood reptile Bob Evans.

As for Akke's post-showgirl life? She retired when *Enter the Night* closed and is now married, a mother, and a successful Las Vegas litigator.

ATROCITIES

Around the time I saw *Enter the Night*, I also made pilgrimage to a four-story walk-up in Hell's Kitchen. You might've mistaken it for a crackhouse were it not for the huge mural of the Toxic Avenger, mascot of schlock outfit Troma Entertainment, emblazoned on the building. Inside this HQ, minions slaved away amid nests of bloodied prop arms and beneath walls decoupaged with posters for the likes of *Class of Nuke 'Em High* ("Readin', Writin', and Radiation!") and *Killer Condom* ("The Rubber That Rubs You Out!"). A three-foot Penis Monster puppet held pride of place on one shelf.

Lloyd Kaufman, Troma cofounder, self-forged cult icon, and aficionado of god-awful ties, proved an enormously entertaining conversationalist. "An oyster gets a piece of sand stuck in his asshole and he produces a pearl. It's very painful but the result is beautiful. That's Troma," he explained. "We're the piece of sand stuck in the asshole of the arts community."

Since 1974, Kaufman and Michael Herz have made and distributed schlock, including early efforts from Kevin Costner, Samuel L. Jackson, Marisa Tomei, and Billy Bob Thornton. But Lloyd also missed out on talents. He told me about rejecting Madonna *three times* for *The First Turn-On!* in 1983 and, more recently, losing the chance at *South Park* because he was too cheap to pay for copyright clearance on music in the show's pilot. Toward the end of our talk, I asked if there was any film he regretted releasing.

"The only movie about which I have second thoughts is *Bloodsucking Freaks*," he said solemnly. "We didn't make the film but we put some money into it and I think, because of the misogyny involved, I'd pass if it came around again."

Seven years later, I met with Lloyd again. He was a bit grayer but no less indefatigable in railing against the devil worshippers who run Hollywood. At the end of this interview, he handed over a Troma goody bag, including *Bloodsucking Freaks*, now in a deluxe DVD version. So much for that mea culpa!

I lock the bedroom door before putting Lloyd's disc on. I'm not worried about Ava, but Clare, whose tolerance for gore is low. I know what to expect because I saw this 1976 flick when I was a teen and I was shocked. This time, I'm amazed by how it's almost *quaint*—well, as quaint as any movie can be in which slave women munch a cock hot dog. *Freaks* is about demented beatnik Master Sardu and his dwarf, Ralphus, who run one of those off-off-off-Broadway torture-slavery operations. I can't help but laugh that they actually have a medico who makes *dungeon calls*. His payment? Pulling a woman's teeth out, forcing her to give him a blow job, and then drilling a hole in her head so he can suck her brains out with a straw. Okay, I *can* see why feminists protested the movie, but the gore is palpably fake and the whole vibe's too over-the-top to seriously offend.

13

January third is my first day back at work after a two-week Christmas vacation. While I enjoyed the time off, hanging with Clare and Ava, I have to admit I did spend a lot of time thinking about this moment. Watching three movies in the past two days—50 percent over target!—was easy, a warm-up. The real challenge will be fitting them in with *Empire* duties *and* a normal home life. That'll mean either staying up late at night or, like today, getting in to work at 7:00 a.m. to use our screening room. It does feel kinda creepy watching 1980's *Cannibal Holocaust* at this hour in the empty office. Something a serial killer might do. That's because this one, like *Bloodsucking Freaks*, also resulted in a media ruckus for its extreme violence. I'm glad I haven't had breakfast when I watch it. The film has four newshounds' vicious provocations causing Amazonian tribespeople to tear them apart and eat them. The centerpiece, featuring castration and vaginal impalement, is utterly compelling, if utterly repellent, and director Ruggero Deodato famously had to produce his actors in court to disprove rumors that he'd actually killed them. What he couldn't dispute was that he really slaughtered a lot of animals to make his movie. A snake, monkey, raccoon, pig, and some turtles are killed on-screen in stomach-churning detail meant to show the Americans' descent into savagery. Deodato's defense was that many of the critters were cooked and eaten by the cast and crew. I suppose it did save on craft services.

A MYSTERY SCIENCE RECOMMENDS

"On the show, we had the likes of *Robot Monster,* which is a cult classic," Kevin Murphy—who played wiseass robot Tom Servo on cult parody TV show *Mystery Science Theater 3000*—told me a few weeks back. "The reason I like it is because there's a certain class of movie that's a noble

failure—and Ed Wood's in this category too. You really can appreciate that these guys did their best to tell an imaginative and interesting story and just really didn't have the talent or the money or the wherewithal to do it. They poured their hearts out onto the screen and still it ended up being a laughable mess."

I'd never seen *MST3K* because it never made it to Australia, but knowing of it—and seeing that Murphy had also written *A Year at the Movies: One Man's Filmgoing Odyssey*, in which he chronicled watching one movie a day in different theaters all over the world—I sensed he'd be my sorta guy. So I'd called him up to talk about my project and get his bad-movie reflections and recommendations. The movies he genuinely loathes, he told me, are much bigger than the Z-grade flicks parodied on the show. "When you see a film like Warren Beatty's *Town & Country*, you can see all the ego in the world on the screen," he said, anticipating a flop already on my list. "Schadenfreude is a classic human emotion. We have a passion for seeing people we hold up as models of success fall down. That goes back to Aristophanes."

For Murphy, knowing the production history of the film can also affect his experience of it. *Town & Country*, for instance, cost $90 million, which makes it a different proposition from the works of Ed Wood. "All the badness just comes off the screen—incompetently made and morally bankrupt, a nice combination," he said of Beatty's folly. "That said, I would challenge anyone, without even knowing the story behind it, to try to sit through *Cutthroat Island*."

Challenge accepted, Captain!

At home that night, I pop an old thrift-store video of the movie into my creaking VHS player. *Cutthroat Island* has a lady pirate evading her evil pirate uncle as she searches for treasure—using her dead dad's scalp map, which she keeps in

her britches. Geena Davis swashbuckles with gusto but is all at sea in awkward romantic scenes with emasculated costar Matthew Modine. Director Renny Harlin—then Davis's hubby—spent $92 million blowing shit up. "I don't want surprising, I want stunning," he wrote in a production memo. "I don't want fast, I want explosive. I don't want accidents, I want disasters." He got his last wish and for years after its 1995 release this was the biggest box office failure on record, grossing just $11 million. I can't say I *hate* it—it's a 40/100 for sheer spectacle—but it is unforgivable that no one *ever* says, "ARRRR!"

Kevin Murphy reserved the inner circle of his movie hell for 1995 Best Picture Oscar winner *Forrest Gump*. "I could have a hand up my ass and I wouldn't feel as manipulated," seethed the former *MST3K* puppet master. "Here's a scene: Cry now. Here's a scene: Laugh wistfully but not too much. Here's a cripple: If you don't find this heartwarming, then you have no heart."

After I watch it again, I lean a *little* more toward Kevin's view. You know the drill. It's *The Dummy's Guide to American History 1955–1983*, scored to fragments of great songs. And sucker that I am, I get swept along. Stupid is as stupid does, I guess.

HOWLERS

It's the weekend and I'm laughing so hard it hurts.

Ava's having her afternoon nap and Clare's getting her daily exercise fix by doing Pilates in the lounge room. She's the physical type, which I respect even if, try as I might sporadically with bursts of the stationary bike or power walking, I can't quite emulate. We're not quite Homer and Marge, but she's definitely an ectomorph to my endomorph. But now I may have discovered a simple way to that six-pack stomach—that

is, if all bad movies could be as funny as 1985's *Howling II: Your Sister Is a Werewolf.* It's hilarious enough to count as an abdominal workout.

This is the story of queen werewolf Stirba's upcoming ten thousandth birthday, causing the world's other lycanthropes to reveal themselves. Sybil Danning's Stirba is a bi-curious beast who breaks out in cotton candy fur and shoots orange lasers from her fingertips. Inspired by so-called New Wave eroticism, she also gets around in an outfit made from black venetian blinds with chrome strips. *Howling II*'s other "stars," Annie McEnroe and Reb Brown, are so bad that in some scenes supporting actor Christopher Lee—still years from his *Lord of the Rings/Star Wars* comeback—closes his eyes, as if wishing himself away. Just when I think it's over, the movie delivers a coup de grâce of end-credits "highlights" that repeats a scene of Sybil baring her boobs *seventeen* times.

"You couldn't do it seriously," French-born Australian director Philippe Mora told me of *Howling II*, which also went by the even sillier names *Howling II: It's Not Over Yet* and *Howling II: Stirba—Werewolf Bitch.* "It was Grand Guignol."

The film was shot in Soviet-controlled Prague and he told me he was constantly yelling "Clit!"—the Czech word for "shut up"—to quell his large local crew, much to the amusement of the few English speakers on the production. "I suspected my assistant director was KGB," he said. "He knew *nothing* about making movies." Mora had to literally import trash from America to clutter the clean communist streets. "And when we put out a call for punks, one thousand showed up! The authorities called out the police and the army. We were surrounded. I spoke to a colonel and he said, 'You can finish shooting the scene but they'll have to leave in no more than groups of three.' That was gung ho."

MORA RETURNED TO HIS big-screen beasties two years later with 1987's *Howling III: The Marsupials*, which he shot on home turf in Australia. It's about an outback girl who flees her incestuous clan of marsupial werewolves to live in Sydney. There she falls pregnant and has to escape to bush exile to birth her "evolutionary freak." But she's pursued by assassins, hunters, and her sister werewolves, disguised as nuns. It's a kitsch explosion of lycanthropic transformations on a city street, a ballet stage, and at the Oscars.

"We Australians have a marsupial version of everything, including the wolf. Why not put that into the pop zeitgeist?" Mora laughed. "It was comedic—werewolves with pouches!—but I wanted to be *pro* these creatures."

Fair enough, but back to *Howling II* for a moment. I *have* to know, how *did* Sybil feel about having her rack shown seventeen times? "Oh, she was absolutely mortified," Mora guffawed. "I had done it five times because I thought it was funny. Unbeknownst to me, the producer saw it and thought it was the greatest thing he'd ever seen. He said to the editor, 'Reprint that!' So he has to get a lot of credit."

CHARACTER FLAWS

Twelve days in and so far so good. Well, kind of. Ava tiptoed through the lounge room yesterday with no pants on, which made me wonder whether she did glimpse *Showgirls*. If she drops out of med school to become a pole dancer, I'll never forgive myself. And now, as I'm about to embark on five comedies about dopey characters, Clare, who has taken to calling herself a "bad-movie widow," drops the question I've dreaded: "How much have you spent so far?"

I pause unwrapping the insanely complicated packaging on the DVD of spy flop *Leonard Part 6*. "I don't know," I say. Like a hack secret agent, I *do* have plausible deniability. I've made a

point of *not* adding up the total expenditure. Cunning, I know.

Clare looks at me.

"Probably around . . . two grand?"

She maintains an inscrutable gaze.

"I'd just better get some screenwriting work," I add quickly.

"That'd be good, baby," Clare says, before heading out to the backyard to hang with Ava.

Did I detect a note of sarcasm there?

But on the screenwriting front, things do look promising. I've received some good Hollywood feedback on the sci-fi thing. A well-regarded British company really liked a zombie outbreak story I wrote for Tim Bullock, the director of my *Two Twisted* episode. A couple of Australian producers want me to do script doctoring. And then there's *Revenants*, my WWII horror about Japanese ghost soldiers, still creeping toward financing after . . . three years under option.

But this afternoon, rather than endorsing seven-figure studio checks, I'm jotting down notes on *Leonard Part 6*, which writer-producer-star Bill Cosby publicly warned people off in 1987. To answer the obvious questions: Yes, Leonard did have adventures one through five. And no, they weren't made into movies, because, as the deeply unfunny narration tells us, they're still highly classified. Instead we're asked to imagine how Leonard came to be a) driving an armor-plated Porsche, b) dancing in ballet shoes, and c) riding an ostrich off a roof. The rest of the film is a flashback to explain these cretinous opening images.

Evil vegetarian Medusa is using brainwashed critters—cats, squirrels, bullfrogs, *trout*—to kill CIA agents as a precursor to an "all-animal offensive" on San Francisco. Only Leonard can save the day. After interminable business with a fortune teller and his ex-wife, he drives to Medusa's headquarters in his Porsche. There Leonard defeats her

caricatured gay henchmen with magical ballet shoes. After surviving attack by lobster and repelling more mincing minions—this time with magical meat patties—he sets the animal army free and escapes on the ostrich.

The movie has to be the worst thing to happen to San Francisco since the 1906 earthquake.

Clare comes in from the backyard. "How was it?" she asks.

The look on my face says it all.

"The worst so far?" she laughs.

"It's hard to imagine there'll be a worse movie than this."

But there is and it's 1994's *It's Pat*, which was released with a PG-13 rating "for bizarre gender-related humor." (I like 1995's *Jefferson in Paris*'s PG-13 better: "Mature theme, some images of violence, and a bawdy puppet show.") Played by Julia Sweeney, Pat was developed as a character on *Saturday Night Live*. The single joke is that from birth onward, no one can decide whether he's a he or she's a she. As the theme song goes, "A lot of people say, 'What's that?' It's Pat!"

I've nothing against gender-bending but I am prejudiced against braying idiots. And *that's* Pat. Sweeney and Co. make him/her a slug-browed, bespectacled eyesore *and* a chortling, nasally moron with a personality like nails on a blackboard as s/he loses a variety of jobs and is wooed by Dave Foley's drag bartender. Put it this way: Kathy Griffin plays herself and she's the *least* grating presence. I'm not sure if the late-movie message of self-acceptance, delivered by Camille Paglia, was meant to be part of the joke. Either way, it's hard to imagine the transgender community regarding this flick as anything but a kick in the nonspecifics.

I breeze through Carrot Top's 1998 surfer-inventor comedy *Chairman of the Board*, which certainly isn't good, but it's nowhere near as dire as the red-haired comic's many haters claim. Same goes for 2006's *Larry the Cable Guy: Health Inspector*. The redneck shtick offered—Larry drives a gas-

guzzling ve-hickle with bumper stickers like GUN CONTROL MEANS HITTING YOUR TARGET—is charmless but also so dumb it'd be churlish to be offended.

In terms of character-centered movie disasters, they don't get much bigger than *Gigli*. To recap for the 99 percent of people who missed it: Affleck is Larry Gigli—it's pronounced to rhyme with "Marry? Really," which was what the world was then saying about its stars, Ben Affleck and Jennifer Lopez— and he's a knucklehead assigned by the mob to kidnap Brian, the Tourette's-afflicted teenage brother of a prosecutor. Because Larry's such a moron, *he is assigned a minder* in J.Lo's lesbian hit woman, Ricki.

Larry doesn't have a single book in his house so when Brian asks for a story, our hero has to read to him from a Tabasco sauce label. Meant to be touching, it's excruciating. More embarrassing is Brian's tender admission that *Baywatch* "made my penis sneeze." The cringiest stuff is between the ill-starred leads. Affleck goes wet-eyed as he professes love to his "dykosaurus rex." But J.Lo gets the worst. Her long discourse about the penis as sea slug and the vagina as a mouth—delivered while bending herself into narcissistic yoga poses—is but a mere warm-up for priceless oral sex come-ons "It's turkey time—gobble, gobble" and the less-celebrated "Lay some of that sweet heterolingus on me."

It's not *all* bad. J.Lo confounding thugs with martial arts mumbo jumbo is okay, Christopher Walken has a typically oddball monologue, and Al Pacino gets a show-stoppingly violent scene. Mostly, the black comedy is just tasteless and mirthless, hitting its lowest point when an idiot plot contrivance dictates Larry hack the thumb off a corpse while Sir Mix-a-Lot's *Baby Got Back* plays.

DESPITE THIS BEING THE first film to win all six major Razzies, Gigli isn't the worst movie of all time, just a smug bore.

BIGFEET

In the late 1970s and early 1980s, whenever we'd go to visit my grandfather in his leafy suburban abode, my younger brother David would race out into the old man's leafy garden to capture little lizards basking in the morning sun. Once we'd tired of our catch-and-release program, we'd spend the afternoon luxuriating in the spare room that contained decadence beyond compare in the form of a second TV, free of parental interference. On such days, there was one show that unfailingly made our world a bigger, more fascinating place: *In Search of . . .* Part *National Geographic* documentary, part *The Twilight Zone*, it was narrated by *Star Trek*'s Leonard Nimoy with the cool detachment of his half-Vulcan science officer. While his investigations into killer bees, ancient astronauts, and Stonehenge were, quite frankly, fucking awesome, it was Bigfoot who always stood head and shoulders above the rest.

That was because of the *evidence*: grainy 1967 footage that showed a big hairy hominid stalking away from a home movie camera. Known as the "Patterson-Gimlin film," it was to cryptozoologists what the Zapruder footage is to JFK conspiracy theorists. Unhappily, the film—which was eventually revealed to be a hoax—also really lowered the bar for Bigfoot movies by demonstrating that all you needed for a DIY Sasquatch saga was some sort of camera, woods, and an ape suit.

In 1970's *Bigfoot*, jiggly Joi Lansing is caught by men in such suits, and short ones at that. Joi ponders her fate. "The only thing I can figure on is that they're a dying race and they want to reproduce more of their own kind," she decides, not sounding *too* perturbed by the prospect.

I lumber on, like a Sasquatch fleeing a Super 8, to the horrible hybrid freak that is *Curse of Bigfoot*. The provenance of this one is murky. Apparently it began production in the late

1950s or early 1960s under the title *Teenagers Battle the Thing* but wasn't completed. In 1976, new footage was shot for release as *Curse of Bigfoot*, before it was then sold to TV under the *Teenagers* title. In any guise, it's awful. The later-shot framing scenes have Leif Garrett–era kids listening to an expert telling them about his Bigfoot experience. "As a result of that field trip, three of those students will spend the rest of their lives in a mental institution," he says. It feels like that's where this flick has escaped from. We flash back to ruddy-colored scenes of Frankie Avalon–era teens mouthing dialogue offcuts from *Leave It to Beaver*. Eventually these nerds find a mummified creature, which, if looked at in the right way—after a head injury or twenty-two beers—*might* be described "Bigfootesque." Otherwise, it's a moth-eaten ape suit with a face mask that looks like a big, greasy breakfast gone moldy. Surely those eyes are dried out eggs? The fangs toast crusts?

But it's a masterpiece next to 1997's *Search for the Beast*. Shot on video with a hissing soundtrack, this begins with a shoddy soft-core porn scene that culminates in a topless girl "attacked" by what appears to be a badly lit photograph of a gorilla's torso. As hero Dave, nonactor Rick Montana is a disaster who literally *reads* his lines in some scenes. As love interest Wendy, even-less-of-an-actress Holly Day is somehow *worse*. I don't believe she understands drawled illiteracies such as, "Are you lookin' for the missin' link? I've read everythin' you've wrote on the subject."

Halfway through the movie, director R. G. Arledge gives up even on such dire-logue altogether. Instead he gets Montana to do a voice-over that combines Dave's thoughts, his lines, *and* the dialogue of other characters. It is *insane*. But the craziness gets crazier.

When we finally see Bigfoot he looks like the lovechild of Marty Feldman and a monkey. Any comical effect is shattered

23

when he forcibly has his way with a hippie girl, who stares into the camera glumly as she's pounded. It's hideous and ties in to the revelation that the film's ominous hillbillies are blood relations to Bigfoot and they're all in the rape-abduction-breeding business.

As the misspelled credits roll, my mind reels. I wonder whether after just two weeks, I've not only searched for but have already *found* my beast. Whereas *Leonard* clocked up 20/100 and *It's Pat* 18/100, this rates just 12/100. Can there be a *worse* movie?

A few nights later, my friend Chris Murray comes over. He was the founding editor of Australia's *Empire*, launching it in 2001 from an office next to *FHM*, where I worked as features editor. I'd gotten that men's magazine gig in 2000, largely on the strength of a story I'd done about Lloyd Kaufman and Troma for a rival, since-defunct publication called *Max*. I had enjoyed my time at *FHM*, and loved doing interesting interviews with guys with great jobs, like the forensic psychologist who specialized in serial killers, or the supercool F/A-18 jet pilot. The downside was the play-hard, work-hard vibe of the mag. We'd do sixty-, seventy-, and even eighty-hour weeks, and then blow off steam in ridiculous drinking frenzies that seemed to go as long. The other downside was having to interview vapid bikini models and ask them embarrassing (for them, and for me) questions about their sex lives.

So, when *Empire* launched, I jumped at the chance to contribute reviews and features as a freelancer and, in 2002, when their reviews editor position needed filling, I took the job, taking a pay cut to do so. But now I was Watching Movies for a Living! A lifelong dream fulfilled.

I've been there ever since. Chris moved on in 2004 to try his hand at movie producing and running the film-event company Popcorn Taxi. Presently, among his numerous projects, Chris

and his business partner are trying to finance my *Revenants* script.

Tonight the first movie they cut their teeth on, a zero-budget crime comedy called *Fink!* that starred our acquaintance, the then-unknown Sam Worthington, is being screened on network TV.

This is the first time that Chris has seen the film because a falling out with another producer saw him leave the project. He delivers a painful live commentary of moans, groans, and the frequent *"Fuck!* I can't believe they cut it that way!" I visited the *Fink!* set and, while it was never going to be more than a romp, the end result is an incoherent shambles. It's a reminder of how bad movies happen to good people.

"Christ that was bad," an ashen Chris says when it's over.

To cheer him up, I say it wasn't *that* bad. He looks at me disbelievingly.

I put *Search for the Beast* on and skip to the highlights.

"Oh my God!" Chris says, wiping away tears, literally trying to catch his breath between laughing convulsions. "I never knew a movie could be like this!"

It's a reminder of how much fun other people's bad movies can be.

MURDERIN' MUTANT MANIACS . . . FROM SPACE

Like literally millions of other kids, my love affair with the movies began with *Star Wars* in 1977. I remember films before that, but only barely. I recall clambering around in the backseat, aged about four, during a drive-in double feature of *Diamonds Are Forever* and *Live and Let Die.* Being dragged to *The Sound of Music* at the church hall. Going with my dad to see the animated *Robin Hood* one Saturday afternoon and throwing up during a school excursion to watch *Pete's Dragon* at the local cinema.

But it was during a family excursion to see *Sinbad and the*

Eye of the Tiger at a beautiful old art deco theater in western Sydney—since converted into apartments—that my brother and I got our first glimpse of the trailer for George Lucas's space epic. "Can we see *that*?" we both yelped, echoed by other kids throughout the auditorium. I remember enjoying Ray Harryhausen's stop-motion saber-tooth vs. cyclops fight in *Sinbad* well enough, but afterward all my brother and I could talk about was that other movie, the one with the spaceships and laser swords and the boy and the girl swinging across that chasm and that goddamned tall black robot strangling that dude.

When *Star Wars* finally made it to our shores, in October of 1977, I was just seven and my brother five, and we loved it. We saw it again. Talked about it. Acted it out. At a Christmas party that year, I insisted on dressing like Han Solo—combining a vest, a white skivvy, and black shorts with boots. The laughter of the girls I'd hoped to impress couldn't quite be drowned out by my toy Han Solo pistol's sound effects. I didn't care too much. I was, as it'd be called decades later, "geeking out," and there ensued half-a-decade's worth of birthdays and Christmases dominated by *Star Wars* action figures, novelizations, and, of course, the countdown to the next sequel. The long wait between films was filled with excitement over any movie or TV show about space and the monsters who inhabited it. So, naturally, when I heard *The Incredible Melting Man* and *Laserblast* were coming out, I was psyched. What could be sweeter? Well, actually being allowed to see them, for one. Unfortunately for me, my parents, who were okay with me watching *Battlestar Galactica* and *Buck Rogers* on TV, adjudged that I was too young for such potentially nightmare-inducing fare.

NOW, THANKS TO MY project, I'm finally to see what I missed out on back in the day. And I feel strangely offended that both of

these movies are in the Bottom 100. Surely they can't be that bad? As a bonus, when I saw the IMDb's Bottom 100 contained another man-monster from space film called *Track of the Moonbeast*, I threw it into this segment.

I start with 1976's *Moonbeast*, which has a young mineralogist hit by a meteor fragment and turning into a hulking monitor lizard mutant. If he's not stopped, the moon will cause him to atomically explode. It's all based on the most rigorous science. Our hero is Professor Johnny Longbow Salina, a Native Indian professor of Plot Exposition, played by Gregorio Sala, clearly a graduate of the William Shatner Drama School: "He said. The camp was. Attacked. By a lizard. That walked. Like a man."

While it's flatly shot and directed, the effects are also terrible, with the meteor looking like a flaming falafel on a string. Future Oscar winner Rick Baker's monster suit is better, but still basically a *Creature from the Black Lagoon* knockoff.

Baker's work on 1977's *The Incredible Melting Man* is more impressive, even if *The Quite Effective Melting Man* is perhaps more accurate. The title character is just plain old astronaut Steve West until space radiation turns him into a rampaging goo monster. Steve is played by Alex Rebar, who'd later be credited with *Sex, Pain and Murder, Episode Two: Castration Elation*. Thankfully, in this it's only his ears and eyes that are dropping off.

The Incredible Melting Man is an oddity. While there's plenty of deliberate jocularity, such as the hobo who says of gloopy Steve, "You think we've got trouble, look at that dude," there's also bizarre unintentional humor as when, in the finale, reluctant hero Ted repeats over and over, "Steve, it's me Ted Nelson!" as though this will somehow reverse the human-candle process.

"The film was supposed to be a spoof on horror films,"

writer-director William Sachs told me of his movie. "During shooting [the producers] decided that it would make more money as a straight horror film. They took it away from me and shot new bad material and attempted to remove the spoof aspect. It became like an Amphicar. If you don't know what that is, or was, it's part boat, part car, and wasn't a good car or boat because it tried to be two things at once and failed." (It reminds me of Ben Affleck's later description of *Gigli*: "It was like trying to put a fish's tail on a donkey's head.") Despite the interference, Sachs still digs parts of his flick. "I can laugh at the funny parts, like his ear on the tree," he said. "How can a serious horror movie end with the monster being shoveled into a garbage can?" He has a point there.

I'm sure as an eight-year-old I would've dug the spectacle of 1978's *Laserblast* in which teen-hunk Billy finds an alien weapon and uses it on his enemies while going green and insane. I have quite a good time watching it now. But as much as I would've enjoyed seeing Billy blow shit up real good, no doubt I would've been enraged by him using his laser gun to destroy a *Star Wars* billboard. Sacrilege!

SPIELBERG AND LUCAS STRIKE OUT

Spookily, Bad Movie Bingo seems to be divining a "six degrees" style higher power, for now it throws out the two films that demonstrated even seventies gods Steven Spielberg and George Lucas weren't immune from making crap. Why it's weird is because Spielberg's *1941* also features *Laserblast*'s nerd-villain Eddie Deezen—just as *Melting Man* and *Laserblast* shared poor doomed Cheryl "Rainbeaux" Smith. Anyway, while geek is now chic, Deezen got there first, beginning with Eugene in *Grease* and then reprising his supporting-insect persona for, well, the rest of his career.

I'm curious and make contact. Eddie's happy to talk—so

long as I pay him *ten dollars*. "I honestly do not need the money, but I love getting checks in the mail," he explains.

I find his reasoning hilarious, endearing, and, well, nerdy. I don't think I'm seriously compromising my ethics by paying for this story, so I sent off his stipend.

Eddie doesn't have much to say about *Laserblast*, other than it was a shoddy production and that he loved the *Mystery Science Theater 3000* parody. But he has plenty of war stories about *1941*. He got sick during one of the days he spent in a Ferris wheel and was led to the director's trailer to recover. "I not only got to lay down on Mr. Spielberg's bed, but I had the very rare honor of throwing up in Steven Spielberg's toilet," he says. Another day, he had lunch with Dan Aykroyd, John Belushi, and Spielberg. "I was scared out of my wits. I tried to act casual as I sat among these great men . . . and then I realized I had no cash on me." Despite the fond memories, Eddie doesn't really rate *1941* either: "It was too disjointed and the jokes do not fly."

Eddie's appraisal is dead on. Spielberg starts by unwisely homage-parodying himself with stuntwoman Denise Cheshire reprising her *Jaws* dip as a WWII Japanese sub surfaces beneath her. It's Christmas, 1941, and Los Angeles is panicked about getting the Pearl Harbor treatment. Women are "khaki wacky" for men in uniform, two jitterbuggers pose as soldiers to woo dames, a home defense is mounted on coastal cliffs, and inept Japanese soldiers come ashore.

The movie is a nonstop barrage of screwball, slapstick, and special effects. Spielberg wound up chewing through $35 million—*$24 million* over budget—and shot more than one million feet of film in 247 days. I picked up the promotional tie-in book at a yard sale recently and it gleefully describes how a $260,000 house was pushed off a cliff, ten thousand feet of neon lights were machine gunned, and how fifteen thousand

nonsense T-shirts were printed on a whim. And that's the problem: Spielberg wants us to get our laughs from his big spend. But it's hollow spectacle, whether it's Aykroyd driving a tank through a paint factory or Belushi's crazy pilot streaking across the sky. The smaller moments are funniest, such as ninja assassins dressed as Christmas trees and Deezen's bit with a ventriloquist doll. Still, this is a 52/100, which ain't too bad.

No such incidental pleasures can be found in 1986's *Howard the Duck*. While coscripted and directed by *Indiana Jones and the Temple of Doom* and *American Graffiti* writer Willard Huyck, this live-action adaptation of Steve Gerber's comic book nevertheless has executive producer George Lucas's stamp from the opening scene, which is—*sigh*—a homage-parody to *Star Wars* that has two moons over Howard the Duck's home world. This quack lives in an apartment in Marshington, D.C., decorated with posters for *Breeders of the Lost Stork* and *Splashdance*. He drinks beer, ogles the birds in *Playduck*, and works as a perfume salesman. His wallet holds a MallardCard. And a little duck condom.

Our featherbrain is sucked out of his parallel duckiverse by a physics experiment on Earth. This scene involves a topless lady duck with lady-duck boobs. Howard lands in Cleveland, where he flirts with Lea Thompson's poodle-haired rock chick, Beverly, evades Tim Robbins's duck-obsessed scientist, and tries to stop Jeffrey Jones's cackling Dark Overlord of the Universe.

Howard the Duck is much, much less fun than it sounds, and rates a painful 28/100. Seeing a duck as a towel-and-lotion boy at a sex club is just wrong. Worse is when Howard and Beverly hop into bed. "You think I might find happiness in the animal kingdom, ducky?" she purrs, as I try to gouge my eyes out with the remote.

Spielberg's *1941* foreshadowed good future work—a deleted scene has the coat-hanger-torture device joke he'd perfect in *Raiders of the Lost Ark*—but *Howard* predicts how Lucas would pummel our senses with Jar Jar Binks. At least that annoying CGI alien didn't try to tap Natalie Portman's ass. *Howard* had one happy outcome. Once it laid an egg at the box office, Lucas was forced to sell off his new CGI animation division. The buyer was Steve Jobs of Apple and the company went on to become Pixar.

STINKY NUMBER TWOS

A legacy of being raised Catholic is a fear of anything "devil-y." You spend your childhood with Satan shadowing your every step, just ready to suck your soul to hell forever. When I was eleven I was freaked out to discover that the "mark of the beast" *really* was in the Book of Revelation. Hey, *I* was *adopted*. Maybe I was—*shudder*—the Antichrist! I spent a nervous evening with a mirror trying to see if I, like Damien in the second *Omen* movie, had the 666 birthmark hidden under my hair. I didn't, but I am forever grateful that it wasn't until a few years later that my parents gave me my original birth certificate on which was recorded my initial name . . . *Damian*. Seriously.

So, sitting down to watch 1977's *Exorcist II: The Heretic*, I'm concerned I'll get freaked out. But the only scary thing is its incoherence. Linda Blair's Regan is now a teen who can heal autistic kids and tap-dance, for which she's targeted by the demon Pazuzu, King of the Evil Spirits of the Air. Meanwhile, Richard Burton's priest, Lamont, investigates the death of Father Merrin in the first movie. He visits Regan in a futuristic headshrinking lab for clinically weird kids and together they don the electrode headbands of the "hypno-sync" machine. They go cross-eyed to its strobes and whoops as it puts them in a virtual reality of shoddily superimposed images

from *The Exorcist*. When it's done, a drunken Richard Burton stares at the camera to say what I've been thinking: "It was horrible . . . utterly horrible . . . and fascinating."

I swear I didn't rig the Bad Movie Bingo but 1982's *Grease 2* is next on my list and it's *another* Eddie Deezen appearance, albeit a brief one, as Eugene. Ever-honest Eddie says the movie is "pretty lame" but that he enjoyed making it. That's because Deezen got to share leading man Maxwell Caulfield's cookies and found himself "mesmerized" by newcomer Michelle Pfeiffer. "I said to her, 'You're beautiful.' She said, 'Thanks.' That was all I ever said to her."

I feel for you, Eddie. Michelle was one of my teen crushes, but despite Pfeiffer fever I never could bring myself to see *Grease 2*. Good call, my former self, because it sucks. Maxwell plays a British chap who falls for Michelle's Pink Lady and adopts a hard-ass Cool Rider biker persona to win her affections. The highlight is Tab Hunter's teacher leading his writhing, thrusting class of teens through a song called "Reproduction." ("Now you see just how the stamen gets its lusty dust on to the stigma/And why this frenzied chlorophyllous orgy starts each spring is no enigma!") This DVD is a keeper for when Ava starts asking the tricky questions.

Like *Grease 2*, 1991's *Return to the Blue Lagoon* is a bomb sequel to a Randal Kleiser–directed hit made minus the original leads. This has baby Richard, son of Brooke Shields and Christopher Atkins, washed back up on the same island with a baby girl, Lilli, and her mother, Sarah.

It pulls out all stops to be uncomfortable, with sex-education talks for the kids referencing cowrie shells and iguanas. Sarah's death accelerates the ick factor, with the children rapidly growing up to become Milla Jovovich and Brian Krause. She loves her new breasts—but not as much as he does. After some token resistance and a DIY beach wedding, they succumb to

their urges in PG-13 soft-core porn. Lilli eventually gives birth to Richard's baby. Faced with the option of leaving for civilization, the little family decides to stay put.

I watch this one in the bedroom while Clare's glued to *America's Next Top Model* in the lounge room. Afterward, we reconvene for a glass of wine.

"And how was that trip to paradise?" she asks.

I fill her in on the vapid story line, blank performances, unresolved heathen-tribe subplot, deeply questionable incest vibe, and queasy sex-ed moments.

"I read in the paper today that Sydney's now in the top ten most expensive places in the world to buy a house or send a kid to school," Clare says.

It's the sort of news you don't want to hear when you're both working full-time and only just covering rent and bills. *Oh.*

"Is this about how much I've spent on bad movies?" I ask defensively.

"No," she laughs, "I was just thinking *Return to the Blue Lagoon* doesn't sound so bad. Tropical island, homeschooling, and, if we were the only ones there, we'd never have to give Ava the 'iguanas and cowries' talk."

Speaking of iguanas and cowries, *Another 9 ½ Weeks* is next. I ask if Clare wants to watch it.

I know she was a fan of the Mickey Rourke–Kim Basinger original.

"What if it turned us on and we had sex?" she says. "You'd have to note that?"

I agree that I would. She goes to bed and leaves me to face the danger alone.

I'd be ashamed to admit I got a boner—or worse—watching a film presently at number 11 on the Bottom 100. But it is possible. Porn is a bigger business than Hollywood and its output is bad movies to get people steamed up.

Then again, the original *9 ½ Weeks* didn't lead to sex, despite my very best intentions. My first-ever girlfriend and I got stoned while watching the video when my parents were out. What could be better for two seventeen-year-olds still in the rabbit phase that follows lost virginity? I'm saying a movie whose eroticism doesn't depend on sticky food items. Mickey and Kim's antics led to the giggles, then an attack of the munchies that saw us eat all the food we'd planned to incorporate into our raunchfest.

I shouldn't have worried. Nor should Clare. Mickey Rourke's wrecked face is the first drip in this 105-minute cinematic cold shower. When we begin, still stuck in 1980s lighting—despite the film being made in 1997—Rourke's gloomy sex addict, John Gray (not, it must be noted, the author of *Men Are from Mars, Women Are from Venus*), plays Russian roulette and flicks a hooker's nipples with a scalpel. Even such extreme erotica bores him; he's much more excited by a *horse being put down* on the street below his hotel. The only thrill he ever knew was Elizabeth. And so he travels to France to find her, unaware that Kim Basinger wasn't dumb enough to sign on for this sequel.

Instead, he meets Angie Everhart, and tries to have sex with her in Marie Antoinette's prison cell before taking her forcefully in a canal populated by copulating New Wave types. There's a reenactment of the original's food-sex fest, which saw Rourke empty the contents of his fridge onto and into Basinger. Angie takes him to an Arabic casino and promises to bankrupt him. "You can't lose all my money," he drones, like us, bored beyond belief. A million years later, Mickey gets into a dull threesome that ends when Steven Berkoff blunders in to announce that Elizabeth is dead. Way to put a downer on the ménage, serious actor guy!

So little happens—and happens so slowly—that this almost

defies description as a moving picture. And it's so antierotic it might be prescribed to psychologically castrate sex offenders, although the Supreme Court would declare it a cruel and unusual punishment.

Clare and I do share 1997's *Speed 2: Cruise Control.* No sex threat here as Sandra Bullock returns as Annie, now girlfriend to Jason Patric's cop. He whisks her onto the giant ocean liner *Seaborn Legend* to pop the question. Problem is, Willem Dafoe's computer hacker terrorist has taken control of the vessel. Upon opting out of this, Keanu Reeves reportedly noted that, um, dude, ocean liners don't actually, like, travel at *speed.* And verily this is notable for a snoozeworthy "climax" where the boat plows through a seaside resort inch by relentless inch. Bullock called the $110 million flop "the biggest piece of crap ever made." Of course, she was a few years away from making *Miss Congeniality's* sequel.

"Well, that was boring," Clare declares as the credits roll.

She's right. And that's the problem—the more of the bad movies she sees, the fewer of them she'll want to watch. As far as paradoxes go, it's up there with Schröedinger's Cat.

I'm resigning myself to flying solo most of the next eleven months.

I am the next night, when we're at Clare's parents' place in the Blue Mountains, sixty miles west of Sydney. After a big family dinner, I curl up in bed with my laptop and headphones. While my beloved sleeps beside me, I blearily watch *Son of the Mask.* Released in 2005, this spin-off stars prank comic Jamie Kennedy as an artist left to take care of his new son, who, because he was conceived when dad was wearing the crazy mask, has all the transformative CGI powers a $74 million budget can buy.

It's loud, frantic, and a lot of the jokes misfire. But I do get a few chuckles from Looney Tunes–style cartoon anarchy, and

recent fatherhood disposes me more to jokes about kids sucking the life out of you. *Son of the Mask*, I think as I close my laptop, isn't so much a bad movie as it is a *bus* movie. It's how I think of the stupid but watchable family-friendly fare long-haul bus drivers play to keep their passengers pacified.

One month down, eleven to go, I drift off to sleep.

STATUS REPORT

Worst this month: *Search for the Beast*
Runners up: *It's Pat, Curse of Bigfoot, Another 9½ Weeks*
Guiltiest pleasure: *Howling II*
Movies watched: *35*

FEBRUARY

It smells so bad I can't think straight.
—Madonna as Bruna, *A Certain Sacrifice*

GROSS ENCOUNTERS OF THE TURD KIND

We leave Ava with Clare's folks for a few days so we can go to a wedding on the coast. It's a delightful mini vacation, shared at a resort with friends. But every so often—be it when the others are walking by the lake or having siestas—I have to duck off to do my "work."

First day that consists of watching the harmless 1953 sci-fi *Project Moonbase*. Then, from cheesy astronauts I move to ass-tronauts. In 2002's *Thunderpants* a kid named Patrick wants to be a spaceman despite his ultraflatulent butthole. He's a stinky social outcast until he befriends schoolboy inventor Alan, who creates a pair of gas-catching trousers for him. That Alan is Rupert Grint from the *Harry Potter* franchise means they should've reworked this into *Ron Weaselly and the Chamber of Secretions*. Anyway, after several mirthless subplots, butt-bugler Patrick is recruited by NASA because only his explosive energy can power a spaceship in trouble.

Farts can be incredibly funny when they're inappropriate exclamation marks or unexpectedly rupture somber silence. Devoting an entire movie to them is like a kid who repeatedly demands you sit on a whoopee cushion.

The day after the nuptials, I put on my second ass-travaganza, 2003's *Anus Magillicutty*. This flick once occupied the number 1 spot on the IMDb's Bottom 100, and the DVD proudly bears the blurb: "The worst movie ever made." It is a series of sequences in which a scumbag named Anus Magillicutty tries to dispose of a body with the help of his even-scummier brother. They're stalked by someone who may be Satan. Random scenes include an ugly dude dancing in his underpants and a character called "the white trash piece of shit" whose head explodes for no reason.

Anus Magillicutty looks like it was shot on a camcorder retrieved from a dumpster, the edits and lighting are desultory, there's barely a token effort at continuity, and the cretins who wander in front of the camera struggle to improvise even idiocies like, "You find yourself in a buncha shit because you are shit." But mostly this comprises horrible sex scenes. "Darling, I think this is a porno film," says Clare, glancing up from her papers on the couch.

I can't disagree because on the TV stripper-looking blondes are getting bi-curious on a bed to a soundtrack that sounds like a demonically possessed bug zapper.

I'm annoyed rather than aroused because this waste of time does fall into the category of a soft-core flick. I'd give it 11/100, but it's disqualified.

SUFFER THE CHILDREN

When we pick up Ava, it's amazing how much she has grown. Sounds silly, but as a parent when they're that age, you notice changes after a few days away. What's also come along of late

is her vocabulary. Ava can now mimic just about any word, as long as they can be made to contain a hint of "Dora." "Har Dorry" is "Hi Daddy" and "Doraffe" is "giraffe." Her favorite word, used any time of day or night, remains the simple screamed: "DOOOOORRRRAAA!"

That, as parents around the world know all too well, is Dora the Explorer, the cartoon Spanish-speaking girl who hangs out with a monkey named Boots as she chases stars and lost toys and thwarts Swiper the Fox. For reasons unknown—satanic subliminal programming is my suspicion—the show is a cult among the under-five set.

Kids' TV is one thing they don't tell you about in the lead-up to having a baby: how much of the stuff you'll soak in, how demanding the little ones are for their beloved shows. I can't complain because, in a way, Ava owes her existence to the phenomena. It was 2004, the day after Christmas, and Clare and I were with her family at a villa in Bali. As the day wore on, our horror at the mounting death toll of the Asian tsunami grew. We were fielding calls from friends and family, unsure whether Bali had been swamped, and we were all freaking out a little because we'd originally planned to go to Thailand's Phuket, now washed away. Nephew Charlie, bless his three-year-old soul, was oblivious to all this. All he knew was that us watching cable news was getting in the way of him putting *Clifford the Big Red Dog* on for its forty-third viewing.

"Cwifford!" Charlie whined. "*Cwifford!*"

Eventually, as the numbers of dead became too great to fathom, Clare and I relented. Charlie put on his DVD and we retreated to our bedroom where our disaster sex made Ava.

Backyardigans. Wonder Pets. Blue's Clues. These names meant nothing back then, but now I often find the theme songs plinging through my head unbidden. And here I am, by choice, watching 2000's *Thomas and the Magic Railroad*, the

critically panned American movie based on the British kids' show. I'm doing it late at night because I don't want Ava to add it to her list of "must-see" TV.

The movie resists all comprehension despite a freight train's worth of exposition. My notes read: "Mr. Conductor, who plies the Magic Railroad between the human world of Shining Time and the talking-train universe of Sodor, has lost his gold dust, meaning he can no longer sparkle between the two places. The key is the lost engine, Lady, which is kept in Muffle Mountain by depressed old man Burnett Stone . . ."

Say what now? None of the stupid little train faces move, but it is amusing to see hard-ass Alec Baldwin as twelve-inch-tall uniformed fairy Mr. Conductor in painted sets while merrily blowing a whistle and saying, "Sparkle! Sparkle! Sparkle!" He's at least watchable, but Peter Fonda as Burnett appears to be having a bad acid flashback.

"Little engines can do big things," Thomas chuffs repeatedly but the one thing he'll *never* do is entertain me. I'd rather be *hit* by a train than watch this again. On the other hand, Charlie, now five, has seen it more than *fifty* times.

While Thomas stretched my comprehension to the limits, I know *Yu-Gi-Oh! The Movie* will break my brain. That's because I've been defeated once already by the cartoon cult. Permit me to rewind.

Early in my career, before I lucked in to movie reviewing, I made ends meet by writing about some pretty arcane subjects for trade magazines and books. If you're an ethicist specializing in accountancy or a resource company boffin, there's a chance I spoke to you in the mid-1990s. Crafting these articles was like pulling teeth—hen's teeth. I'd educate myself as best I could about defensible deductions or gas reserve calculations. I'd transcribe carefully, use verbatim slabs from interviews, paraphrase where necessary, and editorialize with the

utmost caution. My hope was that the learned readership comprising morally upright CPAs and hopeful geophysical surveyors wouldn't catch me out. I never did get a complaint. I'd like to think diligence paid off. More likely no one ever read a word of these dry treatises in company vanity journals.

Regardless, I prided myself on never declining a commission because the subject was too complex. "A good journalist should be able to write about anything," I'd puff. Late last year I met my match when Clare asked me to do a short article on Japanese animation for her magazine *Hot Wheels*, whose readership still consider coloring between the lines a significant academic achievement.

From my own childhood, I knew a bit about *Astro Boy* and *Battle of the Planets* and, with a refreshing Wiki-dip, I came up with peppy descriptions. But *Yu-Gi-Oh!*—a card game turned into multiple cartoons—defeated me entirely. I immersed myself in the online encyclopedia, fan sites, and anime reviews but I may as well have been trying to read a brain surgery textbook—in Urdu. I wound up having to substitute the far simpler *Kimba the White Lion*.

I plunge into the 2004 *Yu-Gi-Oh!* movie spin-off. It's about a boy named Yu-Gi, who unleashes an ancient Egyptian card game that's lain dormant for five thousand years. He is inhabited by the power of the Pharaoh and that makes him the world master of the new global phenomenon of Shadow Games. His enemy is the evil spirit of Anubis incarnated in nemesis Kiber.

Yu-Gi and Kiber face off by dealing cards so their virtual warrior beasts can whoop each other's asses. It's like an animated instruction manual with dialogue. Surely, anyone remotely interested in this already knows how it works?

Thus Kiber will say, "I summon the Feral Imp and next I'll activate the magic of the Card of Demise—it lets me draw five

new cards from my deck, but if I don't use 'em in five turns I lose 'em in five turns! Now I'll sacrifice my Feral Imp and activate one Dragon Ritual . . . to summon Paladin of White Dragon. Paladin! Attack with ionic sphereburst!"

I feel like I'm back in 1983, when my friends got into *Dungeons & Dragons* and bored me stupid with talk about slaying orcs with hit points. After an hour, I sorely wish I could play my Power of Pressing Stop and Flinging Disc Out the Window card.

The third kiddie movie proves the minor charm. *Doogal* is 2006's American-voiced version of a European CGI animated film based on British kids' TV show *The Magic Roundabout*. Doogal is a dog who has to save the world when it's frozen by Zeebad, a bad wizard who looks like porn star Ron Jeremy, right down do his lower body being a slinky. Zeebad's voiced by Jon Stewart and I think he does the so-bad-it's-good puns well enough ("You know there can only be one spring to rule them all. And I am the Lord of the Springs!"), while other vocal work from Ian McKellen, Jimmy Fallon, Judi Dench, Whoopi Goldberg, William H. Macy, and Kevin Smith is also fine. Usually I rail against kiddie movies parodying pop culture to keep parents entertained, but *Thomas* and *Yu-Gi-Oh!*'s obscurities have me so beaten down that I positively welcome lazy riffs on *Rings, The Matrix, Dawn of the Dead,* and many, many others.

BEFORE AND AFTER ALIEN

If *Star Wars* made the galaxy a grand place of good versus evil for Generation X, then *Alien* showed us that life might also be nasty, brutish, and short. Still, I loved it and watched the video every time I was at my Aunty Lee's place as a boy. And because we didn't have a VCR in the early eighties, I audiotaped the movie from her TV so I could listen to it at home as I flicked

through the elaborate tie-in photo book. But articles in magazines like *Fangoria* and *Famous Monsters* revealed how it had "borrowed" from older B movies.

The famous ones are 1958's *It! The Terror from Beyond Space*, about an alien stowaway stalking astronauts, and 1965's *Planet of the Vampires*, which has space explorers discovering the giant skeletons of an extinct race of aliens. But for two of the key attributes of the Alien you've got to visit bad-movie-dom.

America's first satellite mission crashes back to Earth, killing its astronaut and unleashing an alien that looks like a dirty carpet in 1958's *Night of the Blood Beast*. At a nearby base, scientists are stalked by the invader and the spaceman comes back to life and murders the base's doctor in an amnesiac fugue. An X-ray reveals he's been knocked up with alien Sea Monkeys.

Produced by Gene Corman and executive produced by Roger, his legendary B movie–king brother, *Night of the Blood Beast* is cheap but enjoyable and buoyed by its ideas. The same can't be said for 1966's *The Navy vs. the Night Monsters*, whose vegetable monsters are equipped with acid blood. I saw this twenty-five years ago on the late Friday night TV Creature Feature and thought it was pretty good.

Wrong. On a tropical island a cadre of highly sexed meteorologists have their swinging lifestyle rudely interrupted by walking carnivorous plants recently defrosted from Antarctica. Our hero—unwisely named Charlie Brown—seems to want to survive mainly so he can hook up with the base's heaving nurse, half-acted by Mamie Van Doren. It's *Gilligan's Island* meets *The Thing from Another World*.

We don't see these "living fossils" for the longest time and when we do we wish we hadn't. The Triffids were scary but these guys have floppy vinyl fronds into which the unwary

sometimes run. Even sillier are the junior "crawlers," merely buckets draped in leaves. I remember this as filled with battles between soldiers and the monsters, but such confrontations are simply *discussed* in tiresome military briefings and most of the action is scratchy military stock footage.

A welter of chest-bursting, face-sucking rip-offs followed *Alien*'s 1979 success. One of the first worsts was the 1981 British effort *Inseminoid*, in which, after the usual alien archaeology and mess hall freak-out, astrobabe Sandy is abducted by a bug-eyed monster who pumps green sludge into her. Now Sandy loses her shit, messes with corpses in the morgue, creeps around tunnels, and kills off her friends. Prone to the usual pregnancy cravings, she chews on innards and tries to seduce an astronaut. *Inseminoid*'s inevitable coup de grâce comes when Sandy gives birth to twin aliens. It's not as bad as it sounds, but it's close.

B movie babe Linnea Quigley stars in 1987's *Creepozoids*, which was directed by prolific schlockmeister David DeCoteau, who got his start with B movie moguls Charles Band and Roger Corman. This is set in a postapocalypse suggested by close-cropped shots of Los Angeles's river canal and derelict industrial areas. Five army deserters seek shelter from acid rain in an abandoned research facility. Turns out it's home to a deadly mutant from the Giger reject pile *and* an infection that turns people into zombies prone to melting-head moments. Of course, there's a dinner table scene.

Shot for $75,000, *Creepozoids* looks even cheaper, with the set comprising a few rooms and one corridor. When our characters climb into an "air vent," it looks like they're under someone's kitchen table in a dimly lit room. Effectswise, the monster suit seams are obvious and the roaming killer rat is awesomely fake. A new touch is that this has a mutant human baby popping out of an alien's guts.

My last one is 1993's *Dark Universe*, which could be a remake of *The Incredible Melting Man*. Steve Thomas is an astronaut whose space shuttle is infested with alien spores, causing him to crash in the Florida Everglades and turn into a varnished dinosaur puppet. Space-dino Steve drips goo—clearly hair gel squeezed from a tube—and leaves a trail of orange fungus that possesses whoever or whatever it touches. The best scene has TV reporter Kim making out with her producer/cameraman when he's attacked by a mutant armadillo. It's a while before she realizes his screams are agony, not pleasure.

Dark Universe sets a new benchmark for technical ineptitude when, at thirty minutes and forty-nine seconds, a crew member appears in frame "working" the woefully inanimate alien head. The script's also stupid-funny. When a dude is sucked dry, scientist Frank scrutinizes the mummified head and observes, "I don't like this at all." When her lover turns into a goo-possessed zombie, Kim tells him, "You don't look so well." The best moment has Frank—because he's an egghead—determined to communicate with the beast. "What do you want to do?! Take it to lunch, Frank?" demands Kim. "Ask it about its childhood? Huh?! Go ahead!"

The marquee "star" of this is Joe Estevez—brother of Martin Sheen—who pops up as the space boss to say, "It is a dark, dark universe out there." True, and without Joe the cinematic universe would be even darker. While his career has consisted of *hundreds* of Z-grade flicks, we also owe him thanks for a true classic. When his brother was recovering from the heart attack he suffered on *Apocalypse Now*, Joe worked as his stand-in. During postproduction, with Sheen and Francis Ford Coppola fighting, it was Joe who stepped in to do the voice-over, delivering many of the most memorable lines while drunk off his ass.

WACK BLAXPLOITATION

In the past few days, there's been the inevitable downside to the interest my scripts garnered last month. The British company passed on the zombie thriller, saying that they've already got their hands full with an Australian project. An American outfit passed on a psychological horror, saying it's great but too *small* for their needs. As much as I'd like the work, when I'm approached by a local producer to doctor a script about a girl robot with a mechanical vagina and a mind to murder her master, I have to decline because the thing needs a coroner. I'm frankly stunned it's gotten as far as it has in the development process. But then, weirder movies have been made, as I'm finding out now on a regular basis.

In the 1970s, in the wake of blaxploitation hits such as *Cotton Comes to Harlem, Shaft,* and *Sweet Sweetback's Baadasssss Song,* African American versions of every conceivable genre popped up, from *Black Shampoo* to *Blacula* and its spin-off, *Blackenstein.* As the trend wore out, filmmakers tried "any means necessary" to distinguish their product from the hundreds of other ghetto adventures that had pimp-rolled through urban cinemas.

The 1974 *Black Godfather* charts the criminal rise of small-time junkie hustler J. J. and his righteous mission to stomp out white-man's smack in the hood via an alliance with black power radical Diablo. There's some quaintly amusing soul brother dialogue, the requisite funktastic fashions, oddball interludes with a tribally attired minion, and a nightmarish interrogation sequence. But, overall, it's a straight, if slow, flick whose title riffs on Coppola's hit while it rips off *Superfly*'s subject matter.

UCLA student Jamaa Fanaka's killer-black-dick flick *Welcome Home Brother Charles* is, on the other hand, *utterly*

insane. Our hero is a small-time hustler who's partly *castrated* by corrupt white cops before he's thrown in jail. When he's released, we discover that his penis has grown back to "frightening limits." His trouser-conda not only has the power to *hypnotize* the ladies but Charles uses it to *strangle* the bastards that done him wrong. We only see this once but it's more than enough as it elongates down between his legs, slithers across the floor, and coils tightly around his victim's neck.

The nutzoid idea, red-hot hatred between a white cop and his wife, and a ragged, sweaty aesthetic make *Brother Charles* rabidly compelling in places. It's not clear if Fanaka meant this as an African American joke about white man's Fear of a Black Penis, but the potential for a comedy remake is, um, enormous. Dave Chappelle or Chris Rock might manage it, but it'd be a brave brother who tried *any* sort of version of 1975's *The Black Gestapo.*

General Ahmed and his People's Army are trying to inspire the 'hood with their nonviolent activism. But when honky crime boss Vince's violent henchmen attack sweet free-clinic nurse Marsha, Ahmed's second-in-charge, Colonel Kojah, demands the People's Army get a security division. Wearing a more militaristic, jackbooted version of the People's Army uniform, Kojah's security force swings into action against such outrages. They visit the head henchman and avenge Marsha—and, incidentally, Brother Charles—by slicing his penis off and flushing it down the toilet. But soon Kojah is shaking down local businesses for protection and running his Negro-Nazi Reich out of a mansion stocked with white hookers and waiters. His transition to evil is complete when his men switch over to black outfits with peaked caps, while their Black Power salute blurs with its Nazi counterpart and Sieg Heils blare over the soundtrack. There's never been any doubt this was where it was headed, given that the opening funktastic titles

utilize footage of Adolf Hitler and *solarize it to turn him into a black man.*

The Black Gestapo suffers the usual pacing problems and is technically inept, but with so much gonzo stuff going on it's a guilty pleasure. Seeing movies like this—which seem to spring from another universe and seldom if ever figure in pop-culture discourse—provides a sense of discovery that you simply can't get at the multiplex.

Same goes for 1977's *Abar, the First Black Superman.* Like *Gestapo,* it starts with a soapbox soul brother inspiring a crowd to throw off whitey. Our activist—who announces himself as "John Abar, Crusader"—tries to defend Dr. Kincade and family from victimization by racist neighbors in the white enclave of Meadow Park. But after Kincade's son Toby is killed in a hit-and-run, the grief-stricken doc reveals his secret: He's been creating an indestructibility potion and he wants Abar to be the human test case! Now Abar makes *his* own confession: He's nuts. "I got a weakness Doc, passion! Sometimes I wanna kill! KILL! KILL!"

But when Abar takes the formula, he becomes not so much Black Superman as Black Jesus, whose crazy mindwaves turn racist white cops into touchy-feely peaceniks, convert hobos' malt liquor to milk, and force Meadow Park's lead bigot, Mabel, into the stunning confession that she's really a *black woman suffering from sickle-cell anemia.*

Damn, that shit is wack.

As the 1970s dragged on, blaxploitation's political consciousness, however crazy, diluted, so that 1977's *The Guy from Harlem* was but the dullest of *Shaft* rip-offs. Al Connors is a private dick who *used to be from* above 110th Street but now lives in Miami. Connors's old CIA pal hires him to prevent the kidnapping of Mrs. Ashanti, foxy wife of an African head of state. Al's other mission is to retrieve the daughter of

a hoodlum, kidnapped by villain Big Daddy. Shot in a series of rooms with velour wallpaper, *The Guy from Harlem* is flat and deadly slow. It marked only one of two film appearances by star Loye Hawkins, who flubs simple lines ("They'll be picking you, ah, you up") and doesn't do any better with his kung-faux scenes. It scores 17/100, which puts it right down there.

BEATTIED TO A PULP / BLOCKBLUSTERS NOT AT BLOCKBUSTER

I take a couple of days off work so that I can spend time with Ava and Clare and serve Bad Movie Bingo without always having to stay up until the wee small hours. The past six weeks have been taxing. I've mostly given up on early-morning bad movies. It's just not the way to start the day. So, the routine begins around 6:30 a.m. when Ava starts yelping to be freed from her crib. Then, while one of us has the "sleep in," the other begins the messy-funny process of nappy changing, breakfast flinging, and toddler wrangling. When we're both up, I'll get ready for the office and Clare plans how she'll keep Ava entertained while also writing, subediting, and proofreading *Hot Wheels*. I'm typically at *Empire* from about 8:30 to 5:30, then it's home for more Ava shenanigans, until we get her down to bed around 7:00 p.m. Over wine, Clare and I cook dinner and chat. Sometimes, she'll watch the TV shows she likes while I retreat to the bedroom to endure African American Nazis or mutant alien xenomorphs. Usually, however, we'll either watch *The Daily Show* and *The Colbert Report* or talk about our day until 9:00 or 10:00. Such normalcy is important to maintaining our relationship, lest Clare make good on her "bad-movie widow" gag. When it's time, we say our goodnights, she settles in for a sensible and sane eight hours' sleep, and *then* I watch my bad movie, finger ready to hit the pause button when I encounter a line of dialogue or scene I can't

quite believe and need to rewind and take notes on. Typically I'm done by about midnight or 1:00 a.m. Then it all starts again. Needless to say, I'm bleary-eyed a lot. So, a few days off work is a nice breather and I positively embrace bad-movie matinees.

First Bad Movie Bingo throws out ball number 28, the Warren Beatty double bill. Clare is delighted to revisit 1987's *Ishtar*—she's already seen it twice, to my never. And as I watch it, I realize the reputation of this comedy, starring Beatty and Dustin Hoffman as singing rubes stuck in the Middle East, has more to do with its box office failure than being out-and-out terrible. In fact, the first half is pretty funny, and there are still laughs in its stumble to a finale. Not so with 2001's *Town & Country*. This indulgent, horrible comedy stars a past-it Beatty as a lothario who cheats on wife Diane Keaton with Nastassja Kinski, Andie MacDowell, and Goldie Hawn. It's a charmless, geriatric rutting rampage, and the monstrous budget is hard to fathom, given that Woody Allen has lately been making housebound sexual anxiety noncomedies every bit as bad for a fraction of this blowout's $90 million budget.

The next triple bill of flicks were similar or even bigger disasters and have in common that they've been hidden away ever since, like red-haired stepchildren. Imagine it today—flops so bad the studios didn't let them get a DVD release. Come to think of it, not such a bad idea. To find these movies meant tracking down collectors who'd taped them off rare TV screenings.

While Ava naps and Clare works on *Hot Wheels* in the study nook, I settle into 1973's *Lost Horizon*, the legendarily awful *musical* remake of Frank Capra's 1937 classic. An all-star cast of seekers—Sally Kellerman, Michael York, Peter Finch, George Kennedy, and Bobby Van—are spirited to Shangri-La, literally constructed from leftover sets from 1967's *Camelot*,

which is populated by Olivia Hussey, Liv Ullmann, saintly elder John Gielgud, and a lot of monks. The secret of this mountain lamasery is, of course, that its citizens age so slowly as to be immortal.

I experience steadily mounting dread as I brace for the first song. When it arrives—Olivia Hussey dancing like a dervish and lip-synching hippie-drippy *Share the Joy*—I'm relieved it's not *too* bad. Foolishly, I relax, which means that I suffer the full impact when, at precisely fifty minutes, forty-eight seconds in, Ullmann's schoolmarm and her students burst my eardrums. "The world is a circle without a beginning and nobody knows where it really ends!" they chirrup as they skip up a hill.

It gets much worse when monks sing the excruciating pro–family values hymn *Living Together, Growing Together*. "Start with a man and you have one/Add on a woman and then you have two/Add on a child and what have you got? You've got more than threeeee! You have got what they call a famileeeee." Holy God. The original cut extended this sequence to *twenty-three minutes* and included a fertility dance by men in thongs. This footage is mercifully lost.

On it goes. Finch and Ullmann *think* a duet. Kellerman and Hussey trill *The Things I Will Not Miss* while they cavort around the world's greatest library—stacked as it is with what appear to be Reader's Digest Condensed Books. All this schmaltz seems to have been concocted by Burt Bacharach and Hal David pureeing every ad jingle and bumper sticker of the Me Generation.

"Come check this out!" I cry to Clare.

I rewind and start the library scene over. I roll around, beset by cringe attacks. Clare looks from the TV to me a little bemused.

"Okay, neither of them can dance, but it's not *that* bad," she says.

I wonder how two people can hear and see things so differently.

I wish Ava were a bit older. She could settle it. As is, she's up now, redistributing Cheerios on the rug in revenge at being denied quality time with Dora.

I watch *At Long Last Love* the next nap time. After this pastiche of the idle-rich screwball comedies was released in 1975, Peter Bogdanovich took out ads to apologize for his movie—which had been roundly blasted by the critics. I'd say both were overreactions.

The film features sixteen songs by Cole Porter as Burt Reynolds's bored millionaire hooks up with Madeline Kahn's stage siren and Cybill Shepherd's disenfranchised heiress latches onto Duilio Del Prete's playboy. John Hillerman and Eileen Brennan are the hired help. Romantic ping-pong ensues.

The costumes and production design are superb. The cast can't sing but I don't mind because Porter's witty lyrics are like off-key dialogue and often celebrate such vocal flaws. "I feel a sudden urge to sing/The kind of ditty that invokes the spring," warbles Reynolds seductively to Shepherd. "So control your desire to curse/While I crucify the verse."

"I'm quite liking this," I say to Clare, who's again working on articles whose headlines more often than not feature the word "ZOOOOM!"

"It's dreadful," she says.

"You're sure?"

Clare comes over and sits on the couch. Yep, she's sure. Me, I think Cybill and Burt sound all right. The only thing that's sure is that with two such tone-deaf parents Ava's chances of being a musical genius seem limited.

Perhaps if 1980's *Inchon* had been a musical it might've fared better. As is, this fiasco—funded by the Sun Myung Moon's Unification Church to the tune of $48 million, or $140

million adjusted for inflation—remains one of the least-seen financial disasters ever, despite it starring Laurence Olivier as Gen. Douglas MacArthur.

What made it to the screen *is* big—even to eyes accustomed to seeing a million orcs created by a special effects magician pressing Apple-Shift-O. In this artless epic about the Korean War's Battle of Inchon we see endless queues of refugees and it's mind-boggling that every one of them is a real extra, though God knows if they saw any Moonie money. Problem is, we don't care about anyone in the film, least of all putative hero Ben Gazzara's commando, who has to stop screwing his Korean mistress to report for duty, and his ex-wife, Jacqueline Bisset, who has to interrupt her trinket shopping to save orphans. Like the tagline says, "War changes everything."

Nor do we care for Olivier's hewn-from-ham Colossus. At the outset, the general has to get over the notion that, at seventy-one, he's too old for this war shit. His doting wife helps by saying things like, "If there's anyone who can save this world you know it just has to be you." Mac accepts his burden and parts with a hilarious blend of the historic and domestic. "I know, don't say it, I shall return—but not too late for dinner!"

Sir Larry's porcine performance deserves roasting but, in fairness, he also captures the preening nature of MacArthur, who reportedly wore makeup and girdles so he'd look the man of destiny. And, as high camp as Olivier's prayer scenes are, they also sound pretty accurate. MacArthur—who tried to *convert* post-WWII Japan to Christianity by importing two thousand missionaries—hoped the legacy he left to his son would be the memory of their daily recital of the Lord's Prayer. Such piety was what inspired Reverend Moon to choose him as a subject, after his earlier movie projects—reportedly about Jesus Christ and Elvis Presley—failed to get off the ground.

MADONNA: UNCOUTH OR BARE

It's difficult to explain—without going into embarrassing detail—what Madonna meant to a fourteen-year-old Catholic boy as she writhed her way through the *Like a Virgin* video clip. Put it this way. I think I spent a goodly part of that year wishing I was that Venetian gondola. Naturally, such feelings came with a sense of guilt. Until that point, the word "Madonna" had conjured up God's mom, not a smoldering songstress-sexpot.

My pubescent passions for Madge soon cooled. And over the years I've actually grown to dislike her, although that feeling has recently been complicated by the knowledge that her company produced *Material Girls* and without that I wouldn't be where I am today—which is about to watch four of her movies. Wasn't that a *Twilight Zone* episode once?

Anyway, what pisses me off about Madonna is that she, more than anyone, fostered the cult of celebrity whose trickle-down effect now has the world in the thrall of Paris Hilton, Britney Spears, et al. I draw a straight line from the it's-all-about-my-bad-behavior documentary *Madonna: Truth or Dare* to reality TV rubbish like *The Simple Life* or *The Hills*. It paved the way for the obliteration of the public-private divide if there's fame and fortune to be had from "exposing" all.

It's the business-minded cynicism that riles me. Madonna's constant reinvention isn't a sign of creative genius but ruthless financial acumen that parasitically feeds off any youthful trend, be it techno, Latin pop, voguing, crumping, or parkour. Should some enterprising hoaxer from Harlem or Brixton issue a manifesto declaring cheese-grater music impossibly "now" Madonna would no doubt be seen bloodily twanging one in her next video clip.

But it's easy to forget that the Material Girl's richness of

embarrassments began with her *acting* in 1979 in *A Certain Sacrifice*. This grimy specimen of avant-giardia, which marked the start of her four-decade campaign to become a screen siren, is about an angst-ridden suburban slacker, Dash, who runs away to New York City. There he falls for Madonna's Bruna, who already has a "family of lovers." We see her with a girl, two guys, and a toy spider in an achingly pretentious soft-core warehouse sex scene in which Madonna yells garbled rubbish about masters and slaves and simply awful electronic music plays. This was the warning sign the world ignored at its own peril.

Later, when you can make out Madonna's dialogue, the "saucy" inanities prefigure any number of her later lyrical banalities. "I don't want you to be my child and I don't want to be your mother," she tells her boy toy. "I want it to be like a dance, a dance without steps."

After Bruna is raped, she and her family get revenge by torturing and slicing up the offender at a gig where her followers writhe wildly. We exit on another sex scene that has Dash lovingly smearing the dead dude's blood over Madonna's face and breasts.

When this Super 8–shot cheapie surfaced in 1985, Madonna fought to prevent its release—an episode conveniently forgotten by the gal who now goes around in a "Censorship is un-American" T-shirt. Conventional wisdom suggests that she was embarrassed at what she'd done as an aspiring dancer living on the breadline before getting rich on the likes of "Borderline." I think she might've been pissed that the next two decades of her public persona, her game plan, was already laid bare.

At least *Sacrifice* only runs sixty minutes, which is bearable compared to the ninety-seven minutes of 1986's *Shanghai Surprise*, which starred Madonna and her new hubby, Sean Penn, then the world's most famous couple and nicknamed the Poison

Penns for their tabloid antics. Set in Japanese-occupied China of 1937, this has Madonna as a *missionary*—which, by my estimate, is 12 percent *less* believable than Denise Richards as a nuclear physicist in that James Bond movie—named Gloria who enlists her boozehound, Glendon, to help her find a stash of opium that'll ease the suffering of soldiers. Despite her moralizing, she screws him to put him under her obligation. A pseudoreligious figure who uses sex for business manipulations? Say it isn't so! Despite the real-life romance there's less chemistry here than on the *Fame* high school curriculum. It's truly dreadful stuff—long, boring, passionless. Madonna is the worst of it, flatter than a pancake under a stack of whales, unable to deliver a line as fruity as "You deceitful, jelly-spined, back-stabbing bastard!" without it sounding like white noise. She ruins scenes when she's only in the *background*, eyes darting relentlessly despite a frozen expression.

Madonna's repeated movie failures didn't deter her and thus *Body of Evidence*. Here, she has a more familiar role, as sexpot Rebecca Carlson, who's accused of killing her lover through the surefire method of kinky sex. Hence, the title and dialogue like, "She is the murder weapon herself." Willem Dafoe is Rebecca's defense attorney Frank Dulaney. I kick myself for not having asked him about this when I met him at a party a few years back. A down-to-earth fellow, Dafoe had Chris and me in stitches with his story about playing a practical joke that involved something called "Shit-in-a-Can." I would've loved to hear how he kept a straight face at Madonna's deadly delivery of "Have you ever seen animals make love, Frank? It's violent but they never really hurt each other." And it makes no sense anyway because Rebecca's all about hurting him when she's horny. She ties Frank down, pours hot wax on his penis. Ouchy. In another scene, she throws him down on the hood of a car that's covered in

broken glass and grinds him with her Madge-vadge.

Body of Evidence was released in early 1993 as part of Madonna's three-pronged campaign to bring B&D soft-core sex to the masses. Her other efforts were, of course, the *Sex* book and the *Erotica* album. The former assumed people wanted to have their coffee while looking at Madonna in *shocking* poses (her face planted in a dude's butt!) and reading her reminiscences about childhood libido. ("I stayed on fire and burning, tormented and yearning until that glorious day when finger found flesh and with legs spread open and back arched, honey poured from my 14-year-old gash and I wept.") The latter's title song served up all sorts of "liberated" notions about pleasure and pain but drew the line at explicit lyrics that'd cut into profitable airplay ("I'll give you love/I'll hit you like a truck/I'll give you love/ I'll teach you how to"). *Body of Evidence* isn't any sexier and when Rebecca's not giving him a hand job and Frank's not raping her, it's about dull courtroom scenes, random twists, and Madonna playing innocent, the one persona she'll never pull off.

By 2002, Madonna was still at it. Having moved on from flogging fake fetishes, she reinvented herself as a British lass by marrying likely lad film director Guy Ritchie. Their first collaboration was the music video *What It Feels Like for a Girl*, in which she picks up an elderly woman from—*chortle!*— the Ol Kuntz Guest Home in her muscle car and then goes on a crime spree. The clip was banned in many parts of the world. Their feature film *Swept Away* didn't need prohibition—most people had the good sense to stay away, and it went straight to video in Madge's new homeland.

Madonna is Amber Leighton, an heiress billionaire harpy cruising the Mediterranean with her rich asshole friends. Amber reserves the worst of her vitriol for lowly crew member Guiseppe, but on her shrill insistence they take a Zodiac boat

out for a spin, get lost, and wash up on an island where she becomes his slave and he becomes her master. Sexual politics are set back five centuries as romance blossoms.

With her face screwed up, projecting elitist self-absorption, condescension, and hatred ("I would rather fuck a pig than kiss you, monkey boy!"), Madonna's at her most convincing. Alas, woodenness returns in scenes where the couple make cutesy animal noises, play charades, and indulge in sexy-clinch montages assembled with the raw sensuality of a shampoo ad. What also works against Madonna is that Ritchie bathes his wife's leathery tan and overpumped body in golden hues. She's so yellow she looks like she an escapee from *The Simpsons*.

Madonna haters will find abundant pleasures in *Swept Away*. She's forced to wash clothes, gets hit in the face with an octopus, and has to grovel as she whimpers, "Yes master." I can't hate it as much I should—and this is my second viewing of the thing. Perhaps it's because a genetic imprint of the 1974 original's class consciousness somehow lingers, or perhaps because I appreciate that for all the saccharine of the middle act Ritchie at least follows through with a depressing resolution.

Dear God. I'm thinking *positive* thoughts about *Swept Away*! What have the past two months done to me?

STATUS REPORT

Worst this month but disqualified as porn: *Anus Magillicutty*
Worst this month: *The Guy from Harlem*
This month's runners up: *Shanghai Surprise, Thunderpants*
Guiltiest pleasure: *The Black Gestapo*
Movies watched: *66*

MARCH

I look at this slush and try to remember—at one time I made good movies.

—Carl Anthony as film director Johnny Ryde,
in Ed Wood's *The Sinister Urge*

HOLY WOOD!

Growing up, we were always a family of movie watchers. When my mom passed away in 2006, I devoted my only *Empire* editorial to how her guiding me through early screenings of *The Wizard of Oz* and *Psycho* greatly informed my appreciation of how cinema could be artistic, scary, and funny all at once. Her simple advice—"If a movie doesn't grab you within ten minutes, it's probably not going to"—similarly has stuck with me, both as a reviewer and as a would-be scriptwriter.

Dad's appreciation of movies was less theoretical but also resonant. Two decades of watching war movies with a detail-oriented retired army reservist—"Look at that, walking on a ridge in silhouette!" followed by Dad making a machine-gun noise to indicate he'd just killed all of our heroes—bred an intolerance for flagrant inauthenticity. It was also Dad, who as a salesman for Harper & Row, one night brought home J. Hoberman and Jonathan Rosenbaum's fantastic 1983 book

Midnight Movies, which expanded my film reading beyond *Famous Monsters*, *Starlog,* and *Fangoria* and opened my eyes to—and created an appetite for—the alternative cinema of George Romero, John Waters, David Lynch, and Ed Wood. A year later, through his connections, he put me forward for a "Kids Rate the Movies" feature in the *Sydney Morning Herald*. My 300-word review of an Aussie flick called *Street Hero* wasn't exactly Pauline Kael caliber ("The only fault I could pick, in my opinion, is that some scenes are a little unrealistic") but it was a start and definitely helped chart my course.

Dad's staying with us for his seventy-sixth birthday. We have a lovely backyard dinner and he surprises us by telling us he once—long before Mom—romanced a minor model who went on to bit parts in a few Hollywood movies. The things you keep learning about your parents. Usually, at this point in the evening, I'd put on whatever recent Hollywood film it was that Dad hasn't seen. But tonight the first of Ed Wood's feature films beckons. Dad thinks he might want to watch *Glen or Glenda*.

"What's this one about?" he asks.

While he likes costume dramas, I'm not sure he'll enjoy a cross-dressing psychodrama.

"Ed Wood's called the worst director who ever lived," I explain. "He was also a transvestite. When he got to make his first movie, he made it about his love for women's clothes."

"It's a bit like a documentary then," says Dad, unfazed as he plumps the cushions on the other couch.

Um, well, sort of.

Edward D. Wood Jr. is synonymous with bad movies now but he was for two decades almost forgotten by critics and authors. It was the public who rescued him from obscurity by voting him the world's worst director—and *Plan 9 from Outer Space* the worst film ever made—in a poll that formed the basis for Harry and Michael Medved's 1980 book, *The Golden*

Turkey Awards. He'd been left out of the predecessor, Harry and Randy Dreyfus's seminal 1978 tome, *The Fifty Worst Movies of All Time*, but now a cult was well and truly born.

After reading about Wood for years, I first sampled his work in 1987 when, for my birthday, some friends and I went to a "world's worst" triple bill of *Plan 9, Glen or Glenda,* and Phil Tucker's *Robot Monster.* Sufficiently baked, we got the giggles we'd come for, but what surprised us was the *surrealism* of these movies. *Glen or Glenda*, in particular, seemed cut from the same cloth as David Lynch's *Eraserhead*, which we'd caught at the same cinema a few weeks earlier.

Twenty years later and *Glen or Glenda* is still a weird, wild one-off work of art. Wood's 1953 debut opens with Bela Lugosi—once an A-list Universal star on the strength of 1931's *Dracula*, now a half-forgotten morphine addict—rattling around a lab and sitting in an armchair surrounded by Halloween props. He's some sort of God-like creator.

"Life has begun! Ha! Ha! Ha!" Bela rants—only to be cut off by my dad's full-bodied snore. I gently rouse him and pack him off to bed.

Dad misses out on sixty-five minutes of lunacy, ineptitude, and sincerity. Under the screen name Daniel Davis, Wood plays Glen, a secret cross-dresser who needs to come clean to his fiancée, Barbara (Wood's real-life girlfriend Dolores Fuller), not least because his obsession with her angora sweater is getting out of control. The second, less-remembered story is about another man who wants to become a woman via hormones, sex-change surgery, and learning to walk, talk, and smoke like a girl. Producer George Weiss also took it upon himself to splice in a mild B&D lesbian scene.

Laughs come from Wood's bizarre visuals, such as Glen tortured by devils in his living room, and from the tin-eared script, which has Lugosi raving about green dragons, puppy

dog tails, and warnings to "Bevare!" Over stock footage, which comprises about 20 percent of the movie, the narrator muses solemnly, "The world is a strange place to live in. All those cars. All going someplace. All carrying humans, which are carrying out their lives." Lines like that and "I am a man who thrives on learning—we only have one life to live" make me think Wood's spirit mischievously possessed George W. Bush *and* Donald Rumsfeld.

For its time, *Glen or Glenda* has a brave if mixed message. "Glen is a transvestite, but he is not a homosexual," we're told. It's a fantasy of a tolerant 1950s, in that Barbara accepts Glen's ways and offers him her angora sweater and offscreen Average Joes discuss how we should see people who have sex changes as no different from anyone else. Superficially laughable elements also contain grains of truth. Over stock footage of 1950s American men, we're told that hundreds of thousands of Average Joes wear lingerie beneath their suits, which, given rates of cross-dressing and the U.S. population at the time, is about right.

We take Dad up to Clare's parents' place in the mountains. We have lunch at a swanky hotel and I'm slightly mortified that amid these plush, old-world surroundings our Ava careens around, unstoppable, like some noisy, funny little windup demon-clown. Also a tad embarrassing—given that this is a few days for family—is that more than once I have to excuse myself with the now-familiar refrain, "Oh, well, I suppose I'd better watch a bad movie" or the slightly more jaunty, "Well, the next bad movie isn't going to watch itself!"

Thing is, the family doesn't mind, even if I try as much as I can not to discuss the films or the arcane trivia I'm learning about them. I mean, who, other than me, really cares that the producer of *Bigfoot* claimed to have been married to Marilyn

Monroe and promulgated the conspiracy theory that she was murdered? (I know, amazing, right?)

One thing I can't stop myself from doing is venturing into every thrift store, yard sale, and video library I come across, hoping to find bad movies in the bargain box. And on this visit, I strike gold, scoring a VHS of a movie called *Blame It on the Lambada* for two dollars. This thing is the *only* film I've ever encountered with no IMDb listing. And it "stars" Andy Warhol. The temptation to watch it immediately is almost overpowering. But I resist, and adhere to the order of the Bad Movie Bingo.

Wood's 1954 nincompoop noir *Jail Bait* is less inept than *Glen or Glenda* and much less interesting. The story has Don, a plastic surgeon's son, falling in with mobster Vic and his crowd. Because these dunderheads stop to count their loot *during* a robbery, they're forced to kill a night watchman and a secretary. Don wants to confess to the cops so Vic murders him and tricks Don's dad into giving him a new face.

The plastic surgery twist is recycled from the 1935's *Let 'em Have It* as surely as the maddeningly repetitive score is lifted from 1953's *Mesa of Lost Women*. One-time-only actor Clancy Malone is a plank as Don, while Dolores Fuller lumbers through her role as she did in *Glen or Glenda*. But even Edward G. Robinson and Barbara Stanwyck would've been hard-pressed to breathe life into the soft-boiled dialogue, which, in the words of the film's doc, "couldn't be deader."

Jail Bait features no underage temptresses—and was originally called *Hidden Face*—but here "jail bait" is what gangsters call guns. So too Wood's 1955 *Bride of the Monster* doesn't feature a marriage between babe and beast. The original title, *Bride of the Atom*, made at least a neutrino's worth of sense.

Lugosi is Dr. Eric Vornoff, a bat-shit brainiac trying to

create a race of supermen with radioactive mumbo jumbo. Yes, it's sad that the once-great actor has to wrestle himself into the arms of a limp mock-topus but this also has some intentional humor, as when Lugosi straps down a victim and smirks, "You will soon be as big as a giant, with the strength of twenty men. Or . . . like all the others . . . dead!" And there's a genuine pathos in Lugosi's "Home? I have no home!" speech—which Martin Landau recreated so beautifully in Tim Burton's *Ed Wood* that he won an Oscar.

Not *all* of the film's failures are Wood's fault. His investor coughed up on the condition that his talentless son take the lead role and that the movie end with a nuclear explosion, which makes no sense. Critics also take a bit of blame. The Medveds and others claim that Lugosi says of Swedish wrestler Tor Johnson's hulking Tibetan man-beast, Lobo, "He's as harmless as kitchen." Funny, sure, but the line is quite clear and is "He's as harmless as a kitten."

Bride was the last film Wood made with Dolores Fuller. As shown in Burton's biopic, the director relegated his girlfriend to a cameo, replacing her with Loretta King, who he mistakenly thought wanted to invest in the flick. Now in her eighties, Fuller was happy to talk to me about her experiences. What I didn't know, the first time I called her at the Las Vegas home she shares with her husband Phil Chamberlin, is that in the past seven years she has survived *two* strokes *and* a devastating car crash. It took a few calls before she was up to the interview.

A half century hasn't dimmed the pain of Wood's betrayal, a treachery intensified by the fact that Fuller was the first to support him. "I was the only one giving him money," she said. "I had a home and I gave Eddie a bedroom and an office. I had two TV show jobs—*Queen for a Day* and *The Dinah Shore Show*—so I had lots of money coming in and I was able to help him because I believed in him."

When she lost *Bride* to King, Fuller wasn't just miffed, she was suicidal. "I was mad as hell," she said. "I got in the car and just drove like a maniac through the hills! I didn't care if I got killed or not. To work a whole year, and to supply the money, and then have the part that I had studied given to another girl? My God!"

Fuller left Wood soon after, finding greener pastures as a songwriter for Elvis Presley, Nelson Riddle, and Peggy Lee. But she has fond memories of Eddie, as she calls him still. She says he was funny, busy, a great dancer and she remains amazed at what he could get on-screen with the smallest of budgets. As for the drag thing, she says she *didn't* mind once she found out, and that Eddie and Danny Kaye would sometimes indulge their shared fetish together. Her one regret is rebuffing Wood's attempts to stay friends after they split. "I wish I'd stayed closer to him, and not let him be influenced by liquor," she said. "He started drinking after things went bad."

Wood wrote 1956's *The Violent Years*, directed by veteran Hollywood editor William Morgan, and this girl-gang juvenile delinquency flick is hysterical, in both senses of the word. The story is a flashback framed around a judge admonishing bad babe Paula's parents for their neglectful, materialistic ways. Lack of love, see, bred a girl who led her gang in libidinous pajama parties, gas station robberies, beatings, rape of unsuspecting boys, commie-inspired vandalism, murder, and, finally, jailhouse pregnancy

"These fool kids, when will they learn?" asks a cop.

"These aren't kids—they're morons," answers the doctor.

The Violent Years' lurid spiral of sensation dressed up as sanctimony amuses, but it lacks Wood's personal touch. That's because he was saving himself for *Plan 9 from Outer Space*. The most famous bad movie of all time was shot in 1956, but went without a distributor until 1959.

Even having seen *Plan 9* twice, I'm still struck anew by the experience—the true sign of a classic of some sort. The film's enduring appeal—and fame—has much to do with its scope: Wood didn't just make a monster movie, he made an *alien invasion epic.*

Flying saucers have been buzzing America for months, blasted at by the military. The space visitors come in peace and it's the U.S. government that refuses to communicate—or even acknowledge their existence. The spacemen are so fed up they've instigated Plan 9, which revives recently deceased earthlings and controls them via radio. Whatever it takes to get the message across that humanity's on the verge of discovering the Solaranite bomb—a weapon that detonates sunlight itself . . . and will explode the entire universe!

The scenario is like *Night of the Living Dead* via *The Day the Earth Stood Still* and the awesomeness is in the massive gap between Wood's ambition and his talent and resources. The amateurishness is staggering and celebrated. Characters talk across day and night, the cardboard crosses in the tiny set-bound cemetery wobble and fall over. It's charitable to describe hobby kit model saucers as "flying" when "bobbing" will do nicely. Stock footage unspools by the mile, characters are menaced by spotlights, a plane cockpit is famously little more than two chairs, a curtain, and a boom-mike shadow. From thickly accented Tor Johnson on down, no one can act.

Wood's dialogue has an inane circularity that's mesmerizing. "We are all interested in the future, for that is where you and I are going to spend the rest of our lives," warns fake psychic Criswell in his introduction. "And remember my friends, future events such as these will affect you—in the future."

Character banter maintains the pace.

COLONEL: *This is the most fantastic story I've ever heard.*
JEFF: *And every word of it's true, too.*
COLONEL: *That's the most fantastic part of it.*

The pinnacle of Wood's folly was that he built *Plan 9* around snippets he'd shot of Bela Lugosi for another project. After Lugosi died, Wood used the footage and shot new "bridging" scenes replacing the star with his friend and chiropractor, who looked very different and who was considerably taller. Wood thought he'd get away with the switcheroo if the stand-in held a cape up to his face.

But *Plan 9* does have striking images in protogoth Vampira twitching through the cemetery and a spookily lit Tor Johnson rising from his grave.

Wood's subversive ideas also endure. One of the most famous lines has Dudley Manlove as alien Eros denouncing earthlings with, "Your stupid minds! *Stupid!* STUPID!" because all-American, Eisenhower-era hero Jeff has idiotically claimed that a universe-destroying weapon would make the United States *stronger*. In *Plan 9*, it's America that picks a fight with friendly visitors and who keeps news about alien life from their own citizens. No wonder that in *The X-Files* Fox Mulder says he's seen it forty-two times, which, as Douglas Adams fans know, makes it the meaning of life. David Duchovny's Mulder claims *Plan 9* lets his mind shut off so he can make otherwise impossible leaps of logic.

One such leap is found in Wood's next script, 1958's *The Bride and the Beast*. This has he-man Dan Fuller's new bride, Laura, almost molested by his basement-dwelling pet gorilla, Spanky. She's so traumatized by the event that, to recuperate, they go to stock-footage Africa where hypnotism reveals she used to be a gorilla in a past life!

The beast in the basement is Freud 101 but it's daring for

1958 that the hypnosis scene is a thinly disguised depiction of female orgasm, with Wood laughing up his angora sleeve as the doctor says to Laura that posttrance, "You will feel rested, but you will want a cigarette."

Most bizarre is that this ends with Laura spirited off to live in apparent sexual bliss with the ape. From *King Kong* down the genre inevitably intimates interspecies sexy times, but it took Wood to write one that actually follows through on the love that dare not howl its name.

Wood's slide started with phony-spiritualist horror *Night of the Ghouls*. He wrote and directed this in 1959 but it didn't see the light of day in his lifetime because he could never afford to pay the fees owed the processing lab. Criswell narrating from a coffin ties this to *Plan 9* but it's a sort-of sequel to *Bride of the Monster*. There's an attempt at intentional humor. Wood's photo adorns the wall of a police station—presumably he's wanted for something—and, borrowing from *Famous Monsters*' founder, Forrest Ackerman, the fakir's name is Dr. Acula. But this is still a yawn-worthy mishmash.

The last nonporn movie Wood would write and direct, 1960's *The Sinister Urge*, has a gang peddling smut to kids, which inspires a maniac to murder models, which inspires the cops to do a *drag* stakeout. This one sees Wood aware of his own prospects. "I look at this slush and try to remember at one time I made good movies," sighs a director who has succumbed to porn. An office is decorated with posters for *Bride of the Monster, Jail Bait, Plan 9,* and *The Violent Years*. "Those were made by friends of mine," says a sleazy producer to a naive ingenue. "I think you'll find my type of picture entirely different."

I've watched these Woods late at night and, despite their deficiencies, there's a comforting, nostalgic feeling in these creaky black-and-white cheapies. But the prospect of the next

few nights feels entirely different—and not in a good way.

That's because porn was to be Wood's future, with few exceptions.

"But if you're not going to consider them as contenders, then why include them?" asks Clare.

It's not an unreasonable question for my woman to ask as she's getting ready for bed—alone again—while I'm preparing to spend the first of four nights watching grind house porn.

I tell Clare I want to see them as a bulwark against the easy glamorization of his "outsider" life, and as a reminder of his pitiful decline into this sort of dreck, outright alcoholism, homelessness, and early death at fifty-four.

I get a harrumph, a peck on the cheek. I sympathize. For the past nearly five years, we've usually gone to bed at the same time and now the comfortable routine has been shattered. By decades-old filth.

But the shows must go on and I settle in with a DVD of the tastily titled *Orgy of the Dead*, made in 1965 by director A. C. Stephen from Ed Wood's script. To say Wood "wrote" this is misleading because it's mostly a series of supernatural strip-tease acts filmed on a graveyard set. Some of the girls are knockouts, but the long dances are so dull the mid-1960s raincoat brigade must've dozed off mid–jerk off. No boners about it: *Orgy of the Dead* is bore-lesque.

But it's positively charming compared to the next night's offering, 1969's *One Million AC/DC*, which Wood wrote under the pseudonym Akdov Telmig—"vodka gimlet," his favorite drink, spelled backward. The new grimness announces itself when topless cave girls get tangled up in a virgin sacrifice that involves a sacred spear put where it doesn't belong. Inside the cave, it's all grimy soft-core sex, while outside what is literally a cheap toy dinosaur occasionally munches a Barbie doll cave girl.

This is the tar pit of cinema, worse than anything I've seen so far. I give it 10/100. But the hideous occult-sex effort *Necromania*, Wood's last film as director, is even worse, rating 8/100. I only watch the soft-core edit, which is filled with hippies assiduously licking each other's bellies, and I can live without the X-rated version.

The Love Feast, from 1969, is sad for graphically showing how far Wood fell. Ten years earlier, he'd been a handsome Errol Flynn look-alike. Here, aged just forty-five, he has a boozer's bloated body as he plays a lank-haired old photographer who hosts an impromptu orgy. Had Tim Burton re-created this, *Ed Wood* would've taken on a far more bruised pallor, with a leashed Johnny Depp crawling like a dog for women who've made him wear lingerie and heels and lick their boots.

To read about Wood—which I have been obsessively these past few weeks—is to realize that, despite his terrible decline, he never gave up or stopped working. And not everything he did was porn.

The year 1970 saw one of his monster scripts produced as *The Revenge of Dr. X*. This has rocket scientist Dr. Bragan going on vacation to Japan, accompanied by his pet carnivorous plant, which, via the magic of lightning, he turns into a man-sized monster with a turnip head and limbs that end in oversized flytraps. It's Frankenstein, then, and pretty weak, if not without amusement from Bragan, who wants to prove "beyond a shadow of a doubt that man is descended from plant life!"

Most of Wood's writing in the 1970s was for A. C. Stephen's "swinging" flicks but 1974's *Fugitive Girls* is an update of the girl-gang theme of *The Violent Years*. Five prison-farm escapees roam the countryside, steal cars, beat up bikers, and bicker a lot. There's a lot of gratuitous nudity as the girls strip to don

hippie rags—and then take them off again because they're lice-ridden—and rape any men or women they come across.

Fugitive Girls also marks Wood's last screen appearance. He at least avoids *Love Feast*–level degradation as Pop, the doddery old caretaker of an airfield. Fittingly, Wood scripts the latter as a pure nincompoop who calls the sheriff (also Wood) to report the girls while a) three feet from them and b) muttering his intentions loudly. It doesn't work out well for him.

As for Wood being the world's worst filmmaker, well, on my scoring his worst "classic" flick is *Jail Bait*, which ranks 22/100, scoring just 5/20 for general entertainment value. *The Sinister Urge* and *Ghouls* aren't much better—27/100 and 28/100—but film fans of all stripes really ought to see *Plan 9* and *Glen or Glenda*, both of which tip over into the 13/20 mark in terms of perverse enjoyability. As for the porn flicks? Don't go there.

DEL'S DEADLY DOUBLE

Out in the real world, U.S. film magazine *Premiere* "migrates" to an Internet-only version and I wonder how long *Empire* has left. I hear the phrase "dead tree format" bandied about and it's rumored our company is to be sold.

It's during uncertain times like these that I reflect on my alternative existence. Cue swirly flashback to my summer vacation in 1984 when, hunched over my new VIC-20 computer, I taught myself BASIC and invented a bunch of games that'd fit on the machine's measly 3.5KB of memory. My creations were little rip-offs of arcade titles like *Tron* and *Q*Bert* but they were pretty good for a kid. For a while, I sold them— stored on audiotapes, we're really talking the dark ages here— via newspaper classifieds and made a couple hundred bucks. My interest soon waned, replaced by a gnawing desire to be

more integrated with my pot-smoking, girl-chasing peers. But
. . . *but* . . . if only I'd kept going, I might now be a billionaire
IT geek with my own private island staffed by an army of
robot monkeys.

My place in the salaried universe—not to mention advances
in profitable gaming technology and the value of our primate
cousins—became clearer today when *Empire*'s stablemate
men's magazine performs a stunt in which a rhesus macaque
takes on an editor in a PlayStation 3 competition. The little
monkey is as cute as a button but I want to weep when I'm told
he pulls down a *thousand dollars* a day for such appearances.
While I've often second-guessed abandoning my budding
computing career, this is the first time I've thought I might've
been better off as another *species*.

These strands—the Bill Gates life that could've been, the
grand a day made by that damned dirty ape, and the elusive-
ness of a greenlit script—become even more depressing when I
have to bump up my Visa card limit to make ends meet. That I
immediately spend some of these borrowed funds on more bad
movies just makes me worry about my mental health.

But, after this week's late-night grind house marathon, I've
now got a day off work, leaving the night free for quality time
with Clare. With Ava down for her nap, I say, "I gotta watch a
movie. I can do it in the bedroom if you like."

"No, it's okay," says Clare. "Just not too loud." She's on the
couch, reading a mystery novel.

Yesterday morning, after *Fugitive Girls* ran me past mid-
night, before heading into the office, I watched *Zombie Blood-
bath*, the 1964 debut from Connecticut-based filmmaker Del
Tenney. The movie remained unreleased until 1970 when ap-
propriately named distributor Jerry Gross acquired it and re-
titled it *I Eat Your Skin* so it could play more comfortably on a
double bill with his own production *I Drink Your Blood*.

Under either lurid title, it's a clunker. Our hero is novelist Tom Harris (not, it must be noted, the author of *The Silence of the Lambs*) who visits Voodoo Island, home of venomous snakes and voodoo zombies, because the babe-to-dude ratio is five-to-one. "Virgin natives just waiting for some sophisticated swinger like you to come along and pluck them off their tropical vines," is how his publisher sells it. Once there, Tom falls for scientist Dr. Biladeau's comely *white* daughter Jeannie. Shame her virginal status means she's marked for sacrifice by the natives. Even more of a shame that supposed stud Tom can't think of how he might make her less appealing to the tribe. Meanwhile, a six-strong army of porridge-faced zombies lumber around, created by the doc's attempts to cure cancer using snake venom.

Now it's time for Del's second and more famous work, *The Horror of Party Beach*, also from '64. This has distant cousins of Jar Jar Binks invading the natural habitat of himbos and bimbos whose mating ritual involves gyrating to surf-guitar band the Del-Aires. The comedy is deliberate if woeful, as when a jock ogles a jiggling butt and is inspired to ask, "Hey, that reminds me—did I bring my hot dog buns?" The special effects and makeup are dodgy but no matter because the monsters are still very good at killing coeds. Or, as a TV anchor reports it, "Rumors of an invasion from the sea took on a new dimension last night when over twenty teenage girls were brutally attacked and murdered during a slumber party." You don't hear that every day on *Fox News*.

The discordant music and minor gore gets under Clare's skin.

"This isn't very relaxing," she says. "And there's no plot."

"Yes there is," I reply, more engrossed than I care to admit. "Sea monsters are eating people—that's more plot than *Babel*."

Clare takes Ruth Rendell into the backyard.

If she'd stuck around, she'd have seen I was right; the sea monsters aren't just bloodthirsty, they're *horny*. So much so that one severs an arm smashing a shop window trying to get at a mannequin. I s'pose we've all been there. Anyway, the discarded limb is subjected to science that reveals the creatures are sea anemones that need our blood to survive. *And* they're human bodies kept alive by radioactive decay. Thus:

ELAINE: *They are the living dead? They're zombies!*
GAVIN: *Nothing so dramatic as that, Elaine. They're more like a jellyfish.*
ELAINE: *Radioactive zombie jellyfish? Then why do they look amphibian?*

To make up for the week of neglect, Clare and I drop Ava off at her aunty Sarah's place so she can have a sleepover with her three rambunctious cousins. We then do an afternoon date . . . at the movies. That's the bizarre thing about being a critic; when it's time to relax from work, you tend to still go see a film. In this case, it's David Fincher's *Zodiac*, and it's brilliant, providing plenty for us to chew on when we have a Mexican restaurant feast that night. Of course, I can't help but tell Clare about my bad-movie news—Rotten Tomatoes reckons *Ballistic: Ecks vs. Sever* is the worst film ever made—so I'll have to include it on the still-growing list. But she doesn't mind, and is similarly happy to lament with me the rash of remakes—*Piranha* and *Escape from New York* being this week's victims. The conversation rambles beautifully away from movies, though, from Ava's newfound ability to point to her ears-nose-mouth to the Sydney Harbour Bridge's seventy-fifth anniversary celebrations. Later, we taxi home and tumble into bed. This is how it used to be, before Ava, before Bad

Movie Bingo. Not that I'd change things, of course, but it's a nice night of just the two of us.

THE CURIOUS CASE OF BOB CLARK

I'm at *Empire*, helping to write a story on "The 100 Greatest Movies of All Time," when the phone rings. On the other end is Jimmy Foggo from Fremantle Media and he's asking me to audition for a new version of *The Movie Show*, Australia's most respected film TV program, whose American equivalent is perhaps *At the Movies*. Jimmy asks if I'm doing anything other than *Empire*. I mention my sideline as weekly film reviewer on Sydney radio current affairs program not dissimilar to NPR. I don't say anything about my self-imposed regime of sea monsters, cross-dressers, and African American Nazis.

I am going to audition but I am not going to get all excited because last year I tried out for such a gig and it went nowhere. That call came from a cable movie channel looking for a presenter. I was assigned *Dressed to Kill* and I honed a pretty decent review. But my preparation was no match for being slathered under makeup, propped in front of blazing lights, and asked to deliver my spiel from autocue as I tried to follow the red light from camera to camera. I wasn't an unmitigated disaster but my performance belonged in an Ed Wood ensemble.

My other TV misadventure was a two-show stint as fill-in reviewer on a national morning program. The first week my mouth turned into the Gobi Desert and I turned to the wrong camera, so that the back of my head rasped most of a critique before I saw the floor manager frantically waving me to the right lens. Happily, this went out *live*. Amazingly, they had me back and this time I at least looked in the right direction and spoke intelligibly. Unsurprisingly, I wasn't asked to join the "family" of regular presenters. I figured my status was more

that of a mildly brain-damaged exchange student.

Oddly, I'm finding that the Bad Movie Bingo is a great aid for focusing the mind away from day-to-day worries, and when I get home and spin it and it comes up with the bad flicks of Canadian director Bob Clark, all thoughts of what I'll say or wear to the audition in a few weeks fade away as the schlock obsession reasserts its grip.

As of today, Bob Clark has three movies in the IMDb's Bottom 100. It'd be four if more people had voted on *The Karate Dog*. What sets him apart from other hacks is that he's also made some bona fide hits. Clark scored a $100 million–plus success with 1982's *Porky's*, originated the modern slasher film in 1974's *Black Christmas*, and, at the other end of the seasonal-holiday spectrum created 1983's bona fide classic *A Christmas Story*. When I spoke to the amiable director last year, about the DVD release of *Black Christmas*, he was brimming with good cheer, and not at all offended when I probed about some of his less-regarded movies.

I asked him if he regretted giving the world the utterly reviled *Baby Geniuses* and its sequel *Superbabies: Baby Geniuses 2*. "Not at all," he laughed. "*Baby Geniuses* is not a great movie, but it had some charm and heart that most people don't give it credit for. The second one, well, it wasn't as good but it doesn't deserve everything that's heaped on it. I have no apologies to make." I hadn't seen either at the time so I wasn't able to decide if Clark was defending babies that only a parent could love. But I now wish I'd quizzed the man about *The Karate Dog*. And about his first bad movie, 1984's *Rhinestone*, the cowboy musical comedy that paired Dolly Parton and Sylvester Stallone. I make a note to drop him an e-mail.

When I sit down to watch *Rhinestone*, I am joined by Clare and Ava. It's our first bad-movie family event and I'm quietly thrilled we're sharing the silliness for once. Clare loves Dolly,

and is glad this isn't another crappy horror. Ava, meanwhile, misinterprets the TV being switched on as her getting to watch *Dora the Explorer*. No such luck, kiddo. But even Dora might be preferable to *Rhinestone*. Parton plays Jake, an affable gal with a good set of lungs, who's stuck singing in a Manhattan cowboy dive called Rhinestone. To get out from under her sleazy boss, she makes a bet that she can turn the next Average Joe into a country and western warbler good enough to win over the bar's tough crowd. Stallone's loudmouthed Noo Yawk cabbie, Nick, screeches in from stage right. Thus begins cinema's biggest matchup of big hair and bigger chests. In his unauthorized biography, *Smart Blonde Dolly Parton*, author Stephen Miller reports, "It was rumored that originally the film was to have a sequence featuring Dolly dancing cheek to cheek with Sly, but this was ruled out on the grounds that it was 'a physical impossibility.'" Not to say we go without seductive moments, as when she purrs to *him*, "Perfect timing, perfect body." It's a wonderful line, no doubt penned by Sly, who co-wrote the movie.

Dolly is no actress but she has a breezy charm. Any light comic potential is however *stomped to death* by Stallone's brutal mumbling and mugging. If you've ever seen a four-year-old loaded up on sugar showing off obnoxiously with a toy piano then you still can't imagine Sly attacking a keyboard, arms flailing as he screams "Tutti Frutti." It's one of the most infernal scenes I've subjected myself to. His "Drinkenstein" is up there, too.

Rhinestone is not only earsplitting. It's also eye-melting.

"Oh my God!" Clare screams. "Look at that outfit!"

"Which one?" I ask.

In this one frame, Dolly wears a skin-tight musk and cerulean jumpsuit while Sly's in a sport coat with rolled-up sleeves and a nineteenth-century bow tie. The worst-best comes last,

when he rides an electrically lit horse through Times Square dressed as Freddie Mercury might have—had NASA asked him lead an expedition to Alpha Centauri.

"Orse! Orse!" screams Ava, jumping up and down on the couch. Ava's commentary on the equine ending to *Rhinestone* isn't atypical. Almost overnight, she has acquired a vocabulary. There's Daddy and Mummy, car and bus, cat and backpack and map, cheese and cracker, pig, bear, and Tigger. "Uppie!" means "Pick me up, goddamn it!" while "Go-go!" is "Give me some yogurt, goddamn it!"

Being so advanced, and given she's demonstrated a fondness for snippets of Clark's work, I figure she might like *Baby Geniuses*. This 1999 turkey begins with Clark taking a dig at his *Rhinestone* star by naming the diaper-wearing hero Sly and having him bash on a piano as he wails like a cat passing a gallstone. This obscure in-joke—likely apparent to only someone who watches the movies back to back, a.k.a. me—is as funny as it gets.

The plot has Sly and his brother, Whit, overthrowing sinister BabyCo. Sly and Whit may be their names, but sly wit is what *Baby Geniuses* most lacks. There are lots of CG-enhanced babies wisecracking about "diaper gravy" and doing dress-up-and-dance montages. Even queasier are moments of sexual innuendo. When Sly tells a baby girl to take her clothes off, she responds with the flirty zinger, "Okay, slick, but at least you could take me to dinner first."

Ava doesn't watch it much, devoting her energies to pulling the nose off a teddy bear. But I do notice Clare has put her book down and is amused by babies recycling one-liners from *Jerry Maguire* and *Austin Powers: International Man of Mystery*.

"Did you like that?" I ask her as the movie ends on a package of "highlights."

"I thought the babies were cute," she says.

"I liked the bit where Kim Cattrall punched Kathleen Turner in the face," I say. I tally up my score for this one— 28/100, three less than *Rhinestone*.

"Ah, doo, ree, or, ai, ik," chimes in Ava.

We turn. Our child sits on the couch, putting crayons into a tin one by one.

"I think she's counting," says Clare, a mad gleam in her eye.

Ava doles the crayons back out of the box carefully. "Ah, doo, ree, or, ai, ik."

"She is!" beams Clare.

It *does* seem like Ava has suddenly become numerate.

"Either *Baby Geniuses* has superadvanced her," I say, "or it's made us so dumb we're hearing things."

Time to test this startling milestone. I crouch down and assemble the crayons. I hand an orange one to Ava.

"One?" I say.

She takes it, considers it, and sticks it in her mouth.

"Hmmmm."

In an ideal world, Ava would watch *Superbabies* and move straight to algebra. But the fruit of my loins has the attention span of a fruit fly, so I watch this at night, when I'm stricken with insomnia, and I can recommend it as a cure for sleeplessness.

The movie is about a superbaby named Kahuna who drinks green fluoro formula that gives him antigravity powers, CGI muscles, and the ability to beat up adults while making Three Stooges noises. His nemesis is Jon Voight's megalomaniac, Kane, who's set on world domination through children's TV.

Voight's überhammy performance is not recommended for observant Jews or Muslims, as he rambles in a thick East German accent that "ze mind control impulse vill come zhru se character of Modest ze Frog!" As a movie about the mind-

rotting effects of cynically contrived children's media, *Superbabies* is a terrific example of the mind-rotting effects of cynically contrived children's media. It's a 22/100. I hope Ava will watch 2004's *The Karate Dog*. It's about a dog. Who does karate. I put it on.

"Dora!" she demands.

"No, *Karate Dog*," I reply.

"Dora! Dora! Dora!" she screams.

"*Karate Dog*!"

"Dora! Dora! Dora!"

It's like a standoff with a small, nappy-wearing Japanese general ordering the attack on Pearl Harbor. I win only because I know how to work the remote control. She toddles off.

Cho-Cho is a high-kicking, talking mutt made out of computer pixels who's trying to solve the murder of his beloved Zen Master, played by go-to Oriental Pat Morita. Cho-Cho teams up with a geek cop named Fowler and together they bring down Jon Voight's industrial maniac who's bent on creating an eternal-life superfood. Jokes include Cho-Cho using a radio-mike hookup to help Fowler romance a beat-cop babe in an excruciating riff on *Cyrano de Bergerac* and a bunch of dud pop-culture jokes recycled from *Baby Geniuses*.

It's the cast that makes me wonder about this biz called show. Chevy Chase must've wondered how he went from costarring with Benji in 1980's *Oh Heavenly Dog* to *voicing* a dog in this dog. Voight produced on *Baby Geniuses* and *The Karate Dog* but still gave himself scenes in which he's covered in pustules or fights computer-generated Cho-Cho, which surely made him long for the simple dignity of being regurgitated by a snake in *Anaconda*. As the love interest, Jaime Pressly is asked to play it straight—not her strength—and in one supposedly reverent scene she's chewing gum as a measure of her disdain. Simon Rex, who plays Fowler, tries harder but he and

Pressly have no chemistry—even though they costarred in the sitcom *Jack & Jill* and dated in real life. What's astounding to me is that Rex's career began with solo jerk off scenes in gay hardcore movies like *Young, Hard, and Solo #3* and *Hot Sessions 12* and he *still* managed to work his way *down* from there. Even so, I prefer this gang—29/100—to the wisecracking babies.

SILENTS, NOT GOLDEN

It's audition day for *The Movie Show*. I awake at eight, have a shower, and, wrapped in a towel, rehearse reviews of *Rocky Balboa* and *Dreamgirls* into the blurry video function of our digital camera. And try not to think about this footage ever leaking out, Simon Rex style.

When I arrive at Fremantle Media, I'm ushered into a tiny office. There are no scorching lights, makeup, or teleprompter, just three relaxed chatty gents sitting opposite me. They ask about me and I tell them about *Empire*, the radio gig, general film fandom, and—God help me—my bad-movie odyssey. I offer way too much information about *Superbabies*. Happily, they think this is funny, rather than indicative of deep personality dysfunction.

The guys ask me to do my sample reviews into a simple camcorder. For the next four minutes, it's like I'm channeling a higher power. A higher power who doesn't stumble over words, um and ah, and go off on tangents. They say they'll be in touch.

After all that talk, the Bad Movie Bingo decides I need a vow of silents. So begins three late-night marathons of short films made before the sound era. Given most are lost, there's no way to present any comprehensive study of what sucked hardest in the early days of cinema, and their style defies comparison with the talkies anyway. My aim is merely to sample

pioneering efforts to see which of the elements we associate with bad movies were present when it all began. The answer is: all of them. But I can give these guys a break. They were just trying to turn a buck as they inadvertently created an art form.

The first person to capture photographic motion was Eadweard Muybridge and he was eccentric enough to make subsequent movie moguls look *smaller* than life. His debut project, commenced in 1872, was to make a series of rapid-fire photos of a galloping horse. The production took six years and went hugely over budget, making him the James Cameron of his day. It was also interrupted in 1874–75 when Muybridge murdered his wife's lover—a theater *reviewer*—and had to go through the inconvenience of getting a jury to acquit. But when finished, Muybridge's *The Horse in Motion* was a sensation and settled forever the question of whether all four hooves leave the turf at the same time. (Spoiler: They do.) Muybridge then turned his forerunner of the movie camera on naked ladies hopping across rocks or descending staircases. Before long, people started to get the idea that he'd exhausted the scientific value of his "movement studies" and was just a horny old hound.

The other papa of the flickers was Louis Le Prince. His 1888 *Roundhay Garden Scene*, a few seconds of Victorian folks walking on a lawn, is the earliest surviving motion recorded on film. That Le Prince disappeared on his way from Dijon to Paris in 1890, shortly before he was due to unveil his new invention, a movie camera, surely gives Dan Brown his next novel.

And so Thomas Alva Edison was left to be credited as the father of flicks, even though his three-second 1891 *Dickson Greeting*, the first publicly exhibited film, was directed and produced by—and starred—William Dickson greeting us as he

flourishes a straw hat. In 1894, things took a turn for the druggy with the first copyrighted film, the five-second *Fred Ott's Sneeze* showing the Edison employee having a nostril eruption after taking a pinch of snuff. Edison's minions then made shorts about men boxing, cats boxing, a flexing strongman, Annie Oakley firing her rifle, a beauty doing a butterfly dance, and the tasty recreation of the beheading of Mary, Queen of Scots. Thus were set the priorities of cinema: high times, fistfights, novelty animals, muscle-bound dudes, chicks with guns, exotic dance routines, and gory girl deaths.

Thomas Edison added porn to the repertoire with 1896's forty-seven-second *The Kiss*, directed by William Heise. Actors May Irwin and John C. Rice re-creating their already-controversial stage pucker for the camera was a scandal and Chicago editor Herbert Stone thundered, "Neither participant is physically attractive and the spectacle of their prolonged pasturing on each other's lips was hard to beat when only life size but magnified to gargantuan proportions and repeated three times over is absolutely disgusting! Such things call for police intervention." Mimeographed pamphlet *Ye Rotten Tomatoes* thus recorded its first "100% Rotten."

Over the next decade, Edison blazed an exploitation trail. He pitted teenage sorority girls against each other in a nighttime pillow fight. He made blaxploitation with two African Americans having a watermelon-eating contest. Re-creations of Spanish soldiers executing Cuban prisoners offered actuality snuff thrills. The disaster film came into its own with Galveston flattened by a storm surge of 1900. Then, like today, Edison did remakes, "reimaginging" *The Kiss* in 1900, with younger, more attractive lovers who sucked face longer.

But Edison's literally most shocking exploitation of the medium was 1903's *Electrocuting an Elephant*. Topsy was a star attraction at Coney Island but since the turn of the

century had killed three men. Her last victim was an abusive trainer who fed her a lit cigarette. Nevertheless it was decided Topsy had to die. Edison volunteered to fry her—and filmed the execution as a negative ad exposing the danger of competitor George Washington's alternating current. The sequence, showing the three-ton pachyderm billowing steam before she topples over, remains harrowing a century later.

In France, the Lumière brothers filmed workers leaving their factory, a baby getting fed, and a wall being demolished. It's the fascinated-with-the-medium stuff of YouTube. The Lumières hit gold, and accidentally anticipated the 3-D craze, with footage of a train arriving at a station, which had 1895 audiences ducking and screaming in terror. Georges Méliès took moviegoers on the seminal sci-fi *A Trip to the Moon* in 1902, but he also loved dismemberment gimmicks with 1902's *Sure Cure for Indigestion* showing a doctor slicing a patient up and stitching the limbs back in the wrong places, while 1904's *Decapitation in Turkey* saw four heads sliced off with one swoosh of a scimitar. Brits were in on the act, too. Cecil Hepworth's 1900 *Explosion of a Motor Car* has an auto inferno causing bits of burned body to rain down on a street, while G. A. Smith's 1903 lark *Mary Jane's Mishap* has a maid's blown-apart body fragments collected for a tombstone that reads "Rest In Pieces."

And when, half a world away, the first-ever feature film, Australia's 1906 bushranger tale, *The Story of the Kelly Gang*, was released, well, critics were almost as dismissive as Stone had been about *The Kiss*. Rather than celebrate this landmark, the *Bulletin* derided it as merely "twopenny-coloured melodrama."

To some grumps, the first movies were "bad movies"—even when no other alternative existed.

STATUS REPORT

Worst but disqualified as porn: *One Million AC/DC, Love Feast, Necromania*
Worst this month: *Superbabies*
This month's runners up: *Jail Bait, Baby Geniuses*
Guiltiest pleasure: *Glen or Glenda, Plan 9 from Outer Space*
Movies watched: *91*

APRIL

I want to go on record right now that this is the most stupid, dimwitted, idiotic, moronic piece of putrefied garbage that I have ever in my entire professional career—ever—had the displeasure of being involved with.

—Richard Dreyfuss as Detective Chris Lecce, *Another Stakeout*

JAPOCALYPSE NOW!

A writer friend lands a major TV deal for a comedy series with Fox and has serious Hollywood interest in his monster-movie script. Hearing the news makes me panic a little, wondering whether I'm wasting time I should be devoting to scripts. I've spent the past two years writing them in my spare time and on the long commute I did daily when we lived in the Blue Mountains. The screenplays are getting read in Australia, Britain, and the United States, and the feedback's generally good. But am I making a mistake putting them on the back burner when I should be trying to improve them and plug them harder, especially as I've had the *Two Twisted* script produced and screened on TV just six months ago? Strike when the iron's hot, and all that.

For instance, only a few weeks back, I met with an Australian producer named Vince Sheehan about my period romance script, *The Road to Kate*, which is set against Katharine

Hepburn's 1955 tour of Australia. Sheehan's last film, *Little Fish*, starred Cate Blanchett and scooped the AFIs, our version of the Oscars. He liked *Road to Kate* and surprised me by saying he thought Blanchett might be interested. She made for a brilliant and Oscar-winning Hepburn in *The Aviator*, which is why I thought she wouldn't want to play the legendary actress again. Of course, it's just his opinion, but this was terribly exciting until he mentioned the catch—that it'd be good for her in about eight years because Hepburn is forty-eight in the script.

Even with such encouragement, the odds of getting a feature film script bought and made are about the same as being hit by a meteor while riding a unicycle. Still, I should really be working on this screenplay, and trying to push others forward, but . . . I just don't have the time. And there's no way I can set aside the bad-movie quest. Beyond the small fortune I've spent, I've become seriously obsessed with seeing how this turns out. So, I convince myself that this year off scriptwriting will be a "sabbatical" before I come back refreshed. Wait for me, Cate?

I voice all these concerns to Clare and she talks me down. Her support at times like this is crucial. She does get frustrated on occasion, listening to me ramble on at too much length about Lisa Kudrow rapping her heart out in *Marci X* or Matt LeBlanc outacted by a monkey in *Ed*. But she believes this project is worthwhile, that something will come of it, if only the personal satisfaction of seeing the thing through, and she even agrees with my rationalization that the scriptwriting world will still be there in nine months. If Clare wasn't in my corner, I don't think I'd be able to do this. Her support makes me feel better. So does the actual process of Bad Movie Bingo. It was a smart move, if I say so myself, because, though I abhor gambling, turning the silly little toy, not knowing what's coming up keeps this fun. What will it be next? Number 37

(Vanity Vehicles)? Number 10 (Movies That Escaped)? Number 24 (A-Listers' Z-Grade Origins)? And tonight the winner is . . . 44, a triple bill of crappy Japanese sci-fi flicks.

Prince of Space is fun, if awesomely silly. This Japanese TV show was edited into a 1959 feature and dubbed with wild American accents. While the hero is the titular Prince—a.k.a. Wally the shoe-shine boy—the real star is villainous Ambassador Phantom of the Planet Krankor. With a ruffled collar and black cape, massive kneepads, a pantomime witch's nose, and extravagantly upswept moustache, he could be an Elizabethan skateboarder going trick-or-treating. His "Harrr! Harrr! Harr! Harrrrgh! Harrrghh! Harrrrgggh!" laugh is unmatched by *any* screen nemesis and sounds like an asthmatic donkey regurgitating Fran Drescher. "I will show you much here that only you could appreciate," he tells an abducted professor. "For example, how I propose to control the universe!" That's a pretty solid *example* of villainy. But this baddie is so confident he wears tights that leave no doubt about the shape of alien genitals.

Japan faced crap-ocalypse again in 1961's *Invasion of the Neptune Men*, about aliens in silver boiler suits with flashing lights, pointy helmets, and mandatory head-antennae. Space Chief, played by Tarantino favorite Sonny Chiba, is on hand to save the day with lame high kicks and laser blasts. The aliens retaliate by unleashing a "sigma wave band" that makes clocks, jukeboxes, and trains run backward. Much more wacked-out is 1964's *Evil Brain from Outer Space*. Over footage of a rock in space, a narrator tells us, "On the planet Zemar, far within the Mofin galaxy, a decontrolled robot assassinated the omnipotent Balazar, who was known to possess the most brilliant mind in the universe. So powerful was Balazar's genius that as he lay dying his brain ordered built a mechanism that would keep it alive even though his body was

destroyed. And now Balazar's brain seeks universal conquest . . ."

Holy shit. I've barely had time to take this in when I'm treated to galactic officials on the Emerald Planet debating Balazar's threat to Earth, where he's hiding. To get the best picture of this scene, imagine the UN Security Council populated by vacuum cleaners and animated lampshades doing interpretative dance moves against a painted backdrop of Saturn. Anyway, they send Starman to Earth to cause headaches for Balazar's brain.

Evil Brain is another TV chop job and I suspect the American voice-over artists were having a laugh. "It's imperative that we destroy it," says a character of the brain. "But to do so won't be easy—it's indestructible." My favorite is the announcement on police radio: "Attention all patrol cars! Emergency in the Kyoto district! You are to proceed to the area and seek a monster!"

SOUND OFF

I'm closing in on one hundred days now and I have to admit this isn't as tough as I thought it might be. Watching bad movies is a chore but also a refuge. A chore in that I have to do it. A refuge in that this is now my own little mental space, one that has virtually no link to anything else in my life or career. But the nice thing about watching bad movies is the liberation from positive expectation. At the cinema you feel ripped off if a movie isn't as good as you'd hoped. Each day now I experience the reverse—acceptance that what I'm about to watch will suck, which means any entertainment or quality comes as a happy surprise. The other thing I'm noticing is how it's affecting my non-bad-movie watching. I was worried that it'd make me see *all* movies as bad. When I spoke to *MST3K*'s Kevin Murphy before the quest began, I asked him about this

risk. After all, for more than a decade his job was watching schlock.

"I think there's a danger that you stop looking at the quality of good movies and start looking at all the faults," he said. "But I think it's taught me to be a better movie watcher in the sense that I try to point out to people that there's a lot more than what we're seeing, than meets the eye. It's the tendency for audiences to be so goddamned complacent that makes the overall quality of Hollywood suck so much."

And this is pretty much what I've experienced, a sharpening of the movie senses when I'm watching current movies for *Empire*. I feast on what's good about them—*Zodiac* and *Pan's Labyrinth* are both genuine masterpieces and I think I like them all the more because I can't pick a fault in either. I appreciate that *Casino Royale* and *Apocalypto* are big-budget B movies and enjoy them because they embrace their cheeseball qualities. But my bullshit detector sounds loudly in *Miss Potter* and *The Pursuit of Happyness,* and I actively hate *Arthur and the Invisibles* and *The Holiday* more than half the bad movies I've watched deliberately. On the other hand, that *Dreamgirls* and *Rocky Balboa* offered real emotion mixed in with unbelievable corniness and vulgar filmmaking gave me the chance to both provide analysis and crack jokes in my reviews for *The Movie Show* audition.

It's a weird headspace, admittedly, but so far I'd venture that, counterintuitively, a regular (perhaps not daily) serving of bad movies can actually make you a better moviegoer.

Bad Movie Bingo now serves up two legendarily bad horror movies that were filmed without sound decades *after* the silent era. The first is *The Beast of Yucca Flats*, whose writer-director Coleman Francis shared not only Ed Wood's sensibilities but also used two of his ensemble in Tor Johnson and Conrad Brooks. Tor plays a Russian scientist caught in a desert

atomic test that transforms him into a monster. A monster who, thanks to the radioactive powers of abysmal filmmaking, has the uncanny ability to creep up on people without triggering their peripheral vision and who can materialize in the backseats of cars. In time-honored tradition, he abducts a pretty girl and takes her back to his cave. Less time-honored is that his desert death scene has him *kissing* a rabbit that hops into shot.

This last image was apparently a moment of varmint serendipity included despite making no sense whatsoever. But sense wasn't Francis's sensibility. He filmed *Beast of Yucca Flats* without sound and directed his actors to turn their heads away from camera whenever dialogue was absolutely necessary so he could add it later without worrying about syncing. Mostly, the story is told via the director's narration. Although reportedly a coffee obsessive, he sounds like he's tripping. "Touch a button, things happen—a scientist becomes a beast," he tells us, in case we missed the film's *central incident*. "Nothing bothers some people, not even flying saucers," he opines. True enough—except *everyone* is bothered by the beast and UFOs make *no* appearance. "One ten in the shade—and there's no shade," is his greatest Zen moment.

Rescued from obscurity in 1993 by *Mystery Science Theater 3000*, 1966's *Manos: The Hands of Fate* quickly attracted a cult following. In 2005 *Entertainment Weekly* devoted five pages to it as "The Worst Movie Ever Made."

Although shot in color, *Manos* is more primitive than the black-and-white *Beast of Yucca Flats*. Made by Texan fertilizer salesman Hal Warren, this was shot silent and with a camera that could only film thirty-two seconds of footage before it needed to be rewound. The actors delivered their dialogue on set, but different people dubbed the voices in later, including Warren.

The film's first seven minutes are just a family driving and a couple making out in a lover's lane. The boredom's dispelled when mom Margaret, daughter Debbie, and dad Mike—played by Warren—stop at a remote residence. There they meet Torgo, a caretaker with the coloring of a zombie and a hobo's sense of style. Acid-head actor John Reynolds, who'd commit suicide soon after the movie was shot, twitches like a silent film villain, which in a way he is. Torgo has one message, delivered over and over: "The Master would not approve." Most of the "action" takes place in a grungy living room before abruptly relocating to the Master's ritual lair, which is inhabited by his slave-vampire wives and decorated with columns and a pair of big plaster hands. The mustachioed Master looks like a 1970s porn version of Hitler and has purple-tinged skin and nifty robes that, when he extends his arms, turn his whole body into a pair of big red hands. It's a strikingly laughable piece of costuming.

Manos's amateurish ways are legion. "Manos" means "hands" in Spanish, which makes the title *Hands: The Hands of Fate*. A clapperboard is visible, while the lights in a night scene have clearly lured every insect for miles. The use of only short takes makes this a continuity nightmare, and it's a crazy-making situation accentuated by a score crafted from tinkling at the high end of a piano. Just as aurally disturbing is an adult doing Debbie's "childish" voice.

Manos achieves a comic surrealism that stays with me, and it is certainly worse than anything Ed Wood did before porn. But I score it 17/100, which puts it solidly above *Search for the Beast*.

THE LEAST-ACTION HERO

I'm at *Empire* when I hear the news: Bob Clark and his son have been killed by a drunk driver in California. I never did

send that e-mail, and now I'm glad. I relisten to the recording of the Clark interview in order to write his obituary and feel very sad. He sounded so buoyant about the future. There was new interest in his back catalogue—*Black Christmas* had just been remade, and remakes of his *Deathdream* and *Porky's* were in the works. Clark planned to remake his own 1973 horror, *Children Shouldn't Play with Dead Things*, and, after that, he was directing an ambitious Civil War Western script written by his late pal Akira Kurosawa. Now, none of it will happen. At least he was sixty-seven and had seen and done much. But his son, Ariel Hanrath-Clark, was just twenty-two. Two lives snuffed out by an unlicensed twenty-four-year-old driver who was three times over the legal alcohol limit.

ONWARD, AND I'M CHEERED up by Gary Daniels. This kickboxing action star is amazingly prolific, with dozens of film credits, almost all obscure and none held in any regard. I chose two of his lowest-ranked duds and the closest thing he's had to a hit.

First up is 1992's *American Streetfighter*, Daniels's signature role, which is odd because anyone who hears him utter a *syllable* will instantly understand he's British. Our least-action hero is Jake, Hong Kong businessman. He's called on to save his brother, Randy, who's the Cro-Magnon star attraction of an underground *kickboxing nightclub*—run by inscrutable Oriental Mr. Ogawa, reciter of Zen bombs like, "The flower from the ocean pleases heaven." By contrast, Jake's much more straightforward, as when he tells Randy, "Marm shoulda hid thet aborshun."

Despite his mangled misgivings, noble Jake takes his sibling's place in a kickboxing tournament. Now comes the full explanation of the title. The MC notices our boy's accent and calls him a "limey." In his garbled accent, Jake simply declares

he's "American." Asked his martial arts style, he answers, "Street." Mystery solved! Then Jake gets his ass handed to him and is taken to a hospital, where he discovers that Mr. Ogawa's syndicate is stitching drugs into corpses for export.

Daniels is a gaspingly awful screen presence, marked by blank-eyed, expressionless line delivery and a sartorial sense that includes a pony tail and jeans cinched up around his navel. The fights, despite his undeniable physical prowess, are amazingly amateur. But the funniest moments are from his sidekick, Nick, who rides a motorbike through an obviously Styrofoam door, and who snarls, "You piece of lowlife . . . As far as I'm concerned I'm back in Vietnam and there's no mercy!"—to Mr. *Ogawa*'s villainous daughter *Reiko*.

Daniels's most elaborate film—if just as ethnically confused—is 1995's *Fist of the North Star*. He stars as Kenshiro, last bastion of the heroic clan of the North Star, who're up against bad guys called Crossmen. Derived from scraps of the *Mad Max* trilogy, this raggedly designed postapocalypse is spiced up with random acts of mystical nonsense. Daniels can *tickle* people Three Stooges style to make their heads *inflate* fatally. Costas Mandylor's evil Lord Shin summons a magical glowing fist that splits his enemies at the seams. As Shin's chief attack dog, Jackal, Chris Penn is denied supernatural powers but compensated with preternaturally stupid dialogue. "Today we ride on the back of a tiger—and that tiger is hungry!" he roars in his rallying-the-troops scene. "These are not my words, but I do feel them! But my words say this: 'Let's kill some people! Let's kill them—and enjoy it!'" It sure puts to shame *300*'s relatively subtle "This is Sparta!"

Daniels is called on to emote less and he's better for it. The dark, close-cropped hair is an improvement, too. But any notion that he's getting better as a performer are immediately shattered by 1993's *Full Impact*. I feel physically ill in the

opening sequence in which he does a series of insane high kicks and slow-motion hand moves on railway tracks. I pray for an express to take him out.

Daniels plays Jared Taskin, "former cop, full-time screwup," who's trying to put a stop to his old nemesis, a serial killer nicknamed Death Touch. But to get his man, he'll have to deal with various assassins dispatched from a *kickboxing restaurant*.

The Fabio locks and Harry Highpants fashion are back and in every scene he looks like the plumber come to "fix the pipes" in a mid-1980s porno. The accent is *out of control*. "Git outta mi feece, men, I din't nid these" equals "Get out of my face, man, I don't need this." Every attempt to make him look tough backfires ludicrously, especially him mixing cereal with milk . . . in his mouth! Spoons and bowls are so for pussies.

The full impact of *Full Impact* is that I watch it with eyes so wide open I feel like Marty Feldman playing the role of Alex in *A Clockwork Orange*.

BAD COP, BAD COP

My mobile phone croaks to life. I recognize the phone number as being from Sydney's North Shore. That's where Fremantle Media, producers of *The Movie Show*, are located.

"Hello," I say, trying to tamp down nerves and excitement.

"Hi, Michael, is it?"

"That's me."

Me with a racing heartbeat.

"It's Sam Downs, Michael," says the voice. "I'm the executive producer of *The Movie Show* and . . ."

And? *And?*

" . . . we all just loved your audition. It was funny and natural and exactly what we were looking for . . ."

AND?

"We'd like to offer you one of the hosting positions."

They want *me* to be on TV. Amazing.

I call Clare. She screams down the phone. I call Dad. He tells me he was "hammering Heaven's gates" that I'd get the gig. I'm not sure the Creator takes a huge interest in entertainment industry outcomes—despite what Grammy recipients would have us believe—but I'm grateful for any assistance from on high.

That night, as Clare and I sit in the backyard, drink wine, and talk, the idea that I'll be on TV each week gets more surreal. I expect a call to tell me it's all been a mistake. What if the audition was a fluke? What if I'm hopeless? How will *I* cope with getting *bad reviews*?

Clare listens patiently as I voice my doubts, tells me it's natural to be self-conscious and nervous, that the producers will be there to help me get it right. Thus reassured, I let my worries go the other way. What if microcelebrity makes me an asshole? Will I need to have my shopping basket photographed? What if I'm recognized on the street? What if . . . ?

"For God's sake, get a grip," says Clare. "It's only ten minutes a week, half of which will be devoted to your cohost."

She's right. Five minutes a week on the lowest-rated network.

"But you know what?" Clare says.

"What?"

"At least I'll be able to say I nailed you before you were famous."

I'd already come up with a few flicks for my Bad Cop, Bad Movie Bingo category but I got help a few weeks ago from Edgar Wright, director and co-writer of zombie comedy *Shaun of the Dead* and cop spoof *Hot Fuzz*. Slight and impossibly young-looking, Wright is one of those guys you can't help but like even as he turns you green with envy. There he was

matter-of-factly talking about going to screenings at Quentin Tarantino's house with Rosario Dawson and Daryl Hannah.

"Bastard!" I wanted to say but didn't. He'd won me over by offering me some of his hot chips. I'm cheap like that. Beside that, I know he's my kinda guy. That's because he and actor Simon Pegg watched *138* buddy cop movies before they sat down to write *Hot Fuzz*. "So, which were the worst?" I asked Wright in the dungeonlike nightclub that, oddly, the Universal PR people had selected for this morning's interview.

"The worst?" laughed Wright.

I explained the book. He thought for a few moments.

"*Dead Heat*. That was pretty fuckin' terrible," he said. "It's a zombie buddy cop film with Treat Williams and Joe Piscopo. Fuckin' awful."

Wright rattled off a few others—*Invasion U.S.A.*, *Delta Force, Silent Rage*—but qualified they were "entertainingly bad."

"I'm just trying to think of other bad ones," he said.

C'mon, man, dig *deeeeeep*.

"*Another Stakeout!*" he exclaimed. "That was the worst, by far! Any film that resorts to having a comedy bulldog do a double take—they must've been desperate in the edit to include that!"

Another Stakeout is the 1993 sequel to 1987's amiable undercover cop comedy *Stakeout*. Returning stars Richard Dreyfuss and Emilio Estevez are assigned to find a federal witness in a coastal enclave, which results in them posing as father and son—with screechy assistant D.A. Rosie O'Donnell joining as wife and mom, and her little dog, too. The comedy's clunky and the leads cancel each other out with the same shouty shtick. Director John Badham's action sequences aren't much better, with the explosion at the start covered from about eight angles, and thus one of the most

disproportionately overblown blowing-shit-up scenes ever, unless the suburban house in question had a WMD in the basement. That all said, and I hate to disagree with Mr. Wright, but *Another Stakeout*'s not atrocious to me, just another bus movie.

Wright's other pick, 1988's *Dead Heat*, is unlikely to be shown on a bus—or as any sort of in-journey entertainment—thanks to a gory-even-by-1980s-cop-movie standards opening in which two zombie crims rob a jewelry store. Our detective heroes, Joe Piscopo's Doug Bigelow and Treat Williams's Roger Mortis (!) arrive to ensure one perp's blown to pieces with a grenade and the other's squashed between two cars. Piscopo sets the comic tone when he toes a squished corpse and quips, "You have the right to remain disgusting."

Turns out, the "cash-and-dash" gang are a revolving bunch of already-dead criminals reanimated by nefarious goings-on at Dante Pharmaceuticals. When our cops investigate, they're attacked by a three-faced mutant and a zombie biker and Roger is killed. He's brought back to life using the "resurrection machine" but he's decaying and will dissolve into glop in twelve hours.

Treat Williams's performance is lifeless until he dies and can chomp on lines like, "Lady, I'm fuckin' dead!" Sadly, the comic lifting is left to Piscopo, who has the manner of a beefy bouncer denying you entry to a club while cracking witless jokes for his Neanderthal buddies. Along with CHOOSE LIFE T-shirts and the cocaine-smuggling angle to Iran-Contra, his popularity rates as one of the 1980s enduring mysteries.

But the makeup and action are passable so again I have to disagree with the esteemed Mr. Wright. A lot of that probably has to do with 1992's *Stop! Or My Mom Will Shoot* being next up.

As the utterly unappealing title hollers, this is a team-up

between Sylvester Stallone's cop and his mom, played by *Golden Girls'* Estelle Getty. Scenes in which she wakes him up with a gun in his face, commanding, "Go ahead, make your bed!" and cleans his weapon as she sings, "This is the way we wash our gun, wash our gun!" are simply mortifying. Stallone is made to use his mom's come-on lines, wear a diaper in a bank robbery dream, and, horribly, shout the title as dialogue. Sly has said this is the worst movie he's ever appeared in. Bad though it is, *Rhinestone*'s worse.

As a fourteen-year-old, I loved *Police Academy*. Every teenage boy did, and verily the playground was filled with kids trying the replicate the "human beatbox" sound effects of Michael Winslow. Such success ensured that sequels flared up with the regularity of herpes. *Mission to Moscow*, for those still counting in 1994, was the seventh and (so far) final installment. This rubbish comprises unfunny skits around Ron Perlman's Russian computer-game mogul wanting to take over the world via a virus in his software. As a depth indicator of the film's stupidity, Michael Winslow's barely called on to do his crazy voice tricks while the soundtrack is filled with "comic" effects from the "BIIYOOOING!" of a plucked hair to the "WYIIIIIP!" over Christopher Lee pulling his pants up. This scores 17/100 as one of the most interminable, least-interesting flicks so far.

Much more ambitious, but completely insane, is 1995's *Theodore Rex*, a cross-pollination of *Beverly Hills Cop* and—wait for it—*Jurassic Park*. In some dystopian future/alternate universe/*Blade Runner* rip-off, all animals are extinct, except for dinosaurs, who can talk and live in an uneasy coexistence with humans. When a big lizard is murdered, Teddy Rex, a police liaison officer, is assigned to the "dinocide" and partnered with Whoopi Goldberg, a hard-nosed "grid police" officer. The case turns out to be related

to megalomaniacal madman Elizar Kane's plan to use his "New Eden" missile to create another ice age so he can re-populate the Earth with refrigerated animals. Of course it is. Goldberg looks exquisitely uncomfortable, as much for being squeezed into black leather as for having to say, "You can't judge a dino by his scales." Her only believable moment comes when she's told who—*what*—her new partner is. "He's a dinosaur!" she says four times, with such exasperation and disbelief it's like she's only at that second realizing what the script's about.

LITTLE PEOPLE

I meet with Fremantle Media about *The Movie Show*. My new producer Sam tells me the show will premiere on May 31 at 10:00 p.m. and we shoot the first episode in just two weeks. There'll also be some publicity photos and a media launch at the Sydney Opera House. And rather than another nobody, my cohost will be Lisa Hensley, an actress who won the Aussie equivalent of the Golden Globe.

Usually, I work four days a week for *Empire*, which means my day off will now be used to shoot the show, while I'll also be required to go to more advanced screenings and write my show scripts at night. Getting through a bad movie a day is about to get harder. It's daunting but the extra money—my salary is about what Jennifer Aniston got for blinking in one episode of *Friends*—will certainly help make our lives easier. And it'll go some way to offsetting the bad-movie expendi-ture, now—gulp—in the vicinity of five thousand dollars, al-though I'm still too chicken to tally it up properly.

I've got the rest of the day off—soon to be a rare occur-rence—so back home I get down to business and spin that bingo toy. Ball number 2 rolls on out—"Little People"—a four-play of flicks starring tiny humans and regular-sized

humans playing action-figure-sized folks.

First up, all-midget Western *The Terror of Tiny Town*. I'd been aware of this one since it was mentioned on an episode of *M*A*S*H* I saw as a kid. Later, the Dead Kennedys—my teenage rebellion band of choice—used clips from it as the video for "Rawhide." When I was at *FHM*, I used to find random bits of the flick on the Internet and send them to Simon, our off-the-wall, midget-and-dwarf-and-robot-obsessed designer. But I never have seen the whole thing.

Watching it today puts my upcoming two-jobs-daddyhood-and-bad-movies workload into perspective. That's because this was but one of *fifteen* movies Hollywood's most-prolific-ever director, Sam Newfield, made in 1938 alone. In *The Terror of Tiny Town*, cowboy Buck Lawson is sweet on Nancy, belle of the rival plains clan, the Prestons. Villain Bat Haines, a.k.a. the Terror, frames Buck to instigate a clan war he can exploit to his own ends, which include getting his little paws on Nancy. So, it's like a novelty-sized *Deadwood*.

Actually, while a one-off in terms of casting, *Tiny Town* is a surprisingly typical 1930s B Western, concerned with shoot-touts, stagecoach derring-do, melodramatic romance, and stopping all the action for exceedingly average songs. There are laughs in the cowboys walking under saloon doors and riding ponies but both were unavoidable given this was a Poverty Row production that had to use existing Western sets and that galloping on regular-sized horses would've been too dangerous. With no full-sized actors for comparison and most of the film shot from their own perspective, it's *almost* possible to forget you're watching midgets. The most bizarre thing is that it's not as weird as it sounds.

In 1961's *The Phantom Planet*, the production suffers the same problem. It's set in the far-off year of 1980 and envisages the discovery of a world called Rheton that's populated by tiny

humans. Earthling astronaut Frank Chapman and his space-ship are sucked to its surface, where the atmosphere shrinks him down to the natives' six-inch height. He's caught, tried, and found guilty of punching one of the Rhetons but is set free to live among them in their low-budget wonderland. Chapman's cheesy heroics and romance make this enjoyable, but as in *Tiny Town*, the "little people" hook becomes almost incidental because, once he's miniaturized, everything is in proportion.

My disappointment at these, er, diminishing returns is alleviated by 1981's *For Y'ur Height Only*, which stars Weng Weng, Guinness World Record holder as the shortest leading man in film history. At just 2'9" fully grown he was exactly the same height that Ava is now at just over eighteen months. The title declares exactly what we're in for—and that's a nonstop parody of James Bond that trades on its star being knee-high to a grasshopper.

As Agent 00, Weng Weng does everything Messrs. Connery and Moore did in the 1960s and 1970s—but with a Beatles haircut ca. *Rubber Soul* and in a *Saturday Night Fever*-style white suit. Weng Weng is introduced shooting at the camera, while fake Bond music plays, and an action montage shows him firing an M-16 as big as he is and jumping off roofs.

Our hero's nemesis is Mr. Giant, whose minions kidnap Professor Van Kohler for his N-bomb, which I presume is a doomsday weapon. Mr. Giant's motive is basically pure evil. "The forces of good are our sworn enemy and I repeat they must be exterminated, and I mean lethally!" is how one henchman explains it.

Such bizarre ad-libbed dubbing was apparently done by expats stuck in the Philippines after *Apocalypse Now* wrapped. They sound *wasted*. Take this, from one of Mr. Giant's sub-bosses as he instructs his goons on dealing drugs hidden inside

bread. "There's a lot of dough in this dough," he says in the fake-Bogart drawl all the baddies share. "The butcher, the baker, the candlestick maker! Happy pushing! Happy pushing! The boss says to cover every kindergarten—and sandbox. We're gonna teach 'em something about pleasure!" The proceeds from narcotics and gold theft are to be used by Mr. Giant to fund his superweapon because "N-bombs are expensive these days." They sure are—Michael Richards is still paying his off.

Weng Weng is called in to take on Mr. Giant and kitted out with gadgets, including a mini machine gun, poison-detection ring, and X-ray specs, which he tries out on the secretarial pool with sex-etarial results. Double 0, like 007, has an eye for the ladies and he flirts up a storm with a series of random chicks who help him kick bad-guy ass before disappearing from the story. He even beds one girl.

"Are you a sexual animal?" she asks in a fake aristocratic British dub.

"I don't know," Weng Weng replies. He's a man of few words, but each sounds voiced by Jon Lovitz.

"I'm crazy about you Agent 00," the babe continues, like a Princess Margaret impersonator on horse medicine. "Why I don't know. Maybe it's the way you strut your stuff. You know, sex is like tequila, take one sip and you're a goner."

"Shall we get it on?" he asks.

"Yes, darling, bare your bod."

He does, revealing that for a tiny man he had massive nipples.

While a lover of magnitude, our hobbit-sized hero is an even more accomplished fighter, using an armory of guns, blow darts, swords, and a remote-controlled flying razor hat. But Weng Weng is most dangerous as a martial artist able to dart between his enemies' legs and deliver a crushing kick to the

balls or tail bone. And as a man of action, he's fearless, escaping a Ferris wheel on a flying fox, parachuting from a highrise, and flying his jetpack to Mr. Giant's island. I assume Weng Weng did all the stunts himself because, like, where do you find a 2'9" stunt double?

It's during the island HQ finale—with Weng Weng blowing away dozens of goons, all of whom unwisely wear uniforms with big red circles on their chests—that I realize Agent 00 is one of the most violent screen characters ever. By my reckoning, he snuffs eighty-three people in eighty-eight minutes.

I head to www.moviebodycounts.com to see how he rates. Double 0 isn't listed, but he should be. He outslaughters Sylvester Stallone in *Rambo: First Blood Part II* (fifty-one) and *Rambo III* (seventy-two) and Arnold Schwarzenegger in *Total Recall* (forty-four), *True Lies* (fifty-one), and *Commando* (eighty-one). And he makes Tony Fuckin' Montana's twenty-five confirmed kills in *Scarface* look positively pussy. As for Bonds, his nearest rival is Pierce Brosnan in *GoldenEye* (thirty) and he kills more villains than Sean Connery did (fifty-six) in *all* of his official 007 adventures combined.

Weng Weng returned as Agent 00—now working for Interpol against terrorist Mr. X—in 1982's *The Impossible Kid*. This isn't as freaky deaky as *For Y'ur Height Only* but still entertaining in parts. Weng Weng says next to nothing in this one, while the characters around him are dubbed to sound like American rednecks, Boston Brahmins, and Australian tourists. The emphasis is on Weng Weng's martial arts skills, played for laughs, and stunts where he's lowered off a high-rise hotel, walks a tightrope, and jumps his mini motorcycle over a ravine. Most indelible is the theme song, "The Impossible Kid," with its chorus "I love you my Weng Weng/Come to me and kiss me/I love you Weng Weng!" It was recently sampled by rappers the CHUDs in a tribute video that has become a YouTube hit.

I show it to Ava and she's an immediate fan.

"Again, Weng Weng!" she yells. I play it again. "Again, Weng Weng!" It makes a pleasant change from her current mantra—"Oh, oh, dropped it!"—repeated eight hundred times a day, as whatever she's holding slips from her tiny grasp. And I understand Ava's instinctive love of the Weng. He's such a singular movie presence that I need to find out everything I can about him.

I first came across Weng Weng when I got to talking with a secondhand book store owner about bad movies and he said that, back in the 1980s, he'd corresponded with British talk show host Jonathan Ross, who was then making the TV program *The Incredibly Strange Film Show*. Ross and he had traded videotapes of schlock, and Ross, a pioneering Weng Weng enthusiast, had sent him *For Y'ur Height Only*. Thus similarly intrigued, I checked Amazon and, yep, it'd been released.

Discussing the film with Chris Murray this week, he dropped a bombshell: A friend of his—and of our mutual pal Jaimie Leonarder—is the Brisbane owner of Trash Video store, Andrew Leavold, who's *the world's leading authority in all matters Weng Weng*, having spent years researching his story. I call Andrew up and he's plenty friendly and tells me that he'll be down in a few months and will fill me in—and show me his in-progress documentary, *The Search for Weng Weng*.

Sometimes it really is a small world.

THAT'S TRAVOLTING!

For Easter, Clare, Ava, and I fly down to Puckapunyal, about an hour north of Melbourne, to visit my brother David and his girlfriend, Tina. Ava's only previous flight was about six months ago and she was tense and teary the whole way. This time, I buy her a packet of Dora the Explorer cards and she's

content to shuffle them nonstop on the hour-long trip. What amazes Clare and me is that she knows all the characters' names. "Isa! Boots! Señor Toucan!" Ava announces to the whole plane. To us, this supporting cast has just been background noise; to her, they're citizens of a special universe.

David and Tina are, likewise, citizens of a special universe. David, two years younger than I am, has been a career soldier for nearly fifteen years now, serving in both East Timor and Iraq. Tina used to be in the navy. My brother now teaches soldiers to drive armored vehicles, while Tina works in the mess in her second career as a chef, and they live on Puckapunyal's sprawling army base, which is perhaps one of the only places in Australia that actually matches the clichéd expectations the world has of us. Fringed by bush, it's a suburb of modern but modest houses, gleaming new cars, tousle-haired kids, and wide, tree-lined streets—on which roam kangaroos and emus.

With Dad there too, it's a pleasant couple of days spent catching up, snoozing, and eating Easter eggs. While David and I are very different, we've always gotten on well, and while he'd never deliberately watch a bad movie, he's happy to cede me his lounge room for a few hours each afternoon so I can indulge my obsession, which takes me now to the works of John Travolta.

I like John Travolta. Really I do. Ever since I tried to replicate his *Staying Alive* disco strut—something that amused my then-five-year-old brother no end—I've been a fan. But damn has that cool cat made some bad movies.

I discover it's actually how his screen career began, back when he was twenty and scored a bit part in 1975's *The Devil's Rain*. The film's a mess—literally: It ends with an eight-minute sequence in which a satanist horde melt into puddles of waxy goo, like a gathering of the Incredible Melting Man's extended

family. But before we get there, we have to wade through eighty incoherent minutes in which William Shatner's good Christian pits his beliefs against Ernest Borgnine's devil worshipper. They should've called this *Faith/Off*.

The Devil's Rain has creepy opening credits, with Bosch paintings accompanied by the plaintive cries of the damned, but it's all laughs after that. Shatner is his usual constipated self ("Winds. Knock the line. Down."). And Borgnine is fruitier than Carmen Miranda in a San Francisco bathhouse, especially when he spouts ram's horns and a rubbery snout and baptizes Shatner with "the holy water of forgetfulness." Anton Szandor Lavey, High Priest of the Church of Satan, was the film's technical adviser, so I'm assuming all of this is based on fact.

Fans shouldn't get too excited because Travolta's just another eyeless cultist with one line, "Blasphemer! Blasphemer!" Then he melts. But this was a turning point for him. As an extra on location in Mexico, Travolta had plenty of time to stand around talking to fellow cast member Joan Prather, and she turned him on to Scientology. In this way, *The Devil's Rain* is the ultimate cult movie. It's about a cult, has a cult following, was devised with input from a cult leader, and saw a future superstar indoctrinated into a cult he'd help popularize. Weirdly, the film's central idea—that Borgnine has trapped souls in a bauble containing satanic water—echoes the Scientological tenet that seventy-five million years ago evil galactic overlord Xenu imprisoned billions of souls in fluid . . . so he could transport them to Earth in DC-8s, pack them around volcanoes, and blow them up with hydrogen bombs.

Newly empowered by such mumbo jumbo, Travolta returned to the United States to score *Welcome Back, Kotter* and *Carrie* and then shot to megastardom with *Saturday Night Fever* and *Grease*. But even L. Ron Hubbard couldn't protect

him from the engram that was 1978's *Moment by Moment*. Finding this film became an obsession that consumed long hours on the Internet. On eBay I found lobby cards, the novelization, the soundtrack album, and even the press book, but not the film itself. At wit's end, I drifted to John Travolta's official Web site, where I clicked Contact and sent an e-mail about my predicament. "Dear John," I wrote. "How is it possible for me to see *Moment by Moment*? Has it been released on video or DVD?" Maybe he'd read my message, take pity, and dub off a DVD copy from his own pristine 35mm print. Reality pinged back immediately with the computer-generated thanks-for-writing message: "Thank you for your e-mail! John is always interested in his fans and welcomes your letter. Unfortunately, because of his demanding schedule . . ."

I thought that was that but two days later came an e-mail from J. T.! A little checking reveals that it's most likely *June*, his sister and president of his fan club. Her note is short: "It was on video . . . eBay???" I'm so excited at this communication from the inner sanctum that I feel like an honorary Operating Thetan.

I whip back an enthusiastic e-mail saying that I'd appreciate any help in finding a copy, and I ask if I'm speaking with June—just on the off chance it is John. The reply comes back in discussion-ending ALL CAPS: "JUNE IS THE DIRECTOR OF THE INTERNATIONAL FAN CLUB AND CHARITIES SINCE THE 1970'S. . . . WE HAVE NO IDEA WHERE TO FIND MOMENT TO MOMENT. . . ."

Um, okay. I love the fact even the Travoltas can't get the name of this obscurity right. And then, praise Xenu, there it is, lurking in a collector's Internet catalogue of titles taped from TV.

In *Moment by Moment* Travolta plays an L.A. hustler named Strip, who latches puppylike onto Lily Tomlin's older woman,

offers to set her up with drugs, mooches her chicken and wine, and slowly—very slowly—through his nonstop blabbering, worms his way into her sympathies and bed. They nuzzle. He whines. They snuggle. Their rescued dogs play on the beach. Eventually, Strip overhears Trisha talking about ending the relationship and so he nastily preemptively splits with her. She chases his boy toy ass down.

Civilizations could rise and fall in the time it takes for all this to unspool. *Moment by Moment* does what the title says, collecting together all those banal bits we don't usually see in movie relationships because they're so goddamned boring. Also troubling is the narcissistic vibe. With their stick-thin physiques, long faces, and black shaggy hairstyles, Travolta and Tomlin look like siblings, right down to names Trish and Strip being near anagrams.

After *Moment by Moment* bombed and his next movies, *Urban Cowboy* and *Blow Out*, failed to restore him to superstardom, Travolta, with Sylvester Stallone directing and co-writing, tried to recapture the magic of *Saturday Night Fever* with a sequel called *Staying Alive*. In 2006, *Entertainment Weekly* named it the worst sequel ever made. I'd say *Another 9½ Weeks* and *Exorcist II* are worse, but there's no doubt *Staying Alive* should've remained dead.

This opens with Frank Stallone singing "Far From Over"—a threat if ever I heard one—as Travolta's Tony Manero and dozens of other headband-wearing, Lycra-clad hopefuls audition for Broadway. He needs fame so he can ditch his day job as a dance instructor and his night gig as a club waiter.

Manero is an entirely unsympathetic bastard and Travolta is charmless as he sneers through the movie. Physically, he's never looked better but the dance routines are uniformly hideous. Sylvester Stallone takes a chunk of the blame for slow-motion montages and glistening close-ups that make Travolta

look demonically possessed, and the carnal choreography climax is unbelievable. Manero is lowered into Broadway show *Satan's Alley* amid scaffolding and dry ice, where he's attacked by writhing extras. In a loin cloth, knee-wraps, and headband, he's whipped as bitchy leading love interest Laura undulates. Finally, Travolta throws her aside so he can illicitly seize the spotlight with a solo of unparalleled narcissism. This hip-shaking and sweat-flinging nightmare is like the missing reel of *Showgirls*.

That night, over dinner, the conversation turns briefly to bad movies. Tina asks me how many I've watched now. I tell her about 120. She asks me the worst and I say I'm pretty sure it's still *Search for the Beast*, although the other borderline porn ones were worse.

"The worst movie I ever saw was *Superstar*," she says, referring to Molly Shannon's 1999 comedy.

"Mine would be *The Toxic Avenger Part III: The Last Temptation of Toxie*," says David. "The first one was kinda funny—'no tickie, no washie'—but this, this was just so stupid."

I've seen it. Bad, yes, indeed.

"I really think you should've included that one with Leonardo DiCaprio and Tobey Maguire," says Clare. "We watched it together. What was it called?"

I remember this aching indie atrocity, but I can't remember its name either.

"*Don's Plum!*" says Clare triumphantly.

Indeed, that was dreadful. Its A-list stars successfully prevented its distribution in the United States and Canada. But it was allowed to be released on DVD in Australia—an act that could be considered international aggression. Clare and I endured it early in our movie-heavy courtship and she gave it a one-star review in *Empire*.

"Seventy-six trombones!" says Dad.

The table goes silent. We're a few drinks in. Is the old man having a "senior moment"?

"What does that mean, Dad?" I ask.

"Bloody awful movie. 'Seventy-six Trombones,' the song, was in it."

I've never heard of it. Neither have David, Tina, or Clare. Ava's in her cot, so we can't ask her.

"*The Music Man*, I think it was called," he says. "I saw it before I met your mom. A musical, if you can call it music. Worst thing I've ever seen."

THE TITLE RINGS a bell, but I've not seen it. Later that night, I look it up on the IMDb. Average user rating 7.6/10, one Oscar win (Best Music), and five more nominations. I check out the "Seventy-six Trombones" sequence on YouTube. And yep, it's pretty crap.

NEXT MORNING, LOADED WITH Easter eggs, Ava's new favorite cuisine, we bid our farewells and head back to Sydney. Fortunately, our little tyke is again well behaved on the flight, and I appreciate her mellowness all the more when the father across the aisle from us cops a face full of his infant's projectile vomit.

Once we're unpacked and Ava's tucked in for the night, Clare catches up on the reality shows she's taped while I retreat to the bedroom for 1983's *Two of a Kind*, which Travolta made with his *Grease* costar Olivia Newton John. This is belly-lint cinema: fluffy and unpleasant but ultimately harmless. As I've slipped behind a little, thanks to missing a day here and there, I double it with 1985's *Perfect*, which is much more of a physical endurance test.

Travolta is Adam, a *Rolling Stone* reporter doing an exposé

on health clubs as the new singles bars of 1980s and profiling those in pursuit of perfection through plastic surgery and aerobic exercise. To get the scoop, he slips into short-shorts and hooks up with Jamie Lee Curtis's Jessie, "the pied piper of aerobics." Director James Bridges—reteaming with Travolta after *Urban Cowboy*—spices things up with a computer-conspiracy thriller subplot for Adam to investigate. It's *All the President's Men* in legwarmers.

Watching *Perfect* twenty-five years after it hit cinemas—in a Botoxed pop culture that can no longer raise a eyebrow at plastic boobs, calf implants, and collagen-plumped lips—is to see a film both prescient about the rise of body obsession and naive for not realizing it'd break out of the gym to take over society. What's fatal to its "serious" message is that so much time is spent celebrating the early-1980s Lycra-leotard trend. Cynical Adam is quickly swept up in the liberating, mindless joy of rolling his head, shaking his ass, and swinging his junk seductively at Curtis as she pelvic thrusts receptively back at him. With them standing fifteen feet apart and surrounded by dozens of other gyrating aerobicizers in a gym mirrored to infinity, it's like a massive orgy between people too narcissistic to actually touch another human being. When Adam and Jessie get it on, it's one of the most gruesome sex scenes I've ever witnessed—a sweaty competitive event that lacks only an Olympic scoring panel.

The movie wants to set this couple above the rest of the crowd, but they're no different from the preening idiots Adam interviews. "One look at those tits and my whole body got hard," one dude tells him. Another girl concludes her sad confession about high-maintenance body modification and crippling low self-esteem with, "I guess I'll go and see if I can scare up a gang bang." The film's final stab at sensitivity, in which Adam stages an aerobic charity event for *birth defects*,

slides into hilarity as hundreds of extras spank their own asses to a disco version of the William Tell Overture.

Perfect grossed a mere $12 million and secured Travolta his third consecutive Razzie nomination as worst actor. He only made one movie in the next four years, cold war comedy *The Experts*, which was shot in 1987 but not released until 1989. Barely released, it has two New York knuckleheads kidnapped without their knowledge and spirited away to a secret Soviet spy base made in the 1950s to look like a typical American town. The Russkies need to study our heroes to update their agents in the art of being fake Americans.

For once, Travolta's sartorial crimes are eclipsed by his costar, the aptly surnamed Arye Gross. With baggy pants and billowy shirts, man-bangles, neckerchiefs, and Christmas bauble earring, all worn with a teased-out mullet bouffant, he looks like the staff hairdresser on a gay pirate ship. But overall, this isn't too bad.

"It started off pretty good," notes Clare, who watched it with me, keen to see it because it's where Travolta met costar and future wife Kelly Preston.

"Their dance was pretty funny," I say.

We were both gobsmacked by their ridiculous bump-and-grind sequence, which rivals the worst of *Staying Alive*.

"After that, it went kinda blah," says Clare.

"I'd give it 50/100," I say. "Sounds sad, but that'd put it in the top ten—maybe the top five—of the hundred and twenty or so movies I've watched so far."

Clare looks at me with what might be pity in her eyes.

"Oh, bubba," she laughs.

After he did 1994's *Pulp Fiction*, Travolta stormed back onto the A-list and used his regained clout to make . . . *Battlefield Earth*, a partial adaptation of Scientology founder L. Ron Hubbard's 1982 sci-fi potboiler. Even before it was released,

the film was thoroughly tainted by its perceived link to Scientology and the common knowledge that every studio had passed on Travolta's passion project.

The premise of *Battlefield Earth* is that for the past millennium evil aliens called Psychlos have stripped our small blue planet of its minerals, conquering humanity and reducing us to slaves or Stone Age tribes. One of these cave dudes, Barry Pepper's Jonnie Goodboy Tyler, strikes out to confront these "gods" and when he does, is captured by Travolta's Terl, the head of Psychlo Security.

Terl decides to get rich by secretly using "man-animals" to mine gold so he can buy his way off Earth. He selects Jonnie as his foreman, trains his primitive mind with a learning machine, assigns him a gang of slaves, and sends them all off into radioactive territory to bring back the riches. But while Jonnie and his fur-clad, spear-toting men are supposed to be digging out nuggets, they instead fly a Psychlo transport around the United States, retrieving and hot-wiring nukes and, using a flight simulator, learn the simple art of flying Harrier Jump Jets. Clever savages.

The finale has Jonnie and his cave dudes launching an air and land assault against the Psychlos and winning easily—which is weird because we've been told that one thousand years ago Earth's *entire* defenses were destroyed by the invaders in just nine minutes. Director Roger Christian apes *Star Wars* with his dogfights and the exploding Psychlo home world. At the end, with Terl bloodied but unbowed, a sequel is very much threatened.

Opening to a critical massacre, the movie grossed just $21.5 million and later won seven Razzies, equaling *Showgirls*'s record haul. The gongs included Worst Picture and, at long last, Worst Actor for Travolta. In 2003 a poll of 1.2 million Yahoo users voted *Battlefield Earth* the Top Turkey of All

Time and the Razzies membership subsequently named it the worst drama of their first twenty-five years.

Despite being to blame for *Battlefield Earth*'s existence, Travolta is also the reason to see it at least once. Wearing a conehead planted with enough dreadlocks for Bob Marley's extended family, and green of eye and yellow of claw, he gets around in an outfit Gene Simmons of Kiss might've rejected in 1978. But those giant boots never achieve the illusion that he's ten feet tall—even with Christian shooting the whole movie on down-low, crazy angles. Terl's hideously misjudged look might've resulted from the budget squeeze by crooked producer Elie Samaha but this doesn't explain Travolta's high-camp mode. My suspicion is that once he was in his getup, mwu-ha-ha-ing to embarrassed sidekick Forest Whitaker and masticating lines like, "If man-animal likes its rat uncooked it makes our job so much easier!" he realized the only way out was over the top.

' STATUS REPORT

Worst this month: *Manos: The Hands of Fate, Police Academy: Mission to Moscow*
This month's runners up: *Full Impact*
Guiltiest pleasures: *For Y'ur Height Only, Evil Brain from Outer Space*
Movies watched: *118*

MAY

Calculate your chances! Negative! Negative! Negative!
Is there a choice between painless surrender-death
and the horror of resistance-death?

— George Barrows as Ro-man, *Robot Monster*

KEEPING IT REEL

I'm standing next to a nineteenth-century cannon, trying to talk naturally to a camera on the *other side of four lanes of city traffic*. I'm wondering a) what such a weapon has to do with a WWII movie and b) why my producers have chosen this hellish spot for my screen-presenting debut. I figure they know what they're doing. I however, do not.

For the past four months, I've zeroed in on bad performances—and now I'm giving one. And it's not like I'm in character, reciting someone else's words with appropriate emotions. I'm just trying to say what I think about Clint Eastwood's *Flags of Our Fathers* in my first review for *The Movie Show*. In comparing it unfavorably to *Black Hawk Down* I've called the latter film's director "Ridley Hawk" rather than "Ridley Scott" five times in a row. I feel like Marilyn Monroe needing forty takes to say, "Where is that bourbon?" on *Some Like It Hot*. My performance makes me feel like I need a *bottle* of

bourbon. But everyone has to start somewhere, right?

One such bad beginning is 1996's *Phat Beach*. The first of my many "urban movies" in this category, it was directed and co-written by Doug Ellin, who'd go on to create *Entourage*, with second-unit direction from Darren Aronofsky, who'd make *Requiem for a Dream* and *The Wrestler*. Despite their future pedigree, it's a clumsy, stupid comedy about chunky suburban nerd Benny hitting the beach with his pussy-hound pal, Durrel. Booty and bling are their goals. It's tasteless, relentlessly unfunny, and at its very worst when sensitive Benny redeems himself via poetry and volleyball power serving.

The next of these urban efforts, 2001's *Honeybee*, has a promising college student dropping out to become a boxer. Senait Ashenafi brings a mature dramatic sensibility to our heroine—as she should have, because she was *thirty-five* when she made this. But she doesn't look like she can punch her way out of a wet paper bag and director-editor Melvin James doesn't help because he can't stage a fight sequence to save his life. Rock-bottom production values make this a *Thousand Dollar Baby*.

I've had my eye on 2003's *Anne B. Real* for some time. That's because it's a female *8 Mile*–style raps-to-riches story inspired by . . . *The Diary of Anne Frank*. Sounds terrible, right? And a few days ago, this flick finally did claim the number 1 spot on the IMDb's Bottom 100. But what's weird is that *Variety* liked the movie, and it was nominated at the 2004 Independent Spirit Awards.

Cynthia is an introverted Afro-Caribbean teen who, inspired by Anne Frank, uses reading and rhyming to cope with NYC poverty. Things boil over when Cynthia discovers her drug-addicted brother Juan is selling her raps to an arrogant young MC and that he may have murdered her friend.

Janice Richardson's watchful performance makes Cynthia

sympathetic and Carlos Leon—best known as babydaddy to Madonna's daughter, Lourdes—is strong as the frustrated Juan. Director Lisa France judges the emotional moments and uses the New York City locations smartly. *Anne B. Real* does have its flaws—Cynthia's best friend is incessantly "ghett-o" and the climactic rap battle should be more exciting—but it's involving and authentic.

So, what's with the IMDb? "I actually do love our film," France tells me via e-mail of her movie, made for just $100,000 and with the blessing of the Anne Frank Foundation. "We feel for our first effort that it's not too bad." I asked her about being castigated on the IMDb. She says she asked the IMDb about the ranking but got no response. "If the over 1400 people who say they watched *Anne B. Real* really have, well, they're entitled to their opinions. I guess it would be useful if people did have to prove that they had watched the film they rank," she said.

It's not an unreasonable suggestion, given that the Web site's message boards frequently feature users calling on others to "vote down" films they haven't seen.

Whatever its faults, *Anne* is a masterpiece beside 2006's *Grad Night*, which tries to marry gross-outs with serious teen issues. For the first ten minutes, *nothing* happens save for a school principal and teachers telling students the rules of their end-of-year party. When we get a scene to introduce our characters, it ignores the most basic rule of writing dialogue in a moment of stunning banality.

Ext. Schoolyard—Day

A J, LEO, AND JERROD WALK UP TO QUAY QUAY, ANA, AND NEYDA.

AJ: *Hi.*

QUAY QUAY: *Hi.*

JERROD: *Hi.*

NEYDA: *Hi.*

LEO: *Hi.*
ANA: *Hi.*

Riveting. Out in the schoolyard, homeboys compare girls to fast food, i.e., a Chinese chick leaves you horny again in an hour. In the library, a white kid uses cream filling from his lunch dessert as lotion as he masturbates to a lingerie video of his sexy teacher. Sick of being harassed by the brothers, our honky packs a gun for grad night. Sentimentality looms when the wise-owl janitor gives the valedictory speech and his insights include, "I like money too, but I'd rather be happy."

Grad Night beggars belief. The auditorium scenes might've been culled from a parent's camcording of a real graduation. The drably shot narrative scenes aren't any better and the dialogue could be a Dave Chappelle skit. "Oh word, you are the man—now that's what I'm talkin' about!" says one homey. For all its promise of phat times at hip-hop high, *Grad Night* is every bit as bad as *Search for the Beast*, scoring 12/100! Equal bottom spot—first last!

As dizzyingly bad is that the next morning, I'm out on the ice at a rink at a megamall. It's the first time I've been on skates since Reagan was in the White House. I thought *The Movie Show* producers were joking when they sent back my *Blades of Glory* review script amended to include "Michael skates into shot." They weren't.

Michael, most resolutely, does not skate into shot. Michael wobbles across the camera's field of vision as he tries to review Will Ferrell's comedy. You can bet Roger Ebert or Leonard Maltin have never done this, and with good reason. My scissoring legs amuse the rink's teen ice kings as they whiz by *backward*, but at least the concentration needed to remain upright makes me less uptight about my to-camera performance.

That afternoon, still slightly hobbled, I head to a publicity photo session. I'm not sure what to make of the choice of makeup artist. Nikki Gooley has a British Academy Award for *The Chronicles of Narnia* and was nominated for an Oscar for *Star Wars: Episode III*. Here she does the reverse of her usual man-to-monster routine and makes me look rather presentable indeed. It does cause me to wonder, though, why Lisa and I get makeup for these photos but not for the actual show shoots.

I take the night off because it's Clare and my fifth anniversary. We go to a swanky harborside restaurant. I'm on my best behavior and the words "bad" and "movie" don't pass my lips once. Instead, we celebrate the odd sequence of events—random dinner party meeting, yearlong relationship, three-month split, getting back together—that's made us and made Ava. We also have one of the best meals I've ever eaten. I almost weep when I take my last swallow of beef. And just as we finish dessert, the sky explodes with a ten-minute firework display. It's someone else's celebration but it feel like it's just for us.

The next night, I'm back at it with *Nora's Hair Salon*, a lank 2004 comic drama that has noble old Nora dispensing soul wisdom to her fractious minions. These stereotypes spend their days getting all up in each other's shit—and then taking life lessons from the experience. My punishment is worsened by horrible cameos from Whitney Houston and Bobby Brown. Remarkably, this is probably the *least* embarrassing thing they did in 2004, marked as it was by court, rehab, court-ordered rehab, and a visit to Harrod's in London, where the dopey duo demanded $18,300 worth of designer duds for free.

Then, because I'm making up for a lost day, I watch 2005's *The Honeymooners*, an African American version of the old sitcom that stars Cedric the Entertainer. While it was pilloried, I actually find it quite agreeable as a gently amusing

comedy with a surprisingly sympathetic turn from Mr. The Entertainer, who I've not previously rated as much good.

The same can't be said when I switch to the horror subset of the urban category. First up is 1996's *The Embalmer*. Perhaps sensing no sane person will ever watch the entire film, do-it-all auteur S. Torriano Berry opens with a "best of" package of killings from *the film we're about to watch*. He next throws up a text crawl and *reads it for us spookily*: "We've all grown up with STORIES. Books, fairy tales & fables . . . even the ones we made up ourselves. Then there's 'folklore' . . . the scary kind. The Troll that lives under the bridge . . . the Mole-Man in the sand dunes . . ." Hold on just a motherfucking second. *The Mole-Man in the sand dunes?*

Sensing he's losing us, Berry throws in a brief, terribly executed murder, and then douses us with more "folklore," this time a rhyme about Undertaker Zach. But in the movie Zach is a brilliant *surgeon* who went crazy when his beloved mum committed suicide. He killed his wife because she reminded him of his mother. And then slaughtered his daughter because she looked like his wife. We're not told if he murdered his cat because it looked like David Letterman. Anyway, after all that effort, Zach made a deal with the devil to bring his family's embalmed bodies back to life by borrowing other people's precious bodily fluids.

That's bad news for the film's homeboys and girls, who, fleeing the police, hide out in Zach's creepy lair. Having seen his framed certificate for *"post-mortem revitalization,"* these kids do what anyone in their situation would: They talk about their dysfunctional family histories and get busy. One gal shares about the suicide attempts she's made because her parents were drug-addled and her brother molested her. Her boyfriend cheers her up with a bump-and-grind routine. They have sex. She screams, "Do it, Daddy, do it!"

This Oprah 'n' orgasms routine takes up the first seventy minutes until, finally, lured into the basement by the worst, waxy-faced ghost child in the horror history of terror tykes, Zach sets about killing.

Berry wrote *The Embalmer* in 1988, which means it took *eight* years to reach this level of incompetence. Scarier is that he's an associate professor teaching film at Howard University in D.C. Imagine the essay questions. "With specific reference to the use of the python as phallic symbol in *The Embalmer*, discuss the editing rhythms in the nightmare scene where the father figure chases his daughter with his pants around his ankles."

But *The Embalmer* looks like Freddy Krueger next to "Tha Clown," the lime-haired and baggy-suited slasher of Dale Resteghini's 2002 *Urban Massacre*. This kook kills rap superstar Ill One and his protégés, the hip-hop group the Supernatchralz, investigate between songs. Wasn't this the plot of a—or *every*—Scooby-Doo episode? "See you in part two," the film threatens as it closes. Please, no.

Dale Resteghini's earlier rap-horror effort, 2000's *Da Hip Hop Witch*, is—remarkably—far, far worse. Introductory text informs us that in 1989 the Black Witch first appeared in the Newark projects and now she's back to make the lives of East Coast hip-hoppers a living hell.

Mostly this is simply rappers improvising dialogue. Ironically, given that Eminem, Ja Rule, and Mobb Deep are supposed to be able to freestyle, their riffs are utterly moronic. Eminem tells us how the Hip Hop Witch spiked his hot butter with ecstasy. And that made his eyes start coming out of his ears. Then she stuck her finger up his ass. He responded by putting his whole arm up her butt. It takes him a dozen or so scenes filled with garbled repetition to convey this witless "anecdote." None of the other rappers do any better.

An unintentionally amusing side effect is the picture that emerges of the witch. In addition to digging butt sex and distributing drugs in butter, she also drinks beer and Hennessy, has six-feet-long fingers and hairy fingernails, gets around on twenty-inch feet, has green or purple hair done up in Stevie Wonder braids, wears a trench coat that can't hide her big titties and ass, and, overall, looks like Sasquatch. Nevertheless she's sexually irresistible to many of the rappers. As Vanilla Ice tells us, "She could be this fine chick and then completely flip the script and be Satan." The hardest thing to believe about the claim is that any sort of script was involved in these ninety minutes of repetitive misogyny made more excruciating by "cinema verité" narrative links that comprise blurry video shot through a dirty lens. *Da Hip Hop Witch* is definitely down with the worst and it too concludes with "To Be Continued." It's a horrific threat because when I tally up my marks out of 10 and 20 for direction, acting, dialogue, cinematography, production value, themes and ambition, and entertainment value it tallies up to . . . 12/100. Ladies and gentleman, we now have a three-way battle of the worst between this, *Grad Night,* and *Search for the Beast.*

Resteghini hasn't made good on his promised sequels, meaning the prize for crap-rap-horror franchises goes to director Albert Pyun, who excreted *three* such movies. A protégé of Akira Kurosawa, Pyun debuted in 1982 with the enjoyable *The Sword and the Sorcerer* but went downhill after that. In December 1998, Pyun's Filmwerks united with rapper Ice-T to produce the "urban trilogy," which were, supposedly, shot back-to-back in the Slovak Republic and Austria, with second-unit work in Detroit, New York, and Chicago. But to my eye it appears all three films were shot in the same drab warehouse, with exteriors captured by pointing a camcorder out a car window in an American city.

Urban Menace starts with Ice-T looming out of terrible digital flames:

"Attention. If you have any problems with blood, guts, gore, violence, mutilation, guns, knives, bodies on fire, strangulation, words like 'pussy,' 'dick,' 'fuck,' 'asshole,' sentences like 'You low-life piece of fucking shit,' sentences like 'Die, you no-good low-life motherfucker! Die you piece of shit bastard! Fuck you! Rest in hell, you motherfucker' this film will definitely offend you. And by the way? Fuck you."

For fans, it's the last two words that distill the true message of the trilogy.

Snoop Dogg plays Caleb, a Holy Man whose Friendship Church is burned down with his family inside. He becomes a pseudosupernatural avenger—in that he has glowing red eyes and can dematerialize but also needs a knife and .45 to do his business. And that business, Ice-T reappears to tell us, is as a "fucking archangel" who kills whores, pimps, dealers, and other scum because urban renewal is "bullshit." When gang bosses get wind of Caleb's vigilantism, they send hit men into the crumbling warehouse that's now his haunt. The rest of the movie is Snoop popping caps and blades into his enemies.

None of the violence is at all gory, despite Ice-T's promise, but *Urban Menace* makes good on the obscenity, though little of it makes sense, thanks both to poor audio and moronic scripting and ad-libbing. As in, "You better listen to what the motherfuck we tell you, nigger, and do what the fuck we tell you, nigger, or we'll push that motherfuckin' wig back, you bitch-ass motherfucker." It astounds that one of the "writers," Tim Story, somehow jumped to directing *Barber Shop*, *Taxi*, and then the massive *Fantastic Four* films. Maybe he should've jumped behind the camera here, because Pyun's soft-focus video often blows out so that its African American stars look, of all things, *white*.

Why *Urban Menace* appalls is because there was obviously a decision to take advantage of Ice-T and Snoop Dogg's fans and to do it as cheaply and lazily as possible. The ultimate proof is that the film's action takes up just sixty minutes, while the slow-running credits comprise *twelve* whole minutes solely to make this marketable as a "feature." The end credits of *The Lord of the Rings: The Return of the King*—a $100 million movie that runs 201 minutes, won eleven Oscars, and grossed $1.13 billion—are only nine and half minutes long. It's insult upon injury and I tally up 18/100 for this piece of crap.

Pyun's *The Wrecking Crew* and *Corrupt* are more of the same—blurry video action in the warehouse, desultory scripts, misogyny, rapper cameos elevated to star billings, and credits that take up 20 percent of the advertised feature length. This must be the most cynically contrived, shitty trilogy ever.

After such grimy times, I at least enjoy the saturated colors of 2003's multiethnic *Gang of Roses*. The spectacle of trash-talkin', leather-attired cowgals played by the likes of Lil' Kim provides unintentionally funny moments, but Jean-Claude La Marre (who also wrote, produced, and starred in *Nora's*) pushed his luck with 2005's *Brothers in Arms*. Starring David Carradine and rapper Kurupt, it comes off like a dour, over-stylized vodka ad . . . set in the Old West. Kurupt didn't have any better luck when he took a role in Ryan Combs's *I Accidentally Domed Your Son*, a 2004 would-be comic thriller in which four middle-aged homeboys inadvertently kill a mobster's son and go on the run, leading to the same twist Ed Wood used back in *Jail Bait*.

Finally! Finally, I'm at my last urban film—2005's *Fair Game*, written and directed by Michael Whaley. He also stars as Mike, who love-hates on co-worker Stacey. This is like a sitcom made by someone brain-damaged by too many corporate training videos. Inexplicably, as though they're in *Pride*

and Prejudizzle, our love-hate lovebirds address each other as "Mr. Williams" and "Miss Bennett." Much more egregious is that *everyone* in the movie speaks like MBAs on LSD. Thus Stacey is a "designated corporate hitter" for the head office. People say, "We should talk about this on the personal macrolevel," and use catchphrases like "negative evaluations," "significant recognition," and "brand exercises." All of this *might* make sense if they were CEOs, *but they're teachers at a grade school.*

What's bizarre about *Fair Game*—for me at least—is the way our lovers eventually bond. Turns out Stacey's a mad collector of Hot Wheels cars, desperate to get the "elusive white Camaro." Mike wins her love by presenting her not just this fabled classic but with a whole tub of the little metal vehicles.

It's past midnight when I crawl into bed with my own *Hot Wheels* woman and excitedly wake her to tell her about this coincidence.

"Ugggh," she says, able not only to contain her enthusiasm but to fall right back to sleep.

GORILLA SNORE FARE

Less than four hours later the littlest Hot Wheels fan decides it's time to get up. It's my turn to be on toddler duty and I slump onto the couch groggily as Ava pushes her toy cars across the carpet. I have a cup of coffee and decide 4.30 a.m. is as good a time as any to start my next segment: Gorilla Cinema, the worst big-ape movies.

In compiling this I had some help from John Landis, director of *Animal House, The Blues Brothers, An American Werewolf in London*, and less-seen spoofs *Amazon Women on the Moon* and *The Kentucky Fried Movie*. When I told Landis about my bad-movie project a few weeks back, he was very

appreciative—but I expected nothing else from the man whose debut was the 1973 monster send-up *Schlock*.

"So many of them are fun . . . just because they're fun," he said when I asked him why B and bad movies continue to entertain.

"Joe Dante and I used to go to Hollywood Boulevard in the 1970s, when it was very shitty, very down. To what they now call grind houses. Joe and I used to go and see tons of movies and we saw all of that stuff."

"What was the worst?" I asked.

Landis chuckled. "One day Joe looked at me and said, 'You know, life's too short. This is *sooo* bad. We're outta here.'"

"What was it?"

"I won't tell you the name of the movie because the director's someone I know."

Damn!

"We enjoyed that stuff, but then suddenly so much of what was outré and fun is now mainstream," he said. "Like, when Tim Burton's *Ed Wood* came out, I had mixed feelings about it. I really enjoyed the movie but it was also bullshit. It was very inaccurate." He paused. "I am one of the few people you'll ever talk to who met Ed Wood."

"What was he like?"

"He was an old drunk," he sighed. "I met him at the cast and crew screening of *Schlock*. Forrest Ackerman [editor of *Famous Monsters* magazine] brought Ed Wood as his guest to see the movie and he introduced me to him. I was twenty-one. I said, 'Ed Wood? Did you make *Plan 9 from Outer Space*?' And he was dumbfounded that *I* knew who *he* was. At that point he was making porno but I was thrilled to meet him."

"So, what's your favorite bad movie?" I asked.

"There are lots of them," Landis said. "There *are* movies that are so bad they're bad." He mused. "What's a bad movie

that's really fun?" he asked himself. "I'll tell you a B picture that I think is a wonderful movie that everyone thinks is bad. It's called *The Monster and the Girl*. It's fantastic. It's about white slavery, mobsters, gangster film noir, mad scientists, a boy and his dog—*and* it's a gorilla brain transplant movie."

I told him it was going straight onto my list of bad gorilla movies.

"No, it's really good," he protested. "I'm not joking. There are plenty of bad ape movies to choose from." Quickly, he rattled off a few.

So now with Ava crawling over me, I watch 1941's *The Monster and the Girl*. It's certainly as weird as Landis described it.

After falsely accused death row inmate Scot has his brain transplanted into a gorilla, he goes on a revenge killing spree on those who done him wrong—taking his little dog along as an accomplice. His unusual MO comprises WWF-style drops, which makes it a mystery that the press label him the "Mangle Murderer" when the "Krushin' Killer" would've been more accurate.

The Monster and the Girl is a polished production, with strong performances, and it's ahead of its time in dealing openly with some fairly "racy" material. That said, the crims are amusingly antiquated, with urbane gentleman pimps and killers operating out of a swish apartment. I don't love it as much as Landis, but it's is an agreeably demented way to see in the dawn.

A full day of work beckons, then a screening for *The Movie Show*, then dinner with Clare and then, eyes bugging out, I watch 1945's *White Pongo*, a Poverty Row cheapie also recommended by Landis, this time as a bad-bad flick. It's directed by Sam Newfield of *Tiny Town* fame. No midgets this time—just plenty of cheery racism as great white hunters track down an albino gorilla believed to be the missing link . . . because

he's smarter than his darker-furred brethren. This brainy honky gorilla develops a kidnap-happy crush on the white girl in the expedition . . . despite the jungle being filled with luscious African babes. But it's the dark-skinned men who're really insulted, particularly the lead "porter boy" whose name (I shit you not) is Mumbo Jumbo. This film is set in the Congo, meaning this is White Pongo from the Congo, featuring Mumbo Jumbo. If only Oingo Boingo had been around to do the soundtrack.

The weekend arrives and while Ava snoozes in between us, Clare and I watch 1953's *Robot Monster* in bed. Well, initially, I watch it and Clare reads the papers. But gradually she gets sucked in. How can you not? After *Plan 9*, this is arguably the second-most-famous "classic" bad movie ever made. In his memoir *On Writing* Stephen King says it's his first-ever memory of TV, while in reflection on the horror genre *Danse Macabre* he regales readers with a stoned adult viewing that had him rolling on the floor with laughter. (King has no such love for *Plan 9*, though, describing it as an "abysmal, exploitative, misbegotten piece of trash.")

Robot Monster is *The Wizard of Oz* of Z-grade cinema, being the postapocalyptic fantasy of fatherless young boy Johnny in which he, his sister, mom, and aunt and some local archaeologists—"the Professor" and hunky Roy—come up against the fearsome Ro-Man: B actor George Barrows in a gorilla suit worn with diving helmet and TV antenna! Laugh at your own risk because Ro-Man's quite the genocidal maniac and has killed 1,999,999, 992 of the world's two billion population. When he uses a bubble machine hooked up to a reel-to-reel tape machine and video screen to get in touch with his interplanetary boss, the Great Guidance, another gorilla-helmet head, he's told the job's not quite done yet.

Seems that Johnny and Co. have somehow survived and are

hiding out in a bombed-out building whose electrical fence conveniently makes them invisible to Ro-Man. Amid the rubble, the Professor has also whipped up an antibiotic that makes them immune to the death ray. We're told there are two other survivors who're trying to get to the "space platform" in a rocket built of stock footage.

Despite it being an easy equation (Family + Archaeologists + Rocketeers = 8) world-conquering Ro-Man experiences a *lot* of anxiety calculating how many people are left to kill. It's a situation further complicated by his crush on Alice, Johnny's aunt. But Alice wants smooth-talking Roy, who drops romance bombs like, "You know something, you're either too beautiful to be so smart or too smart to be so beautiful." So tantalized, she joins him in a sexual-tension-filled forty-eight-hour marathon of lubricating their ViewScreen so they can communicate with the Space Platform. The Freudian mechanics do no good because the Great Guidance unleashes a cosmic ray that destroys the rocket and the platform.

This at least does simplify Ro-Man's mathematical conundrum. "And now of the two billion there are six! Calculate your chances! Negative! Negative! Negative! Is there a choice between painless surrender-death and the horror of resistance-death?"

Robot Monster may be funnier under the effect of marijuana, but I can also recommend watching it with a hormonal spouse. Clare amplifies the hilarity enormously because, once she puts the newspaper down, she gets so *involved*. At first, her comments are just about Ro-Man's getup: "He looks like a Teletubbie. That's the worst costume I've ever seen." Later, maternal outrage is sparked. "Don't they know that Ro-Man is on the loose?" she demands. "It's fairly irresponsible for them to be getting it on while a small child's wandering the wasteland!" Fortunately, little Johnny's resourceful enough to make

it back to the compound. Not so his sister Carla, who's *strangled* by Ro-Man.

"That's horrible," Clare says, really disturbed now. But what appalls her is the eulogy for Carla.

"No regrets, Johnny," says the ice-cold Professor. "We enjoyed her as long as she was with us and now somehow we must find a way to live without her."

"What the *fuck* is he about?" Clare demands, outraged.

I'd like to answer—"Well, you know, it's a movie with *a robot-gorilla as its villain*"—but I'm laughing too hard to speak.

Robot Monster was made at Los Angeles's go-to "remote" location, Bronson Canyon, by director Phil Tucker in four days for $16,000. And he did it in 3-D. It wasn't always considered a bad movie. The 1953 *Variety* review remarked, "Judged on the basis of novelty, as a showcase for the Tru-Stereo Process, *Robot Monster* comes off surprisingly well." And the movie apparently grossed some $1 million, although Tucker reputedly saw none of it, a situation that drove him to attempt suicide.

Two other participants in *Robot Monster* also had it tough. Future Oscar-winning composer (and later a friend and colleague of Landis) Elmer Bernstein did the score in 1953 when he was "gray listed" as part of the McCarthy hysteria and could only get this and *Cat-Women of the Moon*. Meanwhile, hunky George Nader, who played Roy, would soon find himself hounded out of Hollywood because of his homosexuality in a compromise between Universal and sleaze rag *Confidential* that'd keep his friend Rock Hudson's gay secret.

While Nader's story had a happy-ish ending—he had an acting and writing career in Europe and lifelong relationship with Mark Miller, Hudson's secretary—the same can't be said for Barbara Payton, the star of my next movie, 1951's *Bride of*

the Gorilla. Shot in seven days, this was written and directed by Curt Siodmak, an émigré from Nazi Germany who's best remembered for *The Wolf Man*.

Amazon plantation manager Barney Chavez is having an affair with Dina, the wife of his employer, Klaas Van Gelder. When Klaas is bitten by a snake, Barney leaves him to die and thereafter his guilt—and the poison of an old voodoo crone whose daughter he jilted—causes him to see himself as "Curucu," a gorilla-like beast, which kinda ruins his new marriage to Dina.

This features a pre-*Ironside* appearance for Raymond Burr as Barney and was a post-*Wolf Man* check for Lon Chaney Jr. But the film's real star is the shapely platinum blond sexpot Payton, whose story ranks as one of the most tragic and self-destructive stories Hollywood has ever seen.

Born in 1927 and raised in Minnesota, Payton swept into Hollywood in the late 1940s and soon became a glittering starlet, conquering a who's who of the A-list that reportedly included Bob Hope, George Raft, Gregory Peck, and Gary Cooper, along with a supporting cast of B players, lawyers, drug dealers, and producers. But it was her love triangle with veteran actor Franchot Tone and B movie star Tom Neal that put her on the front pages around the world when, in September 1951, the two men slugged it out for her affections. What followed was even more sensational as, over the next fifteen years, this ten thousand dollar a week contract star sank into alcoholism, drug addiction, homelessness, psychosis, and curbside prostitution before dying at thirty-nine.

Payton's is an utterly heartbreaking story, and one that has only emerged in full thanks to the dedicated detective work of John O'Dowd, author of the excellent biography *Kiss Tomorrow Goodbye: The Barbara Payton Story*.

I next schlep through *Bride*'s producer Jack Broder's *other*

ape movie featuring a star in desperate straits, 1952's *Bela Lugosi Meets a Brooklyn Gorilla*. Directed by William "One Shot" Beaudine, who gave Sam Newfield a run for his money with a career that spanned over two hundred features, it's a horribly unfunny "romp" starring third-rate Dean Martin and Jerry Lewis imitators Duke Mitchell and Sammy Petrillo mugging their way onto the island of Coca Cola where Lugosi's mad scientist has a serum that can turn man into gorilla. Petrillo, the Lewis clone, went on to do not much, but Duke Mitchell surged into B-grade history by making and starring in 1970s flicks *Massacre Mafia Style* and *Gone with the Pope*, unfinished and unreleased when he died in 1981. Grindhouse Releasing has promised DVD versions, including *Pope* as it was meant to be seen. I can't wait. The trailers on YouTube are nuts.

I shouldn't have stayed up so late watching that stuff because, on the morning of *The Movie Show* launch, I stumble to our tiny bathroom, pick up my trimmer, and groggily start mowing away at my skull. I plow about five inches before I realize I've put the number two attachment—the setting marked "neo-Nazi"—into my clippers. Oh, shit. There's nothing to do but keep going.

"Look at you," says my other show producer, Tinzar Lwyn, when I arrive at the Sydney Opera House. I'm not sure whether she hasn't noticed my *American History X* look or whether she's just being diplomatic.

Nerves are buried so down deep today that they don't surface during Lisa and my brief tag team live presentation. We take our seats and the big screen comes alive with the first episode. I forgot to bring my glasses so the show's pleasantly soft focus for me. Adrenaline renders the experience even blurrier. I don't come across as a bumbling idiot but I am talking with my hands so much I could be a cartoon Italian. But Lisa is smooth and the production is slick.

133

Back at home that night, Ava spies a preview for the show on TV and yelps "Daddy!" which is enormously cute. One thing that's really appealing about *The Movie Show* gig—apart from fame and fortune, of course—is that in years to come I'll be able to show Ava what Daddy did for work when she was a tot. Now, though, it's time for her to go to bed.

We still have a few hours until the show hits the airwaves so Clare and I watch 1976's *A*P*E*.

A South Korean production directed by American Paul Leder, *A*P*E* is a genuine so-crap-it's-fun epic. The opening has a toy boat floating in a pool as shipmates discuss their thirty-six-foot ape cargo in what sounds like phonetically remembered dialogue. The exchange culminates in a priceless "Ohhhh sheeeet" when their monkey escapes and the boat explodes in a cascade of five-dollar fireworks. A*P*E then wrestles a clearly real but long dead shark in a bit that makes *Bride of the Monster* seem realistic.

A*P*E goes on to stomp models of South Korean villages and towns, causing hordes of extras to stampede into his monolithic and very hairy legs. He repeatedly kidnaps an American starlet played by Joanna Kerns in her movie debut and is assailed by toy helicopters and tanks. And, as this is filmed 3-D, he often flings wire-supported Styrofoam boulders at us. For the record, this wasn't meant to be entirely serious. During one showdown A*P*E flips the finger at his adversaries.

With *A*P*E* done, we switch over to *The Movie Show*'s debut broadcast.

Aaaaargh!

Now I've got my glasses on and the plasma screen is unforgivably sharp. A wave of total paranoia washes over me.

My head looks as big as A*P*E's and I'm jowly, blotchy and pasty, strained, and speedy and borderline bellicose. My mitts

just won't quit gesticulating meaninglessly. Clare's reassurance helps a little but I can see why so many actors claim they never watch their performances.

STATUS REPORT

Worst this month: *Grad Night, Da Hip Hop Witch*
This month's runners up: *Urban Menace*
Guiltiest pleasures: *A*P*E, Battlefield Earth*
Movies watched: *149*

JUNE

I'm not a fuckin' vampire.

—Me, as Stoned Hippy, *Bloodlust*

SON OF GORILLA SNORE FARE

On the bus to work, no one double takes or jabs me with sticks. I'm not sure if I'm disappointed or relieved. The only official review of *The Movie Show* comes from an online film industry newsletter. "I quickly decided that Michael Adams is going to be the reviewer you're going to love to disagree with," it reads. "He's dogmatic, strongly opinionated, and waves his arms around a lot, and I took issue with him in my mind several times in that first 10-minute show." The *Empire* boys are supportive, although it's hard to know whether they're just being polite. None of it bears thinking about too much. Feeling less like I've made a monkey of myself, that night I watch 1976's *King Kong* remake. Charles Grodin is a petrol company executive leading a maritime expedition for oil in remote Indonesia. Jeff Bridges is primate-chasing stowaway Jack Prescott and Jessica Lange enters as a flotsam floozy named Dwan. When they reach Skull Island, Lange is abducted by natives.

As she lolls, drugged and orgasmic as a sacrifice to the big ape, I wonder, "Why do the natives always build a big door in their enormous anti-Kong fences? Is it because when there are no white women as offerings they ask him in for coffee?" In this version there *is* a reason: 1970s hard-core subtext. The giant door allows for giant hoop locks into which slides a giant greased black log. Going right along with the swinging vibe, Dwan's rage at her "chauvinist" supersimian suitor soon gives way to her flirting with, "I'm a Libra, what sign are you?" The seduction, which includes a waterfall shower, is interrupted— paging Dr. Freud—by a giant snake attack.

Having learned the island's oil is useless, Grodin goes to Plan B: catch Kong for use as a *corporate mascot*. Back on Manhattan and unimpressed at being made a shill, Kong breaks free, squishes Grodin, and goes a-stompin'. Bridges— always ten pages ahead in the script—has a hunch he'll make for the World Trade Center. There the man in the monkey suit is beset by bad helicopter-gunship special effects before taking his deathly fall.

Bridges accounts himself decently, although he's so hairy he might've *played* Kong. Grodin chomps so much scenery he could probably have *eaten* Kong and saved the day. What really sinks this is that Jessica Lange's beauty can't kill her beast of a performance. Her Best Acting Debut at the 1977 Golden Globes ranks alongside that award show's other scandals.

Mighty Peking Man cashed in on *King Kong* with a ten-story-tall Neanderthal freed from frozen hibernation in the Indian Himalayas. A drunk named Johnnie is enjoined by ruthless entrepreneur Lu Tiem to catch the big lug for the usual fame and fortune. Our hero's expedition quickly falls afoul of quicksand, treacherous cliffs, and stampeding back-projected elephants. And when a hungry tiger bites off a

sherpa's leg, Lu Tiem dispenses first aid in the form of a bullet to the head.

But Johnnie has to be rescued from Mighty Peking Man by Samantha, a Swiss stunner who was raised by the big Neanderthal after she was orphaned in a plane crash. A true Sheena type, Sam swings on vines, hugs tigers, and nip-slips out of her animal-skin bikini. When she's bitten on the inner thigh by a cobra, it's Johnnie's turn to do the rescuing by sucking the poison out. An elephant acts as her ambulance and Mighty Peking Man delivers medicinal leaves. It's the sort of health care most Americans only dream of.

Samantha and Johnnie fall in love and go to Hong Kong with Mighty Peking Man. Sam learns English in record time but doesn't change her outfit. Our Neanderthal battles Tonka trucks in a stadium spectacle and later goes crazy when Lu Tiem puts violent moves on Sam. Rampaging through Honkers, he dispenses gorilla-genre justice by flattening the villain. To restore calm Johnnie must find Sam.

"The only thing I know is that she's dressed entirely in animal skins—that ought to narrow it down a little," our hero rightly observes.

Mighty Peking Man climbs a building and then . . . the military attack! It's derivative but Johnnie and Sam's attempts at self-sacrifice are more bloodily convincing than *King Kong*'s. This also offers a better class of exploding tin tank, plastic chopper, and balsa-wood skyscraper than *A*P*E*. I can see why Quentin Tarantino rereleased it in 1999, much to Roger Ebert's delight.

In 1986, *King Kong*'s director, John Guillermin, and producer, Dino De Laurentiis, decided *King Kong Lives*. All the bullets and the 110-story fall didn't kill him after all and for the past decade Linda Hamilton's veterinary surgeon has had him on life support. She's developed a giant artificial heart for

Kong—at the cost of $7 million, which is a lot to spend on the beast *that tore apart New York*. Before any transplant can take place, Kong needs a blood transfusion. Fortunately, at that *very moment* in Asia, an adventurer catches a Lady Kong. We know she's a girl because she has an orange-pink rinse.

Hamilton and her team do the Lady-to-King transfusion, and then lower the truck-engine-sized mechanical heart into his chest. Outside the institute, people in monkey masks party wildly—inexplicable given what happened, you know, *last time*. When King wakes up and smells Lady, he gets agitated. Also playing on his mind is that the last thing he remembers is *humans blowing him off the World Trade Center*. Horny and pissed off, he breaks free and whisks Lady off—saints preserve us—to Honeymoon Ridge.

The military gases Lady but King jumps off a cliff into a river. The powers that be presume him dead—*despite his record of surviving far greater falls*. In the Georgia swamps, King survives by eating one thousand pounds of alligators a day. Provoked by rednecks, he snaps one in half and eats another. "Kong, you've killed now, nothing will stop them from killing you," observes Hamilton solemnly, clearly *having forgotten the events of 1976*.

Kong rescues Lady, and she gives birth to their Baby Kong. That the blessed event takes place in a barn makes me wonder if someone was planning a third *Jesus Kong* film. Soldiers blow chunks out of King. He enacts gorilla-genre justice by flattening the hard-case colonel with a satisfied smile. Then King dies, crying, as he cradles his crying son, watched by a crying Linda Hamilton. At this point, I'm crying, too, but with laughter.

DOWN AND UNDER

The Movie Show has moved me a few rungs up the publicity ladder. That's why I'm sitting opposite Michael Bay, the much-pilloried director of mega-action films like *Bad Boys*, *Armageddon*, *Pearl Harbor*, and now *Transformers*. I saw his robot-spectacle movie night, thought it was okay. Bay has just done a PR barrage in a warehouse decorated with stiletto-wearing Megan Fox and Rachael Taylor, a Humvee, and other penis-substitution technology. Now I'm backstage, surrounded by DreamWorks personnel, local PRs, makeup artists, two camera and sound crews. I'm dying for a piss but too bad because our ten minutes starts *now*.

"Congratulations," I say. "It looked amazing."

It's not a lie, because the special effects wow-factor of *Transformers* was undeniable, but an example of the junket politesse where you single out a praiseworthy aspect if you're not sold wholeheartedly. Saying, "Dude, well, it was better than *The Island,* cos that sure sucked, but nowhere near as good as *The Rock*, which, like rocked," would be a bad start.

The trim, lupine director is laserlike. Not scary, not freaky, just *on*. He talks about thinking only about *Transformers* for the past eighteen months and how there were *thousands* of attempts to hack the production's computers and glean the film's secrets. He jokes how he had to have some "military dude" deal with a nerd who hacked his home computer. When I mention *Team America: World Police*, the puppet-movie parody of Bay's bombast, he bristles ever so slightly. "I think I dated his girlfriend. That's why he's pissed at me. What can I say?" is his Teflon-coated reason for why he'd be so parodied, his statement blithely turning the *South Park* guys Matt Stone and Trey Parker into one person. Our interview time runs out before I get the chance to ask him his worst movie. He wouldn't

have answered anyway. When I ask about his favorite under-rated movie he tells me his head is not in the right space to answer. Anyway, I'm glad we're done because my bladder's about to explode.

Finally, I think I can take a piss. But not before a Dream-Works VP of something corners me.

"Hey, good interview," he says.

"Thanks," I say.

"So, you didn't like *Shrek the Third*?" he asks. The tone is velvet-glove-iron-fist accusatory. "I saw the review on the show last night."

Damn, I forgot about that.

"I was—I mean, I didn't hate it. I thought it was—"

"Disappointing," he finishes for me. "Yeah, we all thought so. It was *crap*."

The suit then launches into a surprising spiel about how it let the franchise's brand values down, something that's of particular concern when sequels *four through ten* are still to come, not to mention the TV show and Broadway musical.

"Hmm, hmm, hmmm" is what I say before bidding him adieu and exiting stage right, power walking off in search of a bathroom. I've never been so relieved to hit the urinal.

I'm told by *The Movie Show*'s producers that some 3.3 million people saw at least one minute of the first episode. I don't know how they calculate such things—perhaps with help from *Robot Monster*'s Ro-Man—but, like, yikes. I watch the second episode—the one with *Shrek*—as a podcast because I'm more acceptable on a smaller screen, even if that tummy-hugging purple shirt was a baaaad fashion mistake.

But while I'm able to avoid seeing my current incarnation on the plasma, I can't duck being confronted with how I looked in 1991. That's because it's time for *Bloodlust* and I'm *in* this one.

I knew Australian co-writer-director Richard Wolstencroft through my university journalism course. With my dreadlocks and druggy ways, he thought I was a natural for the supporting role of Stoned Hippy in a main story about three nightclubbing sex-freak bloodsuckers who rob a casino and are pursued by inept Mafia assassins, a pair of redneck cops, and a gaggle of religious freaks called Zealites.

Bloodlust's claim to fame is that it was the only Australian film ever "banned in Britain." The opening scenes alone feature a vampire-hybrid freak staked and a nude dude hung upside down and eviscerated.

The introduction to our vampire-like trio maintains the violence and weirdness. Long-haired Tad turns a gun dealer's weapons on him in a frenzy of crimson squibs. Blond vixen Frank rides a dead guy, drinking his blood and smearing it over her big boobs. Amazonian redhead Lear gets her feet sucked by an old businessman who declares, "Oh, mistress, I love your feet, especially when they're dirty and I can lick the black from the cracks!"

I wasn't asked to do anything quite so extreme. My first scene has me strolling barefoot down a laneway. I'm carrying a guitar case, wearing a paislcy shirt, beads, and headband. It was cold that morning and I was late to set—and still tripping from the night before. Maybe Richard was right about my suitability for the role. Two radio personalities doing atrocious redneck-cop accents stop to hassle Stoned Hippy, who just wants to be left in peace to hum Bob Dylan and inspect weeds in case they're dope.

"Hey budd-ee, whatchoo got in tha case? Boy-freen's new vi-bray-tor?" drawls one of the pigs.

The last bit of that line was my invention. Man, am I proud.

"You better stay there or I might arrest you for wearing a

loud shirt in a quiet street!" barks the other cop.

Stoned Hippy, of course, runs for it.

I wind up at the creepy disused insane asylum the production used for the vampire lair. There I stumble upon the sleeping bloodsuckers, covered in the red stuff. Tad has a poxy beating heart clamped in one fist. The camera crash zooms into my scream. I flee again, yelling, "Bad trip!"

My final scene has me cornered by the Zealites, led by salivating and stake-happy Brother Bem.

"I'm not a fuckin' vampire!" I yell, before telling them where the lair is. This scene, played opposite actor Phil Motherwell, put me three degrees from Kevin Bacon. (Phil was in *Stir* with Bryan Brown, who was in *Cocktail* with Tom Cruise, who was in *A Few Good Men* with the Kevster; later, the fact that Bryan Brown produced *Two Twisted* and introduced the episode, in which I appear in fleeting photo cameo, put me a degree closer. Sometimes I cackle at my own power.)

Motherwell gives *Bloodlust*'s only decent performance, gleefully thundering "I've just declared hunting season on Satan!" and "I'll deal with you later, hellspawn!" The other actors, myself included, are terrible.

For all its flaws, *Bloodlust* has ambition and personality. And with its take-no-prisoners chicks, supernatural and criminal elements, black comedy mixed with gory violence, it's hard not to think Richard was channeling many of the same influences as Quentin Tarantino. The plot hinges on vampires, robbery, and rendezvous, Brother Bem quotes the Bible as he brandishes a huge pistol called the Gold Bison, hopeless Trivial Pursuit–playing gangsters shoot each other accidentally or mistakenly massacre the innocent. There's a cold-blooded carjacking, anal rape played for laughs, a character tied up in a car trunk and offered as a gift, and, of course, the aforementioned foot fetish scene.

Thing is, while *Reservoir Dogs* inspired countless imitators, *Bloodlust* was made and released a year *earlier*. There's no suggestion of copying. More like Richard and Quentin were cut from similar cosmic cloth. It's reinforced by the former's cameo. Very tall, black-haired, squinty-eyed, square-headed, lantern-jawed, and in a black suit and white shirt, he looks like Tarantino's long-lost twin.

I can attest that no one on *Bloodlust* was making anything other than what they thought would be a great film. The bemused reaction at the premiere—even from friends—made it clear that hadn't happened.

In case it's suggested *Bloodlust* isn't worthy of inclusion, a few notes. It has an average IMDb user rating of 2.6 out of 10—just not enough votes to warrant Bottom 100 status. "Yamaelle" of France is optimistic: "I hope *Bloodlust* will one day reach the bottom 100, because that's its real place." A few other blurbs: "As bad as any movie I've ever seen," "It just keeps getting worse and worse," and "Quite possibly one of the worst films ever made."

Fans of Australian cinema shouldn't think we're immune to creating world-class crap and over the course of two weeks I revisit some hoary old big-budget monstrosities (*The Pirate Movie, Welcome to Woop Woop*, the Barry Humphries vehicle *Les Patterson Saves the World*, and *Crocodile Dundee in Los Angeles*) and discover some cheapies every bit as dreadful (*Phantom Gold, The Glenrowan Affair, Zombie Brigade, Trojan Warrior, Bullet Down Under, Houseboat Horror, Subterano*). Of this two-week Aussiefest, three deserve special attention.

Pandemonium, released in 1988, exploits the sensational true story of baby Azaria Chamberlain's outback disappearance—dramatized by Meryl Streep the same year in *A Cry in the Dark*. This has a grown-up "Dingo Girl" reappearing on

Bondi Beach, where she explains she was raised, not eaten, by Australia's native dogs. Dingo Girl is played—topless and in a loincloth—by Amanda Dole, then a minor celebrity for having been, at just sixteen, in *Playboy*. Her main man is Kales, an escaped mental patient who relates the story.

Writer-director Haydn Keenan's flick revolves around an abandoned movie studio populated by an assortment of freaks, including an ancestor of Hitler's, also named Adolf, who wears a giant strap-on to a swastika-adorned wedding and is controlled by Nazi twin sisters, who're also lesbian lovers. Dressed as a dingo because he's somehow her brother, Kales has sex with Dingo Girl on the floor of a nightclub while the Nazi lesbians masturbate Adolf for IVF because *they* want to impregnate her to create a Master Race. The garishness and incomprehensibility never let up and it's like pretentiously shock-comic dinner theater performed in hell. Half of me thinks it's the work of a radical black-comic surrealist genius—and the other half of me is convinced I've just watched the worst piece of shit in history.

The year 2000 produced *Narcosys*, another strong contender for the Aussie movie brown crown. In a low-budget dystopian future where alleyways are filled with dry ice smoke, a virus has been unleashed in street drugs to eliminate subversives. A riot girl named Matrix Monopoly will avoid execution if she infiltrates the "Junk Unit," a gang of rad dudes who're raiding the Company's chemical refineries so they can get uncontaminated narcotics.

Narcosys plays like the bad meth comedown of people who, back in the day, read way too many *Mondo 2000* magazines and spent their spare time designing robotic genitalia for themselves. There are drug-injection scenes, game-playing "levels" conquered by scoring and killing, bondage-themed rave-dance interludes, and an endless loop of bad drum and

bass. This may have *the* worst dialogue ever speed babbled.

"Let us pray. I was once, Lord, lost, but I found my sheep," intones character Sintax. "I shall not want the Lord as my savior . . . Salvation rides to town on an ass. Love your enema. Turn the other cheek. The city dies like a constipated junkie. Welcome to de-void."

It's even more horrifying when these imbeciles "converse."

SINTAX: *If Jesus would stop hanging up on the cross, maybe the call could get through.*

MATRIX MONOPOLY: *Back up, bomb shelter! Take-away brains in a bunker.*

SIN: *Metro, your Eva Braun here has a maternal instinct.*

METRO CONFETTI: *Why not? I love my mothers.*

MATRIX: *Motherfucker.*

METRO: *Stupid bitch.*

SIN: *Every dad's a motherfucker.*

SUCH BAD BIZARRE STYLINGS make it a 19/100. But for sheer weirdness, 1997's *Maslin Beach* stands alone. My friend Rick Kalowski insisted I include it and he was dead right: If any cinematic eccentricity deserves rediscovery, it's this one. And that's because *Maslin Beach* is a romantic comedy, a soap opera, a raunchy gross-out, an arty and earnest exploration of what it means to be men and women in love and lust—set entirely on a nudist beach and performed by an amateur cast who're almost always completely naked.

"Is there such a thing as perfect love?" ponders Simon as he watches a hottie and a hunk shower nude. He's at the beach with his girlfriend, Marcie, and they're having troubles. Elsewhere, another naked couple argue about their relationship until a nude hippie steals the woman away with his magic tricks.

The vignettes continue. A couple arrive at the beach separately, both on secret computer dates, only to discover they've been match-made with each other. An ice-cream truck driver dispenses wisdom like, "If you don't fart, you don't shit, and if you don't shit you die" to justify his own seismic eruptions. A large naked lady sings opera against the red earth and blue sky for an image both eye-wateringly funny and genuinely striking. I howl as an enormous, floppy-bosomed woman describes how her ex-lover attached himself to her literally by putting Superglue on his penis, landing them both in the hospital, where they had to have sex so he'd "blow himself clear."

Remarkably, many scenes are played out with an Ingmar Bergman level of earnestness. "Is anyone really in love?" the film asks. It's a movie whose heart would be on its sleeve, if only it was wearing one.

SUPERZEROES

"We've seen some pretty dodgy killer animals in horror movies over the years, with serious monsters made of worms and grasshoppers, rabbits and shrews, to name but a few in the crazy menagerie," I'm saying to camera, successfully, against all the odds. "And now a New Zealander newcomer has turned these little guys into ferocious killing machines—"

"Cut!" says Sam, my producer, as one of these "little guys"— that is, a muddy lamb—clambers up my lap, shattering all concentration. There's laughter all around and we try to nail this review of New Zealander horror comedy *Black Sheep* again. I'm not sure "theming" locations like this drippy, sheep-filled farm shed pays off for viewers, but I can't deny it's fun.

We wrap early and I head home, wash the sheep-stink off me, and begin the next segment: Bad Superhero Movies. Following the success of *Superman* in 1978 came Spain's 1979

cash-in *Supersonic Man*. Our hero Kronos is awoken from space hibernation by his father who directs him to go save Earth. With a cosmic zap, our boy's sleepytime eye mask and Y-fronts are replaced by red tights and blue cape and off he flies.

Earth, see, is threatened by Lex Luthor–like Dr. Gulik, who commands laser-shooting storm troopers and a big robot who looks like he should have a key in his back. Fortunately, Supersonic Man can dematerialize trucks, throw rocks, and turn bad guys' guns into bananas. Confusingly, he never breaks the sound barrier . . . which kinda makes him Subsonic Man.

The dubbing, Muzak, and special defects are amusingly crap but there's too much talk, with B movie vet Cameron Mitchell's Dr. Gulik so verbose he's the Oprah of supervillains. The best bit has him enacting Plan 247 to destroy New York City. Ed Wood's aliens have *nothing* on this guy.

Onward, with 1980's *The Pumaman*. Black-vinyl-clad villain Kobras, played by Donald Pleasence, has the Pumamask and wants to use it to exert voodoo mind control on the world's population. Hulking Aztec god guardian Vadinho—hair by Dora the Explorer, jaw by Jay Leno—has to find the new incarnation of Aztec god the Pumaman. His method? Throw people out of windows to see if they float. American paleontologist Prof. Tony Farms passes the test, meaning he must take the Pumantle.

Tony's reluctance is understandable. He gets a scarlet cape and black tunic but has to wear his own slacks and shoes. He doesn't fly so much as leapfrog around a back-projected London, costume bunched where the harness is holding him aloft. Worse, Vadinho keeps saying stuff like, "You are the worst I've seen, but you are the Pumaman!" and offering peyote-influenced advice like, "Dive into nothingness."

Once he gets a handle on his skills—astral traveling, car

flipping, dematerializing—Pumaman still can't beat Kobras's mind-control mannequin-head technology. Thankfully Vadinho has more acid-soaked wisdom—"Each man is a god, each man is free"—that gives Tony the necessary spirituality to Pumaman up in the finale. Once the smiting's done, love-interest Jane asks if she and Tony can have sex in the air. "But that's how you make little Pumamen," he says, hinting at a *Pumakids* sequel.

Unfortunately, Hollywood instead gave us 1987's *Superman IV: The Quest for Peace.* In a "topical" story devised by Christopher Reeve, Supes declares he's a citizen of Earth and collects all our nukes in a big orbiting net before hammer-throwing them into the sun. Meanwhile, Lex Luthor uses a strand of Superman's hair to create superantihero Nuclear Man. This chap has silver talons, a blond bouffant, and shoots orange lasers, like a pimped-up refugee from the WWF.

The regulars—Reeve, Margot Kidder, and Gene Hackman—can't save this one, which, while stupid in concept, wasn't helped by a massive budget slash just before filming began. *Superman IV* is sad, too, thanks to Reeve's fate. His final line to Lex and Jon Cryer's Lemmy as he drops them back to prison is "See you in twenty." Of course, after this movie bombed, killing the franchise, it *would* be two decades before the Man of Steel returned. By then, Reeve was gone.

Superman IV's failure meant a planned *Spiderman* movie was canceled. But Tim Burton's 1989 *Batman*'s success started another superhero cycle—most of which failed.

Captain America, shot in 1990, never saw cinematic release. This starts in 1936 when a brainy boy undergoes a Nazi experiment that turns him into the supervillain Red Skull. Cut to 1943 and the Americans are using the same technology on polio-afflicted Captain Steve Rogers—until Nazi sabotage sends the project haywire, resulting in Steve superpowered to

the extent that he . . . can throw a shield really well and jump quite high.

Donning his costume—charmingly explained as a fireproof suit designed by someone without an eye for camouflage but a love of the red, white, and blue—Steve parachutes behind enemy lines to destroy a Nazi missile silo. Due to Red Skull's perfidy, our hero is crucified on a rocket bound for the White House. He diverts it to Alaska and is buried in the ice—where he remains as the decades fly by in a montage of misspelled newspaper stories accompanied by Duran Duran lite. When Captain America defrosts, he has to thwart Red Skull's plan to mind-control America's environmental president.

This film was shot in Yugoslavia—then still ruled by its own Red Skull Milosevic—and is kinda fun. The dialogue's deadly but future "Urban Trilogy" director Albert Pyun captures the comic book style well enough that Stan Lee said he was happy with the movie and Matt Salinger, son of J. D., is appealing in the title role despite his single expression of stunned disbelief.

While the *Fantastic Four* became a behemoth franchise, the first film version, made in 1994, didn't even merit the ignominy of being dumped to video and remains unreleased. This has Reed, Ben, Sue, and Johnny in cheap costumes aboard a spaceship that crashes thanks to solar storm Colossus, turning them into the FF—or as fantastic as four people can be on such an ultralow budget.

The effects are laughable, deliberately and otherwise. Susan materializing head first is played for mild giggles, but Reed's elasticity, achieved through forced perspective, zooms, and elongated sleeves and trouser legs is unintentionally sidesplitting. Johnny's hand flames and fire sneezes are a little better but the Thing's big cracked face is barely animated. The performances, meanwhile, reach the level of TV soap. Put it this way: I'll never complain about Jessica Alba again.

Fantastic Four is like Saturday morning TV, rather than actually atrocious. It is noteworthy as the most notorious example of an "Ashcan copy" of an artwork. In 1992, production company Constantin Film was going to lose its option on the property unless the film went into production in December. The script was budgeted at *$40 million*. They took it to producer Roger Corman, who got it done for *$1.98 million* in just four weeks. In late 1993 it was revealed the film had never been intended for release but was merely made to fulfill contractual terms. It's hard not to feel sorry for the cast who'd spent months talking the movie up to fans.

Just as the first superhero cycle ended on *Superman IV*, so the second closed ten years later with the ill-conceived fourth Batman outing, *Batman & Robin*, that megacamp effort that put the Dark Knight in a skin-tight suit with nipples. Director Joel Schumacher has said he injected speed six times a day and dropped thousands of acid trips between 1965 and 1970 and he appears to have been having some sort of flashback here, while future Oscar winner Akiva Goldsman seemingly wrote this with assistance from a Pun-O-Tron 3000. The first extreme-action scene—Batman and Robin fighting Mr. Freeze's hockey-team minions in a frenzy of skysurfing and paragliding—is like being trapped inside a pinball machine whose major sound effect is Arnold Schwarzenegger droning "gags" like "Za Ice Man cometh!"

There's no real story, just $125 million worth of such sequences. The money is occasionally well spent. Some sets look like a 1930s Universal horror film wrought in neon. But this fun park is empty, baby. This cast appears, rather than performs. George Clooney is a smirking bobblehead. Chris O'Donnell robs Robin. Batgirl Alicia Silverstone acts with her dimples and curves. The exception is Uma Thurman. She has fun slinking around as Poison Ivy, who wants to kill the

world's animals to make way for her dino plants. At the other end of the scale, Schwarzenegger makes "My name is Freeze, learn it vvell, for it izzz the chilling zzound of your doom" even more turgid than it reads—no mean feat. Born thirty years earlier, Arnie might have been Tor Johnson, stumbling around *Plan 9* and *Yucca Flats*.

Once *Batman & Robin*'s finished, I go for a walk. It's June thirtieth. I'm halfway through.

I am glad I'm taking notes because my head bulges with the badness and the arcana I've picked up. The movies are starting to run together. But sometimes the factoids unite into thoughts like, "I bet vegetable-loving Poison Ivy would get on well with Dr. Bragan from *The Revenge of Doctor X* and Elizar Kane of *Theodore Rex*." And I'm pretty sure that's never been considered by anyone previously.

What is a little distressing is that while I've watched 175 bad features—and about 100 silent shorts—I'm 181 days in. That's only 0.96 features per day. I need to pick up the slack, while ensuring I'm not too zonked to fulfil my day-job obligations to the magazine and the show. Doing some basic math, using an average running time of ninety minutes, I reckon I've dedicated about twelve straight days to bad movies. It seems a lot but then I start thinking about watching *The Soup* last night. Joel McHale irreverently whipping around the week's worst reality TV moments is a reminder there are literally tens of millions of people out there devoting much, much more of their time to watching far, far stupider stuff.

As I'm strolling, feeling a bit smug, I get my first taste of life as an F-list celebrity when a pretty girl looks at me and says, "I *love* that show."

I *bet* Joel McHale gets this all the time!

I'm blushing graciously when it dawns—she's looking at my *Family Guy* T-shirt.

"It's *sooo* funny," she says before hopping on her bus.
Oh, right. Back down to Earth.

MIDWAY STATUS REPORT

Worst so far, three-way tie: *Search for the Beast, Da Hip Hop Witch, Grad Night*
This month's contender: *Narcosys*
This month's guiltiest pleasures: *Mighty Peking Man, King Kong Lives*
Movies watched: *175*

JULY

It ain't much but it's better than nothing—boy,
I've had a lot of nothing.

—John "Bud" Cardos as Firewater, *Satan's Sadists*

AL ADAMSON-O-RAMA

Despite the yawning chasms of boredom that need to be traversed to get from start to finish in many of the movies I've watched so far, I have to say I'm still enjoying myself. There are enough of what critic Pauline Kael identified as "tiny shocks of recognition" to be found in junk to keep me going. I love that perhaps the most influential film critic of all time had this to say about schlock in her 1969 essay "Trash, Art, and the Movies": "The romance of movies is not just in those stories and those people on the screen but in the adolescent dream of meeting others who feel as you do about what you've seen. You do meet them, of course, and you know each other at once because you talk less about good movies than about what you love in bad movies."

That big movie-and-art brains Manny Farber and Susan Sontag also wrote seminal pieces about the value of "termite art" and "camp" found in B-grade fodder also sometimes

helps me delude myself into thinking I ought to be watching these films with a pipe and tweed jacket. I am delighted to experience Kael's "joy of a good performance" (say, Dustin Hoffman in *Ishtar*) or "joy in just a good line" ("You've got the guts to just say, 'To hell with it.' You say that you'd rather have nothing than settle for less," Hoffman in *Ishtar*), but I'm as much here for the sheer surreal fun to be had with the likes of Weng Weng or Mighty Peking Man.

Such enjoyment may be tested by the works of Al Adamson. After all, film critic and *Empire* U.K.'s contributing editor Kim Newman wrote in his book on horror flicks, *Nightmare Movies*: "Any fool who thinks bad films are uproarious fun would be cured if locked in a cinema during an all-night Al Adamson retrospective." Fool that I am, I'm going *waaay* deeper than that.

Before this quest, all I knew about Adamson were some of his racier titles, like *Dracula vs. Frankenstein* and *Horror of the Blood Monsters*, which I'd gleaned from a childhood spent reading books about monster movies. David Konow's biography *Schlock-O-Rama* fills some gaps. Al was born in 1929, the son of New Zealander Victor Adamson, who made cheapie horse operas in Hollywood. Having learned from dad, Al's debut as director, 1965's *Echo of Terror*, didn't see release. But once he teamed up with aspiring distributor and producer Sam Sherman, who since the early 1960s had been a writer and editor for Jim Warren's magazines, including *Famous Monsters*, they'd launch a decade-long, genre-hopping assault on drive-ins and grind houses.

The decline of such venues in the face of video, along with Adamson's actress-wife Regina Carrol's battle with cancer, saw him bow out of the industry for most of the 1980s. After her death in 1992, Adamson announced a comeback—with a documentary about UFOs. It wasn't to be. In June of 1995,

Adamson was reported missing. His body was found five weeks later, cemented into the Jacuzzi of his California home, head caved in from blunt force trauma dealt by Fred Fulford, a building contractor Adamson had been in dispute with over money. Fulford is still doing his twenty-five years.

Adamson made his reputation with *Satan's Sadists*, shot on 16mm for a paltry $65,000 and released in June 1969. The opening has the outlaw gang the Satans drugging two young lovers, gangbanging the girl, putting the couple back in their car, and pushing it off a cliff. The good guy of *Satan's Sadists* is Johnny, a Vietnam vet who runs afoul of the gang. He escapes their desert diner rampage with Tracy, a dune buggy-driving waitress, and for the rest of the movie the Satans are in lukewarm pursuit.

Adamson shot some of his movies at the Spahn Movie Ranch in 1968–69, when the Manson family were in residence prior to Helter Skelter. *Satan's Sadists* was released two months before Manson sent his followers out to murder actress Sharon Tate and six others and I reckon Charlie might've taken in a screening. Why *wouldn't* he have been a fan? After all, Satans' leader, Anchor—played by Oscar nominee Russ Tamblyn—is a sadistic freak with a cultlike grip over his gang. He combines biker, hippie, and Nazi fashions and styles himself as defending the flower power generation by killing pigs.

Satan's Sadists is sloppy stuff. Fast edits can't cover flubbed takes. Scenes barely connect. Some of these tough guys can't ride their bikes and the gore looks like hastily applied ketchup. But despite its deficiencies and disturbing misogyny, it's never boring and has an earnestness that feels like both a genuine document of an era as well as an inadvertent but pitch-perfect parody.

After *Satan's Sadists*, Sherman set about resurrecting Adamson's half-finished films. *Hell's Bloody Devils* began life in

1967–68 as a James Bond–type caper called *Operation M* and then *The Fakers*. A biker angle was added, utilizing a real-life gang called the Hessians and new material shot at the Spahn Ranch. Because László Kovács shot the earlier scenes, the movie was promoted as being from the man who lensed *Easy Rider*. Just as misleading was the claim that the title song, still called "The Fakers," was by Nelson Riddle—when its music had been "adapted" from the famous composer's work.

Hell's Bloody Devils's two plots—one about an Israeli spy infiltrating a neo-Nazi-Mafia-money-laundering operation, the other about bikies burning up bitumen and porking hitch-hikers—don't make sense or intersect. Adamson's ensemble— Vicki Volante, Gary Kent, Robert Dix, and Greydon Clark— and washed-up "name" stars Scott Brady, Kent Taylor, John Carradine, and Broderick Crawford all look sun, nicotine, and booze cured. Then there's Colonel Sanders, who strolls in to extol his greasy poultry in a Kentucky Fried Chicken restaurant scene. Apparently, Adamson was paid for the placement— and the Colonel took care of catering on the shoot.

The 1969 production of *The Female Bunch* brought Adamson and Co. closest to Manson and his family of freaks at Spahn Ranch. Stuntman-actor John "Bud" Cardos threw the cult leader off the set for ogling the actresses and Greydon Clark had a run-in with Charles "Tex" Watson. Titled to cash in on that other end-of-the-1960s explosion of violence, *The Wild Bunch*, *The Female Bunch* is another exercise in Adamson nihilism but, as if to make up for the misogyny of *Satan's Sadists*, this time it's heroin-trafficking women who're lasso-ing, whipping, pitchforking, branding, and shooting unlucky menfolk. They're bad babes, granted, but infinitely more in-teresting than the Playbores in *The Girls Next Door*. Hotter, too.

Kovács's other job for Adamson, before he went on to work

for the likes of Martin Scorsese, Bob Rafelson, and Peter Bogdanovich, was 1969's *Blood of Dracula's Castle*. Ava watches and provides a commentary using her limited but exclamatory vocabulary:

"Puppies!"—would be the hunting dogs tracking the . . .

"Man!"—who's a fugitive murderer who . . .

"Water!"—is fleeing along a river where he stops to drown a . . .

"Girl!"—bathing beauty and bashing in the head of a . . .

"Man!"—whose . . .

"Car!"—he steals.

My daughter toddles off. Good thing because the man is Johnny, a psychopathic killer, and he next randomly shotguns a hitchhiker. He's on his way back to the title abode, an incongruous medieval pile situated in the Californian desert. The place is inhabited by Count Charles Townsend—a.k.a. Count You Know Who—and his countess. Despite being three hundred years old, our bloodsuckers are clearly no good with finances and are apparently renting, and thus can be evicted by the castle's rightful heir, photographer Glen, who arrives from a marine park shoot with his swinging-model girlfriend, Liz. Deliberately kitschy dialogue helps stave off total boredom. Just.

My brother comes to stay for a night. He's on his way up to Queensland to do a training course that involves a lot of firing of artillery. Sometimes his job sounds pretty goddamned cool. While Clare goes out with the girls, we catch up with a few beers and pizza before watching this year's mindless "parody" *Epic Movie* on DVD because I have to review it. Dave finds it marginally funnier than I do—laughing five times to my two exasperated chuckles—but we agree it's a piece of shit. It's bizarre to think a major contemporary release, hitting thousands of cinema screens,

can be on par, or worse, than Adamson's no-budget dreck.

As he settles in for the night with the latest of his beloved *Star Wars* novelizations, I retire to bed to get back to my "official" bad-movie business.

Okay, so Al Adamson's 1970 effort *Horror of the Blood Monsters* is worse than *Epic Movie*. It is direly, head-smashingly dull and a 19/100. Not that that stopped it from being released simultaneously to TV as *Vampire Men of the Lost Planet*—and dragged back in cinemas in *1977* as *Space Mission to the Lost Planet* to cash in on *Star Wars*. Such chicanery is breathtaking because this started life as a 1965 Filipino caveman flick called *Tagani*. Adamson and Sherman inserted new American stuff in which astronauts crash-land and added bits in which John Carradine's scientist mutters coordinates and techno gibberish. Ballsiest of all, they color tinted black-and-white sequences to boast the whole thing had been made in "Spectrum X."

It's a bewildering mishmash. On Sherman's commentary, he admits the footage was pretty much randomly assembled. "Has anybody stayed awake through the whole film?" he asks.

I have—barely—and it's not worth it. Except for the scene where Adamson regulars Robert Dix and Vicki Volante plug in their sex machine, which comprises flashing, phallic-shaped colored lights.

"If I had known we were going to have such a short time, I would have turned it up stronger," she says.

It was a "tiny shock of recognition" that Woody Allen—whose first film as writer-director was 1966's overdubbed mash-up *What's Up, Tiger Lily?*—"borrowed" this for his hilarious orgasmatron scene in 1973's *Sleeper*.

Adamson's next, 1970's *Five Bloody Graves*, is a nihilistic cowboy revenge drama that features Indians played by

Caucasians slathered in Coppertone. It's narrated by Death himself, but that's not half as incongruous as the bebop soundtrack. However, it sometimes reaches the level of a C-grade Western, thanks to cinematography by future Oscar winner Vilmos Zsigmond, who'd go on to work with Martin Scorsese, Steven Spielberg, and Michael Cimino.

During today's shoot of *The Movie Show*, my producer Sam tells me that a major soda company wants to pay me a substantial amount to spruik their short-film festival. Having been a teenage radical, I can't in good conscience accept money tainted with the blood of third world peasants.

"I can see your point, sweetheart, but . . ." says Clare when I tell her. "We could've used that money."

I agree. But I assure her that such a selfless karmic act will no doubt be repaid by the universe.

And it is—someone steals Ava's stroller, a birth gift from Clare's parents—from our front stoop.

Clare and I spend the night fulminating into our wine about the state of the human race and, sensing now's not the time, I skip my bad movie of the day.

ADAMSON'S 1971 *DRACULA VS. Frankenstein* awaits me the next evening. It starts with Regina Carrol's Las Vegas club singer heading to Santa Monica to find her missing sister. "We were both orphaned for some time," she explains to a detective, raising the question when they *stopped* having dead parents. After having a trippy-hippie "psych-out" where she's drugged and caught in a big spiderweb, the movie shifts to being about an amusement park run by the crippled Dr. Duryea, a.k.a. Dr. Frankenstein, who strikes a deal with Dracula. So this is actually *Dracula Allied with Frankenstein* until the third act sets them at each other.

Here, the makeup's dreadfulness has the monster's face like a sharpei sculpted from porridge while the Count's immolation

has him getting grayer and wilder of hair until he first looks like a Nick Nolte mugshot and then becomes a skull version of Andy Warhol. The cast includes twice-Oscar-nominated J. Carrol Naish, Russ Tamblyn as a Nazi biker, and poor booze-addled Lon Chaney Jr., in his last performance. But the most convincing acting is by the sex-machine lights from *Horror of the Blood Monsters*, here pulling duty as equipment in Dr. F.'s lab.

I don't spot the lights in 1972 stinker *Brain of Blood* but much of *Dracula vs. Frankenstein*'s cast is recycled in the tale of a Middle Eastern ruler whose brain is to be transplanted into a new body with predictably sinister results. This is slow, slow stuff, padded with vivid red-paint surgical scenes that are gross but not convincing.

Adamson's first film, *Echo of Terror*, saw its widest release recut as the mash-up that is 1972's *Blood of Ghastly Horror*. On the commentary, Sherman warns that, thanks to all the various footage used, if you fall asleep for five minutes you'll awake to what seems a totally different movie. I'm saying it's a scene-to-scene problem in a movie that's about a resurrectionist doctor creating a strangling ghoul but also about a jewel heist and voodoo telepathy. Or something. The best acting, apart from the always watchable John Carradine, is from the dildo lights, making a cameo as lab equipment.

AS BAD AS THEY are, I'm enjoying Adamson's movies' oddness and obscurity more than some of what I have to watch in my day jobs. I can honestly say I'd rather try to puzzle out *Blood Monsters* with a second viewing than sit through the fifth *Harry Potter* movie—viewed for work today—ever again.

A mentally unbalanced proofreader I used to work with would at least approve of 1972's *Angels' Wild Women,* unlike *Two Weeks Notice* or *The 40 Year-Old Virgin,* whose uncorrectable titles steamed him up so much we feared he might

stalk from cubicle to cubicle, adding little red apostrophes to our heads with a handgun. This grammatically correct movie started life as biker-dude flick *The Screaming Angels*, but in the wake of girls-in-prison exploitation hit *The Big Bird Cage*, was rejiggered to focus on biker molls who avenge rape with a little raping of their own. "Poontang is poontang but these sex orgies is unnatural," says a backward farmer-boy victim. But the only thing that's really wild about this is Adamson's old lady, Regina Carrol. On the verge of exploding from her halter top and short-shorts, with her silver hair and lips and teak skin, she's like a photocopy of Pamela Anderson done on the high-contrast setting. I'm amazed she's not a gay camp icon.

Once blaxploitation and kung fu flicks hit, Adamson and Sherman jumped aboard and with 1974's *Dynamite Brothers* they anticipated *Rush Hour* by twenty-five years by teaming African American NFL star Timothy Brown with Chinese superstar Alan Tang. This is passably shot and edited and some of the fight choreography's better than a lot of stupid modern "wire-fu" work. There's some enjoyably dumb-as-shit stuff, too, most of it involving evil mastermind Wei Chin, who lives in a mock Tudor brick-veneer pagoda mountain HQ and tries to kill people with rattlesnakes and acupuncture.

There's no such diversion in *Mean Mother*, an incomprehensible and unforgivably dull patch job, marrying bits of a 1970 Italian-Spanish coin-smuggling caper with new footage of black pop singer Clifton Brown as a smack-importing Vietnam soldier. The European stuff is eviscerated of all context while Adamson's Vietnam sequences are patently nowhere near Asia. The rest is murkily shot, drawn-out soft-core sex and tamely orchestrated fights. It's the nadir of Adamson's films so far—15/100—and that's saying a lot.

Adamson stuck with blaxploitation in 1976's *Black Heat*. Villain Guido is trading weapons to third world dictators in

return for cocaine while baddies Fay and Ziggy run the Queen's Castle Hotel for Women, where they exploit chicks to get inside dope that can be used in robberies. Investigating these wheels-within-wheels are L.A. cop Kicks Carter, played by Timothy Brown, and his girlfriend reporter, Stephanie. This is scuzzy but entertaining grind house fare whose highlight is Russ Tamblyn as Ziggy. He looks like a gleeful Mike Brady on bad speed and when he's killed, impaled on scrap metal, he goes out with a defiant flip of the finger.

Ziggy's got nothing on the baddie from 1977's *Black Samurai*. Janicot is a drug runner and practicing warlock—who has a *fucking vulture* named Volton that kills on command. Once Janicot kidnaps Toki, daughter of a Hong Kong politician, he raises the ire of the Defense Reserve Agency Guardian of Nations. That's D.R.A.G.O.N., which makes me think Al Adamson must've toyed with a truly copyright-baiting title, especially as, when the man from D.R.A.G.O.N. enters, he's Robert Sand, played by Jim Kelly of *Enter the Dragon* fame.

The acting sucks. So does the dialogue. "As the spider said to the fly, welcome to my den," says Janicot, who clearly never read Lewis Carroll. Dumber are the chop-socky scenes with dubbed-in taunts like "C'mon, sissy!" Dumbest of all? That we'll assume a scene is at a "mansion" simply because it's shot in a Californian backyard that has a pool. On the upside, getting martial arts expert Kelly as the hero was a good move, and Adamson karate kicks things up a notch by giving him a bright red safari suit, a purple sports car with built-in machine guns, and pitting him, variously, against a dwarf with a lasso, tribesmen in leopard skins, more rattlesnakes, and, of course, that *fucking vulture*. Hands down the most awesome scene is when our hero's stunt double dons a jetpack and flies to Janicot's island hideaway—for real.

I show this highlight to the *Empire* guys on YouTube and

they think it's hilarious. It's something I do now and again to reassure myself that there's some value to my odyssey. I suspect however that my colleagues would view me differently —and agree with Kim Newman wholeheartedly—if they had to sit through more than a few of these films in their entirety.

Later in the day, during an interview about his tasteless but funny *Farce of the Penguins*, I ask gravel-voiced comedian Lewis Black what his worst movie is. After all, he is the host of the World Stupidity Awards, which include a Stupidest Movie of the Year prize. Surprisingly, Black says that while he loves watching bad movies in hotel rooms while on the road, he can't name any because they usually star people he regards as friends. I'm secretly glad Black doesn't nominate any because my "still-to-watch" stack looks like an insurmountable mountain that doesn't need additions.

One at a time, Michael.

After *Black Samurai*, Adamson brought Jim Kelly back in 1978 in *Death Dimension*. He plays cop J. Ash, who's up against the Pig, played by Harold Sakata, best known as Oddjob from *Goldfinger*. Adding to the 007-ness of the affair is George Lazenby, once-only superspy *On Her Majesty's Secret Service*. The Pig has an überweapon worthy of James Bond—or, would you believe, Maxwell Smart—in the "Freeze Bomb." It's a machine for global *cooling*. The Pig would get the Nobel Prize today. But not if they found out about his pet tortoise. Unlike Blofeld's pussy, it's more than decorative, as demonstrated when the Pig captures heroine Felicia. "Once he bites your tit, we have to cut his head off before he let go," Sakata says flatly.

Despite such color, I'm glazing over at Al Adamson's stuff. And I've lost count of how many times I've now seen the recycled exploding plane that ends this one.

My fading condition doesn't improve with 1978's *Nurse*

Sherri. This was pitched variously as a horror, a sex romp, *and* a blaxploitation flick. To be fair, it's competent here and there, just padded with a lot of sex scenes.

Finally. My last Adamson movie began life in 1975 as a film called *Lucifer's Women* before Al recut it with new scenes in 1981 and sent it out into the world as *Doctor Dracula*. It's a fittingly incoherent finale—about a dude who claims to be the reincarnation of Svengali and a psychiatrist who's actually Dracula and about drunken exorcisms and black masses and John Carradine reciting the names of demons—in my Adamson festival.

Over the past few movies I've been itching to move on, but I'm pleased I met Al and his eccentric ensemble of beasts, bikers, bitches, and brainiacs. And from what I've read, and despite the subject matter of his flicks, he was a gentle man who didn't deserve his fate, as some have unkindly suggested. I hope when Hollywood finally gets around to making the biopic, they treat Al and Regina well.

PLAYBORES

And when the Al Adamson biopic is made, two of the Playboy bunnies in this segment might find themselves up for the role of Regina Carrol. The other two have already had films made about them.

Dorothy Stratten, the former Dairy Queen from Vancouver turned 1980 *Playboy* Playmate of the Year, took the lead in just one film, sci-fi spoof *Galaxina*, before she was murdered at age twenty by her estranged husband, Paul Snider, because of his jealousy about her affair with director Peter Bogdanovich. The story's well known, but *Galaxina* director William Sachs, who we last met talking about *The Incredible Melting Man*, fills in a few chilling details. "She used to come in crying most mornings," he tells me via e-mail of the great

girl who was being put under enormous pressure by the controlling Snider. "When he came to the set I would always have him kicked him off because she used to freeze up. He also used to walk across the soundstage floor with his cowboy boots that went 'ching' 'ching' on the concrete. It wasn't possible to get a good vibe from Paul. He had cold eyes that stared through you. He always had his back to the wall and hardly spoke. Eric Roberts in *Star 80* was not at all like him. It was his deathly silence that made him so creepy."

Galaxina, as played by Stratten, is a robot servant aboard the *Infinity*, a spaceship under the control of Captain Cornelius Butt that's on traffic patrol in the year 3008. When the crew is sent on a twenty-seven-year cryosleep mission, Galaxina reprograms herself as a talking, feeling, sensual woman, much to Sergeant Thor's delight. But before they can get it on, she has to go to a Wild West planet and defeat a Darth Vader–style bad guy to get the Blue Star.

Sure, it's a *Star Trek/Alien/Star Wars* spoof that a fifteen-year-old with a bucket bong might dream up, but it's also goofily ambitious for a flick made for just $350,000. As for Stratten, she looks great but her performance is pretty stilted, not surprising given the circumstances and the robot role.

Supposedly a comic book adaptation, 1996's *Barb Wire* is actually a remake/rip-off of *Casablanca* . . . starring Pamela Anderson. It's 2017, after the Second Civil War, and we're in Steel Harbor, a free city in a United States now run by Third Reich–dressed fascists, the Congressionals. Pam is Barb Wire, an apolitical babe who runs a club and who moonlights as a bounty hunter. Against her better judgment, she gets caught up in a plot about hi-tech retinal lenses that facilitate entry to the "Free Territories" of Canada.

Burly New Zealander Temuera Morrison takes on the Ingrid Bergman role to Pam's Humphrey Bogart. Just thinking those

words makes me feel dizzy. How the production got away without crediting the original is anyone's guess. What's no mystery is who this film was aimed at—and that is fans of Pamela Anderson's boobs in what is literally a "bust-out" performance. That said, she's more fun than Angelina Jolie was in *Tomb Raider 2* and this is enjoyable crud.

The same is absolutely not true of 1997's *The Journey: Absolution*, putatively a sci-fi booty showcase for a debuting Jaime Pressly. But her hetero fans should be aware that this movie is from openly gay *Creepozoids* director David DeCoteau and his camera is focused on his very firm male cast.

A decade off dancing with the stars, Mario López is the hunky Ryan Murphy, who has gotten himself recruited to a remote military base called the Colony so he can solve the mystery of his murdered buddy. His commander is the sadistic Sergeant Bradley, played by Richard Grieco, and he rides cadets hard so that only the very toughest graduate into his "Z-Team," whose rations include steroids made from his own "blood and fluids." "He's kind of a hard-ass isn't he?" asks Murphy. "I've had my share of those."

Such in-your-end innuendo isn't the half of it and the first half is an interminably dull gay-fantasy boot camp. Pressly is the outpost's hooker, which is hard to credit in this grab-ass universe. It's directed and acted like an infomercial—for assless chaps—but Grieco amuses for fellating a cigar before using it to brand a cadet. When he shouts from the cue cards, "I'll rip your fuckin' dick off!" you know he really wants to do it—with his teeth.

Watching Anna Nicole Smith in 1995's *To the Limit* is just plain depressing. She expired in 2007, a death that took her overnight from media laughingstock to pop-culture tragedy. *To the Limit* was the first time she did a lead role and it proved she lacked all talent. Not that that's what the film was selling.

167

Chunks are taken up with Anna Nicole nude and masturbating. The erotic effect of this is less than zero. She and we can't look past the freakish chest zeppelins that made her, well, Anna Nicole Smith.

Amid its amateur CIA-conspiracy shenanigans, Smith is a bulbous blond blank. Her only spark is in the film's final moment when she spiritedly declares, "The name's not DuBois—it's Vickie-Lynn!" It's tempting to read this break with her character name as a cry from the tortured little girl inside who was, of course, born Vickie Lynn Marshall.

But none of the *Playboy* girls' duds come even close to 2005's *Dirty Love* for sheer awfulness. Jenny McCarthy and her director husband's movie miscalculation has her quest for Mr. Right as a series of loose skits whose guiding principal is that she should become progressively more debased. At the twenty-two-minute mark it'd seem we've reached the nadir when a man vomits on her bare breasts. But this looks tame compared with a later sequence where the heavily menstruating star shops for tampons in a supermarket but is thwarted because she keeps slipping and sliding in a vast lake of her own blood. Even less tolerable are the racist stereotypes, including Carmen Electra doing a putrid parody of a brassy African American woman. *Dirty Love* deservedly scooped the Razzies the year it was released. I'm saying 20/100.

TEEN TROUBLES

I was what you'd call a "troubled teen." Not that I didn't get on with my parents, because I did. But they didn't approve of my dope smoking and neither did my high school principal. So at sixteen, I decided we should part ways and I ran away, accompanied by Karen, the daughter of my religious studies teacher. She wasn't in any trouble, just bored like me, and she wasn't my girlfriend, although that soon changed. We stopped about

four hundred miles from home, lived for six months in a rudimentary caravan by the beach, ate noodles, and scraped by on the three dollars an hour we earned working nights, weekends, and holidays in a local ice-creamery.

Our plans to go further afield were scuttled, though, when I contracted mono and had to quit my job. We moved back to our respective houses, tails between our legs, even though other kids kinda held us in awe for what we'd done.

I got that job with the film distributor. There, out-of-hours, using their bromide machine and photocopying facilities with permission, I started a fanzine about cult movies called *Night Creatures*. I distributed it to inner-city bookstores and cinemas and even got—literally—one subscriber. It only lasted three issues but my boss, impressed with my writing, suggested I quit and go back to school. I did and that led to getting into journalism school.

Whenever I tell people about this they're surprised, think it's exotic. To me, it was a very quotidian teenage rebellion. After the initial escape, we stayed in touch with our parents, assuring them we were safe, and we learned a lot about the business of paying rent, shopping, cooking, cleaning, and the rigors of a live-in relationship.

I've been looking forward to the Teen Troubles segment of my search because, whatever the flaws of the films, the subject matter's guaranteed to be more fever pitched than the reality of my own minor rebellion.

First up, is Sam Newfield's *I Accuse My Parents*. This was released in 1944, shortly after the concept of "teenagers" took hold, and it helped set the pace for the teen genre by casting Robert Lowell (not, it must be noted, the American poet laureate) as its troubled protagonist, despite the fact that he looks about thirty-two.

This is about how rotten kids are created by rotten parents.

It's the same setup as *The Violent Years*. Lowell plays James, charged with manslaughter and using the "I accuse my parents!" defense in court. We flash back to see his mom's a drunken lush, dad's a chronic gambler, and all the neighborhood's middle-aged swingers use the family home as party HQ. Trying to find his own way and impress nightclub gal Kitty, James unknowingly hooks up with Mr. Blake's criminal syndicate and finds himself the getaway driver from a fatal robbery.

The world depicted is as surreal to us now as *The O.C.* would be if beamed back to a 1940s audience. James's obsession with convincing Kitty his home life is normal is pure Norman Rockwell meets Norman Bates. The wild nightclub "debauch" he enjoys with Mr. Blake and Kitty is a refined sit-down affair in evening wear. No one gets drunk or does coke off each other's genitals and then posts the photos on Facebook. Of course, the most bizarre thing is that we're watching a man close to middle age jibbering about his school's essay contest.

Fears of a youthquake of sex and violence manifested memorably in 1957's *I Was a Teenage Werewolf*—if nothing else, one of the most evocative movie titles ever—which was the feature debut for twenty-one-year-old Michael Landon. He does his very best James Dean as surly juvenile delinquent Tony. He picks fights, argues with his dad, and uses lingo like "What's the kick?" and "Boy, this pad is crazy." Clearly very intolerant of lactose, he throws milk at canteen cashiers and smashes bottles of the stuff.

At this point, he's just a rebel without the claws, but after his pals turn the tables on one of his pranks, Tony goes psycho and is sent to school headshrinker Dr. Brandon, played by Whit Bissell. But Dr. Brandon's a nutjob who shoots Tony up with his experimental goo that causes him to sporadically

erupt in fur and fangs and attack his fellow students.

This is actually pretty good—snappy and well directed—but *I Was a Teenage Frankenstein*, cranked out a mere six months later, is far weirder. Bissell returns as Dr. Frankenstein, who wants to create the perfect teenager to save mankind. He has been collecting good bits—the arms of a wrestler, the leg of a footballer—from convenient accidents, and a car crash out in front of his lair provides the last parts he needs. After some surprisingly gory surgery, Frankenstein has made himself a teenager. Now he tries to teach the monster to talk: "Speak—you've got a civil tongue in your head. I know you have because I sewed it back myself!"

While Frankenstein has ensured his creation got a hunky physique, the monster has a totally fucked-up face. One bug eye, molten features, tuft-haired where he's not bald—he makes your average pizza-face fifteen-year-old look like Zac Efron. No surprises then he's a little moody and prone to crying jags. "It seems we have a very sensitive teenager on our hands," Frankenstein notes.

Frankenstein is usually depicted as a decent chap torn between his experiments and his fiancée. Not this time. When his beloved Margaret questions him, he socks her in the kisser. Later, when she discovers the monster, she thinks this will bring her closer to her future husband. Not so. Frankenstein sets his now psychotic creation on her, smokes a pipe as he listens to her screams, and feeds what's left of her to his crocodile—after retrieving the engagement ring from her cold dead finger. And it gets better when Frankenstein agrees to get a new handsome head for the creature. For a quick cash in, *I Was a Teenage Frankenstein* brings all sorts of crazy.

Similarly out there is 1958's *Teenage Cave Man*, shot by Roger Corman for $70,000 in ten days at Bronson Canyon. The original title was *Prehistoric World* before American

International Pictures changed it to cash in on the teen craze. I'm not sure it's semantically correct. Shouldn't it simply be *Cave Teen*?

Robert Vaughn—then a suave twenty-six—plays the title role. He's part of a tribe called the Symbolmakers who're forbidden from going "beyond the river" because it's a place of dinosaur stock footage and home of the God That Gives Death with Its Touch. Being a teenager whose dad's the chief, naturally our hero rebels. His bad-assery makes him irresistible to the tribe's resident blond babe and soon they've got their very own luxury cave. But our truth-seeking hero again ventures to meet God and this time realizes it's benevolent—and that the film he's in is anticipating *Planet of the Apes* by a decade.

Teenage Cave Man's ideas—challenging tradition, isolationism versus globalism, pacifism in place of aggression, forbidden knowledge—are pleasingly big for such fare. Vaughn was embarrassed by his participation and called it the worst movie ever made. But in his autobiography *How I Made A Hundred Movies In Hollywood And Never Lost A Dime* Corman proudly recalled the *Los Angeles Times* review, which began, "Despite its ten-cent title, *Teenage Cave Man* is a surprisingly good picture."

Teenagers from Outer Space (1959) isn't good, but it is charming and heartfelt. This has alien adolescents in jumpsuits wielding toy ray guns capable of skeletonizing any living thing, later homaged in Tim Burton's *Mars Attacks!* These young emissaries of the Supreme Race land in the California desert to assess Earth's suitability as a place to raise flocks of giant lobsters called "gargons." But one of their number—sensitive space teen Derek—rebels and sacrifices himself Christlike to save humanity.

Teenagers from Outer Space was written, directed, and produced by Tom Graeff for a tiny $19,000. The "gargon" gets

my vote for cinema's most ludicrous monster, literally no more than a lobster shadow accompanied by someone making animal noises.

Unfortunately, this was as good as it'd get for Graeff, who'd begun his career promisingly making well-received shorts at UCLA and an independent feature that landed him a job with Roger Corman, who would soon shepherd a whole generation of American film talent. But Graeff struck out on his own to make *Teenagers*, and even though it turned a profit for Warner Bros. it was widely ridiculed. Around this time, the openly gay Graeff split with his long-term lover Chuck Roberts, a.k.a. David Love, who played Derek. The pressure was too much and Graeff snapped, undergoing a very public breakdown in which he took full-page ads in the *Los Angeles Times* declaring he was the Second Coming and that he was changing his name to Jesus Christ II. The next five years were marked by arrests and jail time for disturbing the peace, culminating in an involuntary stint in a mental hospital, where he was given electroshock treatments. In the late 1960s, when he tried to return to filmmaking with a screenplay called *Orf*, he was punished by a gossip columnist dredging up his past. Graeff killed himself with carbon monoxide poisoning on December 19, 1970, aged forty-one.

"I've known about Tom Graeff, without realizing it, for most of my life," American writer and filmmaker Jim Tushinski, whose investigations have unearthed this forgotten story, tells me via e-mail. "When I was eight or nine, I saw *Teenagers from Outer Space* for the first time on television. I remember the sheer terror and thrill I felt when one of the aliens pointed a ray gun at a girl in a swimming pool and turned her into a skeleton. I'd seen people getting killed in movies before, but none of the deaths had affected me as strongly as that ray gun blast. It was as though I understood the total finality of

death for the first time. I was hooked." Tushinski's research is ongoing and he asks anyone with information to contact him at www.tomgraeff.com.

Wow, so far it's five for five in terms of enjoyable bizarreness. I'm almost able to forget that these are "bad" movies.

Then I stumble headlong into *Teenage Zombies*, a 1959 travesty from writer-director Jerry Warren, who we'll encounter again. Filmed almost entirely in rigid master shots, and adhering to the talk-is-cheap philosophy, this is an exquisitely boring seventy-three minutes. Four teenaged waterskiing enthusiasts wind up on Mullet Island, where they confront mad scientistess Dr. Myra, who's planning to release a gas that'll turn Americans into obedient, brain-dead slaves. The kids look about the right age for their teen roles but their acting is hesitant and awful, while Katherine Victor's femme fatale recites her Ed Wood–like dialogue ("The fools! The stupid fools! What good is land that you can't use or go near for years!") and redundancies ("Ivan, I'm preparing the test, be ready to stand by.") as if she's accidentally dosed herself with the zombie-fying gas.

It's a 19/100 and man, the pendulum has really swung against me because 1962's *Ring of Terror* feels, remarkably, about *four* times worse. This is about a phobic college kid who has to steal a ring from a corpse's finger so he can get into a frat. A cat scares him in the cemetery vault and he dies of a heart attack. That's it. Unfortunately it takes seventy-one minutes, padded by a nerd in underpants stalking girls, a dude dressed like Bacchus getting soaked with wine, and a subplot about two fatties in love. The only slight amusement value is that this 1962 obscurity features the oldest "teens" in cinematic history. Lead George E. Mather was *forty-two* when he made this. It's a 15/100 and definitely in my Bottom 10 so far.

And the shits just keep on coming. I've not seen 1976's

Hollywood High but there's no way it could be as hideous as the 1981 in-name-only seem-quel *Hollywood High Part II*, starring longhairs too amateur and shaggy for porn. Not that the "script" asks them to do much, other than get nude, get it on, get wasted, and get revenge on a cop and their principal. *Ring of Terror*'s four syllables of story were complex in comparison and the "action" is padded with languid scenes of Hollywood Boulevard and footage of our teens "comically" sped up. This is pure boredom, without the slightest comic camp for relief. Halfway through I realize that you could waterboard me and I couldn't reveal the name of a single character. By the end I understand that this is a *serious* contender for the worst so far. I'd say more except there's so little movie to talk about. I tally up my score and—AAAGH!—it's 12/100. I've now got a four-way split!

In 1985, *Teenage Werewolf* comic riff *Teen Wolf* was a hit for Michael J. Fox. He declined the sequel, 1987's *Teen Wolf Too*, but Jason Bateman—brother to Fox's *Family Ties* costar Justine—stepped up to the tale as cousin Todd, a freshman who becomes a cuddly-looking werewolf and his college's boxing hero. It's a step up from the last three, definitely, but *Teen Wolf Too* is a shitty, cynical little redux that doesn't even try to make us laugh.

My last teen film, *The Smokers*, doesn't try to make anyone laugh but it does thanks to its hipster pretensions. It's also a cautionary tale of how the Hollywood dream can go awry. *The Smokers* was written and directed by a young, hardworking woman named Christine Peters who came to Los Angeles armed with just a bachelor's degree and determination to make a movie. She worked as secretary and as Todd Haynes's assistant while she wrote a script about three teenage girls who violently turn the tables on the boys they despise. After eight years, Peters attached Quincy Jones as an executive

producer and scored Dominique Swain, Thora Birch, Busy Phillips, and Oliver Hudson to take major roles. The film was shot in 1999 and acquired by MGM but shelved and finally dumped to DVD in 2002. Disillusioned, Peters became Kat Slater, hard-core auteur behind installments in the *Young Sluts* and *Cum Swappers* franchises.

In *The Smokers*, it's Phillips's character Karen who gets sick of being treated badly by guys and comes up with a fairly radical solution. "Fuck them like they fuck us," she spits, brandishing a .45. "Take this big steel schlong and stick it in David's face next time you have sex with him." At this point, I'm very glad I've not seen any of Peters's pornos. Same goes triple when our trio buy crazy masks, lick lollipops in slo-mo, and go out a-rapin'. Thing is, the dudes dig it and start wearing "Rape Me Too" T-shirts.

It gets way worse and yet it's never as bad as the Adam Sandler vehicle I endured this week. "No two ways about it, *I Now Pronounce You Chuck & Larry* is extraordinary," I tell viewers of *The Movie Show*. "It's extraordinary that a film can have virtually no redeeming value, that it can be so staggeringly unfunny and offensive in the name of comedy and tolerance, and that it was a hit in the U.S. when it should've been run out of town by people with pitchforks and flaming torches." It's my most confident review yet, a real one-take affair. I'd be so much better off if I could feel as incensed about every film I have to talk about on TV. And I'd have a better chance of keeping the job.

And as of today, we really do need the income. That's because *Hot Wheels* closed this week and Clare's out of work. Not that she's too upset by it, because it wasn't intellectually challenging, and doing twenty or thirty hours a week with a precocious, demanding, and motor-mouthed toddler isn't exactly easy.

Empire and *The Movie Show* will cover our expenses. We're not about to be out on the street. But it'd be nice to have, say, a seven thousand dollar buffer in the bank. But you know where that went.

STATUS REPORT

Worst this month: *Hollywood High Part II*
This month's contenders: *Ring of Terror, Mean Mother, Dirty Love*
Guiltiest pleasures: *Satan's Sadists, Teenagers from Outer Space, I Was a Teenage Werewolf/Frankenstein*
Movies watched: *207*

AUGUST

Pain don't hurt.

—Patrick Swayze as James Dalton, *Road House*

ANOTHER MYSTERY SCIENTIST RECOMMENDS

"You sound pretty intelligible," laughed Mike Nelson, face of *Mystery Science Theater 3000*, when I told him a few weeks ago I'd watched a terrible movie a day for seven months. As for his own bad-movie obsession, he said, "It's a love-hate thing. For whatever reason, whenever I go out to see a movie I tend to want to see the worst movie. I think it's like the bad restaurant phenomenon. If you have a bad meal, you tell everyone you know. If you have a good experience you might tell someone, you might not."

Like me and like a lot of kids, Nelson grew up watching TV Creature Features when his parents were asleep. The first bad movie he was conscious of was William Castle's *The Tingler*. "I remember I was old enough to make a critical judgment on it, which was 'This is really lame.' Or *The Amazing Colossal Man*—it's just terrible, with awful effects to boot, but a lot of people say, 'Oh, I love that movie.'"

But Nelson's worst-ever movies? Brace yourself, young Jedis. "I know it's controversial, but *Star Wars Episode I & II* are just jaw-droppingly bad. I cannot endure them. They make me angry. They make me just want to fall asleep from the badness. You have literally every resource on the planet and *this* is the crap you come up with?"

With time of the essence, I don't feel the need to revisit these George Lucas flicks. For the record, I kinda liked 'em, while acknowledging the shittiness of the acting and writing. But I *definitely* need to see Nelson's hands-down favorite best-worst flick. "I'm a huge fan of *Road House*," he said. "It's just so entertaining as it's being horrible. A lot of people say, 'What's the worst movie ever made?' The worst movie ever made, you wouldn't want to watch: It's boring. But in the entertaining genre, *Road House* is my favorite."

Nelson ran through his favorite aspects. There's Patrick Swayze's dialogue. The fact that he's a world-famous *bouncer*. He loves Sam Elliott's tough-talking mentor. Best is villainous Ben Gazzara, almost but not quite winking at the camera as he beats up his minions. "I've seen it a hundred times, that particular scene, and I still smile," said Nelson, who honored the film by making it the first of the downloadable parody commentaries he now does with Kevin Murphy, other *MST3K* colleagues, and special guests (www.rifftrax.com).

Now Bad Movie Bingo dumps me at the *Road House*. Swayze is James Dalton, nightclub bouncer with a dark past, who brings a pragmatic pacifism to his job. But his violence-as-a-last resort ethic will be tested at Kansas blood barn the Double Deuce, where "they sweep up the eyeballs after closing." This violence isn't random—Gazzara's crooked local boss Brad Wesley is sending his goons.

Dalton is more than a match for any comers. This is a man who sews up his own wounds. When he does accept the

ministrations of the film's saucy doctor, Kelly Lynch, we learn he carries his medical records for convenience and he's not interested in anesthetic because "pain don't hurt." The latest conclusion, no doubt, came from his philosophy degree, centered on "man's search for faith . . . that sort of shit." He's a thinker but rest assured when the time comes, *Road House* explodes with smashed bottles, broken furniture, facial fisticuffs, flying head kicks, gunfire, explosions . . . and Dalton's trademarked tai chi throat tearing. This is also a riot of fruity dialogue, peaking when redneck minion Jimmy tries to intimidate Dalton with: "I used to *fuck* guys like you in prison." It could be the best line in *history*.

Nelson's right. Damn if *Road House* isn't cheer-along hilarious.

THE HEAD RASPBERRY RECOMMENDS

I interview Matt Damon on the morning he's named the world's most bankable star. I talked to him last five years ago, before the release of the first *Bourne* movie, and I liked that conversation better because it was the two of us in a darkened bar, chain-smoking his cigarettes and talking about the movie but also about his and Ben Affleck's Project Greenlight and how he tries to maintain a normal attitude toward life even though he's a celebrity. This time, he's still an amiable, self-effacing guy but I've got a carefully monitored eight minutes and we're surrounded by bright lights, PRs, makeup people, camera, and sound dudes. No smoking allowed. No time to ask, "Dude, what's the worst movie you've ever seen?"

It's a strange thing, interviewing such A-listers, and I understand why some of them have said they do the movies for free but get paid the megabucks for this publicity. Almost without fail, the ones I've met over the past decade emanate wattage, zero in on you, and create a feeling of intimacy. Guard

against it all you like, but it's hard not to be seduced to some measure. It is, after all, what they get paid millions to do. And this sounds silly, but later when you see said star on another channel or in another publication, reciting verbatim the quote he/she gave you, there's a prickle of betrayal. That they have to do it hundreds of times over in the space of weeks must be a strange sort of hell.

"What was _____ like?" is a question I'm asked pretty regularly. I ask it myself of other journalists who get interviews I miss out on. All I can usually say is "I don't *really* know but he/she seemed *nice*." That said, Damon still seems like a down-to-earth dude. Like Seth Rogen, who I met a few weeks back, he's someone about whom you never hear a bad word.

When I get home, I've still got a bit of Damon's reflected glow. Actually, it's just makeup (I finally got some). As I wash it off, I consider that while my new pal Matt is right at this moment charming an even newer friend—before jetting off to continue his impossibly glamorous but totally grounded existence—I'm about to spin the Bad Movie Bingo and obey its dictates.

Not. Fair. But there you go.

My toy-of-torment now serves up ball number 10, the bad movies recommended to me months ago by John Wilson, who founded the Razzies in 1981.

"It's like using a pea shooter in school," Wilson told me about his love of trash. "It's childish—or childlike. It's like, if your parents fell down and didn't get hurt, that was kinda funny. You know you're not supposed to be laughing but there's something wickedly funny about giving in to the urge to burst out laughing anyway. The best bad movies are the ones where they really meant to be serious."

What was his first-worst? It's 1961's *Snow White and the Three Stooges*. "I just remember even at seven years old

sitting through this thing, thinking, 'This is just garbage! Did adults actually write this thing? Who over five would appreciate it?'"

He's not wrong. This bomb matches Larry, Curly, and Moe with ice-skating goddess Carol Heiss for an all-singing, all-skating retelling of the fairy tale. By the early 1960s, them bopping each other had been called into question as kiddie entertainment and so here they're tamed, relying on lame slapstick and tired puns. Even top-notch production values work against it. Giant sets are captured in lush color and 2.35:1 ratio CinemaScope, but the Stooges are lost, belonging to cheap, black-and-white shorts filmed in the boxy 4:3 format whose claustrophobia aided their ass-kicking, eye-poking routines. This is also some slow shit with the Queen's poisoned apple plot twist not coming for eighty-seven minutes. Yawn.

Clare and I spend two nights sampling Wilson's other recommendations—best-bad movies. We chortle heartily but also genuinely enjoy 1949's Bette Davis melodrama *Beyond the Forest* and 1966's bloated "exposé" *The Oscar*, which Wilson laughingly summarized about "that other Hollywood awards show." As entry-level "bad" movies, I heartily recommend them.

Not necessarily so Wilson's final choice, his "worst-worst," 2001's *Freddy Got Fingered*, which, he said, of *all* the Razzie winners, is "the only one that I loathed. I hate it . . . just wall-to-wall inhuman humor . . . the most disgusting movie I've ever seen in my life."

Freddy won five Razzies, including Worst Picture and three for Tom Green as the film's star, writer, and director. He became the first star to show up to collect his awards. Given how much Wilson hated the movie, it made for a nerve-racking night. "Once we knew he was coming, all of our cast members and crew said, 'You'll have to rewrite the ceremony,' and I said,

'No. He knows what he's coming for, he knows what we do, and he deserves to hear what we have to say.' And he didn't look terribly happy, sitting in his seat as I was reading the review quotes. It was either CNN or one of the trade papers that said it was the worst movie ever released by a studio in the entire history of Hollywood."

I saw *Freddy Got Fingered* on release and I hated it. This time around, I see it *slightly* differently. Yes, it's still the same catalogue of spectacular bad-taste moments in which Green, to name but a few outrages, masturbates a horse while crying for his daddy, cuts open a roadkill deer carcass and wraps himself in it, and swings a newborn baby by its umbilical cord like he's competing in a hammer throw before biting through the umbilicus.

God forgive me but the sheer insanity makes me laugh six times in the first twenty minutes. That's five more times than in the *whole* of *Chuck & Larry*. As it wears on, I don't laugh quite so much but begin to regard this as something like one of those button-pushing artworks by Damien Hirst or Tracey Emin. Green, who throws his own testicular cancer surgery into the mix, really is doing this for his own amusement and catharsis. It's impossible not to respond, either by laughing in exasperation or recoiling in genuine horror. There's also something to be said for Green being self-aware enough to include an extra holding up a placard reading, "When the fuck is this movie going to end?"

MOVIES THAT ESCAPED

Before this journey began with my bad-movie-buying frenzy, I wasn't much of an Internet shopper. But endless trawling for obscurities has created a low-level addiction and a few weeks ago when I saw that someone on eBay was selling the prop finger sawn off by Ben Affleck in *Gigli*, I pounced without a

second thought. My bid was noted on blog The Southern Conservative. "You know, a lot of people still think the internet is mostly a waste of time and that eBay is just a place to buy useless junk. Tell *that* [their emphasis] to michaeladams1970, the current high bidder for the severed finger from *Gigli*. There's just no better use of $29.99."

Damn straight. I'm thrilled when the slimy latex thing arrives, complete with a certificate of authenticity. Affleck's DNA is no doubt still on it. I'm now in a position to clone him. I could live Matt Damon's life yet.

That experience led to frequent eBay trawls for movie memorabilia, although I've resisted buying anything further. Well, until this week, when I bid on items owned by Lana Turner that are being sold by her daughter, Cheryl Crane, who at fourteen famously stabbed mom's lover, mobster Johnny Stompanato, to death—or took the blame for mom's crime, depending on who you believe. What I'm after are a vintage purse and a pair of earrings that Ava Gardner gave to Turner. In case you're thinking bad movies have turned me from Glen to Glenda, they're for Clare's birthday.

Several of the movies I've looked at so far languished for years between production and release, but I've lumped the three in this segment together because these babies share an amazingly long conception-to-delivery time.

The Dead Talk Back was made in 1957 and sat on production office shelves until discovered and released by Sinister Video in 1993. *MST3K* made it a cult flick. It has wild-haired metaphysician Henry Krasker using his necromancy radio to help police solve the murder of a young model. Mostly set in the rooming house that Krasker shares with a D.J., a record-store clerk, and a Bible-quoting nutjob, this would struggle to cut it as a one-act play, let alone a movie. The best bit is that there's some dialogue to remind us that Thomas Edison, father

of the cinema, really was into such experiments. Maybe he wanted to say sorry to Topsy.

A rival for such cinematic cryogenics is *Death Bed: The Bed That Eats*, suggested by my friend, the novelist Mic Looby. Comedian Patton Oswalt's routine about it is hilarious but not nearly as funny as the movie itself. This was written, directed, and produced by Detroit's George Barry, who began shooting on 16mm in 1972 and for five long years slaved over his backyard masterpiece only to find no one would distribute it. Cut to 2001, when Barry stumbled upon Web reviews of his unreleased flick. Somewhere along the line, a copy of *Death Bed* had been made and given a pirate video release in the U.K., where it had gathered a cult fan base. A theatrical premiere was held at the San Francisco Independent Film Festival in 2003 and the U.S. DVD release followed, just thirty-one years after the cameras first rolled.

It'd take as long to explain *Death Bed*. It goes something like this: Back in the olden days, a demon living in a tree took human form to seduce a girl and their unholy union created the chuckling, snoring Death Bed. Since then, this four-poster from hell has gobbled up thousands of people, using frothy orange bubbles to suck them down into its golden, flesh-stripping gastric juices. Victims include a Bible-thumping reverend, an old lady who reads a newspaper called *Oral Lesbians*, and the participants of an orgy orchestrated by a quack sexual healer. We learn much of this from the narrator, a consumption-riddled artist who fell victim to the Death Bed and who for sixty years has lived behind his Aubrey Beardsley-style painting in the death bedroom. During the movie proper, several hippies are drawn to the Death Bed and it doesn't just eat them but also drinks their wine, chews up their luggage, and, when indigestion strikes, chugs their Pepto Bismol.

Despite *Death Bed*'s shoddy everything, it's not without

charm and a weird, dreamlike quality. The freakiest and fun-
niest moment comes when a heroic hippie stabs the bed, only
to draw back a ridiculous skeletonized hand. He calmly asks
his girlfriend if she'll snap the useless finger bones off. The
acting and production values bring it down, so that this one
only gets 29/100, but the general enjoyment level is relatively
high, a 10/20. I'm glad *Death Bed* was exhumed from its
grave.

I've resisted thinking of my quest this year as an "obses-
sion" but I'm reevaluating that position. Possibly because I
splashed out one hundred dollars on the admittedly awesome
book *Gods in Polyester* because I needed to read *Death Bed*
director George Barry's recollection of rediscovering his own
movie via random Web trawling one insomniac evening. Also
possibly because, ever mindful of falling behind on my bad-
movie quota, I today turned down a set visit to a film called
Nim's Island that would've entailed a) two days on a tropical
resort and b) the chance to meet Jodie Foster.

So instead of free five-star accommodation and meeting
one of the Hollywood artists I most admire, I opt instead to
watch *Carnivore*, a microbudget monster movie shot on video
between 1989 and 1991. Filmmakers Joseph Kurtz and Ken-
neth Mader then spent seven years funding postproduction.
Their movie was finally released on video in 2000.

It'd be nice to report that this is a DIY triumph, but this
eighty minutes make you feel all eleven years it took to make.
The title creature is a hybrid mutant created by a spy agency
scientist who operates out of a suburban house. Carny kills his
creator and gets loose—but in the interests of budget stays in-
doors. Four big-haired teenagers break in—and that's a prob-
lem because the monster seems engineered to get kill-crazy
when exposed to pheromones, big hair, and stone-washed
fashions.

What amuses most is the credit taking of Kenneth Mader, who lists himself as director, writer, producer, executive producer, director of photography, camera operator, film loader, chief lighting technician, editor, sound designer, and ADR editor—along with twenty-two other jobs, ranging from title artwork to weapon design. After eleven years, maybe it's understandable. I also think I might have more of an understanding into such obsessive behavior.

OH, MOMMIE DEAREST!

When I spoke to John Wilson, he also singled out *Mommie Dearest* as a "perfect example" of so-bad-it's-good filmmaking. "A picture that meant to be an important film about child abuse is what they thought they were making," he said. "But Faye Dunaway's hair and makeup and costumes and line deliveries and dialogue and *everything* is just so off. It really is a harsh, dramatic subject, but it's so awfully done I've never known anyone who can sit through that movie with a straight face."

I haven't seen it. But I have to wait because first I need to do the *Trog*. Joan Crawford joked that if she weren't a Christian Scientist she would've committed suicide because she was so embarrassed by this 1970 Neanderthal nonsense, which John Landis closely parodied in *Schlock*.

This has angry ape-man Trog returned to life in a river system underneath the British countryside. Joan Crawford's primate specialist Dr. Brockton settles the monkey-man's ass down with her tranquilizer gun—and ensures her Pepsi stock portfolio is boosted by wildly silly product placements. Back at her conveniently local laboratory, she tries to civilize Trog with windup toys, classical music, and a game of catch. They also try a pink scarf on him. Given his wild spray of dreadlocks and Ugg boots, I'm saying a haircut and decent shoes

would've been a better idea. Next it's invasive surgery to make him talk and a shot of Pentothal to jolt a flashback to his memories of T. rexes—neglecting, of course, the sixty-four-million-year gap between such thunder lizards and our first human ancestors.

Trog runs on that sort of logic and it's slow going even when the ape-man escapes, starts tipping cars, and hangs a butcher on his own meat hook. Crawford, who was drunk on vodka throughout the shoot, is bad but not *that* bad. She has a light slur when she says she's feeding Trog "fish and lizards" but she doesn't sound plastered, as has been claimed. She has also been mocked for her delivery of the line, "Music hath charms that soothe a savage *breast*." The quote, from poet William Congreve, is correct.

After she died, Crawford's reputation was shredded in *Mommie Dearest*, her daughter Christine's tell-all memoir that became the 1981 camp classic. Sporting eyebrows like skid marks, Faye Dunaway plays Crawford with a histrionic intensity. She has three settings: "calm before the storm," "manic," and "BUGFUCK BERSERK!" The movie's rhythm has little Christina lulled into thinking her mother is softening only to discover she's crazier than ever. The pinnacle is Crawford screaming, "No. Wire. Hangers. EVER!" as she tears apart her terrified kid's closet in the middle of the night. It's freakier for Dunaway being in a face mask so she looks like a demon from *The Evil Dead*. In another nighttime outburst, Crawford attacks her garden, shrieking, "Box office poison!" before she ominously orders, "Tiiiiina . . . bring me the AXE!"

This monstrously entertaining film became the first movie to sweep the Razzies, winning five including Worst Picture and a shared (with Bo Derek) Worst Actress for Faye Dunaway. I'm not sure I agree. Her performance in a complex role

transcends good or bad. In the scene where Crawford breaks down with the plea, "I'm not acting! I'm not acting!" we realize that Crawford is—and badly. That Dunaway gets this across—playing someone who played herself, so as to play other people, while not playing with a full deck—is no mean feat.

LOW, LOWER, LOMMEL

Although I don't know it yet, I'm about to enter Bad Movie Bingo's grimmest segment, one that'll get worse with each passing movie. I'm now in the dank dungeon that is the CV of Ulli Lommel.

Born in Nazi-occupied Poland near the end of WWII, he became an actor in Germany in the 1960s and worked on more than twenty films with Rainer Werner Fassbinder, including his feature debut *Love Is Colder Than Death*. In 1973, Fassbinder produced Lommel's second film, *The Tenderness of Wolves*, which was nominated for a Golden Bear at the Berlin Film Festival. In 1977, he moved to the United States to work with Andy Warhol, who reputedly introduced him to Jackie Kennedy as "the greatest filmmaker in the world." In 1979, Lommel married DuPont heiress Suzanna Love, who'd for a time star in and fund many of his productions, now made in Hollywood. Then he went on to become perhaps the worst, most cynical director of all time.

After 1979's deadly dull Andy Warhol and Jack Palance vehicle, *Cocaine Cowboys*, Lommel had his biggest hit with *Halloween* rip-off *The Boogeyman*. In this 1980 cheapie, a little boy kills his mother's lover and twenty years later the victim's evil spirit possesses a mirror to seek vengeance. The heroine is his grown-up sister Lacey, played by Love, who'll face horrors that also imitate *Carrie*, *The Amityville Horror*, and *The Exorcist*.

Even for a B-grade slasher, this is stupid. After seeing the demon image in the mirror, Lacey smashes it into hundreds of pieces. Rather than wrap all the broken glass and *throw it in the trash*, her family glue the mirror *back together* and rehang it. The dumbest bit has an errant shard's reflection levitating an ice pick to skewer a guy through the neck as he sits in a car on lover's lane. When his girlfriend leans in, the car door slams on her ass, pushing her mouth onto the ice pick protruding from his mouth for a French kiss of death. *Boogeyman* makes even less sense when Lacey gets a mirror eye that shoots lasers and causes heads to leak blood. It makes the least sense when you realize there is no boogeyman in *Boogeyman*.

It's when I watch *Boogeyman II* that I realize just what a cynical hack Lommel is, with the sequel composed of 50 percent footage recycled from the original, with the rest ridiculous murders that see victims killed by electric toothbrush, a facial spray of shaving cream, and unwise oral sex with an exhaust pipe.

His 1984 sci-fi musical camp, *Strangers in Paradise*, is at least more ambitious if as amateurish. Lommel plays a Nazi-era mesmerist named Jonathan Sage who's ordered by Hitler—also Lommel—to win WWII via hypnosis. Instead, he flees to England, where he's put into cryogenic storage so he doesn't fall into German hands. Cut to forty years later and California where right-wing parents defrost Sage to tame American teens from their punk-loving, androgynous ways. But Sage gets down with the kids, declaring "Zerr's nuzzin za matta wiz you!" and turns his magical mystery mind powers against the adults.

Strangers in Paradise is as nutty as a schizophrenic squirrel's shit and you've got to imagine this all interspersed with young punks singing in plane graveyards shrouded in dry ice fog and their parents belting out evil schemes as they mow the

lawn in short pants. It's an unintentionally funny imbecilic cousin to *The Rocky Horror Picture Show*.

Lommel returned, behind and in front of the camera, in 1985's *Revenge of the Stolen Stars*, a deadly Indiana Jones rip-off shot in Asian backwaters about holy rubies that cause vines and ceiling fans to turn murderous. Our hero also encounters reanimated mummies, a homicidal hooker, and a prince who temporarily changes him into a chimp and love interest Suzanna Love into a pig. As bad, and also from 1985, *I.F.O.* rips off *WarGames*, *Blue Thunder*, and *E.T.* The title stands for "identified flying object," which is a remote control toy helicopter fitted with binocular eyes. Rembrandt—or Rem for short—has been developed for $80 million by a secret branch of the military that operates out of a warehouse furnished with a 1960s computer, a dentist's chair, and a TV turned on its side. The tiny chopper, who babbles "comically" nonstop, has been pimped so it can now shoot mind-control lasers that—in the same nonsensical magic-comic vein of *Strangers* or *Stolen Stars*—make a depressed teen's parents fall back in love and cause boffins to babble like upper-class British twits. As an extended demonstration of a comic sensibility Lommel doesn't actually possess it's close to unbearable.

1989's *Cold Heat* saw Lommel at last get his Bogie Man—in that this flick stars Robert Sacchi, whose resemblance to Humphrey Bogart is so uncanny the 1980 feature *The Man with Bogart's Face* was built around him. Here, he's private dick Mikey Musconi and he wears a white tux, drives a 1930s roadster, dabs at his face with a handkerchief, and says he'll get TV when there are chickens on the moon. All of which is weird, given this is set in the late 1980s. Anyway, Mikey is hired to nab the son of a mob boss from his ex-wife and a series of truly spectacular car chases begin.

Sure enough, all of this footage is lifted from 1982's *The Junkman*, legendary stunt man H. B. Halicki's follow-up to 1974's *Gone in 60 Seconds*. Not that *Cold Heat* was much, but this is like finding the few clever sentences in an otherwise D essay have been plagiarized. This gets an F all the way, then, especially as Halicki isn't even acknowledged in credits padded with Lommel's pseudonyms. A nod would've been nice, given Halicki was killed performing a stunt in August 1989 just before *Cold Heat* was released.

After that, Lommel did little that's available until 2004's *Daniel the Wizard*, released only in its German-language version. I watch it anyway. Amazingly, the advent of video production made him cheaper and lazier. The sets are flatly lit, makeup is troweled on and when a dog scratches itself distractingly in the frame Lommel lets the camera roll.

Daniel Küblböck, third runner-up of the first season of Germany's version of *American Idol*, is like a cross between Harry Potter and Boy George. He plays himself. Assassins try to abduct and kill him. I can wholly sympathize. So did many Germans, who voted him the most annoying national celebrity in a 2003 poll.

He enters female beauty pageants in his underwear, plays with tiger cubs while dressed like Wally of *Where's Wally?* It'd simply be gauche if not for his singing. "Hey hey I'm the man in the moon/Watching your world from a big balloon," he pop-chirps in English with the Eurotrash power of an entire Eurovision song contest. And Lommel pops up in cameo as a wizard to introduce his trademark nonsensical magical transformations. I doubt it'd make any more sense if I spoke German. Or smoked a pound of crack a day.

All this is bad but I have the sense that studying this crap has critical merit, however slight, because movies like *I.F.O.* and *Strangers in Paradise* are all but forgotten. But now I'm

about to suffer for my insistence on watching as much as I can.

That's because in 2004 Lommel set up a "mini studio" called Hollywood House of Horror and was enabled by distributor Lionsgate to embark on an egregious exploitation plan.

The first of these video crimes was *Zombie Nation*, about a serial-killing cop named Joe Singer, who was raised in an asylum. Now he lives in a furniture warehouse and spends his time abducting women who he kills with a syringe to the butt after carefully inspecting their noses, teeth, and ears. His cop colleagues at Precinct 707 turn a blind eye, even framing a low-level scumbag for his crimes. Joe only comes unstuck when he kills a Romanian girl who is under voodoo protection and she and four of his other victims come back to life and track Joe down for gut-tearing justice. Inexplicably, by film's end, the zombie women, now dressed like strippers, become cops at Precinct 707.

This is utter swill with staggeringly bad production values. Precinct 707 is a warehouse with partitions, desks, and movie lights serving as props. The zombie effect is achieved with dark eye makeup and flyaway hair—basically Brittany Murphy in any role. Gore appears to be pasta sauce.

Much, much worse followed when Lommel realized he could use the "brand recognition" of real serial killers to shift DVD units.

B.T.K. Killer, from 2005, exploits the case of Dennis Rader, who terrorized Wichita between 1974 and 1991, murdering ten people with his "bind, torture, kill" modus operandi. We meet B.T.K. in his home, where he gloats to his terrified wife about how dumb the cops are. Flashing back to 1974, we see Dennis breaking into a woman's bedroom and choking her with a rat. He's shown being pious at his Bible group while he fantasizes about the other women he's murdered with rodents. He progresses to suffocation with worms and mince. Eventually,

Bill's busted because he uses the church's computer and winds up, of all places, in the 707 Precinct.

Lommel's ignorance of—or indifference to—filmmaking technique is amazing. Lighting is less planned than it is in your garage. The church set is merely a curtained off area, presumably adjacent to the bit of the warehouse cordoned off as the "707." Scenes are shot from any angle, including upside down. The script repeats risible "psycho" dialogue as if on a loop. "You've got a show to do at six, which starts in twelve minutes," is mangled enough, but it's delivered by a guy standing under a newsroom clock that reads 10:45. This ineptitude might amuse if it weren't for Lommel also including actual footage of cows and pigs being killed, gutted, and dismembered.

It's the lowest form of schlock shock, relying on slaughterhouse vérité, but worse is that Lommel casually mixes fact with his feverish imaginings. So, in this "version," the names of the real B.T.K. victims are sometimes used but how they died is freely invented. Lommel gets marketing mileage from a "true story" but doesn't give a fuck how his victims' families might feel.

Lommel sank lower with *Green River Killer*, also from 2005, and "based" on Gary Ridgway, who murdered forty-eight women in Washington state from 1982 to 1998, making him America's most prolific convicted serial killer.

This version is make it up as you go. An early sequence has Ridgway taking a hooker home. He forces her to shower and shit at gunpoint before she fellates the barrel as a prelude to sex and her strangulation murder. All of this takes place in the house where his terrified young son hides under a sheet. Ridgway's voice-over explains he told his son he was saving these girls' souls. And that the murders are actually his wife's fault because if he had a nicer woman fewer hookers would be dead.

We see Gary at work in *the* warehouse, even though in real life he painted trucks for thirty-two years—a detail crucial in establishing his guilt. He cruises 1980s bars for victims even though almost all the girls were last seen on highways. Bodies are dumped next to a "Green River" sign when Ridgway actually eluded the cops in large part due to his cunning disposal methods. Lommel pads things out with real-looking autopsy footage and a subplot about a murderous mentor named Boris.

None of this bears any resemblance to fact but Lommel keeps two final insults in store. The first has him in cameo as one of the arresting detectives, surely an affront to those who worked the case for twenty years. The second is the conclusion when Ridgway's wife gets a phone message from her son where he says he thinks he's killed a girl. Ridgway has a son, who must live with his father's awful legacy.

Excreted to cash in on David Fincher's *Zodiac*, 2007's *Curse of the Zodiac* is worse still. This is set in 1978 and Lommel has the uncaptured Zodiac serial killer living in a tunnel near the Golden Gate Bridge. He's corresponding with a reporter he calls Fat Fuck. This crack investigator mostly sits in a room where he sweats, smokes, and sighs a lot as he doodles the Zodiac's gunsight crosshairs logo. Zodiac pops up to kill a hippie dancer in her dressing room, shoot a gay piano player, and commit other wholly imagined crimes.

It's no wonder Zodiac wasn't caught because Lommel reveals he's a *faceless ghost*. At this point, I conclude that the filmmaker is possibly quite insane. *Curse of the Zodiac* runs footage backward, speeds it up, warps the screen, and has constantly shimmering and superimposed imagery—all for no discernible reason other than to pad the running time and, perhaps, induce bad acid flashbacks.

Actors glance at the camera and can barely get their

dialogue out. When they do, the audio's ruined by background noise and we're distracted by the boom mike. Much of what is audible is Ulli Lommel doing a hate-filled stream-of-consciousness rant as the Zodiac: "You want me to slice up your ass, hippie girl? . . . Hey, hippie girl, you a fag? You got a penis? You're a fag, hippie girl." When Zodiac confronts the journalist, we hear the phrase "fat fuck" eighteen times in eighty seconds. It's a psychotic tone poem.

Lommel's recent movies make him by far the most horrible filmmaker I've encountered. The last three, respectively, rate 14/100, 13/100, and 15/100, which puts each of them in the Bottom 10. It's hard to imagine cinema that's cheaper, more artistically void, technically incompetent, infuriatingly taste-less, or shamelessly geared to rip off its audience—*all at once*. I e-mail Lommel for an interview. He doesn't respond. I expect I would've received the same guff he spun in 2006 for the *Toronto Globe & Mail* when the release of his *Killer Pickton* had to be delayed so it wouldn't cause a mistrial of Canadian serial killer Robert Pickton. Saying his movie both was—and wasn't—about the real-life case, Lommel also claimed, "I am an agent of the truth" and that "we are all guilty" of turning violence into entertainment, which causes people like B.T.K. to exist. "I am committed to make my contribution by con-tinuing to show violence in its true form," he said, equal parts sophistry and psychosis.

STATUS REPORT

Worst this month: *Green River Killer*
Worst director ever: *Ulli Lommel*
This month's contenders: Anything else by *Ulli Lommel*
Guiltiest pleasures: *The Oscar, Death Bed: The Bed That Eats*
Movies watched: *238*

SEPTEMBER

*I hope I smell so bad it makes your head dizzy
and you fall down dead.*

—Bo Derek as Anastasia, *Fantasies*

SEX BOMBS

Climbing out of the filmic filth of Ulli Lommel, everything looks a bit brighter. For my day job, I see *Bratz: The Movie* and in my one-and-a-half-star review I am forced to admit its saving grace is it's not as bad as you'd expect. Even the prospect of a weeklong marathon of egregious erotica doesn't faze me after the likes of *Curse of the Zodiac*.

And indeed the first two don't faze me. Joan Collins's disco-era sex opera *The Stud* proves gauzy sex-opera fun, and even its tiresome follow-up, *The Bitch*, has a few stupid-good moments.

Much more beautiful is that Ava today says "I love you" to each of us for the first time. Yes, it's the clichéd, childish not-quite-getting it "I wuv you," said first to Clare in the morning while she's getting Ava dressed and later to me as I'm making her dinner, but we both get choked up and it makes for a sweet birthday present for Clare.

And on that score, I won the eBay auctions for Lana Turner's items. It was a heart-pounding, down-to-the-wire 4:00 a.m. affair for the Ava Gardner earrings, and, fueled by adrenaline, it was more expensive than I hoped. But, hey, the man who's spent many, many times that amount on shitty movies can't complain. And it's worth every cent to see my beloved's thrilled and disbelieving expression when she unwraps presents once owned by two bona fide Hollywood goddesses.

On the downside, our real estate agent informs us the owners of our house are selling and we'll have to move. That, combined with news that the company that owns *Empire* is up for sale and Clare's continuing unemployment, contributes to an air of uncertainty.

Amid taking mornings and afternoons off work to look for a new place to rent, I start on the oeuvre of my next 1970s sex symbol: Bo Derek.

Fantasies was directed, written, and shot in Greece in 1973 by actor John Derek, then forty-eight, as a showcase for his new muse and future wife Kathleen Collins, then sixteen. This cinematically illiterate soft-core porn mash note went unreleased until 1981, by which point his wife "Bo Derek" was regarded as the "perfect 10" thanks to some savvy promotion of her movie *10*.

Put simply, *Fantasies* is fucked-up shit. The story has Kathleen/Bo as teen virgin Anastasia who finds that Damir, her much older stepbrother, desperately wants to shtup her, but only when he's sure she's a woman and only in the sacred bonds of arranged marriage.

John Derek puts all of his creepy inner workings on the screen. Damir tries to hang out in her bathroom and asks, "You've started having bosoms, is that right?" Anastasia models in a sheer dress that answers the question while a song on the soundtrack crows, "Now that childhood's gone at last!"

When we arrive at the semi-incestuous wedding, it's celebrated by the whole village gathering to watch Anastasia step into a marital *spa* Damir has devised from a reclaimed *sarcophagus*. Hmm, *spa-phagus*.

Bo is beautiful but her eyes are like a clear blue sky in the sense that they're empty. As Damir, Peter Hooten is like Will Ferrell possessed by Borat. *Fantasies* is so bad it makes *Return to the Blue Lagoon* look logical and tasteful.

After *10*, Bo and John were able to hustle up real money—presumably from those who hadn't seen *Fantasies*—for their sex-therapy vanity projects. MGM swung *Tarzan, the Ape Man* into cinemas in 1981 and it rightly died on the vine. Told from Jane's point of view, this has her in deepest darkest Africa with James, her Kurtz-like explorer father. Jane is all he has left of his deceased wife ("She was so weak, your *conception* almost killed her") and, spookily, she looks just like mom. She worships dad. Dad clearly wants to have sex with her, saying, "I see Aphrodite and she's not half as beautiful as you." He's so pissed off when Tarzan steals her affections that he wants to shoot and stuff the Ape Man. Finally, when dad dies, Jane's free to set up a nude household with Tarzan and their orangutan who, from my calculations, is about nine thousand miles from his home in Borneo.

Tarzan is staggeringly crappy. Bo again looks great, but again can't act, and in both respects she's matched by strapping Miles O'Keeffe as the Ape Man. Boozehound Richard Harris had already had binge-induced last rites twice when he signed on to this and he's clearly drunk off his ass when bellowing lines like, "I wallow in me . . . Turn yourself into a god and you will not have to look for another!"

John Derek's direction creeps me out reliably. He concludes a lingering, gratuitous nude scene with Bo attacked by—ahem—a python and stretches this out in slow-motion and

superimposition for a sequence that makes Lugosi's *Bride of the Monster* octopus tango look professional. And not content with the queasy father-daughter incest angle, Derek wraps things up with the orangutan almost sucking on Bo's tit before she spends a full five minutes topless playing with the primate.

The idea of 1984's *Bolero* was to cash in on the fact that in *10* Dudley Moore had sex with her while Ravel's *Bo*-lero played. Clever! Bo, now pushing thirty, is Ayre, a young boarding school graduate who embarks on a globe-trotting mission to get deflowered. Bo finds true lust in Spain with a bullfighter named Angel and they have a groin-groin humpfest that must've seriously tested any modesty patches. Tragically, a bull gores Angel "down there" and renders him impotent. Ayre sets about bringing him back to manhood, succeeding when she dons a Zorro hat and cigar. They're swept into the dry ice fantasy heavens for a slo-mo fuckfest against a neon sign that reads EXTASY.

Holy shit, it's bad, filled with John Derek's horrible obsessions. There's a fourteen-year-old actress, who's seen naked a lot and who declares herself "juicy." Ayre's re-seduction of Angel includes her telling him, "We didn't do it this way last time. But then I was a little girl. Now, I'm a woman . . . Do you wanna taste my blood?" The bestial vibe rears it snout again, too. In addition to the signature image of naked Bo on a stallion, there's a sex scene watched by a dog and Ayre's creepily appreciative guardian George Kennedy ("You've grown well") recalls how he used to kiss horses. For utter tastelessness, *Bolero* deserves a perfect -10. But it rates 25/100 because the production values are decent and it's funny in its horribleness.

By 1990, John Derek clearly felt mortality encroaching. Thus, *Ghosts Can't Do It,* a self-tribute in that it's about *his*

hot naked wife's utter devotion to him. Derek selected Anthony Quinn as his proxy. The double Oscar winner plays Scott, rugged man of the high cattle country, who's married to Bo's Katie. But "married" doesn't seem a strong enough term, given that she, seriously, refers to him as Great One and describes being "born into your arms." Again we have a sick father-daughter vibe with a side order of God complex.

Scott survives a heart attack but is impotent and so—sex being all—blows his head off. Now he finds himself literally dispirited, until they can find him a new hunky vessel so he can resume boning her. When they do, she says, "Welcome back, you awesome bastard!" They remarry. And have sex. In a barnyard. While a horse looks on.

Pia Zadora was Bo Derek's nearest rival in the 1980s and these gals share more than just being to acting what camels are to Japanese tea ceremonies. At seventeen, Zadora hooked up with Israeli billionaire crook Meshulam Riklis, forty-nine, and they married in 1977. And just as their age difference is the same as John and Bo's, so too did he try to force his woman onto the world in loathsome sex-siren roles.

Based on the novel by James M. Cain, 1982's *Butterfly* has Zadora, then twenty-eight but looking *much* younger, as sexpot Kady, who turns up on the dusty doorstep of a hermit named Jess, played by Stacy Keach. She perches on the porch—tanned leg swinging, tits all but spilling from her dress—licks fresh cream from her lips and asks, "Don't it get lonely out here? Or is milking that cow good enough for you?" And then, just as Jess thinks all of his wet dreams have come at once, Kady reveals she's his long-lost daughter *and* that she's also made him a granddaddy by getting knocked up by the scion of the rich family whose silver mine it's Jess's job to guard.

It's the double whammy to destroy all boners. So you'd think. But after a hard day's pilfering from the mine, he pours

her a bath and takes a grope of her boobs before breaking it off with, "You're my daughter, Kady."

"And I'm a woman too!" she replies, forcing his hand between her legs.

I won't go into all the soap operatics, but there's Orson Welles as a drunk judge, the revelation that she's only *fifteen* and the appearance of various relatives, spouses, and children. Suffice to say that she's not *really* his daughter but he doesn't let her know that until *after* they have sex.

Wrong on so many levels, it's most famous because Zadora won the Golden Globe for Best New Star for the same performance that netted her a Worst Actress and Worst New Star at the Razzies. The rumor was that Riklis had "bought" the award for her by lavishing his wealth on the Hollywood Foreign Press Association.

As if baiting her detractors, Zadora's next movie, 1983's adaptation of Harold Robbins's novel *The Lonely Lady*, opens with her as a screenwriter named Jerilee Randall who's up for a gong at the "Awards Presentation Ceremony." This is the sort of campy crap that can still get Clare interested and she settles in on the couch with me.

We flash back to Jeri celebrating a school writing award at a teen party. Bad boy Joe—played by Ray Liotta, in his screen debut—rapes Jerilee . . . with a garden hose. During her recuperation, she meets screenwriter Walter Thornton, played by Lloyd Bochner, then nearly sixty. Because her daddy died when she was a baby, Jeri throws herself on his Wookie body—only to find he can't get it up. And when she becomes a famous author, he can't handle it. She takes to drink. He offers her the garden hose with, "Is this more your kick?"

Then she hooks up with a married actor, who pressures her into an abortion.

"She's not exactly lonely, is she?" Clare observes correctly.

It's the only laugh I've had so far.

Jeri's tortured relationships continue with a would-be producer who . . . defiles her on a pool table, forces her to take coke, pimps her into lesbian sex, and throws her script back at her in the midst of his three-way.

"God, this is boring," Clare says.

Despite the lurid subject material, this is dull stuff.

Its only saving grace is when Jeri goes nuts and Zadora gets a bravura freak-out scene. She tries to scrub herself clean in the shower while fully dressed, destroys her apartment, and attacks her typewriter while the faces of all her bastard men loom up in a *Vertigo*-style psych-out. John Wilson, who worked as a marketing consultant on the film, told me he convinced the producers to keep this scene, not letting on that he desperately wanted to feature it at the next Razzies. They did. It did.

BOLLED OVER

We have a fun second-birthday party for Ava, who's just old enough to get that it's all about her and that the presents— a plush monkey, a little bike—are more interesting than the packaging they came in. She impresses everyone with her vocabulary, now centered on shapes. "Tha a rianga, a ectanga, a rare," she says. I puff up like the clichéd proud father, only just able to resist shouting, "See! See! A genius, I tells ya!"

As Ava and her cousins and little buddies play, I chat with our adult friends fleetingly, as you do when you have one eye out for pulled cats' tails, spilled apple juice, and squabbles over freshly unwrapped toys. But it's great to catch up with Emma Jensen, a budding movie producer and an unreconstructed *Grease 2* fan who'll break into "Reproduction" at the slightest prompting, and with Clare's best friend, Amanda Ryding, a lawyer and writer who insisted I include *Two of a*

Kind in my quest. At some point in each of the conversations, I'm asked, "*Soooo*, how are the bad movies going?" And each time I sigh and say, yes, it's still good, if tiring, but the end is in sight. Then come the requests for updates on what's the worst so far. The great thing about this quest is that I never encounter anyone—friend, family member, or stranger—who doesn't get it immediately and have an opinion or suggestion of the worst flick they ever saw or their guiltiest pleasure bad movie. Such interaction has helped sustain me, and maybe even keep me half-sane. I can't imagine how much tougher it'd be explaining to people exactly why you were dressed like an Old Testament prophet or making every recipe in Julia Childs's cookbook.

After the sugar-infused children have been packed off from Ava's party, and the cleaning up is done and we've rewarded ourselves with a glass or four of wine, I settle in with the works of another German filmmaker.

It has become a pop culture truism in the past few years that German filmmaker Uwe Boll is "the twenty-first-century Ed Wood." His American video game adaptations have made him a favorite new-media whipping boy. The reasons are obvious. His movies are shoddy. There's puzzlement at how he raises large budgets when his box office results are poor. I suspect the vitriol, though, is so intense because video game aficionados hold the source material dear. Ruin a "reimagining" of *Macbeth* and you might get a "meh" from this crowd. Piss on a beloved Sega title and you're Joseph Goebbels.

People love to hate him. The hatred is such that Boll's movies are now voted onto the IMDb's Bottom 100 chart months *before* anyone's seen them. And the flames are fanned by Boll being quite literally willing to take on his detractors, as demonstrated when he punched out five "haters" at a September 2006 invitational boxing match dubbed Raging Boll. (P.S. In 2008,

inspired by Boll's comment that he'd retire if presented with a petition signed by one million people, just such a petition was launched. At the time of writing it has garnered 341,382 signatories. The Long Live Uwe Boll petition has just 6,926 . . . Well, now, 6,927.)

When I get to speak to Boll, he's very proud of his latest movies, the $60 million *In the Name of the King: A Dungeon Siege Tale* and the cheaper $10 million *Postal*, and talks them up before we get down to business.

"So you admit there were problems with your other movies?" I ask.

I'm wondering if I'll cop a boll-ocking now. But Boll is surprisingly self-aware.

"Well, absolutely," he says. "But *House of the Dead* is a zombie shooter game and I don't think I actually failed in translating the game to the screen. But, of course, the question is, 'Is this a good movie?' And the answer is definitely, 'No.' It's a cheesy movie, but I fulfilled what my goal was. I did an overdrive action zombie shooter, basically."

"On *Alone in the Dark* I failed more because I was not happy with the script, and it was my mistake that we didn't fix the script when we started shooting. We thought we could turn it around, but it didn't work out. And, of course, Tara Reid—she's a nice woman, and she can do comedy, but she couldn't do the part, and this hurt the movie additionally. Put all together, it makes me not happy with *Alone in the Dark*, but I think it had some good scenes and some good special effects also. It's not a boring movie but it definitely has story problems."

Boll continues. "*BloodRayne* was better developed. We had a lot of famous actors in it, although Michael Madsen was a little . . . slow, let's say it this way. He was really lazy. Michael Madsen has, let's say, an alcohol problem, and he had a big problem with the whole Romanian location. It made him

insecure and he was drinking. I thought Ben Kingsley was good—I don't know why people say he plays that part flat. Billy Zane was really funny, and Meat Loaf too in the vampire bordello."

I ask him if his critics annoy him. "I was only upset—and this was what led to that boxing match—with reviews that are completely over-the-top unfair, and have nothing to do with the movies. When *BloodRayne* came out, a lot of people destroyed the movie in their reviews without seeing it. I've written to the IMDb, asking why they open up my movies for votes before the movies come out. If you open up the details on my movies on the IMDb, you will see that they have lots of seven, eight, and nine points—and then they have also many one points. Both have nothing to with reality. If you take a really bad movie, like *Elektra* or *Ultraviolet*, they have four or five points, and then you see where *BloodRayne* has two points. I think this is unfair. Is *Alone in the Dark* so much worse than *Resident Evil 2*? This is the thing that I don't get. It's so over-the-top wrong. I would personally give *Alone in the Dark* and *House of the Dead* three and a half points and I would give *BloodRayne* maybe four and a half points."

Boll hit infamy with 2003's video game adaptation *House of the Dead*. The movie has brain-dead ravers hiring smugglers to take them to a dance party on a remote island that turns out to be swarming with zombies. Our club kids instantly become expert marksmen capable of mowing down dozens of the undead. When they reach the house of the title, it's revealed the zombie plague is the work of a demented Spanish explorer-experimenter named Castillo.

"You created it all so you could be immortal—why?" demands lead dipstick Rudy.

"To live forever!" explains the crackpot Spaniard.

Inevitably, once the undead have been grenaded, lead hottie

Alicia gets to bring her heel down to splat the Zombie King's brains and declare, "Game over, fucker!"

I thought the same should be said of Boll's career when I first saw this because it's mindless rubbish made worse by naff flashbacks to ye olden times, shitty metal music, and, even harder on the ears, an atrocious voice-over ("It all started a few days ago . . . when I came here for a rave. And, now, all that remains is the rotten smell of death"). Boll's worst decision is to include actual footage from the game. But the young main cast earnestly mouthing inanities provides comic relief while actual actors Jürgen Prochnow and Clint Howard clearly ain't taking it too seriously.

House was as simple as its origins but Boll's adaptation of *Alone in the Dark* is complicated to incomprehensibility. A text crawl that's read aloud for the illiterate tells us that ten thousand years ago ancient Indians called the Abkani opened a portal to another world. U.S. government agency Bureau 713 was set up to investigate Abkani artifacts and twenty-two years ago Professor Lionel Hudgens stole twenty orphan children in order to merge them with supernatural beings. One orphan, Edward Carnby, escaped to become a 713 paranormal artifact investigator, but his nineteen brethren remained evil "sleepers" in society. Now madmen and invisible monsters are attacking. Um, huh?

Boll insists on including mindless shoot-em-up action that offers all the excitement of hearing someone talk about a dream they once had about playing a video game. Christian Slater is at his Jack Nicholsoniest as Carnby. "Fear is what protects you from what you don't believe in," he says in voice-over, not caring that it doesn't make sense. Stephen Dorff is at his Kiefer Sutherlandiest as Bureau 713 boss. "My guys are dying out there for nothing—for fucking nothing!" he howls, not caring that I'm laughing my ass off. Both come off well

compared with Tara Reid as a busty museum curator. She looks like a confused chipmunk in lip gloss and her expression is that of someone who's just stepped in something unpleasant, which, in the case of *Alone in the Dark*, is true.

No matter how bad *Alone*'s actors, none reach the depths of nonperformance seen in Boll's next vid-game flick, 2005's *BloodRayne*. This has Kristanna Loken from *Terminator 3* as Rayne, a half-human, half-vampire "dhampir" who teams up with medieval warrior types to get revenge on Kagan, the castle-dwelling creep who cursed her—and created her by raping her mother.

Loken rattles a dungeon in her sex scene and is energetic as she slits throats, smashes heads, and skewers eyeballs. From a soft-core and gore viewpoint, she gives her all. But Michael Madsen is astoundingly bored as a warrior with a bad wig. "If it's a fight they want, it's a fight they shall get," he says, sounding like Steven Wright. As Kagan, Ben Kingsley tries to conserve all energy by barely moving and positively races through his lines without the slightest inflection. Michelle Rodriguez just looks really, really angry—but then that's the way she always looks. They're all like soldiers behind enemy lines made to confess for the cameras; they're saying this shit but they're making sure you know they don't believe it. But Boll's right about Billy Zane and Meat Loaf, who ham things up.

For the record, I give *House* 31/100, *Alone* 31/100, and *BloodRayne* 39/100. Boll is no doubt a very coarse filmmaker who works with derivative, commercially hackneyed material, but he's also far from the worst director ever. Any who doubt this should visit Ulli Lommel's cinematic sewer.

THE MOST OBSCURE DIRECTOR EVER?

While hundreds of hours spent trawling through books and magazines and Web sites devoted to bad, weird, obscure, and

forgotten cinema often feels like an obsessive indulgence, sometimes it kicks up treasures. Such was the case when I came across reviews of Chester Turner's movies in Joe Kane's wonderful book *Videoscope*.

Chester Turner makes Al Adamson seem like Steven Spielberg. He made just two video movies in the mid-1980s and there's no information available at all about who he is—or was. For one freaky moment I think he might be the same Chester Turner sentenced to death for eleven murders in Los Angeles in July. But that serial killer's middle name is Dewayne and the one thing we know about our man is that his middle name was Novell. I've sent off e-mails to people I think might have known him back in the day but I've gotten nowhere. It's like he disappeared into thin air. (After my year's done, I'll buy the excellent book *Nightmare USA* and discover its author Stephen Thrower shares exactly the same fascination and hit the same dead ends.)

Turner's legacy begins with 1984's *Black Devil Doll from Hell*. It has my jaw on the floor. After a six-minute, forty-five-second credit sequence, we enter the world of Helen, a God-fearing African American virgin who buys a Rastafarian-looking puppet that makes wishes come true. Back home, she has a long shower in front of her new toy while fantasizing about fucking him. Soon after, he comes to life and rapes her, which she digs enormously. Sexuality unleashed, she seeks out neighborhood men. They can't satisfy her because, let's face it, once you've had real wood, it's never as good; once you've tasted mahogany it's as sweet as it's gonna be. The puppet's sick of her, though, and returns himself to the thrift store, only for Helen to buy him again. When he refuses to fuck her, she threatens to destroy him. His eyes glow red, reversing time, and he kills her.

Black Devil Doll boasts random camcorder pans and zooms,

barely a thought for focus, and audio muffled by car and plane noises and wind buffeting the microphone. In his white suit and dreadlocks, the puppet is like the third member of Milli Vanilli. But the words put into his mouth are far more egregious than anything those guys ever lip synched. "I'm going to give you your heartfelt wish," he rages after he has tied Helen to the bed. "I'm going to fuck you, you bitch!" What follows is a surrealistically long sex scene that includes puppetlingus and his long moldy tongue on lead actress Shirley L. Jones's disturbingly erect nipples. She awakes the next morning and wonders whether it was all a dream until she starts masturbating and discovers puppet goo down there. What the hell could it be? Wood glue?

If all of this wasn't bad enough, Turner scores the entire film with a Casio's repetitive bippity-bip-bips and a percussion loop. It even provides the "swinging" soundtrack to a disco scene where hipsters jive appreciatively.

I give *Black Devil Doll* 13/100, *almost* giving it admittance to the antielite gang of four that've staked out the equal bottom spot. It's terrible, but mesmerizingly so. It's hard to credit that it was commercially released on video. Even harder to credit is that so was Turner's follow-up, 1987's *Tales from the Quadead Zone*. This reunites Chester with his beloved Casio, introduced at full bleep in the credits, and with his muse, Shirley, who stars as a momma reading stories from a book called *Tales from the Quadead Zone* (someone's Bible, with the title written in marker) to her video-fx ghost son, Bobby.

The first tale, "Food For?", is about a white trash family who each night have dinner and, upon discovering there's not enough food, have one of their sons thin their herd with his shotgun. This repeats until we're told the son went to the electric chair but the mother and father are "living high on the hog in the witness protection program." Chester was

presumably living high on something when he came up with this nonstory, which is executed without gunshot sound effects but plenty of random close-ups.

"The Brothers" maintains the 100 percent insanity, telling the story of a man who plans to murder his wife and inheritance-stealing brother but is thwarted when the sibling dies of a heart attack. So he steals his brother's corpse from a funeral home and berates it viciously before dressing the dead guy in a pimped-out clown suit for an improper burial. The clown brother's eyes glow red and he comes back to life, pitchforking our hero in the guts.

"Oh, that was one of the strangest stories I've ever read," says Bobby's mom. Now Bobby's daddy drops by to beat Shirley with the book. She stabs him. Then she discovers that Bobby has been knifed dead. She sits on the toilet, thinks about happy times with her boy, and, with the Casio plinking away relentlessly, opens her throat with a razor blade. We get a happy ending as their two ghosts sit down to read their own tale, now part of the book.

Turner never fulfilled his end-credits threat that "Tales from the Quadead Zone Will Return." It's a shame because whoever he was, he created two of the very worst movies ever. His ability to *always* make the wrong technical, artistic, narrative, and thematic choice is incredible. At the risk of sounding pretentious, it invests the movies with an alternative-universe resonance that makes them art.

SIZE DOES MATTER

The first half of my week is spent churning through three of Demi Moore's worst—*Parasite, The Scarlet Letter,* and *Striptease*—but realize it's a measure of how far gone I am that none would even rank in my Bottom 50. Same goes for two of Dennis Rodman's stabs at acting, the idiotically entertaining

cartoons that are *Double Team* and *Simon Sez*. Though I am totally appalled by *Kazaam*, which stars Shaq as a rapping genie. I presume the screenwriters got their rhyming dictionary at a discount store: "Trapped in a box like a premature burial/Used to mull in the space cemeterial/Suffered a curse that was more than malarial/Lived as a ghost granted wishes material/Served every Tom, Dick, and Harrial."

With just over three months to go, I calculate I'm almost on target. But the pressure's on. Happily, a round of big-monster nonsense feels like it'll be fun. Few images evoke "bad-movie" goodness like a cheap outsized critter wreaking havoc. And it takes me back to the fondly remembered time in my childhood when I'd excitedly scour the TV listings in the hope of a matinee *Godzilla* screening or a Creature Feature appearance of *The Giant Claw*.

I only saw one of Bert I. Gordon's movies back then but no director who has ever lived has more appropriate initials than this dude. B.I.G.'s specialty was cheap sci-fi flicks about small creatures made great by mankind's dabbling—and by his DIY dodgy special effects. Occasionally, he went the other way, too.

B.I.G.'s first effort as writer-director-producer was 1955's *King Dinosaur*. The first twelve minutes are mostly stock footage stitched together to explain that a new planet has moved into orbit around Earth. Two married couples land their spaceship on it and declare that this planet is, in a development friendly to the $18,000 budget, just like Earth. They go on a stock-footage safari of dinosaurs and faced with such monsters, nuke the place with atomic-test footage and declare, "We've brought civilization to planet Nova. C'mon, let's go home."

Much B.I.G.-ger things were to come. 1957's *Beginning of the End* has Peter Graves as Dr. Wainwright, an egghead who

accidentally unleashes giant locusts on Chicago. The politicians in Washington—perhaps having seen *King Dinosaur*—think nuking the Windy City is the answer.

Graves is so stoic—"I've reasoned deadly danger if those locusts break out of the forest"—that I can't help but flash to his send-up of such a persona in *Airplane!* Also funny is that this is a frenzy of people menaced by back-projected close-ups or soldiers running into frame to shoot at superimposed critters. But B.I.G.'s boldest strategy is to film *photos* of Chicago buildings as the bugs crawl over them.

In 1957, B.I.G. made two movies about giant men. *The Cyclops* I'm unable to locate, but it's supposed to be okay, while *The Amazing Colossal Man* is the one I saw as a kid and I regard it quite fondly, making me one of those people Mike Nelson was talking about.

Gordon's next effort, in 1958, saw him go micro with *Attack of the Puppet People*. This is about folks shrunk to action-figure size by doll maker Mr. Franz. He sees himself as a benevolent god and he just wants his little pals to enjoy the lingerie and champagne he supplies. Most of his captives are perfectly happy with this arrangement. But his latest miniatures, engaged couple Bob and Sally, would rather escape than frolic is food-tin baths or put on puppet-people shows. *Attack of the Party Poopers*.

John Agar, one-time Mr. Shirley Temple, and his costars do reasonable work but their main requirement is to be dwarfed by B.I.G.'s oversized props and sets and optical effects. What's really disappointing is that the promised attack never comes. Rather, the little ones get back to normal size and run to the cops. I suppose the title *Police Report by the Former Puppet People* wouldn't have gotten the kids in.

B.I.G.'s 1958 *Earth vs. the Spider* is similarly misleading, unless, of course, you consider Earth to be comprised solely of

a small American town called River Falls. This has teens Mike and Carol up against a big arachnid, achieved by the usual back projection, superimposition, and a hairy outsized spider-leg prop. I wonder why this courtship anecdote never made it into a Brady Bunch episode? Especially because eventually the spider breaks loose in a dance hall. Talk about doing the jitterbug.

War of the Colossal Beast—the sequel to *The Amazing Colossal Man*—tells us that outsized Glen survived a double bazooka hit and 700-foot fall and is now menacing Mexico. American officials don't believe terrified locals until they find a footprint ten times normal size.

"That'd make him about sixty feet tall," says Dr. Carmichael.

"Glen was sixty feet tall!" says his sister Joyce, in case they think it's *another* Colossal Man.

The film's weirdest moment has Washington bureaucrats, from social security to health, passing the buck on caring for their new colossal captive. Eventually, the Pentagon steps up, which makes sense, lest this be *Congressional Hearings on the Colossal Beast*.

As in *Puppet People*, the suicidal "villain" here is more sympathetic than the heroes. Bald, scarred, and dressed in a giant nappy, he's been driven mad by a) being made colossal and then b) having his colossal ass extensively blasted by the military's colossal assholes.

B.I.G. returned to his favorite theme in 1965's *Village of the Giants*, which married H. G. Wells's *The Food of the Gods* with the teen-party movie craze. Little kid Genius has created orange goo with giant-making properties, which is stolen by the town's punks so they can grow to be thirty feet tall and kick adult ass.

Executed with tongue-in-cheek good cheer, it's fun when

B.I.G. breaks out a massive boobs-in-bra prop and teenspeak like "Dig that nitty gritty!" Beau Bridges and Toni Basil star, alongside little Ron Howard as Genius. But most enduring is Jack Nitzsche's twangy-bass theme "The Last Race," recently resurrected by Tarantino in *Death Proof.*

In the mid-1970s, after a period in which working with outsized creatures was limited to directing Orson Welles in a 1972 movie called *Necromancy*, B.I.G. sought to ride the *Jaws* and *King Kong* big-creature revival. His 1976 *The Food of the Gods*—rats eat enlarging goo and attack!—is perfect for a few beers. Marginally worse-better is his other H. G. Wells riff, 1977's *Empire of the Ants*, in which Joan Collins takes on insects embiggened by radioactive waste. In this, the ants herd people like cattle into their HQ at the old sugar refinery and gas them with the Queen's pheromones for total obedience. "Work for them, feed them, for they are superior," says the ant-Sheriff.

Of course, from the fifties to the seventies, B.I.G. wasn't the only source of bigger-is-badder moviemaking. For mine, the best-worst example of the big-monster genre is 1957's *The Giant Claw*. I taped this as a kid and, and via a VHS-to-VHS made a six-minute "highlight reel" to show buddies while we smoked bongs. I was wrong to do so. It deserves to be seen in its seventy-five-minute entirety.

This has La Cocona, an "overgrown buzzard," arriving from "some godforsaken antimatter galaxy millions and millions of light-years from the Earth" to unleash a "fantastic orgy of destruction." It's invisible to radar, invincible to nukes, and happiest when munching hot-rodding teens and attacking fighter jets and gulping parachuting pilots. Heroic Mitch, played by falling star Jeff Morrow, comes up with new technology that can bust the bird's force field and cook its goose.

The Giant Claw is *fabulous*, rating 45/100 but scoring a

huge 13/20 for entertainment. Director Fred F. Sears, who'd made *Rock Around the Clock* and *Earth vs. the Flying Saucers*, was undercut by cheapo producer Sam Katzman nixing Ray Harryhausen's stop-motion effects in favor of a ridiculous bird puppet. The insanity is amplified by the script. "This should be the end of the Big Bird that was there—that wasn't," says an inadvertently Zen military type. Even better is Sears's narration, which tries to breathe excitement into scenes in which the love child of Big Bird and Gonzo is held aloft by very visible wires: "No corner of the Earth was spared the terror of looking up into God's blue sky and seeing not peace and security but the feathered nightmare on wings!" (P.S. In 2009, I'll be totally delighted when for my birthday Clare gives me an original daybill poster for the movie.)

Another late-night stoner fave was 1972's *Night of the Lepus* but it holds up less well. A well-meaning scientist inadvertently creates a plague of giant bunnies "as big and as ferocious as wolves." These plus-size psycho pets rampage through farmyards and a drive-in, tearing people limb from limb.

Unsurprisingly, it's impossible to take slo-mo close-ups of Flopsy and friends hopping around tiny model cars seriously. There are some campy laughs but this is slow going. A side note: Lepus is actually Latin for "hare" but, with hard-core porn becoming popular in the 1970s, you can see why they didn't opt for the more correct but smutty sounding *Night of the Cuniculus*.

My childhood bedroom wall used to be decorated with a poster for 1975's *The Giant Spider Invasion*. I can't remember where the one-sheet came from, or what became of it, but it's an indelible piece of artwork. Now I finally get to see it, just some thirty years later. As expected, the movie offers about 10 percent of the promised spectacle. But it has its moments.

A comet crashes into northern Wisconsin, which stops cars

and radios, and scatters geodes that contain a) diamonds and b) alien spiders. Greedy rednecks are distracted by the former long enough for one of the latter to grow huge in a barn. The massive arachnid kills off the white trash before it strikes out across the countryside, upsetting a little league BBQ, laying waste to the town, and inspiring the citizenry to rock-throwing resistance. Director Bill Rebane created his monster by draping a giant spider costume over a VW Beetle whose passengers had to wave the massive legs as the arachnid-bug trundled here and there. The film's crap, but I like its deliberate sense of the ridiculous and my favorite sequence centers on the redneck couple.

She tells him, "Sometimes the only way I know you're still alive is when I hear you flush the toilet."

He tells her, "You're so dumb you wouldn't know rabbit turds from Rice Krispies."

When she claims to be seeing spiders everywhere, he tells her to lay off the booze. Instead, she makes another Bloody Mary, unaware a spider's in the blender. After this schlocktail, she goes out in the barn to drape a monster spider's legs over herself until she's dead. This frees him up to flirt with the local cock tease, who says she's not eleven anymore but is instead "35-24-35." Once *he's* fed himself to the spider, a cousin drops over to find the jailbait topless.

"You're no relation of mine," she says.

"Then when can we *have* relations?" he leers. Spurned by the little tramp, he drives off into a huge spiderweb, leaving her half-naked and beset by lots of little spiders and one big arachnid arm coming through the window.

FINDLAY'S FINAL CUT

All the reading and research and interviews this year have yielded a lot of tragedy in the lives of those behind the bad

movies I've watched. Ed Wood, Barbara Payton, Tom Graeff, Al Adamson, Cheryl "Rainbeaux" Smith, John Reynolds from *Manos*, half the cast of *Bloodsucking Freaks*—they all expired in sad fashion. I don't know that it means anything other than that most bad movies come out of the margins and they're a more dangerous place to live than, say, Beverly Hills. And then, of course, there's also just terrible, terrible luck. Which is what ended cult film director Michael Findlay's life in a spectacle so gory it could've been taken from one of his movies.

Findlay and his wife, Roberta, were encouraged into filmmaking by *Glen or Glenda* producer George Weiss and in the 1960s became notorious for their sadomasochistic sexploitation flicks known as "roughies." In the early 1970s, they turned their attention to the horror genre. Michael then got interested in 3-D, devising his own portable camera, and it was this invention he was carrying at the helipad atop Manhattan's Pan Am building—fittingly, located on Forty-second Street, where the Findlays, movies played—on May 16, 1977, when the chopper's landing gear crumbled, sending the spinning rotors into him and three other boarding passengers. Another person was killed by a rotor spearing down onto Madison Avenue far below.

Findlay wasn't decapitated, as is often claimed, but it might've been a more merciful outcome. Newspaper reports from the day make for morbidly amusing reading because of the willingness of city officials to *go there*. "They were chopped up. Legs. Heads. It was messy," fireman John McAllister, one of the first on the scene, told reporters. Not to be outdone, Deputy Police Commissioner Frank McLaughlin, created an even more ghastly word picture: "The bodies were mangled, terribly mangled. Bits and pieces are all over the place. The blades hit them and everything went everywhere."

Chief Wiggum couldn't have put it more insensitively.

As for Roberta, she went on to more notoriety as a hard-core porn director but made herself persona non grata even in that industry when she took it upon herself to release a sex flick "starring" old footage of porn princess Shauna Grant—just *after* she'd shot herself dead.

It's hard not to think of Michael's end when you watch his 1974 flick, entitled *Shriek of the Mutilated*. Not quite as bad as it sounds, this at first appears to be a hacky yeti story set, rather incongruently, on a Hudson Bay island. When we finally see the monster, it's obvious that it's a dude with white face paint and plastic fangs under a furry hood. That's because it is! See, the whole yeti angle is but a ruse to kill and cannibalize curious undergraduates as part of a worldwide satanic cult.

This is pure grind house sleaze, and pretty tedious. Although I like the sequence where one bastard cuts his girlfriend's throat and then relaxes in the bath with a beer. Thing is, his gal has enough life left in her to crawl across the floor with an electric toaster . . . And Findlay wasn't entirely serious, hence the yeti song ("He's mean and he's gruesome/He'll make your threesome into a twosome!") and the final scene where creepy Native American Laughing Crow lowers an electric knife into a girl and, in a moment Eli Roth would homage in *Grindhouse*, asks our hero Keith, now to be inducted into cannibal conspiracy, "Mr. Henshaw, white meat or dark?"

There's nothing to laugh about in *Snuff*, one of the most notorious exploitation capers in history. In 1971, the Findlays shot a movie in Argentina called *The Slaughter* that was so atrocious as to be deemed unreleasable. Which is pretty awesome, considering what Al Adamson and Sam Sherman were able to get into cinemas that same year.

The Slaughter featured an occult loser named Satan arguing with fascists, extemporizing on the greatness of butchers, and, inevitably, having sex with an initiate while his female followers get it on. The cultists stage robberies, kill a grandma and a teenager, and flash back to the abuse that fucked them up in the first place. Eventually, Satan announces, "The time has come for Slaughter!" and, in a love letter to Manson, his girls raid a compound, tie people up, castrate a guy, and stab a pregnant actress character.

So far, so vile and shockingly amateur, but, in the *Snuff* version, we now cut out of the story to see this is *all* just a movie shoot and the day has wrapped. However, the camera keeps rolling as "crew members" torture and murder an "actress" in graphic gut-tearing detail that's unbelievably fake but a true forerunner to today's "torture porn." Then the screen goes dark and we hear, "Shit, we ran out of film. Did you get it? Did you get it all?"

Of course, what had happened was that a low-budget producer and distributor named Allan Shackleton added this last "real murder" to *The Slaughter* and sent it out in 1976 as *Snuff*, without credits, but with the tagline: "A film that could only be made in South America, where life is cheap!" Predictable outrage, spurred by Shackleton *hiring* protestors, guaranteed profits, although the Findlays sued for how their schlock had been repurposed. More bad blood followed when Roberta left her husband for Shackleton. Not that Michael had too long to mull on it.

JOHN WATERS GOES BOOM!

I fell in love with the work of John Waters before I saw a single projected frame, thanks to Dad bringing home the book *Midnight Movies*. Reading the descriptions of his subversive black comedies, such as *Pink Flamingos* and *Desperate Living*

tickled me no end. A transvestite eating dog shit on camera for real? A town filled with idiots? It'd be a while before I'd find a Sydney cult video store that rented these imported tapes—so long as you laid down a hundred dollar deposit—but I then eagerly devoured all of Waters's movies. I even homaged his *Mondo Trasho* with a Super 8mm effort in which a fake-blood-stained statue of the Virgin Mary floated around my bedroom. Mom, whose devotional object was irrevocably gore-soaked, didn't quite see the artistic merit.

In the years since, I've interviewed Waters a couple times on the phone, and saw him speak and introduce his movies at the Museum of the Moving Image in New York on the same American visit that took me to Troma HQ and the Stardust. Whether in conversation, in documentaries, or guesting on *The Simpsons,* Waters is always a treat. He's one of the funniest, smartest, and most compassionate guys in pop culture. So I was stoked I had the opportunity to chat to him about his stand-up show documentary, *This Filthy World*, when it arose a few months back. When we were done talking about that, I asked him what I've now come to think of as "the question"—i.e., "What's the worst movie you've ever seen?"

The wily Mr. Waters wasn't to be easily pinned down. He told me instead about the three so-called bad movies that he genuinely loves. Waters sang the praises of *Mommie Dearest* ("There are a few scenes that are too much—and if they weren't in it, it would've been a serious hit") and *Christmas Evil* ("A really moving story about someone who gets obsessed by Christmas and turns into Santa Claus") as being literally, unironically good. But his all-time favorite is 1968's *Boom!*, director Joseph Losey's adaptation of Tennessee Williams's *The Milk Train Doesn't Stop Here Anymore* starring Elizabeth Taylor and Richard Burton.

"Tennessee Williams said before he died it was the best

movie they ever did of his work," Waters told me. "And I agree. It's *supposed* to be funny. I've only met Elizabeth Taylor once, in her house, and I told her how much I liked it and she got mad. She thought I was making fun of her. She goes, 'That was a terrible movie.' And I said, 'No, it's not!' And I convinced her finally that I was serious about it. But I thought she was going to throw me out! It's a failed art movie but it is a jaw-dropping movie. And I actually think that they got it right in the weirdest way because Tennessee Williams did mean it to have humor. I use it as a litmus test if I have a date with somebody. If they hate that movie, I can't go out with them. But a lot of times they'll not want to go out with me if I show it to them! It's a double-edged sword."

"So *Boom!* is your best-worst movie?" I asked.

"Not even worst—it's just so feral it's perfect."

"If you were to choose a best-worst movie, what would it be?"

"Oh, I don't see them," he said. "There's millions of worst movies that come out. I know better. I'm not a masochist. I go to movies I think I'll like."

All that's left to me then is to see whether I'd do well on a date with John Waters. I watch *Boom!* It is jaw-dropping and staggering but genuinely interesting too. Not least for Liz's pill-popping, booze-sucking, seemingly terminally ill Mediterranean medusa who commands an island kingdom as she dictates her memoirs via speakerphone. This gorgon—she has a military-attired dwarf to control her attack dogs—has had six husbands but now turns her attentions to Burton's "professional houseguest" after he swims ashore. She dresses him in a Samurai outfit and gives him a sword. Noël Coward pops in, too, as Bill, the Witch of Capri, who lives on blood transfusions and monkey-gland treatments. And that's all in the first twenty-five minutes.

It is impenetrable but interesting. I like it but don't love it. Guess John and I will have to remain just friends.

ZAAT'S ALL FOLKS!

Apart from the occasional movie shared with Clare, this year's quest has been a solitary pursuit. So I'm thrilled that my friend Jaimie Leonarder, cult movie archivist, screens *Zaat*, a.k.a. the *Blood Waters of Dr. Z*, at his occasional alternative movie afternoon at Sydney's last remaining repertory cinema. I defy the rigors of Bad Movie Bingo to attend.

That's because I wasn't able to buy this one in its non–*Mystery Science Theater 3000* version. I also want to see at least one of my movies with an audience. Sadly, the turnout's just sixteen people, although they're a vocal and funny bunch. It's due to such lack of popular demand that Jaimie announces this is to be the last such afternoon at this venue. It's bittersweet, particularly because on this day the city's choked by hundreds of thousands of people streaming to a sporting grand final and a massive music festival.

The fools! They don't know what they're missing. *Zaat*'s a crack-up about a seething scientist who, in a very amusing Vincent Price–like voice-over, talks of his love for all fish and his hatred of the scientific elite who wouldn't let him test his wackjob theories. Now ensconced in a swamp lair, he uses a Wheel of Fortune to keep track of his world domination "to-do" list and utilizes a large deep fryer to turn himself into a catfish man with furry shoulders and butt merkins. His plan: to lead a piscatorial army against puny humanity! Staggering around muddy foreshores, he manages a modest killing spree, overcooks his would-be gill-friend, and incurs the wrath of an X-Files–style outfit who travel the country in an RV. But it's his monologue that resonates with me, perhaps a bit too much: "They think I'm insane! THEY'RE the ones who are insane!

Oh, my friends of the deep! This day, this very day, I'll become one of YOU! My family! And together we'll conquer the universe!"

STATUS REPORT

Worst this month: *Black Devil Doll from Hell*
This month's contenders: *Tales from the Quadead Zone, Bolero, Fantasies, Ghosts Can't Do It, Snuff*
Guiltiest pleasures: *The Giant Claw, Village of the Giants, The Giant Spider Invasion*
Movies watched: *275*

OCTOBER

To be or not to be—what kinda lousy option is that, huh?

—Dwight, played by Brad Pitt, *Cutting Class*

EARLY WORSTS: WHEN THE A-LIST DID Z-GRADE

"Over here, Michael!" shouts the chorus of photographers, and when I look in their direction I'm blinded by a barrage of flashes. Okay, so there's only five or so snappers, but for a moment I have a tiny inkling of what it must be like to be an A-lister on the red carpet. Not that today's quite that extravagant. Lisa, my cohost on *The Movie Show*, and I have just MC'd the launch event for the *Inside Film* magazine awards. I'm in a $1,600 suit, chosen by a stylist and paid for by the show, and in it I feel about four inches taller and twenty pounds lighter. For someone who supposedly hates public speaking, having his picture taken, and who has for years dressed in thrift-store threads, this is a fairly surreal experience.

I think I could get used to it.

It certainly beats: pouring chlorine into five-gallon containers as a pool-shop boy, advising men on tools and materials in a hardware shop despite not being able to hammer a

nail, telemarketing hideous timeshares to suburban moms and pops who're barely making their rent payments, scrubbing dishes in a kitchen as lesbian chefs in a disintegrating relationship scream at each other, Monday early mornings spent scrubbing toilets left to fester in a bar over the weekend, writing fifteen hundred names and addresses on envelopes a week as my brain rotted to half-watched daytime TV.

I've done some crappy jobs. Everyone has to start somewhere. Thing is, most of us don't have a camera trained on us as we make our faltering first steps.

Not so Sylvester Stallone. He was paid two hundred dollars for his work in 1970's *The Party at Kitty and Stud's*—also re-released as *The Italian Stallion* to cash in on Rocky and, er, studliness—and it's a must-see for anyone who needs to know what his scrotum looked like at age twenty-four. Others can probably skip it. Stud is, well, a stud who spends most of his time pleasuring Kitty, a girl who, well, spends most of her time waiting to be pleasured by Stud. Later, the party begins, with everyone crowding into a toilet to drink and smoke dope—and watch a girl poo—before heading out onto the rug where a crazy-faced Stallone leaves no doubt as to his studliness by taking on three women.

Stallone looks at himself in the mirror and flexes a lot and there's even one scene with a distorted reflection that warps his face into an accurate version of the molten Easter Island statue it is today. When he returns home with an injured hand, Kitty sucks on it, noting, "Hmmm, I wish I was sucking his cock." Then, she does, declaring, "I'll be velvet mouthed on your shank of love." But her devotion's not enough to stop him whipping her when she accidentally nips said shank.

Nasty. It'd be funny if it weren't so embarrassing. Every other big-star appearance—from Madonna as a nun to Travolta as an alien—improves in comparison.

What was in the air in 1970? Because just two weeks later *Hercules in New York*, Arnold Schwarzenegger's debut, was released. He's the mythical hero zapped to Manhattan by a cranky Zeus. Arnie, billed as "Arnold Strong—Mr. Universe," ripples his muscle boobs a lot and declares, "No man iz zzzuperiorr to Hurkeleeezzz!" He gets in fights, romances a girl, and, um, beats up a bear in Central Park before becoming a star wrestler and bodybuilder. Like we needed *more* gratuitous flexing. Or a chariot race through Manhattan.

You haven't seen Ah-nuld at his Ah-nuldiest until you've checked out this expressionless performance with English so strangled his lines were originally *dubbed*.

I watch Nicole Kidman's debut in *BMX Bandits* and while not good, it's nothing to be embarrassed about. And you can actually see the qualities that made Jennifer Aniston and Leonardo DiCaprio stars in their respective schlock-horror debuts, *Leprechaun* and *Critters 3*.

Jim Carrey's 1983 bow is another matter. It's especially ignominious because *Copper Mountain*—subtitle: *A Club Med Experience*—is an *advertisement* disguised as a feature film. I count eleven Club mentions as Carrey plays nervous nerd Bobby, who wants to shrug off his mopey "I wish I was something or someone" personality to win over the tourist babes of a ski resort. Carrey does a lot of rubber-faced expressions and a bunch of appalling impersonations, including him "doing" Steve Martin doing "happy feet."

As bad as he is, Carrey's a comic genius compared with Adam Sandler in his 1989 debut *Going Overboard*. Sandler breaks the fourth wall and speaks to camera to tell us that this is a no-budget movie made because they had access to a) a cruise ship and b) a lot of beauty queens. He then does a "goofy" walk up the gangplank. Problem was, at that point the filmmakers should've been checking they had the right

lenses. They didn't, and once they were out to sea had no choice but to use what they'd brought, resulting in some scenes being stretched vertically.

Similar to *Copper Mountain*, Sandler is a would-be entertainer. His waiter, Schecky Moskowitz, wants to replace the ship's awful comedian. When he does, he's far, far worse. Sandler—who co-wrote "additional material"—exhibits no comic or acting ability. None. That the main plot is about stand-up comedians means there are literally *hundreds* of attempted jokes. Not *one* works. In one scene, Sandler ponders, "I wonder where I'll be in, like, in like ten years." The answer, if you'd seen this back in the day, would have been, "Waiting tables." It's a 16/100 that makes *Chuck & Larry* look like *His Girl Friday.*

Sandra Bullock appears in 1987's confusing-as-hell Z-grade gun-porn *Hangmen* for about ten minutes, doing a Mae West impression, a breakdown scene, and enduring a terribly filmed kidnapping. It wasn't enough to get her name in the opening credits back then, but sure enough she's plastered all over the DVD box today.

A young Brad Pitt gets more screen time in 1989's tongue-in-cheek slasher *Cutting Class*. He's a high school asshole named Dwight, who gets around in a yellow singlet and red car, and who wants to get into his girlfriend Paula's pants. "I'm much bigger where it really counts," he says as a come-on. But she's also interested in Brian, Dwight's former best friend . . . who has just returned from a mental asylum because he accidentally killed his dad. There's a goofy quality to this—such as the dudes-dueling-with-power-grinders finale—and the identity of the serial killer is an engaging whodunit. Fans of Pitt, who's third billed here and in one scene given less attention than the Pepsi product placements, will be pleased to know he radiated star quality in this cocky

performance. And he's not bad-looking, either.

Pitt's future love, Angelina Jolie, made her lead debut in 1993's *Cyborg 2: Glass Shadow*. You know a sequel's in trouble when original star Jean-Claude Van Damme turns it down. Set in 2074, in one of those dystopian futures where an unseen army spends millions of man hours lighting fires in forty-four-gallon drums, this has Angelina as Cash, a made-in-America, near-human machine devised for a suicide mission to blow up a rival Japanese corporation. But her trainer, Colt, played by Elias Koteas, wants to pump her full of something other than the explosive "glass shadow." When Colt asks his computer the punishment for fucking a cyborg, he's told, "Minimum penalty solitary confinement until death." Angelina at eighteen? Clearly worth it.

Jolie looks amazing but you wouldn't have predicted an Oscar in her future based on this Galaxina-type role. Nor would you have expected Jack Palance, fresh from his Oscar win for *City Slickers*, to appear in this dross. But there he is, as the omniscient God character, Mercy, uttering mantras like, "Remember the difference between champ and chump is you."

My last early-worst is 1994's *The Return of the Texas Chainsaw Massacre*, which showcases the talents of both Renée Zellweger *and* Matthew McConaughey. Everyone in this is screaming, almost all the time, whether because they're either a) a bugfuck crazy motherfucker or b) someone about to be tortured, murdered, and/or eaten by a bugfuck crazy motherfucker. It's undeniably intense. What's also undeniable is how good these future stars are. McConaughey is totally off the (meat) hook as the maniac with the robot leg. And, as the fly trapped in his web, Zellweger is also very good as she's licked, zapped, beaten, wrapped in plastic, and stuffed in a trunk before she finally fights back. Ghastly though it is, and despite the fact no one gets killed with a chainsaw, I'd rather sit

through this any day than be made to rewatch, say, the stars' recent respective duds *Failure to Launch* and *Miss Potter*.

JOE DANTE'S INFERNO

John Landis recommended I speak to Joe Dante, director of *The Howling* and *Gremlins*—but also love-letter movies about B movies *Hollywood Boulevard* and *Matinee*—because he "knows more about bad movies than anyone else alive."

Like Stephen King, Dante had an early formative experience with *Robot Monster* on TV. "It didn't occur to me that it was incongruous for the guy to have a gorilla suit and a diving helmet," he said when we spoke. "All I knew was that it was an end-of-the-world story, it had a family in it, it had a little boy like me. The craziness of the picture was not as apparent to me." Laughing, Dante also recounted the story of a friend who was terrified by *Plan 9 from Outer Space*. "I think that these movies make an incredible impression on people who see them early in life."

At age fourteen, in 1962, Dante's first-ever writing gig, for *Famous Monsters of Filmland*, was about bad movies. "I had written dozens of letters with different topics—'Great Movies That I've Seen,' 'Most Exciting Movies That I've Seen'—and the one they chose to run as an article was titled 'The 50 Worst Horror Movies,'" he says. "But the trouble was, as I was so young, I hadn't really seen a lot of these pictures! So I just put in the ones that I saw got bad ratings in the newspaper. Of course, that came back to haunt me when the Medveds wrote their book, which I thought was scurrilous. And also now that I've become a filmmaker and realize how hard it is to make even a bad movie, I'm a little less sympathetic to people who just like to jump on the grave of bad movies."

I reassured him that's not my intention.

"I think there's a major difference to be made between bad

movies and boring movies," Dante continued. "A guy like Ed Wood wasn't a good filmmaker by any stretch of the imagination, and yet his movies all have a certain consistency and you have to probably say this guy was an auteur of sorts because you can recognize his movies. That's quite an achievement in this day of homogenized movies, where people's personalities are not really encouraged to shine on feature film. So, you have to have a lot of respect for someone like that."

So what's the worst movie Dante has ever seen? "*The Phynx*," he replied, without a moment's hesitation. "I can't think of a worse picture. It's just jaw-droppingly terrible. Sometimes it's difficult to specify what it is about a movie that's bad, but sometimes they just blindside you with sheer awfulness on a conceptual level."

Made in 1969, *The Phynx* has America's top entertainers kidnapped by . . . Albanian communists! The only way to get behind the iron curtain and rescue them is to form a . . . pop group! Four young groovers are abducted in wacky fashion and trained to become . . . the Phynx! They play a few songs and through the power of hack montage become so big that Richard Nixon . . . creates the national holiday of Phynx-giving!

Now they're ready to go to Albania and rescue the A-list—which comprises Johnny Weismuller and Maureen O' Sullivan of Tarzan and Jane fame, Busby Berkley and his Golddiggers, and Butterfly McQueen from *Gone with the Wind*, among other relics. These appearances must have had the 1970 teen target audience for this Warner Bros. misfire asking "*Who?*" Oddly, Colonel Sanders makes his second bad-movie cameo, and then-rising comic Richard Pryor's in the mix, too.

Some gags are okay. That Ed Sullivan is forced at gunpoint to put the Phynx on his show is funny because their ode to astrology "What's Your Sign?" is so deliberately bland. That

the government's computer MOTHA (mechanical oracle that helps Americans) is shaped like a woman, with reel-to-reel breasts and a vaginal slot where answer cards are ejected, is so misjudged I can't help laugh. Same goes for the Borat-like depiction of Albania. Mostly this hopes we'll laugh at the Phynx wearing X-ray specs to ogle girls, be thrilled to see Joe Louis or Dick Clark or tap along to witheringly dull songs. I don't loathe it as much as Dante does but neither can I understand why *Sight & Sound* recently named it one of the seventy-five most underappreciated movies of all time.

"One of my favorite bad movies is *Confessions of an Opium Eater*," said Dante when I asked his best-worst movie. "It was directed by the prolific Albert Zugsmith, who produced a lot of major pictures for Douglas Sirk and Jack Arnold and Orson Welles. But he would make these cheap pictures for the studios. It's an Oriental potboiler and it has no real coherence. But because the movie is so unrelentingly bizarre, it has a pop poetry to it. I really can't believe it was intentional but it makes it quite a remarkable piece of film. People watch it and they can't tell whether they're stoned or not. Is it a 'bad' movie? Yes. But is it a great experience? Yeah! And so what does that mean? Is it as good as *Lawrence of Arabia*? No, but it does have its own quality and I would often rather put that picture on than a lot of movies that won Academy Awards."

Confessions of an Opium Eater (1962) has Vincent Price as Gilbert De Quincey, rescuing Chinese sex slaves from being auctioned for opium by the Tongs in San Francisco in 1902. Bogus slo-mo bits, bad editing, and weirdly empty sets make this like an oddly boring dream. But Price's mellifluous tones help get us through a script so overwrought it's as if Edgar Allan Poe penned fortune cookies. "Devil and drunkard, ghost and poet, was I," he explains. Getting his smoke on, he's

freaked by visions of Chinese demon masks and slithering snakes. But still he won't shut up: "What is a dream? What is reality? Sometimes a man's life can be nightmare . . . Was I dead or was I only beginning to live?" Escaping assassins into the sewers toward the end, he's still at it: "Who knows—maybe we are going to arrive where we were meant to be from the beginning?"

TED V. MIKELS: MASTER OF ASTRO ZOMBIES

After the downs—Clare's job loss, having to move—come the ups. We pitch Clare's editorial talents to *The Movie Show* and they take her on board as news editor for their Web site, starting immediately. Huzzah! We are back in the black. Clearly on a roll, a couple days later, we find a new place to rent. It's not as cute as our present house, but it is more spacious. And that's a good thing, given that my bad movies now fill two enormous boxes, while the accompanying collection of books and materials fill another one. And yet, like a magpie, I still can't resist any opportunity to add to my accumulation of bad-movie bric-a-brac.

Today, taking a break from cleaning and packing—a process meant to *declutter*—I spy a yard sale across the road. I am there in an instant, flicking through the detritus of someone else's life in the hope of finding gold. And I do. A paperback copy of *The Making of King Kong* for 50 cents. Bargain! And what's this? Joan Collins's 1985 autobiography *Past Imperfect* and it's *inscribed* by the woman herself: "If Ethel Merman can sing disco, I can write a book and here it is! JC."

"Holy shit!" I say.

"What?" says the woman selling her stuff.

"How much do you want for this?"

She takes the book from my hand, opens it.

"Wow," she says. "I don't think I want to sell this."

Me and my big mouth.

That night, surrounded by boxes, I begin my journey into the works of Ted V. Mikels. This Las Vegas–based auteur can claim an unbroken Z-grade output from the days of Ed Wood (he worked on *Orgy of the Dead*) through to the era of DVD. Deep into his seventies, he's still a strapping individual, instantly identifiable for his magician's moustache and trademark boar-tusk necklace. When I asked him for an interview three months ago, he insisted I needed to first watch ten of his movies and sold them to me directly.

While I'm not one to shirk such a task, I limit myself to those that are considered bad. It's not much of a reduction because Mikels is known—and mostly loved—as a schlockmeister.

Mikels's 1968 *Girl in Gold Boots* is both bad and boring, a hippie-era go-go proto-*Showgirls* featuring a lot of arrhythmic shimmying from the admittedly stunning Leslie McCrae.

It's the next night, after another day of boxing up our possessions and scrubbing away the alien topography of moldy Cheerios and sticky dust bunnies that's accumulated under the fridge, that I get into Mikels's "good stuff."

The Astro-Zombies, also from 1968, and co-written by Wayne Rogers of *M*A*S*H* fame, is just as slow as *Girl* but watchable thanks to its subject matter. Tom Pace, who was doomed Buz in the last one, plays an agent assigned to watch over Dr. DeMarco, a government scientist whose experiments were meant to make remote-controlled astronauts but, through his ill-advised use of psychotic brains, have unleashed Astro-Zombies responsible for a string of mutilation murders.

IT'S HARD TO IMAGINE Mikels could have spent any less. The creatures are dudes in trench coats wearing alien-skull rubber masks and wielding cleavers. DeMarco's lab equipment includes a spice rack, a heart in a goldfish tank, a sponge cake

brain, and some bubbly shit. It almost goes without saying that he's played by John Carradine, whose chief requirement is remembering lines like, "We must feed this memory circuit through the emotional quotient rectifier to determine if there's any residual impurity!" The film's other star is exotic Tura Satana, best known from Russ Meyer's *Faster, Pussycat! Kill! Kill!* and she gets to stub her cigarette out on a guy's neck before killing him. Sweet.

There's no way *Astro-Zombies* is the worst movie ever made, as some claim, and I'm giving it 23/100. It's boring, sure, but also offers a few giggles, as when an Astro-Zombie is stripped of his electrocell and has to press a flashlight to his forehead to survive.

Mid-October, I interrupt Mikels-fest to move house. We hire a trio of backpackers to help us out. There's high hilarity when the German guy looks at the labels on the two massive boxes. "Bad movies—*vatched*? Bad movies—*to* vatch? Vat is *ziss*?" I explain but he doesn't understand. He does tell us he's going to start his career as an underwear model tomorrow.

We unpack and settle in well enough, except we have to keep our cats Spencer and Asta inside for a few days to stop them running off in a panic. That they're on the couch with me tonight watching *The Corpse Grinders* makes me nervous.

That's because this 1972 effort is about cats killing and eating their masters after being fed feline food made from, um, ground-up corpses. The Lotus Cat Food Company— motto: "For cats who love people"—is run by enterprising creeps Landau and Maltby, who have a mortician to embalm corpses with pork juice, a gravedigger to exhume bodies, and a staff of assorted geeks and freaks. And when naturally oc- curring resources run low, Landau and Maltby aren't above "retiring" an employee or knocking off a drunk.

The film is built around the "showstopping" scenes in which unfortunates are fed into one end of a plywood grinder and are spat out as what looks like minced plasticine. The cat attacks are no more convincing, relying on tiny unthreatening Siamese and taxidermied felines "munching" on intestines.

The Corpse Grinders is impeccably bad, getting everything wrong in just the right proportions to make it very entertaining. With its black-comic premise, unrepentant villains, lovesick hero and heroine ("Can you forget pet food for just one minute," he says, sweeping her into his arms), and oddball characters (Landau has an insane wife, who feeds soup to a doll), vast potential exists for turning this into a Broadway musical like *Little Shop of Horrors* or *Sweeney Todd*.

In an echo of how the Phynx were formed, 1973's *The Doll Squad* has the government told by its computer, Bertha, that they need to get an evil-fighting "Doll Squad" together—under the control of a dude, naturally—recruited from the ranks of Olympic swimming, librarianship, and, in Tura Satana's case, stripperdom. Once the team is assembled—and armed with a *Cyborg 2*-style potion that explodes people—they set out to take down evil mastermind Eamon, whose island headquarters is guarded by an endless supply of hopeless minions apparently filled with red paint. Mikels claims this inspired *Charlie's Angels* and I can definitely see his argument, down to the lead gal being named Sabrina. This is so slow in parts I think it should be called *The Dull Squad* but the girls are curvy and pointy in their NATO-approved jumpsuit-and-stiletto uniforms and it picks up at the end when they shoot, stab, and rocket grenade their way through dozens of minions. Poor pacing drags it down, but this is a strong 37/100.

Made nearly ten years later, *Ten Violent Women* is peppier, and I like it better. After *eight* girls get sick of mining gold, they rob a jewelry store, hit Vegas to fence the gems (to a

cameoing Mikels), wind up double crossed with a coke payoff, commit murder, get busted trying to sell the drugs to an undercover cop, and are sent to a prison run by sadistic lesbian Miss Terry. That's just in the first half.

With its heist and freeze-frame and narrative captions, I'm saying this, like *Doll Squad*, is a Quentin Tarantino favorite. One of the girls even has hair like Uma Thurman's in *Pulp Fiction* and smokes in bed while she plays cards with her feet. This is low-rent, but the characters and situations are wild, it's fast, and everyone looks like they're having fun.

Mikels was still on a warrior woman kick in 1987's *War Cat*, which wants to be a female *First Blood*. The heroine is Tina, who's raped and kidnapped by a gang of survivalist psychos. She convinces their leader to give her a two-hour head start before his men hunt her to the death. *The Most Dangerous Dame* then. Looking like a renegade Linda Ronstadt, she has herself a risible rampage of revenge. Working against the subject matter are murkier than usual cinematography, woefully plodding pace, and dreadful acting. *War Cat* is like a medically induced coma. Even the scene where nutjobs kill a *baby* isn't enough to jolt a response.

Mikels made little of consequence between 1987 and 2000, when he began to produce straight-to-DVD flicks to cash in on his cult faves. Thus, I'm watching *The Corpse Grinders 2*. The nephews of Landau and Maltby are at it again in their revived Lotus Cat Food Company. The difference is this has *cat people from outer space* who desperately want Lotus's product for their home planet.

These cat people have strap-on feline ears and "meow" reverently in prayer in their lounge room headquarters decorated with discount-store cat statues. Other sets are *less* inspired. Check out the "phasing platform" for interstellar travel, no more than a wooden staircase leading to a terracotta roof.

Everything, *everything* else is slapped together as poorly. Not least the grinding machine, with blades of aluminum foil and "on switch" clearly marked "Hitachi Camera Power Unit." Mikels pops up as a professor, and his friend—Ed Wood's old gal, Dolores Fuller—has a bit as a Lotus saleslady.

Mark of the Astro-Zombies, from 2002, comes with an ugly green text crawl to explain itself: "Dr. Mikacevich, a mad scientist and archenemy of Malvira, has preserved the head of Dr. DeMarco hoping to extract from it the secrets of creating the ultimate astro-man, the obedient half-human robots that could take over and kill the world's populations, and who are controlled by signals sent thru cyberspace." Theo Mikacevich is Mikels's birth name, and he plays this role, while the now-matronly Tura Satana does villainess duties. DeMarco meanwhile is poor old John Carradine in thirty-five-year-old footage resurrected fourteen years after his death.

This is shoddy beyond belief. Space tech and aliens are comprised of insulation tiles, medallions, foam rubber, kitchen bric-a-brac, disco lights, and a huffers' convention's worth of silver spray paint. Characters have to step over electrical cords used by the production. With the exception of Tura, the "actors" are always searching for their pointlessly repetitive dialogue, and some throw nervous glances at the frequently smudged camera.

Mark of the Astro-Zombies is either deliberately as bad as it can be or the result of staggering laziness and indifference. A group of moderately intelligent fourteen-year-olds, armed with a video camera and a budget of $500, could come up with something smarter and funnier, more professional and interesting. I rate it 16/100 and it makes the very worst of 1950s sci-fi look like *Star Wars*.

Such reactions make me feel guilty when I talk to Mikels, because he seems a lovely man. "I dedicate my life to making

movies, and I like making movies," he says. "It's an obsession; that's the only way I can explain it. If I was money-minded, I probably would've quit fifty years ago."

Mikels began doing magic tricks for the neighbors when he was five and by his teens had worked up a two-and-a-half-hour show that included ventriloquism, fire eating, and Houdini-style escapes. His desire to film the spectacular led to a life on the cinematic margins.

"Good movies from the heart and the soul and the gut," is how Mikels sums up his career credo. "I'm not out to outdo anybody who blows up heads of zombies. I like to tell a story that is easy to follow, they hold your attention, and that above all entertains."

Delicately, I ask if he's offended when people say his films are bad.

"They're usually only considered bad by people who've never seen them," he says. "I am offended because if you really look at *The Black Klansman*, *Strike Me Deadly*, or *Doll Squad* when somebody calls them trash I want to punch them in the face."

Yikes. I'm glad we're doing this over the phone, although it's worth acknowledging that the first two, from his preschlock days, *are* reasonably regarded.

"I'd like to see them make a movie," Mikels continues. "The people who hate the movies usually are people who want to make them and cannot and think they speak for the entire world and that everyone thinks like they do. And they're full of crap!" He fulminates some more, pauses, sighs. "There's a little bit of bitterness there."

This bitterness—which he'll later, sweetly and unnecessarily, apologize for in an e-mail—also has a lot to do with not making money on some of his hits. Ergo, the recent cash-in sequels.

"*Corpse Grinders* was such a fantastic success . . . so I tried

to do something campy again, with *Corpse Grinders 2*," Mikels says. "And it's so far out—people from another planet come here because they're cat people who love cat food? How funny, you know? And *Mark of the Astro-Zombies* was meant to be a continuance and again it's camp. Why not try to capitalize? I got cheated out of the original *Astro-Zombies* because it was sold out from under me before I made a nickel. Never got a dime from thirteen months of my life making that movie. There's a little bit of bitterness."

Even though I don't hold out hopes that it'll be any sort of masterpiece, I'm pleased when I learn Mikels is making a *third* installment in the *Astro-Zombies* saga and that New York filmmaker Kevin Sean Michaels—who worked as an art director for Lloyd Kaufman's Troma, natch—is celebrating his life and films in a documentary called *The Wild World of Ted V. Mikels*. Keep on trucking, Ted.

THREE NIGHTS WITH PARIS

Confession time: I used to think Paris Hilton was "hot." Clare and her friends have never let me live it down.

But something about her insouciance appealed, her obviousness. And then, in 2004, I had a personal encounter with the heiress.

She was remaking *House of Wax*, which represented the peak of her campaign to become a movie star. I and a handful of other writers were escorted around the impressive sets on Queensland's Gold Coast, given round table interviews with Hilton's costars, the spunky Elisha Cuthbert and the amusingly earnest Chad Michael Murray, and talked with the producers Joel Silver and Susan Levin (later Downey), who both matter-of-factly admitted they'd cast Paris before anyone else specifically because her tabloid antics would generate a year or more of free publicity for the film.

Finally, the big moment arrived and Paris was delivered unto us, in fluoro tracksuit and flip-flops that made her look, well, chunkier than usual. But it was her lack of presence that was breathtaking as she tried to convince us she was a real actress, and explained that she was widely loved and admired because she was so real and genuine and nice before she blithely prattled on about recent shopping excursions. The effect was that of an undereducated fourteen-year-old girl. Paris's vapidity was astounding. She sucked all the air out of the room—and we were outside. Hallelujah, I was cured.

House of Wax was no hit but, to be fair, neither it nor Paris were terrible. The same can't be said for her "indie" projects before and after.

2004's *The Hillz* was written and directed by Saran Barnum—which must've lead to no end of "that's a wrap" jokes on set—and is narrated by Steve 5, a romantic douche bag in love with Hilton's Heather, despite her wanting only the riches offered by her banker boyfriend. As one of Steve's buddies puts it, "Why do you waste your time on that bulimic backstabbing, two-timing, fucking materialistic shallow twat?"

Anyway, Steve 5 has other problems. See, as he tells it, he and his buddy Duff and their crew are among the most dangerous people on the planet simply because they're white, rich, bored, and born after 1980. Our wannabe white-bread gangstas are the type of tough guys who play rock-paper-scissors to see who gets to rape a girl they've drugged. But Duff quickly graduates to cappin' mofos, including a trainee cop. This is too much for Steve.

The misogyny is unbelievable, with every woman referred to as a "slut," "pussy," "twat," "ass," "whore," "bitch," "ho," "betty," and "it" who're to be "tapped," "fucked," "raped," "hit," and so forth. Amid it, Hilton is simply blond and blank,

preening in an animal-print bikini, turning up to a funeral in a dress that threatens nipple slippage. As for the dudes, it's impossible to take Jesse Woodrow's Steve 5 seriously but at least Rene Heger gives a crazed, intense performance as Duff. *The Hillz* is remarkably awful—really less than zero—but sometimes entertainingly so. If it's an even partially accurate depiction of any kind of Gen Y reality, the world is doomed.

And verily we *are* doomed. "Never has the world ever seen the war that's about to begin—if we're not already at the beginning stages of it—that's going to kill over two billion people." That's what Jesse Woodrow, who played Steve 5 but is now a Dallas-based born-again Christian radio and TV evangelist, tells me over the phone.

"Working with Paris tipped you over the edge into Christianity?" I ask.

"You're saying that, not me," he says, laughing heartily, but confirms that, yes, he converted within weeks of *The Hillz* shoot finishing. "I will say that Paris is a dear friend of mine. There's a perception of Paris Hilton that she's this, or whatever, but behind closed doors she's very sweet, she's a very kind girl, she's not an idiot. She's made some bad decisions in her life—like I have, like you have, like we all have."

Was one of his bad decisions using a lot of drugs, I ask.

"Oh yeah, man, oh yeah," he says. "During that movie I was probably high almost every day. That's probably why I was so bad in it." Woodrow laughs and then recounts how, for close to ten years as a male model and jobbing actor, he lived the very fastest of lives, doing drugs and running with celebrity pals like Paris, Leif Garrett, and Cher's son, Elijah Blue Allman. "I don't know how I'm alive, to be honest with you."

So what does Woodrow think of starring in the decidedly anti-Christian *The Hillz* now?

"I'm sure there are Christians out there that wouldn't like my

answer, but I think we're called to be lighted on places," he says. "I don't have a problem with what I did. Would I do it again? I don't know. It's not one of my most proudest moments."

Even the most tolerant Christian would find it hard to say a nice thing about 2006's *Bottoms Up*. While *The Hillz* wanted to be *A Clockwork O.C.*, this is a *Unintelligentourage*. Jason Mewes is Owen, a Minnesota bartender who goes to Hollywood for a cocktail championship but ends up falling into a love-hate relationship with Lisa, daughter of a studio boss. Plot permutations see him join the entourage of a rising star named Hayden, whose secret shame is that he got his start making jerk off videos. Owen also finds that while Lisa *seems* to be a vapid rich bitch she's *actually* a sweet girl who, like, totally runs a charity.

To achieve this surprising characterization, Hilton dyed her hair brunette. Otherwise, she's just Paris. And Mewes is just Mewes, mumbling his way through scenes, while his mentor Kevin Smith has an early cameo so he can squeeze off a fart. David Keith disgraces himself with an achingly caricatured gay performance as Uncle Earl that sees him dress like Olivia Newton John, ca. 1982. Writer-director Erik MacArthur ensures there's misogyny to go with the homophobia, so we get a party with gang bang overtones and a song whose lyrics go "titties-ass-titties-ass." Stuff that tries to satirize Hollywood foibles, such as all the stars using a "fecal therapist" or "shit whisperer," falls as flat as the flairless bartending scenes.

Hayden's secret history was obviously based on Simon Rex and he costars in Hilton's *Pledge This!*—also from 2006. I watch this one before heading out to do a *Movie Show* interview that I really wanted to duck. Again, the bad movie as distraction from anxiety. Cheaper and less harmful than Xanax. Probably.

Hilton is Victoria English, president of Gamma Gamma at South Beach University. After *FHM* decides it's going to hold a more diverse "hottest sorority" competition, she has to admit the "nonhot" to her fold and train them how to be "hot." These candidates are fat, old, gay, alternative, from the south, African American, and Native American—in essence, anything that doesn't fit into Hilton's peroxided greyhound definition of "hot"—and their education comes from bastardization that sees them collect used condoms and eat day-old sushi on all fours.

Lips like a frosted donut, Hilton pretty much plays herself. She does a sexy dance for a teacher so she can say, "Bet you wish I was yours. Hot, aren't I?" There's a bit where her dog watches a bathroom threeway. "My dog is such a perv. I love it," she intones, adding, "Now I'm craving sushi." It's weird that her on-screen boyfriend, Simon Rex, became her real-life man-bag because in the film she sets her dog to fellating his "babydick" and he romances her with, "My balls miss your chin."

Now *I'm* craving a vomit bag. What's amusing to me as a former *FHM* staffer is that the magazine thought it was a good idea to be product placed in this turd. The finale has Paris telling us, "I loved my cover so much I bought *FHM* magazine." In reality, the American edition closed less than two months after *Pledge This!* flopped.

BUT NOW I'M OFF, to face the music. Or, more accurately, the muscle. "Please don't ask me what I thought of the movie." This is the thought that runs through my head over and over as I'm introduced to Dwayne "the Rock" Johnson in a Sydney hotel room for our TV interview. That's because he's promoting *The Game Plan*, which I think deserves its place amid all the other crap I've watched this year.

If he does ask, I'll have to tell him. And if I tell him, then this strapping man-mountain, whose skin glows like polished

teak and whose teeth are so bright he could make a living as a lighthouse, will snap me in half.

Happily, Mr. Rock is savvy enough not to ask and instead we have a jovial interview. He does the eyebrow thing. He's amused by the Aussie colloquialism "take the piss." He doesn't crush my hand to powder when he shakes it at the end of the interview. Interestingly, when we're done, I learn from the publicist that Mr. Rock today had four chicken breasts for lunch. Wow. The day's shoot done, and with Clare buried in her work for *The Movie Show*, I have my lunch (not four chicken breasts) and shimmy my way home.

MINI MONSTERS

Bad Movie Bingo spits out a ball number 56, for a category inhabited by evil little monsters. But before I go there, I finally get to pick up where April's Little People segment left off. That's because at an evening hosted by my friend Jaimie Leonarder, he of *Zaat* awesomeness, I finally get to meet Andrew Leavold, Brisbane Trash Video store owner, broadcaster, writer, and the world's leading authority on Weng Weng, that tiny person about whom I've thought so much since seeing his movie.

I fly my freak flag tonight, with a Weng Weng T-shirt purchased over the Internet from an even more obsessed fan. Andrew and I have corresponded by e-mail these past few months and he's shared volumes of information he's gathered in numerous trips to the Philippines. But now, for a small audience, he talks us through the rough cut of his documentary, *The Search for Weng Weng*. It's a mind-blowing story, a convergence of triumph and tragedy that saw the tiny Filipino rise out of some of the world's poorest slums to attain huge stardom and the favor of the Marcos family before returning to poverty, anonymity, and a sad early death.

Afterward, Andrew and I decamp to a local bar and have

far, far too many beers. It's a pleasure to be able to rave excitedly about obscure stuff I've discovered to someone who appreciates it all and shoots arcana right back at me.

Happily, the next morning is a Saturday. Unhappily, I'm awake at 6:00 a.m. and feel like a garbage truck has parked on my head and tipped its contents down my throat. Ava, of course, is oblivious to this and burbling away loudly for TV, for play, for breakfast, for chocolate milk. For God's sake.

Clare lets me sleep long enough so that the afternoon's visit to the park playground with Ava is survivable. The downside is that Clare's exhausted that night and so goes to bed early. And that leaves me with my first Little Monsters movie, which is 1987's *The Garbage Pail Kids Movie*. This is a spin-off from the Topps chewing gum cards that satirized the Cabbage Patch Kids. Mackenzie Astin from *The Facts of Life* is Dodger, a little twerp who turns snotnose Messy Tessy, flatulent Foul Phil, eyeball-eating Ali Gator, puke-happy Valerie Vomit, and other Kids into sweatshop workers creating lurid fashions in an effort to romance sour bully moll Tangerine. Despite the distastefulness of their unamusing farting, pissing, and puking, someone still did a product placement deal so these gross freaks are Pepsi fans.

But it's 1988's *Mac and Me* that's perhaps history's most egregious exercise in product placement. This *E.T.* rip-off has an alien family inadvertently sucked up by a NASA probe and brought back to Earth. The baby of the group makes friends with wheelchair-bound kid Eric, played by real-life spina bifida sufferer Jade Calegory, who tries to protect Mac from the Feds and reunite him with his peeps.

Steven Spielberg set the precedent when he made *E.T.* a fan of Reese's Pieces, which turned the candy into a huge hit. In *Mac and Me*, the alien's name supposedly means "mysterious alien creature" but it's actually named for McDonald's, whose

restaurant hosts a protracted dance-off scene. Ronald Mc-Donald presides over the gruesome spectacle and the fast-food clown was further pressed into service to "introduce" the trailer in cinemas. *Mac*'s other beneficiary is the Coca-Cola Company. Every meal in the film is served with their soda. The aliens drink it, too, and are such diehards they'll break and enter to get a fix. When they're dying in the desert, Eric revives them with a couple of cold cans.

Director Stewart Raffill does a great job ensuring every corporate logo faces camera. Pity, then, he wasn't as invested in getting the kids to act, guarding against continuity errors, or instructing the effects department to come up with a creature design that looked less like scrotums with elf ears. *Mac and Me*'s atrocious cynicism helps make it fascinatingly bad. So does its straight-out badness. Actor Paul Rudd is a huge fan and whenever he'd appear on *Late Night with Conan O'Brien* to plug a new film, he'd do a deadpan introduction to the supposed movie clip but then substitute *Mac*'s funniest scene, which has Eric and wheelchair going off a cliff.

Even more awesome is 1990's *Troll 2*, a deliciously crap seem-quel to 1986's *Troll*. Young Josh and his family take a month's house exchange in a town populated by goblins that feed people bright green goo . . . which dissolves them into edible vegetables.

There's so much to enjoy here. The actors compete to see who can be the most stilted. The production values suck, with the goblins simply dwarves wearing Halloween masks, floppy gloves, and burlap bags. Just as grisly are the human fashions—pastel T-shirts, headbands, and oversized Garfield T-shirts. The ideas are wack. The goblins have a vegan-cult philosophy that says meat leads to smelly bladders and hemorrhoids. Their "mother" is a wild-haired hag who uses corn cobs to seduce youngsters and turn them into human-plant

hybrids. Recalling *Leonard Part 6*, mystical ghost grandpa Seth gives Josh a magic double-decker baloney sandwich as protection. And throughout, the word "troll" is never uttered. That's because this wasn't made as any sort of sequel to 1986's *Troll*. Rather, the town's name—Nilbog—spelled backward is the film's original title.

What tickles me as much is that Ava is old enough to get into her first Halloween. We never celebrated it as kids—it's not an Australian tradition—but over the past few years it has gained in popularity, given a push, I suspect, by the confectionary industry. Not that I mind, because it's great fun. Clare and I sit at the gate as Ava excitedly jumps up and down and hands out candy to the procession of little trolls, aliens, vampires, and goblins who traipse up and down our street. It amuses me no end that their crappy costumes and makeup and little pitchforks and masks could belong to any number of the movies I've gorged on this year.

"These guys could be out of *Troll 2*," I don't say to Clare, who's beaming and laughing with a junior witch as Ava plays with gossamer strands of fake spiderweb. I figure sometimes it's best not to verbally relate everything back to the quest. But it is spooky.

Halloween also marks the end of the month. Ten down, two to go. I've passed the three-hundred-movie mark now and finally feel confident I can make it. What I've also realized, spurred by the brilliance of *No Country for Old Men*, is that while this was officially my year of bad movies, it also sneakily shaped up as one of the best years in cinema I can recall. *Zodiac*, *Knocked Up*, *The Lives of Others*, *Ratatouille*, *Gone Baby Gone*, *Before the Devil Knows You're Dead*, *The Bourne Ultimatum*, *Enchanted*, and *Hairspray*, among others, have had me handing out the four- and five-star ratings in *Empire* and on *The Movie Show* like they're going out of fashion.

It's a welcome development because, going into this year, I'd also wondered whether the disproportionate number of post-2000 movies on the IMDb's Bottom 100 was an indicator that cinema was getting worse—a claim that's been made ever since the first frame was projected. Based on what I'm seeing, that's not the case.

STATUS REPORT

Worst this month: *The Corpse Grinders II, Mark of the Astro-Zombies*
Guiltiest pleasures: *Mac and Me, Troll 2, The Corpse Grinders*
Movies watched: *305*

NOVEMBER

When you don't know what to do, don't do anything.

—Joe Estevez as Saint Offender,
Return of the Roller Blade Seven

FORBIDDEN DANCES

Bad Movie Bingo dictates that I bust a move, yo. Or, more precisely, watch how others did so in the mid-1980s and early 1990s. Back when I was fourteen, I spent a goodly hour or two convinced I could not just learn to break-dance but become one of the greats. The reason for this was seeing the magical movements of the art in that year's *Breakin'*.

But by the time awesomely named sequel *Breakin' 2: Electric Boogaloo* was released—just *seven* months later—I was no longer interested. Watching it now makes me wish I'd learned how to moonwalk or do the robot. This reunites Lucinda Dickey, Adolfo "Shabba-Doo" Quinones, and Michael "Boogaloo Shrimp" Chambers as, respectively, Kelly, Ozone, and Turbo. The film's a raptacular break-splosion as they try to stage a show to save their community center from an evil developer but it's the trio's fashions that floor me. These kids change clothes in virtually *every* sequence.

I'll limit myself to Ozone who, by my count, has nineteen costume changes. And what outfits the brother has! We see him in black leather confederate cap, matching singlet, six-inch gold earring, and foot-long faux rabbit tail dangling from his poodle hair. We see him in a checkerboard-pattern cutoff T-shirt with a red *waist-kerchief.* When he goes to lodge a protest at town hall, he dresses in formal wear, which for him consists of a hot pink sleeveless safari shirt, black silk parachute pants, and red leg warmers.

The songs are terribly great. In a hospital scene, everyone breaks into "Emergency," whose lyrics include, "When I see you it's so intensive!" The dialogue's funny, too. "Electro Rock rules the dance floor now, sucka!" says a villain. And the rival gangs' break-dance battle is mind-blowingly good-bad. How awesome would it be if the world could settle its differences in such harmless fashion? Imagine CNN: "Twenty-three sprained ankles in a fierce dance-off in Baghdad today. In other news, four ligaments torn in an outbreak of poppin' and lockin' in Gaza."

Made the same year, *Body Rock* is, like *Showgirls, Stayin' Alive,* and *Girl in Gold Boots,* a cautionary tale about the corrupting power of horrible hoofing. Lorenzo Lamas stars as Chilly D., a spray-painting moron who learns to break-dance and sells out his "Body Rock" crew so he can become a rap star with a bitch girlfriend.

The lyrics to Chilly's hits are crap-rap. "I've got a hole in my pocket where I keep my rocket and it shows in the way I walk," warbles Lorenzo in "Smooth Talker," adding, "I'm gonna suck you like an animal and eat you like a cannibal and MAKE YOUR BODY PAY!"

Just when I'm about to conclude the fashion here at least isn't as garish as *Electric Boogaloo, Body Rock* blows it away with Lorenzo's routine at the Zone Club. In a flowing fluoro outfit

and New Wave makeup, he looks like a bi-curious space sheik. Surrounded by orange tribal skeletons who "dance attack," he "dance defends" himself with kung fu and glow-stick nunchakus. Funny as it is, Chilly's too cold—like Travolta in *Stayin' Alive*—to warrant even my ironic affections. I just don't care when he comes good for his homies at the Rapstravaganza, especially because the event features *no rap* at all.

Since breakin', I've had no interest to learn new dances and can report with pride I never did the Macarena or crumped. I did bootscoot once, but I was in Texas, where it's the law that you have to join in.

I most certainly never did the lambada. For those who've forgotten, or blocked it out, this was a sexy-times South American four-step dance that turned into a craze that burned around the globe in 1989–90. "The Lambada, a Torrid New Dance, Is Not for the Bashful or the Demure" warned the headline to a *New York Times* article that included helpful subheads "The Intimacy Can Be Awkward" and "You Have to Be Open Minded" before quoting a dance instructor who said it was "a definite form of safe sex."

No surprises that movie cash-ins were but seconds away. The weirdest was *Blame It on the Lambada*, apparently released in 1990, and the only movie I've ever encountered that has no IMDb listing and is virtually unknown. *The Daily Snoop*'s star reporter, Jimmy Lawson, investigates claims that Andy Warhol faked his death and is now hanging out in Greenwich Village lambada clubs. The film is assembled from barely linked moments that congeal into a weird dreamlike experience. There's a reel of the real Andy Warhol rambling away about the magical presence some people have. A Warhol double slinks around and eventually shakes his lambada. There's screwball cop dialogue, megachinned Robert Z'dar as a coroner in eyeliner, murders, and . . . the revelation that this is all

actually taking place in Warhol's after-death purgatory, where he wants to start a *lambada* version of *Interview* magazine and have Jimmy profile dead legends like Jim Morrison, Janis Joplin, and Jimmy Hoffa.

What? Who were they appealing to? Hipster Warhol fans who also love lambada? It's one of the weirdest flicks so far.

The Forbidden Dance is another 1990 lambada cash-in. This stars Laura Harring—former Miss USA, real-life countess, and future muse for David Lynch in *Mulholland Drive*—as Nisa, an Amazonian tribeswoman whose happy life of lambada is disrupted by an evil developer. She travels to the United States to plead her case but winds up the star attraction at a sleazy club.

The script was literally written in ten days. Why it took so long is unclear because two dozen pages must have contained only the words: "Nisa dry humps natives/boyfriend/bad guy/sleazebags/pillows." It must be said that Harring looks pretty in such scenes, and some interest is added by B-grade legends Sid Haig as a juju man and career villain and former acidhead Richard Lynch (his facial scars were the result of him setting himself on fire while tripping on LSD in '67) as the enviro-vandal. Mainly, it's boring PG-13 "sensuality" and ridiculously po-faced. "They must stop killing the trees or the sun will eat the air," Nisa explains. "This film is dedicated to the preservation of the rain forest," reads a declaration at the end, although it's unclear if a cut of the ticket sales went to the cause. What is certain is that it's criminal noise pollution to make repeated use of Kid Creole and the Coconuts' insidious, inexplicable number one hit "Lambada" on the soundtrack.

More horrible is that Vanilla Ice's massive hit "Ice, Ice Baby" *isn't* featured in his 1992 vanity vehicle *Cool as Ice*. The song's a classic and anyone who says they don't like it is a liar. I can't say the same for the movie, which has Ice and his motorbike

posse rolling into a small town, where he aggressively woos equestrian champion Kathy away from her boyfriend and helps save her dad from mobsters.

It's a slender story, broken up with scenes in which Vanilla gets to rap 'n' dance and do da romance, yo. He's not bad at the former and I reckon he has been maligned by people embarrassed that they at one time moonwalked to his stuff. The latter's another story and not helped by horrible Ice-is-cool dialogue. "Drop that zero and get with the hero," he advises Kat. Either "surprised" or "brooding," Ice obviously can't stop thinking about how he looks long enough to even try acting. None of this is helped by his "rebel" fashion, from the flattop with shaved-furrow sides to the leather jacket decorated with "outlaw" stencils like "Lust, danger," and "Down by law."

Cool as Ice is not all terrible. When *Playboy* video director David Kellogg lets him, cinematographer Janusz Kaminski gets some good shots—within a few years he'd have Oscars for *Schindler's List* and *Saving Private Ryan*. Michael Gross, dad from *Family Ties*, is fine doing patriarchal duties. Kristin Minter's okay as Kathy but I desperately wish Gwyneth Paltrow had taken the part. She wanted it but her dad objected to the sexual content. "One line said something like, 'My phone number is 555-6969.' He closed the script and said, 'Over my dead body!'" she recalled to Britain's *Star* magazine in 2006.

Much cooler is that, through the happy coincidence that he's planning an Australian tour, I get Vanilla Ice, a.k.a. Robert Van Winkle, on the phone. He's at his home in Florida and sounds pretty, um, chilled for someone the world's supposedly hated for the better part of two decades. He says he has no regrets about *Cool as Ice*. "I watched it just last week for the first time in, like, ten years," he says. "I thought it was pretty good myself; I just laugh at it now. But I laugh at everything now. I made good investments." Making the movie was fun, he

says. "I love riding bikes and got to ride them in the movie and jump fences and chase girls."

Less enjoyable was the controversy over the unauthorized use of Queen and David Bowie's "Under Pressure" in *Ice Ice Baby*, revelations he'd fabricated his background, and the critical backlash that skewered *Cool as Ice*. "Did you care?" I ask. "Yeah, I did," he sighs. How did he cope? "I had a weekend that lasted a few years. I can say it with a smile on my face now because what doesn't kill you makes you stronger."

"Tell me about *Da Hip Hop Witch*," I say.

Ice guffaws. "I can't even believe you know about that!"

"How'd it happen?" I ask.

"I don't even know," he laughs. "This guy just came to one of my concerts and paid me like twenty thousand just to say five minutes on the camera, and I did it but didn't know that he was making a movie or anything. Then all of the sudden this thing comes out—*Da Hip Hop Witch* and it's just horrible!"

THEY CAME FROM THE DEEP

I'm reading Ava her favorite book, *Freckleface Strawberry*, a celebration of red-hairedness by actress Julianne Moore, when I have what I think is an "Aha" brainwave. I tuck my daughter in, say goodnight, and pour a glass of wine for Clare and myself.

"You know Vanilla Ice is playing on New Year's Eve?" I say. Clare deadeyes me.

"What about we go? What better way to end a year of bad movies?"

"You're kidding, right?"

Hmm, maybe I should've kept this one to myself.

"Look," she says. "I'm happy you're doing this, and I've been supportive, right?"

I agree that yes, through all the expenditure, obsessive discussion, and midnight screenings, Clare has been a real sport.

"Well, the last thing I want to do on New Year's Eve is be stuck in some heaving club listening to a bad rapper so you can have some sort of convenient 'closure,' okay? I want to be with you, with my friends, talking and hanging out and—"

"Not having anything to do with bad movies?" I finish.

"Bingo."

Fair enough, really. And, honestly, I'm kinda glad she said so because no doubt if she'd agreed I would've bought tickets and then, come the night, felt obliged to go rather than actually wanting to. I have a feeling that come New Year's Eve, I, too, will be ready for a break.

For instance, this afternoon, leaving work, my editor Rod asked me, "So, what are you up to tonight?"

"Watching *Tentacles*," I said.

"Did you ever ask yourself, 'How did it come to this?'" he replied.

"Every day," I said, no longer even able to make a joke of it.

SAID TENTACLES SLITHERED INTO cinemas in 1977. Directed by "Oliver Hellman," a.k.a. Ovidio G. Assonitis, who'd already been sued for ripping off *The Exorcist* with his 1974 schlocker *Beyond the Door*. This *Jaws* riff starts with a baby and stroller sucked right into the water from the shore. Soon other locals are turning up as picked-clean skeletons and it's up to reporter Ned Turner to discover that this is the work of a giant octopus made cranky by a corporation's underwater tunneling activities.

It's enough premise to sustain a B movie but there are way too many gabfests and too few attacks. I stay awake by wondering how *three* Oscar winners—John Huston, Henry Fonda, and Shelley Winters—were lured into this. All of them vanish

before the end—having fulfilled contractual obligations rather than having fallen prey to octopus shenanigans. Finishing off the monster is left to shark whisperer Bo Hopkins. "I'm asking you to help me kill this octopus," he says to two orcas. The climactic scene is accomplished with two killer whale sock puppets tearing to pieces a small but live cephalopod.

The *Jaws* series sank to similar depths in the fourth film, 1987's *Jaws: The Revenge.* The late American comedian Richard Jeni did a celebrated routine lambasting its inanities. As funny as he was, he perpetuated one exaggeration because, while it is true that the great white shark is so focused on eating the Brody family it *follows* them from Amity Island to the Bahamas, it's not true that it actually beats them to their destination and is waiting when their plane lands. The shark arrives about two days after its would-be victims. Given the distance from Amity (which, though fictional, is meant to be around Montauk) to the Bahamas is 1,200 miles and a great white's top speed is 25 mph, it's *feasible* for a shark to do it in forty-eight hours—so long as it didn't stop for coffee.

What am I doing defending this? It's thoroughly ridiculous. While Roy Scheider bowed out after *Jaws 2*, Lorraine Gary returns as his widow, Ellen. She flees Amity after her son Sean is munched in the opening reel. In the Bahamas, her foam-rubber nemesis chews on her son marine biologist Michael Brody's submarine and tries to get little Thea Brody on her banana boat. Ellen has an ally in Michael Caine's pilot and she has also developed ESP—extra sharky perception—that alerts her to danger. But it's her good old-fashioned boat-ramming of the *roaring* shark that saves the day. That this causes the fish to *explode* means it's one of the stupidest endings ever. Caine famously said of his folly, "I have never seen it, but by all accounts it is terrible. However, I have seen the house that it built, and it is terrific."

Much more terrible and much more terrific is 2002's *Shark*

Attack 3: Megalodon. This echoes *Tentacles* in that it's the partly dubbed story of a massive monster sent mad by man's interference with the seafloor. This fifteen-foot prehistoric bastard animal waits for couples under waterslides and pulls parasailers out of the sky. But it's nothing compared to *mama* megalodon—"bigger than a Greyhound bus!"—who swallows lifeboats whole. The most amazing scene has a corporate villain jetskiing straight down the throat of the big fish.

That this is all achieved with flimsy CGI, and gratuitous T&A and gore make it a riot. Best of all is British actor John Barrowman who has a ball as hero Ben. He's clearly laughing in some parts of the finale that have him in a submarine and love-interest Cat in a chopper, like demented Thunderbirds. But he's most famous for "the line." Skip the next paragraph if you don't want a spoiler.

At sixty-six minutes in, Ben and Cat have just escaped shark-y death.

"I'm exhausted," she says.

"Yeah, me too . . . but I'm really wired. What do you say I take you home and eat your pussy?"

In an interview with British talk show host Jonathan Ross, Barrowman explained he'd ad-libbed it as a joke to try to get a response out of his stone-faced costar—and the producers left the gag in. It really is the pièce de résistance in a tremendously paced, utterly idiotic example of one of the best bad movies going.

Like *Shark Attack 3*, 2003's *Aquanoids* is top-class bottom-shelf stuff. Yes, it's disappointing that the Aquanoid is a barely glimpsed merman and that this is shot on crappy video with a dirty lens. But the pace is peppy—the story takes up sixty-seven minutes—and there's a lot of T&A and crappy gore. That heroine Vanessa and her girlfriend get around in bikinis on motorized scooters in sped-up footage perhaps make this a

very specialized sort of fetish video. Things reach their funniest when the mayor's daughter gives birth to a fish baby that looks like a rubber chicken. The coroner tries to explain it away as simply a deformity with, "One in every five million children looks like this."

But my favorite bit has the himbo-bimbo crowd hanging on the beach talking about fishy fright flicks *just like the one they're in.*

"You know one of these days we need to have a horror movie marathon with all water-based movies," says a dude.

Future fish-freak momma says they should include *Jaws, Deep Star Six, Leviathan.*

"And we can't forget *Tentacles*!" insists her friend.

They're my piscatorial peeps.

INSANITY CLAUS

It would've been cool if this category had rolled out of Bad Movie Bingo at Christmas but at least it's close to the season. I know it's nigh because there was an advanced screening for Vince Vaughn's new Yuletide yuckfest *Fred Claus* today. We took Ava, hoping she might finally sit through an entire movie. Uh-uh. After devouring the complimentary cookies left on the seat by the studio publicity team, our daughter began her rampage around the cinema. I took her down the front so she could bust out some crazy, sugar-high moves to "Rubberneckin'" but after that it was time to go.

It's possible 1959's *Santa Claus* might have settled her little ass down. Directed by Cuban-born Mexican filmmaker René Cardona Sr., this is supposedly meant for kids but it's so sinister it's the original nightmare before Christmas.

After a nauseatingly cutesy opening in which Santa introduces his child laborers, this has Satan's minion Pitch trying to turn the kids of Earth evil so they'll be out of Santa's good

graces. A little red devil in a tutu who's invisible to the film's characters, his whispers encourage children to steal, throw rocks, and catch Santa, and he convinces adults that Santa's a murderer. When Pitch succeeds in getting three boys to fight, he declares, "Lucifer will be very pleased!" When he traps Santa, he rejoices with the cheery, "Your reindeer will turn to powder, you will starve to death, and I will rule the Earth—hahahaha!"

Cheery. Santa is hardly less sinister. He doesn't so much "ho ho ho" as "mwu-ha-ha." His windup reindeer are creepy and his freaky "kid-watching" tech includes a computer that talks via giant lips and a telescope with an extendable eye. His best pal Merlin's job is to drug the world's population while he relies on red-maned Vulcano for the "golden key" to open a "thousand magic portals." Every room in Santa's floating Toyland palace is decorated with pentagrams. You could base an occult religion on this flick.

A more kid-friendly proposition is 1964's *Santa Claus Conquers the Martians*, which is silly and gaudy enough for eggnog-infused parents to enjoy. It's the month of Septober on Mars—our December—and Martian parents Kimar and Momar are worried that their kids Bomar and Girmar (*Lonely Lady*'s Pia Zadora in her debut, aged ten) aren't eating their food pills and are relying on sleep spray. They're only interested in watching Christmas TV broadcasts from Earth—so a gathering of chieftains decide to kidnap Santa.

Objecting to this is as pointless as deriding *The Wiggles* for not being realistic. It's a colorful pantomime. The Martians wear green shorts over tights and have glitter helmets sprouting antennae. They wield 1960s toy Wham-O Air Blasters. Villainous Voldar's robot Torg has a trash can head, a couple of lights, arms clad in insulation, and a body made out of a silver cardboard box. "Crush them!" commands Voldar. Torg

looks like a gentle breeze would knock him down. Tiny children might dig Santa's jokes about "Martianmallow," a finale where toys and bubbles are used against Voldar, and even the theme song "Hooray for Santy Claus" despite its confusing-for-young-spellers chorus: "Hooray for Santy Claus/You spell it S-A-N-T-A C-L-A-U-S."

Silly me, I had assumed that *Santa Claus* alone occupied the satanic-tinged Christmas kids movie genre, but I didn't count on 1964's *The Magic Christmas Tree*, an undeservedly obscure atrocity that rips off *The Wizard of Oz*. This opens at Halloween in black and white with three boys daring each other to go around to old lady Finch's place on Elm Street. Only Mark doesn't chicken out and is grabbed by the old hag because she wants him to get her cat, Lucifer, out of a tree. With puss saved, the film moves into color and Finch reveals she's a witch. She gives Mark a magic ring with Santa on it and says that inside is a seed that, when planted under the wishbone of a Thanksgiving turkey, will grow a tree to grant him three wishes. The kid performs the ritual and a tree appears in a flash of lightning that disturbs his parents' sleep. Or, as Mark's dad says as he reads the newspaper the next morning, "What is it that there's nothing in the paper about?"

This magic Christmas tree is a sparse spruce. Thus, Mark's first wish is for decorations, which appear, all $1.41 worth of them. The sad fir talks, saying stuff like, "All that magic has made me kinda tired" and it does an Elvis-like "Thank you very much." Our boy's second wish is for an hour of power, which allows for primitive trick photography and a pie fight and other slapstick that wouldn't have passed muster in 1914. But Mark's last wish is that Santa becomes his personal slave. It's only after a very random encounter with a creepy "Giant"—who gives off a definite child-molesting vibe—that Mark realizes his last wish has thrown the world into a stock-footage panic.

Abysmally conceived, *The Magic Christmas Tree* is *amazingly* dreadful, rating 15/100. The worst scene has Mark's dad "comically" trying to start a lawn mower—for four minutes. Then dad mows endlessly before "hilariously" running into a tree he's failed to *notice in his own backyard*. Intercut with mum talking on the phone about a casserole, it's one of the worst sequences ever and, alone, qualifies this for the Bottom 10.

Released three decades later, 1996's *Santa with Muscles* is better produced but no more entertaining. Hulk Hogan is millionaire Blake Thorn who's stricken with amnesia and comes to believe he's Santa and thus has to save a bunch of orphans from Ed Begley Jr.'s evil developer Mr. Frost. We get a plethora of intensely mawkish scenes. Mr. Frost has hench-people who include a perv with weird gas breath and a bondage girl with electric hands and they all get around in an ice-cream truck. Santa gets a cutoff sleeve outfit, thanks to an orphan played by future pinup Mila Kunis. Santa reprimands an orphan when he tries to use a slingshot but justifies his own violence with "I did what I had to do."

I did what I had to do, too, by watching this, and I recommend you don't. It would, however, make a perfect Christmas present for a child you didn't like.

ROLLER BOOGERS

I first came to the films of Donald G. Jackson when I was seventeen and worked that production assistant job for the film distribution company. When I saw his 1986 flick *Roller Blade* as part of my quality control duties, I nearly fell off my chair. "We should put little roller skates on the bottom of every video box and with luck they'll roll out of stores and under the wheels of passing trucks," I wrote in the "Marketing Suggestions" section of my analysis sheet. I thought that was hilarious. My boss disagreed and it earned me a reprimand.

Jackson was a Mississippi native who worked in a car factory until his first flick, 1977 horror *The Demon Lover*, made it possible for him to come to California and make his very idiosyncratic films until his death from leukemia in 2003, aged sixty. His first L.A. film, 1985's *Roller Blade* was a tripped-out mix of New Age Christianity, soft-core porn, and philosophical treatise—all refracted through the mind of someone who, in the words of Scott Shaw, his confidant and colleague, was "known to trip on magic mushrooms and ecstasy."

Twenty years after I first saw it *Roller Blade* is every bit as weird as it was. Despite the title, it's about roller skaters. More precisely, roller-skating nuns of the Cosmic Order of Roller Blade. Who skate in G-strings. And red wimples. Decorated with iron crosses and smiley faces. When they're not totally nude, that is. These chicks wield hockey sticks and switchblades in the name of justice in the Second Dark Age and they heal each other's wounds with bisexual spa baths. They're ruled over by the German-accented, wheelchair-bound Mother Speed, who commands things like, "Skate za path of sisterhood!" Elsewhere, Marshall Goodman of the Roller Patrol is trying to teach his son the way of the skates. The villain is a nasty S&M hand puppet named Dr. Saticoy.

There's a lot more, but explaining it won't make it make any more sense. The combination of dud acting, soft-core nudity, po-faced "skate or die" mysticism, and postapocalyptic back alleys and stormwater drains have a strange cumulative and substantially comic effect. The dialogue—"Halt, ye sinner," "On thy skates, it is only a flesh wound," "Tears will cause thy wheels to rust"—adds to the otherworldliness, not least because much of it is postdubbed by the same few people.

Amazingly, this *$5,000* production made some $1 million on video, ensuring Jackson would keep on putting his bizarre visions on celluloid and videotape. I'm unable to acquire 1989's

Roller Blade Warriors: Taken by Force, but throughout the year I watched eBay until I found a reasonably priced VHS ($20) of his 1991 *The Roller Blade Seven* (they go for $300).

Possibly an anti-art masterpiece, this stars Scott Shaw, an action hero who makes Gary Daniels look like Bruce Willis, as Hawk Goodman, descendant of Marshall. He's a roving ninja of the skate-pocalypse called to save his sister, roller-nun Sparrow, who has been abducted by the minions of Frank Stallone's Black Knight.

Hawk's quest sees him chew magic mushrooms with Karen Black's Tarot, confront William Smith's murderous, wheel-chair-bound Pharaoh, and team up with blond skate-enforcer Stella Speed. There are a lot of lame faux-fights with skate freaks in metal ninja/demon horns/bondage gear and/or kabuki makeup. Hawk and the Black Knight do swordplay foreplay—rather than actually fight—in parallel places and time zones. Jackson is Reverend Donaldo of the "Master of Light Institute" and he body swaps with Hawk while Joe Estevez rambles on as Saint Offender.

We're dropped into scenes at random and exit them just as unexpectedly. There's plenty of toplessness and soft-core bondage. Credits and intertitles extend throughout most of the movie, which is 90 percent without dialogue. What talk there is was apparently based on Scott Shaw's self-penned Zen texts, not that it matters because much of it is inaudible in a shitty sound mix that favors electronica loops.

How much of this was meant seriously is a mystery. More mysterious is that no matter how I count 'em, I can't come up with seven roller bladers.

That incongruity is at least explained in 1992's *Return of the Roller Blade Seven*. Seems that "Roller Blade Seven" refers to the highest level one can attain in the Cosmic Order. This "sequel" differs little from its predecessor, simply being

a series of titles followed by nonsensical scenes and dialogue that's half "jokey" and half "deep." "Behold Saint Offender!" gives us Joe Estevez in a black cape and goggles leading a girl in a leotard by a neck chain. "Hawk and His Brides" offers a fully clothed Scott Shaw with two girls in a spa joking that his samurai sword is like his dick. "Preparing the Feast Flesh" has topless canal girls in G-strings menaced unpleasantly by punks.

Titles promise "more action coming up soon" or "pure cinema" and "optional fast forward" as Donald G. Jackson as Donaldo solicits donations for his Master of Light Institute before later bowing down to be "wheelized," which means having his throat cut in a multiangle welter of crimson. There are desert lesbians, toad-headed men, Elvis looking for Buddy Holly, seemingly endless fake fights filmed with "roller-cam," repetitive hypnotic music, sound effects of fighter planes, and trains that are as random as the reappearance of Frank Stallone and Karen Black. Throughout it all, Saint Offender and Hawk talk. And talk. And talk. All nonsense philosophy, epitomized by Saint Offender's mad mantra, "When you don't know what to do, don't do anything."

By the usual standards applicable to motion picture production and exhibition, this is unwatchable dreck. But I am more on its wavelength and a few of the exchanges are funny because they're delivered with a knowing comic wink. But I wonder *who* Jackson and Shaw are winking at? Who did they think the audience might be for their futuristic religious instructional sci-fi porn music video comedies?

Jackson made ten movies in the next three years and I manage to get my hands on a few of these epics. Seemingly shot largely in a stormwater drain, 1995's *Big Sister 2000* is grim S&M fantasy about an interrogation prison where young seminaked women are tortured by older seminaked women.

So it's Franz Kafka's *The Trial*, as reimagined by Bret Michaels. Jackson and Shaw codirected 1996's *Toad Warrior*, which taps one of their other obsessions: amphibian ninjas. We're in an alternate universe, set during the Third Toad Resistance, in which Joe Estevez is the president, who lives in a tent with dirt-covered babes. Shaw fights ninjas in a car park. Old Ed Wood player Conrad Brooks wears a beekeeper's getup and sleeps while a purple alligator puppet talks to him. The mostly inanimate puppet pops up in *Rollergator*, also from 1996 and probably shot in the same afternoon. This time the alligator raps ("I dig the slime and I like to rhyme!") and does Bogart and Schwarzenegger voices and is thus pursued by Estevez's carnival owner.

Just to be clear, *Rollergator*, like *Big Sister 2000* and *Toad Warrior*, is utterly leaden, intensely unfunny, and resists all comprehension, and they score, respectively 15/100, 14/100, and 15/100. We're in Ulli Lommel territory here, just nowhere near as offensive.

But I have to admit, I'm down the rabbit hole with these guys. I head to Scott Shaw's Web site and, having digested the theory of "Zen filmmaking" (short summary: turn up with a camera, make it up as you go) he shared with the late Jackson, I make my last big splurge of the year, buying some of his more recent movies for late inclusion in the Bad Movie Bingo. I also e-mail him with an interview request. I have a so-bad-it's-good feeling about this guy.

THE INCREDIBLE MALTIN MAN RECOMMENDS

"I grew up watching some of those Ed Wood movies on New York television so I do have an abiding fondness for *Plan 9 from Outer Space*, like a lot of other people. I saw it when I was a kid and the wonderful thing was you could feel superior to that movie when you were ten years old."

I was thrilled that Leonard Maltin agreed to a chat four months ago. As a kid, Mom and I would religiously watch him on *Entertainment This Week* and I'd amuse her with my imitation of his thoughtful sign-off while stroking my imaginary beard. Each year, at Christmas, my folks bought me the new edition of his annual TV and video guide and I would *read* this bricklike compendium of capsule reviews, looking out for what he'd thought of movies that I'd also seen in the past twelve months and how our star ratings might align or differ. (You give 1½ stars for *The Thing*? Surely, sir, you jest!) It's not lost on me that he's a major influence on what I'm doing now in print and on TV. I've always loved that he's both a popular critic and an esteemed academic and historian. Best of all: You can see the glint of movie love in his eyes and the pleasure it gives him in his big smile.

Well, strictly speaking, I didn't see either of those things when I spoke to him over the phone. But how's this for self-effacing? When we started talking he apologized for earlier having to reschedule the interview, adding, "I hope you don't think I'm some sort of flake."

I assured him I did not and asked Maltin for his best-worst movie. "It'd be a cross between *Plan 9* and *Bela Lugosi Meets a Brooklyn Gorilla*," he said. "Wonderful."

And the worst-worst, from his decades of viewing. "There are so many," he said. "I have a pretty big appetite for films, and I would say I have a lot of patience, too, but there are times when you just know from the first moment that you're watching a piece of junk. It's not sixth sense, because it's pretty obvious, and that's very discouraging because I won't leave. I stay. I stay to the bitter end."

"I remember having that feeling years ago when I watched *Transylvania 6-500*," he continued. "I remember feeling the same way when I had to go and see *Police Academy 3*. What I

usually cite as the worst movie I've ever seen is Stephen King's *Maximum Overdrive*. What amuses me is that he said at the time that he decided to direct because he was tired of people buying the rights to his stories and novels and lousing them up. Here he did it himself. But there are times when it's tempting to leave. Then there was a film in 2002 called *Spun*. To willingly sit through that was very hard. I think that was the one that opens with a guy vomiting on his girlfriend. Why?"

When he's confronted but trapped by such a movie, can he still find amusement? "I welcome so-bad-it's-good but most of these are so bad they're bad," he said. "There are all the classic bad movies, the Ed Wood movies and such, that at least give you some perverse amusement. You could say the same of *Showgirls*. There's some entertainment value, whether it was intended that way or not. But you can't say that about these other films."

Before we ended our talk, Maltin made special note of a movie still then in cinemas.

"I can't tell you how appalled I was by *Pirates of the Caribbean: At World's End*," he said.

I told him I hadn't seen it, having been so disappointed by the second one.

"The second one was so awful that I couldn't believe the third wouldn't be an improvement. It's not. I don't look at my watch during movies but I sure did during that one. And like a lot of these films it had false endings so your spirits would be lifted momentarily. I couldn't wait for it to be over. I'll give it a bad rap anywhere people will listen."

And so now Bad Movie Bingo delivers me into Maltin's Bottom 5.

Perhaps not the worst movie ever made, 1985's *Transylvania 6-5000* is definitely one of the tallest, with five of its principal cast—Jeff Goldblum, Ed Begley Jr., Michael Richards,

Jeffrey Jones, and Geena Davis—clocking in at 6'0" or over. The first two are reporters on a sensationalist tabloid, sent to Transylvania for a Frankenstein story. They check into a slapstick hotel run by the next two, plus Carol Kane. There's the slightest of giggles from Joseph Bologna's mad scientist and Davis in vampire fangs raises a smile but Goldblum's nervy mercurial schtick clashes terribly with his obvious boredom and bemusement. It's a dreadful effort, given the talent involved, and it was reportedly only made by the Dow Chemical Company to use corporate funds frozen in Yugoslavia. As the cinematic equivalent of their other "hits," it's up there with silicone breast implants and napalm. The movie prompted Maltin's shortest-ever TV review. "*Transylvania 6-500* stunk. I'm Leonard Maltin, *Entertainment Tonight*."

I'll follow his concise lead with my summation of his next nomination. *Police Academy 3: Back in Training* is worse than *Police Academy: Mission to Moscow* by four points. I score it at 15/100.

I saw *Maximum Overdrive* on release and watch it again. The gist is that an asteroid's tail has turned all of Earth's machines evil. A mechanized bridge tosses cars, an electric knife turns on a waitress, and a coach and his little league team are mowed down by a soda machine firing cans. Various survivors hole up in a gas station, workplace of heroic parolee Emilio Estevez, and are terrorized into becoming gas-pumping slaves for a fleet of intelligent, malevolent vehicles led by a sinister Mack truck.

King's script is littered with howlers like, "You sure make love like a hero," and Estevez's performance isn't helped by him having to chat to an eighteen-wheeler. Dumb as a carburetor, definitely, but bordering on enjoyably bad, it makes Maltin's previous two recommendations look like classics.

I saw 2002's meth-addict comedy-drama *Spun* on release,

too, and, gulp, I kinda liked it as a no-holds-barred, frenzied depiction of drug delirium propelled by a record five thousand edits. Watching it over, I can see validity in Maltin's criticism. The cast—Mena Suvari, Brittany Murphy, Patrick Fugit, Jason Schwartzman, John Leguizamo, Mickey Rourke, and Deborah Harry—are all reduced to hideous scumbags who live to snort, smoke, and inject, and there's some intensely unpleasant sexual and self-abuse scenes, but the film has a crazy energy I can't deny.

In any event, it's *vastly* preferable to *Pirates of the Caribbean: At World's End*, which is tedious and borderline incomprehensible as it layers in mumbo jumbo about pirate councils, codes, kings, curses, goddesses, etc. Scenes go on forever without much point, the jokes are flat and the franchise's treasure Captain Jack now seems labored. There are some great visuals—multiple Depps during a hallucination, a pirate ship sailing across a starlit horizon, epic whirlpool action—but little excitement. It's not the worst movie of my year but is a very unnecessary 168 minutes. Then again, both Maltin and I might be wrong on this score: The thing did sell $958 million worth of tickets in the past six months.

STATUS REPORT

Worst this month: *Big Sister 2000, Toad Warrior*
Runners up: *The Magic Christmas Tree, Rollergator*
Guiltiest pleasures: *Maximum Overdrive, Shark Attack 3: Megalodon*
Movies watched: *316*

DECEMBER

JERRY, JERRY BAD

I've clocked up 339 flicks so far—just over target, in fact, and
with *The Movie Show* and *Empire* wrapping up for the year
mid-December, I reckon I'll end up watching more than one a
day. Thing is, that still won't get me through all the movies I
bought in the early-year buying frenzies. As reluctant as I am
to interfere with the Bad Movie Bingo, I remove sixty-eight
titles that don't sound as though they'll be as bad as the more
essential ones that remain. Sayonara, then, 1970s soft-core
romp *Weekend with the Babysitter* and William Shatner as a
serial killer in *Impulse*.

Obviously, I couldn't do without Jerry Warren, who I sam-
pled in *Teenage Zombies*.

"He made a couple of movies but for the most part he bought
up other people's pictures," said Joe Dante when we spoke
midyear. "He chopped 'em up so they were incomprehensible
and then added new scenes of actors standing against walls

with bad lighting saying bad dialogue. And he managed to get these abortions released to theaters—and people booked them! Here's a guy whose career had absolutely no redeeming value. He never made a picture that approached mediocre and yet he was a fairly successful rock-bottom filmmaker."

With that endorsement ringing in my ears, I delve into Warren's 1957 undersea unadventure *The Incredible Petrified World*. Six minutes of oceanic stock footage and voice-over ease me into the petrifying dullness that has a diving expedition under John Carradine's guidance trying to set a depth record but forced to take cover in oddly dry underwater caves inhabited by lizards, a horny old man, and a skeleton. The guys and gals quite like it down there and plan a new civilization. The script makes not a lick of sense and the badness isn't amusing, although I like the credit "Wardrobe by Kelpsuit." If I'm not mistaken, he was also Sigmund the Sea Monster's preferred designer.

The title of 1965's *Creature of the Walking Dead* describes how I feel after watching it. This is one of Warren's cut-and-paste jobs, utilizing 1961's decently filmed black-and-white Mexican mad-doctor movie *La marca del muerto*. Warren's additions actually subtract from our understanding, with the rambling English-language narration often seeming to come from the mouths of the Mexican cast. And the "filmmaker" piles insult on injury with his inserts of seminude cops getting a massage as they discuss the plot for *seven* minutes or Katherine Victor of *Teenage Zombies* providing further narrative "illumination."

Victor took the lead in 1966's *The Wild World of Batwoman*, a copyright-infringing cash-in that saw Warner Bros. sue Warren. She's Batwoman, who commands an army of Batgirls from her suburban living room. Her costume and outfit is certainly as cheap as her lair—masquerade-ball

mask, hair like a permed penguin, evening gloves worn with a diamond ring the size of Ohio, all set off by a bat tattoo above her cleavage.

The plot has scientist Prof. Neon kidnapping a Batgirl at the bidding of archcriminal Rat Fink. It's a ruse to make Batwoman steal an atomic hearing aid, that Rat will use to listen to the conversations of world leaders, and that, when mixed with cobalt, will cause a nuclear explosion. But the baddies already have a secret weapon: happy pills to make people go-go dance . . . nonstop! Other sinister schemes include devising the world's most potent tranquilizer and mating Batgirls with stock-footage monsters from 1956's *The Mole People*. Meant to be a campy send-up of TV's *Batman*—which was *already* a spoof—it's completely laugh-free and reliably amateurish in every conceivable department (the set designs are by "Color Master Studios"; the film's in black and white). There's no amount of happy pills to make this fun.

Also not fun is interviewing *Blade Runner* star Rutger Hauer. I do it for *The Movie Show*—in conjunction with the 119-disc release of the über-ultimate-special-collector's edition of the Blu-ray. I've always loved the movie and admired Hauer, so it pisses me off that he's so truculent, antagonistic, and uncooperative. You'd think the former star—who now supports himself in straight-to-video rubbish like *Dracula III: Legacy* and *Minotaur*—might be grateful that Warner Bros. is flying him around the world and that a legion of Generation X media types like myself are hanging out to hear his stories about *Blade Runner*.

But no. After he keeps us waiting in the hotel room's living room for close to thirty minutes—it's not like he's detained in traffic, we can hear him in the next room—he sits down and gives either a) rambling, nonsensical answers or b) acts as though I'm asking personal secrets when I ask him to

comment on long-discussed production problems on *Blade Runner*.

I come very close to stopping the interview. When we're done, I get out of there as soon as possible, making no secret of my annoyance to either his publicist or my producer. Afterward, *The Movie Show* producers manage to scrape together a few minutes of usable footage from the awkward conversation.

That, and enduring *Eagle vs Shark* and *Daddy Day Camp*, two theatrical releases that make *I Now Pronounce You Chuck & Larry* and *Bratz* look passable, leaves me in a foul mood. I am suffering an overload of badness, finally, and, having done three atrocious Jerry Warren movies, I sulk my way into the fourth and last.

Warren clearly learned *nothing* in the fifteen-year gap between *Batwoman* and 1981's *Frankenstein Island*, which stars his "name" ensemble players and is a remake of all his "best stuff." Four dudes trying for a hot-air balloon world record crash and wash up on an island populated by hippie cave girls who smoke skull bongs and zombie hordes under the control of Katherine Victor's mad scientess Sheila Frankenstein.

This is *far* weirder than *Lost*. There's telepathy, animal voodoo, perfect vegetables, vampires created with a toy pitchfork, psychedelic planetary montage, wrestling and karate, fire dancing, necromancy, and the revelation that the girls are alien-human hybrids because the island was the ancient landing place of E.T.s. Oh, there's also a disembodied brain in a jar, *a back-up brain in a back-up jar*, and good ol' John Carradine as a disembodied ghost head ranting about "The power! The power!" in a performance nearly as nuts as Lugosi's in *Glen or Glenda*.

Falling into the category of "must be seen to be disbelieved," *Frankenstein Island* is across-the-board awful, but

one of the best bad movies I've seen. It cheers me up enormously.

CAVE-MANIA

I love Cate Blanchett and want to see her at the premiere of her new film, *I'm Not There*. So does Clare. But I can't, see, because I've got caveman movies to watch.

"But you've said you're on track to do 365 movies easily now," Clare says. "Especially once work wraps up for the year."

"I know, I know, but the deal was at least one per day and . . ."

"And?"

"It's only for a few more weeks."

Clare nods, tamping her frustration down.

"You won't be doing it on Christmas day?"

"No, of course not."

"And I better get a nice Christmas present."

While a few miles away Cate Blanchett glows for the premiere crowd and a few yards away in the next room Clare relaxes with some reality TV, I sprawl on the bed and watch 1962's *Eegah*.

It's an act of love, this movie. Arch Hall Sr. tried to bestow the gift of stardom on his son, Arch Hall Jr., in a series of drive-in flicks that cast him as a hunk with tonsils as golden as his pompadour. Their most infamous collaboration was this one. This has teen gal Roxy crashing into a giant caveman while out driving. Her dad (Hall Sr.) heads out to find the beast and is promptly caught by Eegah, played by professional tall person Richard Kiel. Roxy and her boyfriend Tom—our boy Arch Jr.—stage their own rescue, leading to *her* abduction. Dad, daughter, and Eegah bond over a meal of charred bone and she *shaves* the men. More intimacy follows with Eegah

introducing Roxy to his mummified ancestors. She takes things further by appreciating his cave drawings, offering the film's one knowing line: "Believe it or not, Dad, I'm going to look at his etchings." It's hardly surprising that once Tom reappears to rescue Roxy, Eegah has developed a healthy case of Roxy lust that'll cause him to first tear at her clothes and then storm the country club.

Arch Sr. wrote, directed, produced, and costarred. The budget was $15,000, which dictated that credits be painted onto hessian sacks. It's a pity they didn't have *less* money because at an hour this might be a cult classic but stretched over ninety minutes it feels like time's standing still. As Tom, Arch Jr. is a leading man only his father could love, and is positively at his worst when warbling love tunes to his girlfriend Roxy, least of all because the songs are called "Vicki" and "Valerie."

Once I'm done, I get researching and find that, after he wisely gave up acting, Arch Jr. became a decorated pilot who helped evacuate Cambodia in 1975 and flew in the first Gulf War.

I share this with Clare and she's goodly enough to appear interested. Her eagerness for this to be over is palpable, though, especially when she says things like, "I can't wait for you to be finished with this."

Next night, it's *Yor, the Hunter from the Future*. This 1983 grunt-a-thon stars Reb Brown—that nonactor from *Howling II*—as a cave dude who's different from his prehistoric peeps. We know this from a) his Sharon Stone–like hair, b) his mysterious metallic medallion, and c) the film's title. The first half has Yor slaughtering papier-mâché dinosaurs, taming and riding a giant bat-thing, accidentally committing genocide against not one but *two* underground barbarian civilizations, allying with tribesmen and their comely daughters, and trying to figure out the clues to his origins.

Sounds fun. Isn't. *Yawn, this Hunter from the Future.* Happily, its antidote is 1990's *Ultra Warrior.* Despite the video cover artwork, this is not a caveman movie. And, in fact, it's more than a movie—it's a metamovie, the Frankensteinian mash-up of Al Adamson's dreams. "Produced" by Roger Corman's Concorde-New Horizons company, it *plunders* footage from the schlockmeister's back catalogue, including *Battle Beyond the Stars, Lords of the Deep, Battletruck,* and an unknown number of other sci-fi, barbarian, and Mad Maxsploitation movies. Stunningly, even the *sex scenes* are shamelessly sourced from elsewhere so that our hero's hair color changes whenever he gets busy.

What is astoundingly original is the zany "story" that tries to link all this footage. Kenner, a.k.a. the Great White Wolf, has to free an oppressed people amid stock scenes of intergalactic war, a ground battle on Mars, mutant rampages, undersea mining, slavery camps, and gladiatorial combat staged by bad-guy the Bishop. When a mutant girl asks Kenner what life is like in his world, the Outside, it's time for yet more stock footage as he tells her it has been overrun by robots called the Enforcers: "Mock trials were held in front of robot juries. Judges, congressmen, bureaucrats were tortured with red lasers and executed on national television. It was a bloodbath of epic proportions. So, things aren't so good."

Best is the finale where he writes a letter to the president, asking him to remember the "soul of a man is not measured by the height of his hat or the width of his shoe. Indeed not."

Indeed, indeed not!

STOP ME BEFORE I MILLIGAN

Like I was with Al Adamson, my only familiarity with Andy Milligan came via passing references to titles like *Torture Dungeon* and *The Rats Are Coming! The Werewolves Are*

Here! in horror-movie books. To get up to speed for when Milligan's obscurities came oozing out of Bad Movie Bingo I read Jimmy McDonough's biography *The Ghastly One: The Sex-Gore Netherworld of Filmmaker Andy Milligan.* It was exceptional—a fascinating, repulsive, and painstaking re-creation of a misanthropic, misogynistic masochist.

Born in 1929, to a mother he grew to hate, Milligan was a discharged sailor and a dressmaker before he became one of the pioneers of off-off-Broadway at New York's Caffe Cino and La Mama Experimental Theatre Club. He briefly made avant-garde films about the gay scene before devoting himself to horror period pieces shot in and around his house on Staten Island that were but platforms for his ultragrim outlook on humanity. In his latter years, he moved to California, where McDonough befriended him and, later, nursed him through his agonizing death from AIDS in 1991. These passages in the book humanize the man but McDonough never varnishes who he was.

As for Milligan's movies, which were made on budgets from $8,000 to $30,000 and indifferent to story, pacing, sound, and picture control? "When Andy's movies are bad, there's nothing—*nothing*—worse," McDonough writes. "If one looks at them with expectations of a 'real' movie—or the kind of velvet painting–bad thrills associated with many exploitation movies—one will be frustrated. But scratch the dirty surface of Milligan's pictures and a very personal kind of poison seeps out of every frame."

During my preparations, I e-mailed McDonough to ask which of Milligan's twenty-nine movies are the worst. He suggested seven. "Keep a stimulant on hand, you'll need it," he advised. "If you can stand any more—well, I've heard France awards medals for achievements such as that. Hell, they gave one to Jerry Lewis."

Despite modern hair and underpants, 1968's *The Ghastly*

Ones appears to be set in Edwardian times and has three women only able to inherit their father's fortune if they spend three days in "sexual harmony" with their husbands at the family manse, Crenshaw House. Such a setup allows for plenty of sickly out-of-focus pans over blotchy, hairy bodies. The intimate interludes are interrupted by murders that might be gruesome if Milligan didn't end scenes with his bizarre tilt-a-whirl camera move, described in his scripts as "swirl camera." Beyond the blurry sex and murky gore, this is really endless talk to immerse us in a bubbling broth of familial hatred. There's an implication that the brothers have been lovers, the sisters all hate each other, there's a mentally defective servant, and a secret, mother-hating half-sister psycho. Mix in library music and bad period costumes (self-designed by Andy under the name "Raffine") and this comes off like a maniacal 1940s melodrama.

Even more vitriolic is 1968's contemporary-set *Seeds*—like a low-rent Tennessee Williams on angel dust. The tagline— "Sowed in incest! Harvested in hate!"—says it all. It's an insane horror-psychodrama and thankfully the surviving work print is only forty minutes long.

With a heady dose of Raffine's renaissance faire costuming and a lot of wigs modeled on the Beatles ca. Sgt. Pepper's, 1970's *Torture Dungeon* takes violent incestuous family warfare back to ye olde medieval England.

After the King is decapitated, his evil and sterile half brother, Norman, the Duke of Norwich, who's last in line for the throne, schemes to manipulate the succession of slobbering royal halfwit Albert. A peasant bride is selected to produce a male heir and then Norman slaughters those who stand between him and the crown, including Jane, who wasn't just the dead king's sister but, of course, also his lover and the mother of his unborn child.

Torture Dungeon's entertaining because the bitterness and evil bubbles so far into over-the-top territory. The Duke's little hunchback, Ivan, voices Milligan's maternal issues, explaining that his mother hated him so much she got two of her male friends to rape him and then stomp him so he'd be a hunchbacked beggar. "Mother was happy; I was miserable," he concludes. But the Duke's evil appetites drive the story. His best-worst moment comes when his wife discovers little Ivan in his bed. Norman's sneering response is to try to get her to join them for a ménage à trois. As he explains, "I live for pleasure, only second to power, of course, and I'll try anything. I'm not a homosexual, I'm not a heterosexual, I'm not asexual. Try-sexual. Yes, that's it. I'll try anything for pleasure." I'm not sure they said such things in the Middle Ages, and I'm certain they didn't have Noo Yawk accents.

Milligan actually made 1970's *Bloodthirsty Butchers* in England so at least the British accents in this nineteenth-century tale are genuine. Other than that, he may as well have filmed it in his house on Staten Island because most of the action takes place in drab rooms shot in typically claustrophobic fashion.

This is putatively an adaptation of the story of the murderous barber Sweeney Todd whose lover, Mrs. Lovett, uses his victims as ingredients in her pies. Even so, the hacked limbs and swirl-cam murders are almost incidental to lengthy scenes of nasty talk between hateful lovers who specialize in rough sex, rape, and spitting on each other. The breast-in-the-pie moment's pretty funny, though.

Also released in 1970, *Guru, the Mad Monk* favors a more general misanthropy. Set in the fifteenth century, it has split-personality Guru ruling over the Lost Souls Church on the island of Mortavia, a place where the condemned are sent to be branded, snipped, spiked, lopped, and exsanguinated.

The Rats Are Coming! The Werewolves Are Here! (1972) is set in 1899—a slender illusion destroyed by car horns in the background—and returns to Milligan's primary obsession in that it's about the hateful, dysfunctional, and incestuously mutated Mooney clan reunited with disastrous consequences. It takes seventy-six minutes to get to the "revelation" comprehensively spoiled by the title and then, typical of Milligan, all the familial werewolves attack each other. As for the rats? They are a nonsense subplot added to cash in on 1971 rodent-horror hit *Willard*. Revoltingly, one's mutilated on-screen for real. For director Mick Garris, an all-around nice guy who has adapted numerous Stephen King stories and who created the *Masters of Horror* TV series, Andy Milligan is as bad as moviemakers get—and *Rats* is the bottom of that barrel. He tells me it's "the most agonizing filmgoing experience I ever had."

My seventh and last Milligan film is 1972's *The Man with Two Heads*. Despite the title, it's an adaptation of Robert Louis Stephenson's *The Strange Case of Dr. Jekyll and Mr. Hyde*, with our crazed scientist violating his way through London's underworld in a swirl-camera tour of blurry gizzards and the usual misanthropy.

Milligan's movies are very bad and I am happy to be moving on. But they're also instantly recognizable for their subject matter, themes, period setting, theatrical performances, character types, masses of dialogue, shaky handheld camera and swirl-cam, desultory edits, garish costumes, colors, and gore. Milligan fascinates because, more than any other filmmaker I've ever encountered, he really was an auteur.

BEWARE TONY BLAIR

The Tony Blair Witch Project, made in 2000, is definitely the worst movie I've seen so far! On my ranking system, it rates

8/100, scoring straight *zeroes* for direction, acting, and production value. It topped the IMDb's Bottom 100 in June. Problem is, it's *not* a commercially released movie. Virtually *none* of the one thousand–plus people who voted for it have seen it. I know this because I contacted Alaska-based writer-director Mike Martinez and he reassured me that it has never been released, pirated onto YouTube, or, to his knowledge, seen by anyone but a few of his friends.

Martinez was kind enough to send me a disc of the flick. It begins with fake credits to parody Italian cannibal-sploitation, and even features a public domain version of the theme from Umberti Lenzi's 1980 zombie movie *Nightmare City*. According to a so-called BBC news report it has been a year since Tony Blair and a four-man film crew were lost in the West Virginia wilderness while making a documentary. Now the footage has been found. That scuzzy video comprises the rest of the film and it's one guy in a cutout Tony Blair mask and four frat brothers doing English accents, including one who pointlessly claims to be British film critic Alexander Walker. For fifty-five minutes they ad-lib, moronically, and mug for the camera.

"What have you heard about the Tony Blair Witch?"

The answers—"Nothing," "It's pretty cool I guess," "What in the hell are you talking about?"—betray that the wit begins and ends with the title.

In the woods, the boys smoke, spit, shit, and smash windows in an abandoned house. And they find the site of the Tony Blair Witch massacre, where people were apparently anally raped. There's also a gunfight with rednecks featuring deliberately bad blood bags.

Search for the Beast was funny and had the semblance of a story. This has even *less* ambition than *Da Hip Hop Witch*, is more amateur than *Grad Night*, duller than *Hollywood High*

Part II. But it's a goof-off home movie, not intended for wider consumption, and so it's disqualified. We're still at a four-way split.

HEROINE OVERDOSE

With *Empire* and *The Movie Show* wrapped for the year, the second half of December quickly becomes a blur of bad movies as I sprint to the finish.

I have a bit of fun with drive-in trash *Hustler Squad*, tolerate Charlie's Angels rip-off *Angels' Brigade*, find it looks terrific in comparison to *The Hellcats*. Worse than them all, by magnitude is *Panther Squad* in which Sybil Danning recruits a bunch of New Wave hookers to fight evil. Grainy, dubbed, mind-bogglingly stupid, it has to be one of the most actionless action movies ever conceived. Even fans of scantily clad women firing guns should go to the grave without seeing this 16/100 effort.

On the other hand, I quite enjoy *Superchick*, starring Joyce Jillson, who later turned to astrology and claimed to be a Reagan administration adviser. *V. I. Warshawksi*, made by a company that had George Dubya Bush on its board, is a passable bus movie, even though die-hard Kathleen Turner fan Clare falls asleep halfway through. *Sheena: Queen of the Jungle* is glossy and overlong but entertainingly terrible on occasion. *Brenda Starr*, the Brooke Shields project funded by a fanboy Saudi sheik who funneled $22.3 million from the Bank of Credit and Commerce International (BCCI), is simply a confusing mess.

But these heroines are all palatable compared to a grim double bill of films by Doris Wishman, one of the only female schlockmeisters. Both movies star "Chesty Morgan," a.k.a. Liliana Wilczkowska, whose claim to fame were her 73-22-36 measurements. In 1974's *Double Agent 73*, she's a secret-agent

assassin with a camera implanted in one of her stupendous breasts. The twist? The camera's set to explode—a booby trap! Sounds retro-kitsch fun? Uh-uh. While Wishman's random pans and zooms on inanimate objects are bewildering, and it's impossible not to laugh at the world's slowest and possibly worst-ever car chase, complete with radical tire squeals on a straight length of road, this is dominated by a grim vibe. Sad-faced Chesty, whose voice is dubbed, can't act and she seems, quite literally, painfully aware that her only "assets" are those drooping down past her elbows. As for any "eroticism," it's telling that, in a movie in which the star is called upon to get her breasts out continually, she keeps them under wraps during the one sex scene. It's a 16/100.

Deadly Weapons, also from 1974, offers more of the same, with Chesty avenging her dead fiancé by going to Las Vegas as a burlesque dancer so she can smother his murderers with her bosoms. In this one, she's betrayed not by her lover but by her own dad—who shoots her between the boobs. This is another smorgasbord of terrible acting, dubbed dialogue, Wishman focusing on dog paintings, ashtrays, and shoes. To be fair, porn star Harry Reems gives an okay performance, even if his moustache is so big it *sweeps* the faces of girls he kisses.

Factoring in this year's releases—*Chuck & Larry*, *Bratz*, *Eagle vs Shark*, and *Daddy Day Camp*, which I think is fair because I don't include *Epic Movie*, *The Number 23*, *30 Days of Night*, *The Hills Have Eyes II*, *The Hawk Is Dying*, *Perfect Stranger*, *Hot Rod*, *The Nanny Diaries*, *August Rush*, *Hitman*, and the fifth *Harry Potter* movie, among many others—*Brenda Starr* marks my 365th movie.

I've done it. With two weeks to go.

"Well done, baby," says Clare as we start a celebratory nicer-than-usual bottle of sauvignon blanc. "How do you feel?"

"Exhausted," I admit.

But I tell her my theory that this has also become my year of excellent movies, that I'm amazed at how many *good* or *great* movies I've seen this year. The list has expanded to include *Waitress, Paris, 3:10 to Yuma, In the Valley of Elah, Into the Wild, The Darjeeling Limited, Sweeney Todd,* and the towering *There Will Be Blood.*

"It's like some sort of karmic balancing act's in place," I say. "I might've gone nuts without it. And without you. Thanks for all your support and understanding."

"So you're definitely going to keep going?" she asks.

I suppose I could stop now but the goal was to do the whole year. Besides, I still want to cram in as many as I can. I'm like some sort of addict, who has planned to quit the vice on New Year's Eve but is now determined to smoke/drink/sniff/shoot as much of the preferred substance as possible for the next two weeks.

"Just two more weeks," I say, sounding like a junkie.

WRATH OF ROTH

"My favorite so-bad-it's-good movie has to be the so-bad-it-almost-went-straight-to-audio classic *Ax 'Em*," Eli Roth, director of *Cabin Fever* and the *Hostel* movies tells me. "Not many people have heard of this, and neither had I, until I watched it at [*Evil Dead II* writer] Scott Spiegel's house, with director Boaz Yakin, and a few other cinephiles.

"Right from the opening title cards you knew the film was going to be pure cinema magic: Not only were the title cards completely incomprehensible, with spelling and grammatical errors in nearly every sentence, but they flew by so fast we had to rewind and step through frame by frame to even read them. They made absolutely no sense, as if they were written by a foreigner who only spoke second-grade English.

"After a lengthy debate about what the cards could mean, we watched the opening scene, where you could even hear the director yell 'Cut!' after one of the takes. The opening murder makes absolutely no sense. I think it's a flashback, but it ends with the killer raising an axe to an old man's head, and the old man saying, 'Aw, shit!' This line delivery, by this ninety-seven-year-old man in overalls, brings the house down every time. We watched it over and over and over, and 'Aw, shit!' became part of our vernacular."

I met Roth in Sydney when he was touring his first movie, *Cabin Fever*, and I was astounded at what a force of nature he became when you get him going. Although he's replying by e-mail, I can hear him—speaking faster, louder:

"I still honestly couldn't tell you what the film is about, but what makes the film great is the backstory of the director, Michael Mfume. It's an urban horror film, yet it plays as if it was directed by a KKK member. Not only does the grammar make absolutely no sense, but people speak lines and behave as if they're in *Birth of a Nation*. The director's father, Kwame Mfume, was the *head of the N.A.A.C.P.* at the time the film was made! Scott Spiegel told me that footage exists from a premiere the film had in Washington D.C. with all the staff of the N.A.A.C.P. Apparently they all left the theater looking like zombies, completely shell-shocked by what they had just seen, but they had to go because it was the head of the N.A.A.C.P.'s son who had written, produced, directed, and starred in it! The backstory makes the film even that much more enjoyable. It's just too bad to be true and a must-see for any fan of trash cinema."

There is so little I can add to Roth's summary. He's correct on every level and hacky slasher *Ax 'Em*—apparently filmed in 1992 under the title *The Weekend It Lives* for $650 and shelved for a decade—instantly goes straight to . . . number 1!

. . . with an almost completely imperfect 10/100.

A few notes. My favorite bit is when footage of a girl running away from camera into the forest is simply looped to make her escape longer. A close second is a white girl tripping over nothing *four* times on vacant terrain measuring twelve feet square. And after "Aw, shit," the choicest line of wack dialogue is: "You phatter than a swamp possum with tha mumps—boy you so fine I could kiss yo daddy's ass."

Ax 'Em—the shittiest movie I've ever seen, but also funny enough to recommend. Ax for it by name.

PUBLIC DISSERVICE

Bad Movie Bingo unveils its stash of "documentaries" made to warn youngsters off all the good things in life: drugs, sex, and madness.

The first one I toke up is 1936's *Marihuana*, made by exploitation pioneer Dwain Esper. Poor Burma is a nice gal lured into the world of "giggle weed" and then heroin—although surely her parents set her on a druggy course with *her name*. Anyway, not long after her first toke, she develops nympho tendencies and has a bastard child, which she gives away for adoption. From there, she becomes a dealer and heroin addict who plots to steal her society bitch sister's kid so she can sell it—only to discover it's her own child! And then she dies of a smack overdose, right in front of her little one!

Sounds grim, but what fun she has along the way! There are booze- and smoke-filled parties characterized by licentious jiving, joking, and incessant fits of stoner laughter. There are trips to lovers' lanes and beach houses where all the flappers go skinny dipping, offering nudity that wouldn't be seen again on screens for decades. Seeing people this high and happy and horny might've sent some 1936 Great Depression audiences out looking to score some weed.

Louis Gasnier's 1936's *Reefer Madness* became one of the first cult-camp midnight movies shown on college campuses in the 1970s, thanks to its awesomely exaggerated claims for cannabis. (Its success filled the coffers of start-up distributor New Line Cinema, paving the long road to them producing *The Lord of the Rings* some three decades later. Put that in your pipe and smoke it, Bilbo.) The "square up"—that is, the premovie text to explain to audiences how grave the reality of drug addiction is—tells us pot is "the real public enemy number one" whose "soul-destroying" effects include "the loss of all power to resist physical emotions" and "acts of shocking violence . . . ending often in incurable insanity."

After telling us weed is more vicious and deadly than heroin, good Dr. Carrol leads us into the typical story of sweet high schooler Mary, who, with her boyfriend Bill and brother Jimmy, gets caught up in the "apartment parties" held by local mary-jane moguls Jack and Mae and their addict-pushers Ralph and Blanche. Things go quite wrong. Jimmy runs over a pedestrian due to his potheadedness. After accidentally succumbing to a joint, Mary is accidentally shot dead by Jack when a hallucinating Bill tries to defend her honor against reefer-rapey Ralph. Bill is framed for the killing and sentenced to hang. The pot pushers lay low but raccoon-eyed Ralph progressively loses his shit thanks to guilt and giggle weed. The most famous moment has Blanche puffing on a joint as she tries to soothe him with piano tinkling. Ralph, similarly wreathed in smoke, gets wilder- and wilder-eyed as he demands, "Faster! FASTER! Play it faster! Faster! Play it FASTER!" The finale features murder, suicide, and imprisonment in a home for the criminally insane. My favorite bit has a federal officer relating how a sixteen-year-old marijuana addict committed a robbery to fund his pot addiction, which leads to Dr. Carroll recalling the *other* salient detail of the case: "Yes, I remember—just a young boy, under the influence

of the drug, he killed his entire family with an axe." Amazingly, the fed comes back with: "Then there is the *more vicious type of case* [my italics]—here, in Michigan, a young girl, seventeen years old, a reefer smoker, taken in a raid in the company of five young men." Family massacre or gang bang, the wicked weed will get you every time.

Bad movies about marijuana are but a gateway to bad movies about harder drugs. The square up for 1935's *Cocaine Fiends* also calls for an education campaign before going on to provide just over an hour's worth of narcotic nonsense. Small-town waitress Jane meets big-city pusher Nick at her diner. Complaining of headache, he gives her some stuff to sniff. "Why, that's marvelous! I feel better already!" she exclaims. Lured to the bright lights, she finally realizes what she's hooked on—"You mean I've been taking dope?!" Tragedy and murder follow.

Dwain Esper was apparently a ruthless, litigation-happy huckster who answered his phone with "I'll sue!" instead of "Hello." Other "educational" career highlights included exhibiting the mummified body of an outlaw, his 1933 debut drug flick *Narcotic*, 1934's lost abortion-infidelity film *Modern Motherhood*, and the 1937 short *How to Undress in Front of Your Husband*. I watch his 1938 *Sex Madness*, about the risk of syphilis, and it's a creaky old amusement as the protagonist harlot risks infecting her husband and newborn child with her diabolical disease.

But Esper's most enduring achievement wasn't warning kids off/on sex or on/off drugs. It was warning everyone off becoming a *Maniac*. The square up to this extraordinarily nutty 1934 blend of Poe and propaganda tells us: "Fear is a psychic disease which is highly contagious and extraordinarily infectious."

Maniac has nothing to do with mental hygiene, despite regular intertitles defining "Manic-Depressive Psychoses,"

"Paranoiac," and "Dementia Praecox." Instead, it's an utterly mad mad-scientist movie that has Dr, Meirschultz killed by his assistant Maxwell, a former vaudevillian ham. Donning the doc's crazy hair, cotton-candy beard, and spectacles, Maxwell then tries to cover up his crime. His madness—caused by the need to *entertain*—sees him use a serum to supercharge his neighbor Mr. Buckley into a growling freak, pop the eyeball out of a cat, and eat it because "It's not unlike a grape or oyster!" and set his long-lost wife Alice and Mrs. Buckley against each other in a gal-gal hypodermic-needle duel. Ed Wood must've seen this one. The scene in which Maxwell makes a speech about the spark of life while horned devils with pitchforks are superimposed over him predates *Glen or Glenda* by two decades. In any case, *Maniac*'s a terrifically enjoyable bad movie.

Amazingly, as bad as all of this 1930s stuff is, 1967's *The Weird World of LSD* is worse than *any* of them—and just about anything else I've *ever* seen. After a *Twilight Zone*-style square up in which a portentous narrator promises "better insight into the strange and terrifying world of LSD" the movie lurches through a series of vignettes, filmed silent and in black and white—making it cheaper than even *Manos* or anything Andy Milligan did.

These "trips" haven't the slightest resemblance to any reality, LSD-suffused or otherwise. First up is a dude lying on a couch, eyes rolling back in his head, flapping his arms as an animated chicken cutout circles around. "We call his trip of terror, To Fly a Giant Bird!" says the narrator solemnly. Then there's the small-town office gal who, now in the big city, scores a tab in the park with her secretary friend at lunch, swallows the marshmallow-sized chunk and then, presumably, goes back to work. Then we see her playing with kittens. "She passes the line of real and unreal and believes herself to

be a cat," the narrator rambles. "LSD may have given her a few hours of escape but the relationship to cats can hardly be satisfying or fulfilling to a normal person." Another girl drops a trip to intensify her tanning experience and a salesman alone in a motel room takes some so he can freak out. "With wild abandon he runs," drones the narrator. "No man can outrun his fears no more than he can outrun his legs—the end is failure."

Wow, speaking of failures, in its utter inanity and ineptitude, *The Weird World of LSD* makes *Reefer Madness* look positively balanced and professional. It's like a feature-length version of *Plan 9*'s nonsensically narrated "old man" segment. With zero genuine interest in terms of a story, characters, visuals, music, or dialogue, this is fascinatingly awful and . . . rates 10/100, equal first-worst with *Ax 'Em*. Another tie! Ten days to go. The excitement builds!

POPPET THEATER

Well, for me. The bad-movie marathon's acceleration means I'm locking myself away for either hours during the day or staying up half the night. Clare's resigned to this. It's not like I'm totally neglecting her or Ava. I'm still doing my share of the housework and cooking and toddler entertaining, and she and I are still having our nightly dinner and wine. But I'm definitely not entering into the relaxed vibe she's in and I can feel a tad of mania emanating from me. Perhaps I should've paid closer attention to the warning of Esper's *Maniac*.

I am glad, then, that the Bad Movie Bingo spits out the segment of crappy cinema made by pop-music moppets. They might be bad, but at least they won't feature massive breasts, eyeball eating, or tripping hippies, and I can watch them in the living room, joined by Clare and Ava if they so desire.

First up is *Can't Stop the Music*. Oddly, my very Catholic

parents took my brother and me to see this in 1980, not real-izing it was the gayest thing ever to come out of Hollywood. Even weirder, it was a flop around the world but a hit in Aus-tralia. While it's dreadful and way too long, rewatching it is amusing and nostalgic and I can't help but sing along to red-hot "Y.M.C.A.," red-hot "I Love You to Death" and, of course, the uplifting title track.

Clare wanders through, chortling at roller-skating Steve Guttenberg and short-shorts wearing Bruce Jenner, and tries to enlist Ava in "Y.M.C.A." without much success.

When Ava has her nap, Clare and I watch *Xanadu*, released the same year and later translated to a Broadway musical. I've never seen it. Olivia Newton-John is roller-skating muse Kira to struggling earthly artist Sonny Malone. Together with big band–era mogul Danny, played by Gene Kelly, they turn an old auditorium into a nightclub. Idiotic fantasy sequences ensue. The worst has Sonny's dreams of a rock venue clashing with Danny's ideas of a swing joint, resulting in ten audience-ignoring minutes in which the musical styles compete before uniting in a hideous funk-gasm.

"Man, that was just terrible," I say.

"Xan-aaaa-dooooooooo," sings Clare. "C'mon, the songs are great!"

Infectious, yes. But so's avian flu.

Next morning, after a walk to ensure at least some oxygen gets into my system, I put on 2001's *Glitter*, while Clare and Ava go visit her cousins. I saw this one and remember laughing a lot. I think I was drunk. Sober, it's pretty dull for the first forty minutes as Terrence Howard's mogul-playa takes Mariah Car-ey's Billie from backup warbler to overnight singing sensation. But it does get more amusing as the downside of stardom comes a-calling in a welter of cheap emotions. Chipmunk-cheeked Carey's perpetual expression of mild surprise is also pretty

funny. What's inexplicable—from a symbol-motif perspective—
is the streak of silver paint that migrates around her body
during the film. Perhaps it's her robot interior showing
through.

When the girls come home, I'm watching 1997's *Spice World*.
While *Glitter*'s kinda gentle in its awfulness, this one pisses
me off with its aggressive, in-your-face hurl-power. The Spices
are wholly unconvincing—Posh is the worst—as *themselves* as
they chat about their celebrity, have pillow fights, play dress-
ups, appear in a movie-within-a-movie, and chirp out dispos-
able, overproduced pop. This loathsomely jokey offering isn't
spiced up at all by star cameos from the likes of Elton John,
Stephen Fry, and Bob Geldof. An end-credits outtake has
Richard E. Grant only half joking of his role as their manager,
"I don't want to end my career." In the movie, Barry Humphries's
media magnate plots to split up the band by making them fall
out. In reality, Geri—if I remember right, she was "Loudmouth
Spice"—fell out with and left her four BFFs six months after
the film released.

But *Spice World*—and the other moppet offerings, the ach-
ingly mediocre Usher vanity vehicle *In the Mix* and the un-
fairly drubbed Britney Spears movie *Crossroads*—aren't a
patch on 2003's *From Justin to Kelly*. First *American Idol*
winner Kelly Clarkson and runner-up Justin Guarini try to
have a Florida spring break romance amid bitchy sabotage
and nerd shenanigans. This is like Frankie Avalon and An-
nette Funicello's *Beach Blanket Bingo* for Gen Y, with toned,
buffed, nipped, tucked, and implanted youngsters spontane-
ously breaking into joyless, poorly choreographed dance rou-
tines to R&B songs as interchangeable as musical Lego. It's no
surprise it was executive produced by *Idol* creator Simon
Fuller, who rose to fame as manager of the Spice Girls, from a
brain-dead script by his brother Kim, who wrote *Spice World*.

The Razzie membership voted this the worst musical of their first twenty-five years. I reckon its status might be safe for another quarter century.

HEADACHES

"I'd never deny . . . that most of my books have been derivative to some extent, though a few of the short stories are fairly sui generis, and *Cujo* and *The Dead Zone* are both basically original conceptions. But *Carrie*, for example, derived to a considerable extent from a terrible B-grade movie called *The Brain from Planet Arous*." So said Stephen King in a 1983 *Playboy* interview about the inspiration for his debut published novel. That the first of his stories to ever be published, in 1965, was called *I Was a Teenage Grave Robber* makes me think without B movies, modern horror might look very different. *The Brain from Planet Arous* was released in 1957 and has John Agar as pith-helmeted scientist Steve, whose cookout with girlfriend Sally is interrupted by strange, radioactive goings-on at Mystery Mountain. When he investigates with a hair-dryer Geiger counter, a giant transparent and floating space-brain named Gor shrinks itself down and enters his head.

The titular galactic gray matter has the usual plans. "I, Gor, in your stupid body, will have power of life and death over this civilization!" he mwu-ha-has. His endgame's quite ambitious: Take over the UN, raise a slave army, build rockets, and invade his home planet Arous. As a side benefit, Gor is very pleased that as Steve he gets to hook up with Sally. Or, as he says, "I will enjoy being you tonight—she gives me a very strange and very new elation!" The newly horny Gor-Steve tells Sally his sudden quest for money and power is for her benefit. "I want those things for you, you silly little idiot."

This is a cavalcade of such funny dialogue, the occasional great shot, and bizarro plotting that eventually has a good

space-brain—Bor—taking over Sally's dog, George, so he can get close enough to bring down his longtime criminal adversary. It's like the showdown in *Heat*, if De Niro and Pacino were bean bags with eyes hanging by strings. As for the Stephen King influence, Gor-Steve is telekinetic, like Carrie, bringing down a plane with his shiny eyes, but he can also incinerate stuff with his mind, making him a touch *Firestarter*.

Back when I spoke to John Landis, he unrecommended 1962's *The Brain That Wouldn't Die* as one of the most genuinely terrible films he'd seen. And it's certainly down there. Seemingly filmed in green and white, this has Dr. Bill as the typical Frankensteinian figure who tries to balance his mad dream of organ and limb transplantation with his wholesome love for his nurse fiancée, Jan. But, when she's decapitated in a car crash, his two interests intersect and he spends the rest of the movie trying to find a new body for her head, which he keeps alive in a lasagne tray of his special formula.

In her bandages, "Jan in the Pan" looks like a nun—and she's none too grateful to her lover. "Let me die," she moans to Bill. No wonder because despite going to all this trouble, the doc's headside manner is so lacking he barely speaks a word to his beloved. Instead, he reserves his affections for the city's floozies—burlesque dancers, beauty-pageant babes, art models—whose sexy curves he sizes up for surgical purposes in preporn "teasecake" scenes laden with lame double entendres. This is cheap, sleazy, with static direction, but the demented story is especially amusing if you've seen how Carl Reiner and Steve Martin riffed on it in *The Man with Two Brains*.

EVEN MORE TERRIBLY EXECUTED is 1963's *The Madmen of Mandoras*, which, after being padded with an extra thirty minutes of footage shot by UCLA film students in 1968, was sold to

TV under the brilliant—and more accurate—title *They Saved Hitler's Brain*. Sadly, it's only the concept here that's intriguing and this is as dull a mishmash as *Mean Mother*. See, Mr. H., as he was known, had his head sawed off and frozen back in the Berlin bunker in 1945, and now a guy who looks like a seventies porn actor and a gal who looks like Cybill Shepherd's drunk cousin are on the trail of South American Nazis. But wait, no they're not, because they get killed by the Blues Brothers twenty-eight minutes in, to make way for new heroes. It's amazingly convoluted and mostly boring, despite the occasional nice noirish cinematography from Stanley Cortez, one-time shooter for Orson Welles. The temptation to hit fast-forward is high but I'm glad I don't because there's a hilarious moment where Hitler's *Futurama*-style head-in-a-fishbowl melts in a finale that's like a Z-grade *Raiders of the Lost Ark*.

Dr. Otto Frank tries to atomically transplant brains to achieve immortality in 1964's *Monstrosity*. His patron is rich drunk crone Hetty March, who dreams of living forever. Frank's experiments haven't gone too well so far: He has implanted a dog's brain into a dude, creating a hairy mutant named Hans. Hetty's not put off though, and, with the help of her greedy fiftysomething gigolo Victor, she hires three hot maids for Frank to experiment on. "Victor wondered which one Mrs. March would pick," the narrator says. "The little Mexican, the girl from Vienna, or the buxom blond? Victor knew his pick, but he still felt uneasy, making love to an eighty-year-old woman in the body of a twenty-year-old girl. It's insanity!"

You got that right—and there's more craziness in store when the doc starts putting *cat brains* into the ladies. Meow.

DITZY LARRY

I take three days off over Christmas—criminal, I know, but necessary to keep Clare from murdering me in my sleep. We have a superb time at her parents' house with her sister and her husband and kids. I hit one out of the park with an Akira Isogawa designer dress as a gift for my beloved.

But when we're clear of December 26 and the relatives, I'm back into the movie madness, now running at the rate of three or more a day. I visit my friend Jaimie Leonarder and borrow five movies from director Larry Buchanan, who upon his death in 2004, was eulogized by the *Washington Post* as a "spectacularly awful visionary." The *New York Times* at least reached for H. L. Mencken's description of President Warren Harding's prose—"It is so bad that a sort of grandeur creeps into it"—to describe Buchanan's work.

Churning through the five, I can't really disagree. All achieve the same level of boring badness. The best thing about 1967's *Mars Needs Women* is the title. *The Eye Creatures*, oozing out in 1965, and 1969's *"It's Alive!"* (not Larry Cohen's 1974 demon baby flick of the same name) are simply snoozers, but at least 1966's *Zontar: The Thing from Venus* has its cheesy moments, thanks to a ballsy heroine taking on a mind-control bat-thing. What I like most about *The Loch Ness Horror* is that Ava watches most of it with me and is convinced the title creature is Nemo.

VANITY INSANITY

But the door is definitely locked against the little one for my next viewing, despite the film's kid-friendly sounding title.

It's a special sort of person who presumes other people will pay to watch a blurry closeup of your face in profile for a significant portion of a movie—and then cap the experience with

a hard-core sequence in which you cop a lengthy blow job from indie actress Chloë Sevigny. But that person is Vincent Gallo in his movie *The Brown Bunny*. To be fair, the twist here is interesting, just not enough to make up for all the indulgent art angst.

I am grateful to Gallo in a roundabout way, though, because trying to find other vanity projects to match up with *Bunny* led me to Tommy Wiseau and 2003's *The Room*.

An auteur and actor of no talent, Wiseau wrote, directed, produced, executive produced, and starred in this romantic drama about wonderful guy Johnny, who's repeatedly betrayed by his bitch girlfriend Lisa and best friend Mark.

Set mostly in one apartment block, this is like Melrose Place as a halfway house for psychiatric patients who are, by turns, affectless, manic, and depressive—sometimes all in the same scene.

Wiseau, a cockeyed, ripple-muscled narcissist with straggly black hair, is the worst as Johnny. His accent, delivery, and cadences make him Borat Schwarzen-Walken and, matched with his witless script and narrative made up of non sequiturs, he's a mind-boggling screen presence.

Wiseau's dialogue includes hellos and good-byes in many scenes and he chuckles apropos of nothing constantly, even an anecdote about a woman being beaten. The best moments are when he shifts emotional gears in a split second, as in the scene where he stumbles out onto the apartment rooftop, enraged that Lisa has falsely accused him of beating her.

"I deed NORTT heet HER!" he protests to himself. "It's NORRT true. It's BULLSHEET. I deed NORTT heet HER! I DEEEED NAAAAT." He hurls his water bottle down, looks up, sees his friend Mark, smiles, is totally calm, and says, "Oh, hi Mark."

My notes read: "38 minutes in—*worst acting ever*!"

Then there's his James Dean "You're tearing me apart!" moment. And try this exchange between Lisa and her mother.

MOM: *I got the results of the test back. I definitely have breast cancer.*
LISA: *Look, don't worry about it. Everything will be fine.*
MOM: *Hmm.*
LISA: *They're curing lots of people every day.*
MOM: *I'm sure I'll be all right.*
AND THEN THEY GO BACK TO TALKING ABOUT JOHNNY.

The Room also features three sex sequences in the first twenty-six minutes—gauzy and including footage recycled from scene to scene and all filled with R&B and rose petals and focused on Wiseau's freaky bod.

And *The Room* has the funniest twists ever, right down to . . .

But I say too much: If you've come this far with me, you *have* to see this movie. It's no wonder it has become a midnight movie cult sensation in Los Angeles (it'd spread to New York in 2009) because this is definitely one of the funniest bad movies ever. It'd also be the worst of the year—scoring straight zeroes for acting, script, themes, and emotional response, 1/10 for direction, and 7/20 for production. It'd be on the road to damnation if it wasn't for the pesky fact that I laughed so much I had to give it 10/20 for enjoyment.

Unfortunately, Wiseau doesn't respond to my e-mail overtures for a chat during my year of bad movies (P.S. I later spoke to him for my column at TheWrap.com and found him to be agreeable if every bit as deluded and nutty as I'd expected. Then we had a much testier exchange in which he insisted I needed his express permission to refer to *The Room* in any

way in the book you're now holding or I'd be infringing copyright.)

If *The Room* was to have a companion piece, it'd be 2002's *Ben & Arthur*. While Wiseau's movie cost $6 million and utilized professional cinematography, sound stages, and even green-screen effects, this flick was seemingly shot in the filmmakers' residences, perhaps on a cell phone. What it shares with *The Room*, though, is a violent, hilariously overwrought, self-pitying, and paranoid view of love and romance. The difference here is that Wiseau's movie was hetero, and Sam Mraovich's flick is gay.

The auteur and star doesn't stint on self-promotion, with the first four credits reading: "A Sam Mraovich Production/A Sam Mraovich Film/Sam Mraovich/Ben&Arthur." He then takes credit or cocredit for cinematography, editing, music, and screenplay.

Sam is Arthur, in love with Ben, and excited by the news that gay marriage has been made legal in Hawaii. When it's overturned before they can get there, Arthur is apoplectic. "This is ignorance and completely unfair! This country fuckin' sucks! It just fuckin' sucks! Ooooooh!" he erupts, before going into another room to smash shit up.

Apart from the marriage subplot, more hissy fits, and Arthur's dream of opening "my own little porno shop," the main plot has him clashing with his long-lost born-again Christian brother Victor, while Ben tries to deal with his long-lost bitch ex-wife Tammy who tries to remarry him at gunpoint. After Victor assassinates the boys' attorney, he plots with his parish priest to kill his brother. After Victor murders Ben with what's clearly a water pistol, he baptizes his nude brother in the shower at gunpoint. Arthur, who has already immolated the priest, isn't taking this lying down and pulls a similarly fake gun on his brother, strokes his chest, says, "Is this what you

want? You want to fuck me, don't you, Victor?" I won't spoil the ending.

Ben & Arthur is as over-the-top insane as it is ludicrously executed. Every character is some sort of psychotic and all the actors struggle to get their lines out. The production values, from biscuits on plates comprising the main course of a candlelit dinner to a church literally having a cardboard cross and a cartoon Jesus on the wall, are as bad as anything I've seen. The clothes are as appalling. Arthur gets around in black billowing shorts, a Batik shirt, white socks and sandals, like some middle-aged Dutch sex tourist, while hetero Victor, in his short-shorts and with peroxided hair, is the gayest-looking dude in the movie.

This scores zero for script, direction, 1/10 for acting, 1/20 for production value, 3/10 for themes, and 4/20 for enjoyment value. It's a 9/100 folks! Bottom place.

After months of deadlock, Bad Movie Bingo is assaulting me, literally having saved the worst for last.

SHAW FOR SORE EYES

Last month, having suffered the cinema of Donald G. Jackson and Scott Shaw in the Roller Madness segment, my obsession led me to buy five more Zen Films over the Internet at US $30 a pop.

Now the Bad Movie Bingo serves 'em up. I tackle 1997's *Guns of El Chupacabra* first. It was directed by Jackson, written and produced by Shaw. This has B-grade pinup Julie Strain as priestess Queen B. Her then-real-life husband, *Teenage Mutant Ninja Turtles'* cocreator Kevin Eastman, plays King Allmedia. From their space boudoir, comprising as it does candelabras, a chaise lounge, and some curtains, they summon Scott Shaw's Space Sheriff, Jack B. Quick, and tell him they'll reward him with his own action-hero franchise if

he defeats Robert Z'dar's Z-Man Lord Invader, who has un-leashed the mythical monster the Chupacabra on Earth. So far, so low-rent, but comprehensible, at least by the standards of Jackson and Shaw.

Jack heads to Earth and all sense goes out the window. Conrad Brooks wanders around earthmoving equipment and gets "munched" by an invisible Chupacabra. Then he's alive again. We get dudes in novelty ski masks offering a naked gal as a sacrifice, a talking head from so-called Parasite News doing reports on exsanguinated livestock, shots of cowboys eating ribs, explanations that Chupacabra is the result of gov-ernment conspiracy and Queen B and her King enacting a "love ritual." Scott Shaw and a pal fire their guns at nothing and Joe Estevez waltzes in as Rocket Ranger Dan Danger to talk about the Old West. A girl who's totally naked except for sandals shoots a pump-action shotgun, which, I guess, is some-thing you don't see every day unless your homepage is www.nudechickswithguns.com.

Here's the depressing part: I check the display on the DVD player and I'm only forty-two minutes into an eighty-five-minute running time. On it goes, getting looser and more disconnected.

It's like weird wallpaper and, as Zen filmmaking, has no ambition. Any enjoyment is purely incidental—a pretty girl here, some nice desert light there. I rate it 11/100.

Next is *Yin Yang Insane*, which comprises not much more than Robert Z'dar driving around and talking to himself, boom mike in shot. It's twenty-three minutes before he gets out of the car to be stalked by his doppelganger. I'm thinking I have a winner on my hands when the thing just ends at the forty-minute mark. It's not a feature. Disqualified!

I move on to Shaw's 2006 flick *Killer: Dead or Alive*. It, too, hasn't got a running time on the DVD box. We open on costar

Kevin Thompson in a jungle with an M-16. Amid random footage of Hong Kong, Scott Shaw rides a ferry and stares thoughtfully. A voice-over tells us these guys are, respectively, X and Black who were, long ago and in the far far away, sent on a mission by the Overseer to save a girl from a monster. Now all they know is how to kill. Shaw and Thompson mutter to each other like crackheads about having been tasked to assassinate three motherfuckers and each motherfuckin' time they turned up some other motherfucker had already killed the motherfucker in question. They run through this routine perhaps six times, while Thompson babbles about it even more frequently to supporting actor Hae Won Shin. They start to suspect the blond girl they rescued from the monster is the source of their troubles. After all, she prowls alleys with a gun in slo-mo. Scott Shaw's dance music (under D.J. Acid X) thumps away nonstop and we're told they've been tasked with finding the meaning of life in the wake of a time-space continuum slip up. The four "characters" sit on couches in apartments decorated with posters for *E.T.*, *Pulp Fiction*, and other members of a different species known as "movies." They drink beer. Shout at each other. This has to be the one, the worst.

Eventually, Shaw and Thompson kill each other—or had they already done that back in the jungle and have they been dead the whole time? Like who cares. But, then after just fifty-five minutes, it ends abruptly with Thompson awaking from a bad dream! Definitions of feature-length vary but I'm sticking with sixty minutes and above. D'oh! It's disqualified.

At least 2004's *Vampire Blvd.* sounds more ambitious: 1970s setting, supernatural theme. But the only concession to the period is Scott Shaw's costar, Kevin Thompson's, massive joke Afro, flares, and platform shoes. Other than that, this is filled with twenty-first-century dance music, vehicles, and fashion. Scott Shaw is a Vietnam vet. We know this because we

"flash back" to him near a creek that's supposed to be the mighty Mekong. "There were angels and demons to guide me and sometimes they were one and the same," he says of his war experience as we cut to a nude girl on skates putting a blade to his neck. A mad scientist has created bondage-clad zombie girls, an Asian babe thinks she's being stalked by vampires, a black-and-white-painted ninja gal writhes in a fast-food restaurant, wigged skate freaks zoom through a canal, Joe Estevez wears a cape and sings and lights a candle, a robot Robert Z'dar beats his female robot equivalent, Shaw fights invisible bat things in an effects sequence that might've been created with a dot matrix printer, and porn star Jill Kelly wriggles about on a toilet. We conclude with Shaw, dressed like a Gen X samurai, wandering along the beach with a nude woman and talking about getting his "tantra groove thing on."

Whatever. This is wall-to-wall inanity from people who don't understand the difference between improvisation based on character and story and babbling meaninglessly just because a camera is switched on. "Well, now I'd gotten my freak on and my bid'ness taken care of, I was much more up to the task . . . up to the task of, ah, seeing what was coming next, and I was ready," is a line of "dialogue" that sums up that no one knows what they're doing in any "scene" or how it relates to any "story."

Vampire Blvd. is like porn without the sex scenes, skit without comedy, action-horror with neither. I cannot think of a worse or more worthless movie experience. This film's seventy-eight minutes—yes, it's a *feature*—make time stand still. You could play this in a terminal ward and patients' decline might be suspended long enough for a cure to be found. More likely though they'd just beg for death. Clare walks out of the bedroom. It's 1:05 a.m. I'm staring blankly at the blank plasma screen. She looks at me, looks at the TV.

"What are you doing, bubble?" she asks, a flicker of concern mixed in with amusement.

"I've cracked," I say. "I can't watch any more of this dude's movies. I think this guy has broken my brain."

"They're that bad, huh?"

I nod. "And they're all the same."

"Theeeey're allll the saaaame," she says in a suitably B movie ghost voice.

Ladies and gentlemen, I'm ready to call it, with two days to go.

Scott Shaw's *Vampire Blvd.* is as bad as it gets. I rate it 4/100 because it'd be unfair not to give it 1/10 for its acting, 2/20 for production value, and 1/20 for enjoyment.

I've still got one more of Shaw's movies to go—*Witch's Brew*—but it's gonna have to stay on the shelf. I can't face it.

Next morning, after a sleep in, I call Shaw up in Los Angeles.

Given that he's always so surly-looking in his movies, and on the covers of the books he writes about martial arts and Buddhism, I'm surprised that he's so thoroughly polite, inquisitive, and amiable. He laughs a lot. Not the maniacal cackle you'd expect, but the chortle of what sounds like a good-natured, balanced individual.

"How should one approach watching a Zen movie?" I ask.

"I think you need to go into a Zen movie as if you're going into an art museum, okay? You have to see it as what it is. As I always say, you might hate the art of Picasso but you can't say it isn't art. It's art, you may love it, you may hate it, but it's made purely from the sense of art."

I ask him how much his movies cost. He tells me he funds them himself, using monies from his writing and acting and directing work he does in Japan. Something like *Vampire Blvd.*, he says, was thrown together for less than $10,000.

Other more elaborate flicks, the ones partly shot in Asia, might run up to $60,000 in total.

I ask who sees them, if they ever make any money. Shaw says that *Guns of El Chupacabra* was popular in South America, while *Samurai Vampire Bikers from Hell* did well in Asia. "If one person sees them that's great and if a million people see them that's great . . . I'm not doing it to make money. I'm doing it for the art of it."

"How seriously should people take the movies?" I ask.

"*Roller Blade Seven* has been called the worst movie ever made but to me that's a compliment," he laughs. "We did not set out to make *Gone with the Wind*. What we did was very conscious. I think that's what most people misunderstand. What we're doing is what we're doing. For lack of a better term, it's in-your-face art and you may love it, you may hate it. Either way's fine. If you call it the worst movie ever made, thank you, it's a compliment. At least you've taken the time to watch it and see it. It's not intended to be good."

"Last night my partner came out and said, 'How's it going?' " I tell him. "And I said, 'I think this guy's broken my brain.' I've watched four of your movies in a row."

Shaw lets out a "whoa" as though this is even something he wouldn't do and hoots with laughter.

"I've literally watched something like four hundred bad movies this year," I continue. "Ed Wood, Andy Milligan, Al Adamson, Larry Buchanan, but you—*you*—"

This cracks him right up. "Hahaha, thank you, that's a compliment. Ahahahaha! I take that as a compliment."

We talk some more. He tells me how Donald G. Jackson's immersion in 1970s culture led to the recurring motifs of smiley faces and roller-skaters as subject matter. And as for all those naked women? "Don't you love beautiful women? Don't we all?" He laughs some more. "I think it was Roger Corman who said nudity is the cheapest special effect."

"How," I ask, "do you rate yourself as an actor?"

"I've never trained as an actor. I don't rate myself as an actor. Why am I in most of my movies? Because I know I'm going to show up. I'll be there."

I ask him what his family thinks of his movies.

"I don't know if they even watch them," he says.

Except for his wife, Hae Won Shin, of course, who's part of the Zen crew, having played, among other roles, the Overseer in *Killer: Dead or Alive*. "Once I get done filming a movie, whenever the story doesn't make any sense at all, what I do is bring her in and get her into the movie with the story justification," says Shaw. "For people who want things like that—a story, you know."

THE HORROR, THE HORROR

I swear this is the way it happens.

It's December 30 and I feel liberated. But I don't feel done yet. Clare's got activities planned—she's dropping Ava up to her grandparents in the Blue Mountains to have a New Year's sleepover—and, well, I was gonna watch bad movies anyway. Another two days won't kill me. But, as I'm feeling kinda loose, I decide, to hell with Bad Movie Bingo, I'll just choose the category I want from what's left (Random Horrors, Z-Grade Zombies, Ninja Nonsense) and I'll even watch 'em in any order I like, rather than chronologically.

I choose Random Horrors, which contains six titles, and decide to watch 2004's *Dark Harvest 2*, which has a pretty slick DVD cover featuring a freaky scarecrow-with-a-scythe slasher.

Turns out it's another of this year's many seem-quels. This was originally *The Maize: The Movie*, an independent production that was released by Lionsgate under the title *Dark Harvest 2: The Maize* to cash in on another 2004 horror movie called *Dark Harvest* that actually *was* about a killer

scarecrow. Written, produced, directed, and shot by Bill Cowell of Buffalo, New York, *The Maize* is for people who thought *The Blair Witch Project* didn't have nearly enough aimless wandering around captured on grainy video.

Cowell stars as Shy Walker, a psychic who has a premonition his daughters are going to come to harm inside a corn row maze. A maze of maize! He rushes there, rushes in. "Girls?" he calls as he squelches through mud between drooping tendrils of dead crop under a gray sky. "Girls, it's Dad. You gotta come out!" The videography of him is blurry and backlit so his face is often in shadow, while his psychic flashes are conveyed by the most rudimentary of video paintbox effects. Not that his "abilities" lead him to his daughters in any hurry. In fact, early on, he runs into the little tykes, who are dressed as vampires because it's Halloween, but promptly loses them again, which sets off a whole new round of "Girls, where are you?" hollering. For their part, the daughters scream a lot for no reason and talk to the ghosts of the Netti sisters, murdered in the maize maze by their father, who, in his yellow galoshes, now glacially prowls after Shy with a steel bar. The only way this situation can be resolved is for Shy to find a locket one of the Netti girls lost. And that involves digging a shallow hole in the mud. Which he does. For *eight minutes*.

There are interludes with the cops, giggling pumpkins, his wife, and random cutaways to his dog and some cows. Mostly it's Shy stalking between the stalks, calling out.

For *104 minutes*.

There's nothing to take pleasure in here. Replace the "n" in *The Shining* with two "t's" and you've got it. This is so deadening and mirthless it's the sort of cult film a cult would show to make followers *want* the Kool Aid. I'd rather sit through any random two hours of a stranger's holiday footage. And here's the kicker that I can't believe—I'd score it 4/100, too.

Back to a deadlock!

If the next thirty-six hours don't throw up something worse, it'll have to go to *The Maize* for sucking half an hour more of my life away than *Vampire Blvd.* Dwelling on it, I'd rather watch seventy-eight minutes of *Vampire Blvd.* again than endure another full bout of *The Maize.* I'd rather watch a blank screen for twice that time.

I now wonder whether it's not the movie but me? Have I reached a point where each flick just seems worse than the last? Have I indeed cracked?

I put 1982's *Nightbeast* on. It cures me of the notion by being at least six times more enjoyable than *Dark Harvest 2*—that, despite being the lowest-IMDb-rated movie from Baltimore DIY auteur Don Dohler, who helped inspire a generation of technicians with his special effects magazine *Cinemagic.* This stars a lizard in a silver jumpsuit who uses a laser gun to dematerialize people into disco lights. It's bad, but cheesy fun, and offered a sixteen-year-old kid named Jeffrey J. Abrams the chance to help out with the music and sound effects, giving the creator of *Alias, Lost, Mission: Impossible III, Cloverfield,* and *Star Trek* his first credit.

Natas: The Reflection, from 1983, comes off as a cousin to *Manos.* Reporter Steve is trying to get to solve the Native American mystery of "Natas: The Reflection." It's a jumble of illusions and cowboy zombies. But I love when our hero Steve tells his girl, Terri, "I gotta figure this thing out. We'll get the answer, we will. Probably be so simple I'll feel like a fool." We are *seventy-five minutes* into a movie called *Natas: The Reflection*, which is about the curse of Natas: The Reflection. Steve reckons it might be related to some sort of reflection. Terri says that mirrors see things in reverse. And then they *still* don't get it. After they find Natas, a tall bumpy bat, and use mirrors to shoot his evil energy back at him, the penny drops.

"Natas was the reflection! Satan spelled backwards!" declares Steve.

To that I say, "!Kcolrehs tihs on."

DECEMBER 31 DAWNS AND I have a decision to make. Whether or not to call Bill Cowell and tell him I think *Dark Harvest 2: The Maize* is the worst film ever made. As much as I should, I resolve not to. It's New Year's Eve, for God's sake, and hearing from me might just ruin his whole 2008. Besides, I might not even be right. When I visit Bill Cowell's Web site I discover he has made a sequel to *Dark Harvest 2* called *The Maize 2: Forever Yours.*

Oh my God.

The trailer has more stalks and stalking, along with a wild-eyed Cowell wearing a red bow tie—without a shirt. But even if I wanted to watch it, it's not available to buy yet.

So, instead of making the call, I settle in with the last three movies of the year. *The Invisible Maniac* was written and directed by Adam Rifkin in 1990 fresh off co-writing Adam Sandler's *Going Overboard.* It is similarly leaden, a soft-core horror take on *The Invisible Man.* I barely draw breath before putting on 1996's *Feeders* directed by Jon McBride, and John and Mark Polonia, identical twins of Wellsboro, Pennsylvania, who're like the Coen brothers of bad moviemaking. This is the tale of swingin' dudes Bennett, played by John, and Derek, played by McBride, who're doing a cross-country trip and looking for lovely ladies when they're caught up in an alien invasion of papier-mâché puppets. Everyone in this looks dressed and styled by Napoleon Dynamite, the CGI is laughably primitive, and the dialogue and performances are so uniformly ghastly they're quite entertaining. *Nightbeast* 22/100, *Natas* 19/100, *Invisible Maniac* 20/100, and *Feeders* 18/100. None are even in the Bottom 20.

It's 4:00 p.m., Clare will be home at 6:00 p.m., our friend Amanda is to arrive at 7:00 p.m., and then we're due at Emma's place for a New Year's Eve party. I've got time for just one more and it's the Polonia brothers' follow-up: *Feeders 2: Slay Bells*—because the world demanded it. Actually, at the end of *Feeders*, the world got blown up. Never mind. In this one, Mark Polonia takes the lead as a family man whose Christmas plans are thwarted by the reappearance of the Feeders. Incredibly enough, the aliens have been redesigned to look even less convincing—a feat I didn't think possible. These really are tennis balls on sticks that've been papier-mâchéd over and given little eyes and fangs. Nevertheless, they go about stalking in "video vision," munching a cat to muppet parts and devouring an old lady. When our nerd hero accidentally kills a Feeder he, not unreasonably, mistakes it for an ugly dog. But the real defense against the alien menace will come from Santa Claus, who turns up shooting a laser gun. "It was too surreal to be a dream, but too unreal to be believable," says Polonia at one point.

Damned straight. I'm gobsmacked afresh at how awful *Feeders 2* is. I give it 13/100. Terrible. But not nearly terrible enough to dislodge the winning loser.

I turn off the DVD player, take a deep breath.

I HAVE A BEER. *Dark Harvest 2: The Maize* it is then.

I feel exhausted and elated. I did it. Clare arrives home. "Are you getting ready?" she asks.

"I'll just have a shower," I say. I feel like I could use one.

"All done?" she says, looking at the blank screen.

I nod. "All done."

EPILOGUE

OCTOBER 2009

But of course, I wasn't all done because as the New Year rolled on, the IMDb's Bottom 100 kept throwing up new contenders. The more I looked, the more I wondered whether I'd really seen the worst movie ever made. As of this writing, *The Maize: Forever Yours* is unreleased commercially—not that that's stopped 597 IMDb users from voting to give it an average rating of 1.1/10.

Instead of a one-a-day habit, my bad-movie obsession became more of a low-grade fever. Now, like Mike Nelson, I perversely relished the prospect of having to see *Next* or *I Know Who Killed Me* for *Empire* or *The Movie Show*. I'd watch Uwe Boll's *Seed, In the Name of the King*, and *Postal*, and detect gradual improvement in his filmmaking, with *Postal*'s bad taste comedy sometimes hitting the mark and *King* enlivened by Ray Liotta's camp and Jason Statham's growling. In 2008, Paris would hit number 1 on the Bottom 100 again with *The Hottie & the Nottie*. It's dreadful, but I'd

be one of the few reviewers who could actually say it was better than *Bottoms Up, The Hillz,* and *Pledge This!*

Now and again, I'd watch one of the sixty-eight tapes and discs I hadn't got to, usually with my friend Luke around, and we'd chortle through *Impulse* or *Cybernator*. It was nice not to have to worry about note-taking.

As I had during the year of bad movies, when possible and appropriate, I'd ask interviewees what they regarded as the worst film they'd ever seen. Often this led to a spirited off-topic conversation and, in the case of George Romero, a friendship and the invitation to come and get my head blown off as one of his zombies in *Survival of the Dead*.

David Sedaris loved talking about it more than his own book. He cited 1968's *Planet of the Apes*, a movie he'd loved and seen seventeen times on release, but had rewatched recently in Paris. "There's a point where Charlton Heston, at the beginning of the movie, he gets into that pod and he's got a cigar and he tamps that cigar out," he told me in a Sydney hotel room overlooking Hyde Park. "Then we go light-years into the future or whatever and he's still got that cigar and he lights it again. Then someone says, 'Captain, come here!' and he takes the cigar and he throws it and he runs. If you were on a strange planet, you wouldn't throw that to the ground unless someone had said, 'Hey Captain, come here—there's a cigar store!'"

He was right—and it's one of those details that's like a crack in a dam wall.

"I was just stopped by so many things where I thought, 'What?' The dialogue seemed so hokey. And bodies change so much too. Charlton Heston's in that movie . . ." Sedaris burst out laughing. "He was supposed to be so he-manly and like a sex symbol but it's like Will Ferrell's body!"

Sedaris also had a good laugh about *Lady Sings the Blues* and *Valley of the Dolls*.

David Koepp, incredibly successful writer of *Indiana Jones and the Kingdom of the Crystal Skull*, *War of the Worlds*, *Jurassic Park*, and countless other blockbusters didn't want to be mean to other filmmakers—"A movie I just really hate is . . . whatever's opening opposite my movie," he joked—but confessed loving the cheesy and speedy zombies of 1985's *The Return of the Living Dead*. "It also contains the great sequence where, for no apparent reason, one of the characters says, of a female character, 'Trash is taking off her clothes again,' and then there's a long sequence where she dances naked on top of a grave." Toby Young, author of *How to Lose Friends & Alienate People*, dissed the acclaimed 1992 British film *The Long Day Closes*. "There is literally a scene in which you're forced to stare at the same spot on a wall for five minutes watching paint dry," he told me. "I thought it was a distillation of everything that was wrong with self-indulgent, art house cinema."

Next time I spoke to John Landis, he remembered our conversation and was stoked I'd watched *The Monster and the Girl*, *White Pongo*, *The Brain That Wouldn't Die*, and others he'd recommended. "I thought of a movie you should have in there," he said excitedly down the line from London as he prepped his new film about nineteenth-century murderers Burke and Hare with Simon Pegg. "Have you ever seen *Sextette*?" he asked.

"That's the one with Mae West, right?" I ask.

"Yeah, it's Mae West's last film. It is so bizarre because this woman, who's in her eighties, and she looks stuffed, and she has Tim Dalton and Ringo Starr and George Hamilton, all these then-young guys, making love to her. It's like necrophilia."

I add it to my list. I'll see it one day.

BUT THERE WAS ONE person that I needed to speak to, Bill Cowell, writer-director-producer-star of *Dark Harvest 2: The Maize*.

It gnawed at me that I'd not called him and gotten his side of the story. So in late September this year I finally bit the bullet. I was quite nervous that I'd gotten lucky with Scott Shaw and that Cowell might not be so laid-back.

Happily, he was just fine, even after I told him that I'd not been kind to his movie.

"The film was really an experimental film and not made to get out there," he told me from Buffalo, New York, of the movie he had made with friends, family and locals simply to test out a new digital video camera. "My daughter had said, 'Why don't you do something at the corn maze?' We really didn't even have a script or a story. I said, 'Let's just have some fun.'" Cowell set out to make a thriller that stood in contrast with the gory film trend that had *Saw* raking in big bucks. "I said, 'I can't compete with that.' We did the film for no money, basically nothing, and we had to go the other way, make it [about] suspense. And then a couple of the sales guys I knew in the past got a hold of it and said, 'Hey, Lionsgate's interested . . .' They gave us a bunch of money. So, what was I gonna do?

"I was little shocked the first time I thought, My God, this thing's getting out there like that." "Like that," of course, included Lionsgate releasing it with the scarecrow cover and a new cash-in title. "I wasn't particularly happy with it, but it wasn't my call." Had he known the movie would be seen, Cowell "definitely would've put a lot more thought into the storyline and photography. But I'm really proud of how fast we did it and what we did."

The payment led him to do that so-far unreleased sequel and gave him the confidence to keep at moviemaking, as so many B-grade auteurs have before him. When we spoke, Cowell said he said he had twenty-two projects in various stages of development. He'd also, since *The Maize*, founded the

Buffalo Niagara Film Festival, now in its fourth year.

"I made a movie and I got paid for it," he laughed.

"Not everyone can say that," I said.

And I, for one, can't.

Speaking to Cowell made me wonder all over again: Was his really the worst film ever made? It was basically a home movie, given a cynical release, which could've happened to *The Tony Blair Witch Project*. But his attitude and comments also brought to mind so many auteurs, from Ted V. Mikels to Scott Shaw and what Dolores Fuller had said of Ed Wood that he seemed right at home among them. I watched *Dark Harvest 2* again to see if I thought any better of it. I didn't.

Workwise, the time after my year of bad movies was up and down. Sadly, *The Movie Show* was canceled mid-2008, but *Empire* survived and prospered. Clare went back to fulltime work and similarly thrived, while I got a shorter office day and some very amusing Mr. Mom time. At the time of writing, Ava has watched *Star Wars Episode IV: A New Hope* three times in the past three days and mastered "Use the fork, Luke." But she's totally perfected "Forget it, Jake, it's China-town" and uses it at the most surprising moments. The bad movie experience also paved the way for writing at The Wrap, Rotten Tomatoes and being privileged to restart the late, lamented "Bad Movies We Love" column for Movieline. As for Cate Blanchett? I got to interview her at length. And no, I didn't mention *The Road to Kate* script. Or ask her worst-ever movie. Scriptwise, *Revenants* got close to greenlit, and to landing a pretty well-known actor in the lead, before it fell apart. It now lies dormant. For the time being.

As for whether I've seen the worst movie ever made, I can't be sure. Even if I had seen every movie *ever* made, it'd still be a subjective judgment. But if you can watch all of these and then find something worse, please let me know.

Dark Harvest 2: The Maize	*Manos: The Hands of Fate*
Vampire Blvd.	*The Party at Kitty and Stud's*
Big Sister 2000	*The Magic Christmas Tree*
Rollergator	*Curse of the Zodiac*
Search for the Beast	*Green River Killer*
Hollywood High Part II	*B.T.K. Killer*
The Room	*The Weird World of LSD*
Ben & Arthur	*Ring of Terror*
Curse of Bigfoot	*Ax 'Em*
Da Hip Hop Witch	*Police Academy 3*

As for the question of whether the movies are getting worse, I fell into this thinking trap again. Thus far, 2009 has thrown up—pun intended—*Transformers: Revenge of the Fallen*, *Knowing*, *Terminator Salvation*, *Friday the 13th*, *Fast & Furious*, *Race to Witch Mountain*, *Bride Wars*, and *The Uninvited*. Then there had been the mediocre *X-Men Origins: Wolverine*, *Land of the Lost*, and *Night at the Museum: Battle of the Smithsonian.* They were all such big films with such little brains that each time I couldn't help but wonder what Scott Shaw would do if someone handed him $250 million.

There were high points—*Star Trek*, *The Hangover*, *Watchmen*, *State of Play*, and *The Brothers Bloom* were all damned fine—but it just wasn't like it had been in 2007. And then—bang—one after another came *Up*, *Coraline*, *Moon*, *Drag Me to Hell*, *The Hurt Locker*, *District 9, Anvil! The Story of Anvil*, and the brilliant *Inglourious Basterds*. Suddenly, it seemed like not just a good but perhaps a great year. And we weren't even in Oscar season yet. Nor had *Avatar* been unveiled.

Every year cinema seems to plumb new depths as it reaches new heights.

As for what I learned from that year, well, I think it enriched my love of films and the people who make them. While at first it felt like a quest to find everything that was wrong with crappy movies, it turned out to be at least as much the opposite in that I tried to attune myself to seeing what was interesting or even innovative about them and why they were the way they were. Conversely, that approach helped me see that what's regarded as classy, sophisticated, or important filmmaking is sometimes less honest, authentic, and passionate than the clumsy efforts of spirited amateurs. The year made me more aware of just how few degrees of separation there are between the A-list and the Z-grade, that we're all interconnected, that . . . oh, listen to me.

Actually, as to the whys and what was learned, I'll defer to George Mallory.

In 1923, he supposedly answered "because it's there" when the *New York Times* asked why he was about climb Mt. Everest. Given that his obsession killed him—the man who may have been first to make the summit—this seems a glib epitaph. When I was considering this quest, and looking for justification for my silliness, I came across a better answer Mallory gave a year earlier to the same question:

The first question which you will ask and which I must try to answer is this, "What is the use of climbing Mount Everest ?" and my answer must at once be, "It is no use." There is not the slightest prospect of any gain whatsoever. Oh, we may learn a little about the behavior of the human body at high altitudes, and possibly medical men may turn our observation to some account for the purposes of aviation. But otherwise nothing will come of it. We shall not bring back a single bit of gold or silver, not a gem, nor any coal or iron. We shall not find a single foot

of earth that can be planted with crops to raise food. It's no use.

Mallory continued:

So, if you cannot understand that there is something in man which responds to the challenge of this mountain and goes out to meet it, that the struggle is the struggle of life itself upward and forever upward, then you won't see why we go. What we get from this adventure is just sheer joy. And joy is, after all, the end of life. We do not live to eat and make money. We eat and make money to be able to enjoy life. That is what life means and what life is for.

I LOVE IT: **JOY** is, after all, the end of life.

So, I suppose, beyond why I did it and what it taught me, the important thing question is: Did I get joy from my year? Well, if you'll forgive me another learned quote after a year spent citing so much Z-grade dialogue: "It was the best of times, it was the worst of times." I have it on good authority that Charles Dickens wrote that after watching *Robot Monster*.

DELETED SCENES

JANUARY

Howling IV: The Original Nightmare (1988): A lady author moves to a village of werewolves, sometimes played by German shepherds with crappy red-eye effects.

Backyard Dogs (2000): Two college boys try to break into the "pro" backyard wrestling circuit, aided by sexy Kristy's PR campaign to "Steven Spielberg you straight into Blair Witch Territory."

The Las Vegas Hillbillys (1966): In-between mind-numbing jamboree sequences, two backwoods dumb-clucks try to run the casino they've inherited, aided by Jayne Mansfield and Mamie Van Doren.

Hillbillys in a Haunted House (1967): The boys are back, this time stuck in a fake haunted house run by spies John Carradine, Basil Rathbone, and Lon Chaney Jr. Joi Lansing's on jiggle duty.

The Capture of Bigfoot (1979): Bill Rebane, director of *The*

Giant Spider Invasion, unleashes an even-less-impressive threat in the form of white-furred Sasquatch. The evil-developer plot apes *Jaws*. Snores, more like.

Tail Sting (2001): A trans-Pacific flight is menaced by giant scorpions that roll about on barely concealed wheels. Laughably low-rent but with deliberate offbeat laughs. Released five years before *Snakes on a Plane*.

Den (2001): A psycho abducts seeming strangers, chains them in his basement, and forces them to kill each other as they reveal their dirty interlocking little secrets. Released three years before *Saw*.

Lawnmower Man 2: Jobe's War (1996): In this "seem-quel" Matt Frewer—once Max Headroom—cracks dumb as the near-death idiot savant unleashed into a cyberworld where he becomes an evil overlord.

FEBRUARY

Rectuma (2004): Zero-budget parodist Mark Pirro gets a few silly laughs as a man's ass is invaded by a Mexican Butt-Humping Frog and detaches, first to become a serial killer and then a giant Godzilla-style monster.

Navy Seals (1990): Special ops hard-asses take on Middle Eastern terrorists. Charlie Sheen's at his douche-iest, referencing "ragheads," calling beers "brain grenades," and living by the motto: "Trust me with your money or your life but not your wife!"

Extreme Honor (2001): Shoddy as hell "action" movie stars Dan Anderson as a disgraced Navy Seal who rips off an IT billionaire to save his terminally ill son. Or, as his ex-wife puts it: "Jason's dying and the cancer's getting worse!"

Titan Find (a.k.a. *Creature*; 1985): Moderately enjoyable *Alien* rip-off has Klaus Kinski making up dialogue as he goes along, brain lobsters, an exploding head, and a monster so close to H. R. Giger's original I'm surprised he didn't sue.

Frankenstein Meets the Space Monster (1965): A Martian

sexpot and her Dr. Evil-like sidekick try to capture Earth women—only to be thwarted by the rampage of half-mad cyborg astronaut Frank. Crispin Glover's dad plays a Martian.

Die Hard Dracula (1998): Amusingly terrible fangtasy has American hunk going to Prague and finding the doppelganger of his recently drowned gal—along with Dracula, who looks like Ozzy Osbourne after he's been snorting ants. Crispin's dad is Van Helsing.

MARCH

I Woke Up Early the Day I Died (1998): One for trivia fans: based on Ed Wood's script about a madman tracking down those he thinks stole his loot, this silent movie stars Billy Zane, Ron Perlman, Christina Ricci, and many others. Not that it's any good.

Ed (1996): Matt Le Blanc teams up with a baseball-playing ape who spends too much of its time acting like an incontinent hobo.

Marci X (2003): Lisa Kudrow—*Friends*' nervy, leggy folk singer—is Marci, a nervy, leggy Jewish American Princess-turned-rapper saving her dad's record label. Some funny scenes amid the awkwardness.

Zoom (2006): From Peter Hewitt, director of *Thunderpants*, another superdud, this time with Courtney Cox playing klutz to Tim Allen's washed-up comic book crusader. Like a reheat of *Leonard Part 6* and *Superbabies*.

APRIL

Voyeur.Com (2000): "Innocent" Mary joins five skanks in a house that's wired for 24/7 Webcast. Basically, a slasher with camcorder production values.

Love.Com (2002): A 1980s-style "erotic" thriller spruced up with cyber-adornment as a probation officer investigates the death of her identical twin, an online B&D mistress. Moments of surreal badness. And Michael Madsen.

FeardotCom (2002): Presumably, *SevendotCom* would've attracted a lawsuit. Ridiculously derivative and overstylized serial killer thriller has Stephen Dorff and Natascha McElhone investigating a haunted torture-death Web site.

Net G@mes (2003): The cyber-riff rips off *F@t@l @ttr@ction* but is kinda trashy fun as C. Thomas Howell sweats a lot after an online affair goes awry. Instead of a bunny boiling, we get a cat lynching!

.com for Murder (2002): Like *Psycho* shot by a demented wedding videographer, this has a Goethe-obsessed maniac stalking women in a mansion. Eclectic cast includes Nicollette Sheridan, Nastassja Kinski, Roger Daltrey, and Huey Lewis.

Collision Course (1989): Jay Leno and Pat Morita team up as cops investigating corporate espionage in Detroit. It's about cars, but this is a bus movie.

Cop and 1/2 (1993): Henry Winkler, once the Fonz, directs Burt Reynolds, once Hollywood's most bankable star, in this dire matchup of cop and mouthy kid, like *Beverly Hills Cop* meets *Home Alone*.

Little Man (2006): Via expensive CGI, Marlon Wayans plays a dwarf criminal posing as a baby in the house of a suburban couple. Predictably gross diaper and sex-with-mom jokes ensue.

MAY

Metalstorm: The Destruction of Jared-Syn (1983): Dodgy space-worms-in-the-face 3-D effort marked the lead debut of Kelly Preston, future Mrs. Travolta. Weirdly, this also has a Scientology-style story line about a crystal that traps souls.

Starship (1985): Cheap, turgid, and unexciting *Star Wars* variant, notable only because it was directed by Roger Christian, who'd repeat himself, as unsuccessfully, on *Battlefield Earth*.

Chains of Gold (1991): Made at the nadir of Travolta's career, this has him as an alcoholic social worker who kicks ass to

save a kid at risk from Benjamin Bratt's villain, who uses youngsters for an underground slave cult.

The Mighty Gorga (1969): An American circus owner teams up with a lady big-game hunter to capture the title creature, who's worshipped by African "Indians"—that is, spray-painted hippies in wigs. Just dreadful.

JUNE

The Psychotronic Man (1980): The title coined a word, with "psychotronic" now used to describe, roughly, the sort of movies found in this book, and made popular by the wonderful *Psychotronic Video Guide*. The movie has a barber who can kill people with his thoughts. Great idea, executed poorly.

The Punisher (1989): Dolph Lundgren rumbles incomprehensibly as the titular vigilante although *Dead Heat* director Mark Goldblatt again provides reasonable action moments.

Blankman (1994): Deliberately dumb effort from the Wayans brothers has titular DIY dimwit fighting crime. Occasionally— *very* occasionally—amusing.

JULY

Jesse James Meets Frankenstein's Daughter (1966): From veteran quickie director William "One Shot" Beaudine, this has Germanic brother-sister resurrectionists taking advantage of Jesse James and his simpleminded sidekick. Minor gripe: She's Frankenstein's *granddaughter*.

Billy the Kid versus Dracula (1966): Another effort from Beaudine has John Carradine's Dracula hiring wimpy Billy the Kid as a ruse to get close to the retired gunslinger's gal. Carradine, who made hundreds of Z-grade flicks, reckoned this his *worst*. Presumably he never watched *Horror of the Blood Monsters*.

Demon Island (2002): Jaime Pressly, now a star, somehow finds herself on said island infested with said demon from said piñata, done with crummy CGI. Most annoying, though, are

the screeching co-ed buffoons, and the slow rate at which they're killed off.

AUGUST

Surf II (1984): The title's the first joke—there was no *Surf.* Eddie Deezen takes a rare lead role as a geeky villain using toxic cola to turn surfers into zombies. Some inventive jokes and good soundtrack.

Sorority Babes in the Slimeball Bowl-O-Rama (1988): Director David DeCoteau uses a ninety-nine-cent wisecracking muppet to comically menace B movie babes and their beaus at a bowling alley. Not funny or scary, sadly.

Slapstick (Of Another Kind; 1982): Ouch. Jerry Lewis and Madeline Kahn play aliens in the form of oversized babies with huge foreheads and novelty teeth. Lewis lets his worst excesses have free reign, Kahn goes along for the raspberry-blowing ride. Just horrible.

Car 54, Where Are You? (1994): Horribly unfunny and possibly the worst adaptation of a TV show ever. David Johansen is an abrasive and amateur lead. Most annoying? His voice—like gravel down a rusty drainpipe—which is no mean feat given this costars Rosie O'Donnell *and* Fran Drescher.

The Carpetbaggers (1964): Recommended by *Seinfeld* and *Borat*'s Larry Charles, this adaptation of the Harold Robbins novel is a bloated but amusing take on a Howard Hughes–style tycoon. *The Oscar* is similar but better. It was also recommended by Charles.

SEPTEMBER

Blackwoods (2002): Uwe Boll's English-language debut has a dude facing a backwoods nightmare after his gal goes missing. Not subtle, but not too bad either. Dad liked it.

Parasite (1982): Demi Moore's first lead role sees her in slug-contaminated postapocalypse—and in 3-D. Low-rent nonsense, but bolstered by some good makeup and Stan Winston creature effects.

The Scarlet Letter (1995): "Freely adapted" from Nathaniel Hawthorne's classic—which is Hollywood for "given a happy ending." Demi's all wrong for this, but director Roland Joffé bears responsibility for ludicrously "arty" sex and nude scenes.

Striptease (1996): Demi got $12.5 million to show off her extensively renovated body and do a lot of sexy-snarly face. She's bad, but Burt Reynolds is worse.

The Killer Shrews (1959): Dogs in masks play oversized rodents on the rampage. Not *quite* as silly as it sounds, thanks to moments of proto–George Romero siege suspense.

The Giant Gila Monster (1959): From *Shrews'* eclectic producer-director team and every bit as silly as it sounds. Close-ups of a gila monster threaten teens. With mind-numbing songs.

The Swarm (1978): Cheesily entertaining Irwin Allen epic has Michael Caine and a roster of other big names delivering earnest emotion as millions of bees attack. Best moment? Katharine Ross hallucinates a giant bee.

OCTOBER

Hobgoblins (1988): Wish-granting alien creatures are holed up in an abandoned movie studio. Stupid kids break in so they can hold these inanimate muppets against themselves to facilitate their own deaths. Lame horror, lame comedy.

Ghoulies III: Ghoulies Go to College (1991): Toilet-dwelling puppets are summoned by a mythology teacher to attack fraternities and sororities during Prank Week. Creepiest when a trouserless ghoulie says, "I'm sporting half a chubby" while watching girls shower.

A Very Unlucky Leprechaun (1998): Underwhelming if harmless kiddie comedy has Tim Matheson and daughter Molly moving to Ireland and moving into a house with a well-meaning leprechaun. Undeserving of its 1.1/10 on IMDb.

NOVEMBER

Ballistic: Ecks vs. Sever (2002): According to Rotten Tomatoes during the year of my quest, this was the worst-reviewed movie *ever*. Directed by someone named "Kaos" (Wych Kaosayananda), this has Lucy Liu and Antonio Banderas blowing up everything in the frame. If you think Michael Bay's movies are too slow and character-driven, meet your new favorite film.

The Crater Lake Monster (1977): Had this been made in 1957, it might be a Creature Feature B classic. Twenty years too late, it's still endearingly bad as a stop-motion Nessie snacks on locals before heading into town for an all-you-can-eat buffet.

Cat-Women of the Moon (1953): These feline fatale beatnik babes want to seduce human astro-men so they can pilot their ship back to Earth and establish the purr-fect girl-race through eugenics. Best line: "You're too smart for me baby, I like 'em stupid!"

Mesa of Lost Women (1953): Former child star and future Uncle Fester Jackie Coogan works toward world domination by swapping the glands of humans and tarantulas to create man-dwarves and monobrowed spider-women. Direly dull.

Fire Maidens from Outer Space (1956): When a joint U.S.-U.K mission to Jupiter's thirteenth moon touches down, the astronauts have to try to a) tap the asses of the native hotties and b) save them from a mythological beast-man because this is New Atlantis. Agonizingly cheap, slow, and stupid. One of the worst.

The Astounding She-Monster (1957): A blurry girl in a body suit arrives on Earth to invite us into the Council of Planets. Strange then that she tries to deliver the message to backwoods crooks staging a kidnapping.

Queen of Outer Space (1958): Shot in lush color and CinemaScope and based on a story by Oscar winner Ben Hecht, this is the *Titanic* of B movies. Spacemen are sucked down to

Venus, ruled over by a disfigured queen. They ally with a faction of babes led by Zsa Zsa Gabor.

Invasion of the Star Creatures (1963): God-awful "comedy" stars Robert Ball and Frankie Ray—imitating Abbott and Costello—as knuckleheaded soldiers who get mixed up with vegetable monsters and space girls.

Voyage to the Planet of Prehistoric Women (1968): Using footage from a 1962 Soviet sci-fi film, Peter Bogdanovich adds in footage of telepathic cave babes led by Mamie Van Doren.

Invasion of the Bee Girls (1973): Sexy and knowingly silly cinematic sin-sation has the men of a small town boinked to death by bee-girls. These horror honeys operate out of an underground base, to which they lure the town's ladies for bee-sexual rituals that involve rubbing boo-bees to turn them into more black-eyed zom-bees. Great fun.

DECEMBER

The Wild Women of Wongo (1958): Set ten thousand years ago, when Mother Nature and Father Time created an experiment that separated the ugly and beautiful men and women on different islands. Stupid but a good concept for a reality TV show.

An Enraged New World (2002): From Mike Martinez, director of *The Tony Blair Witch Project*, this is a psycho-killer drama seemingly set on another planet. Still a home movie, but better than *TTBWP*.

Assassin of Youth (1937): Another flick warning of the dangers of pot, only to inadvertently make it seem like jolly fun, especially when the stoners lie down and waggle their legs in the air for a laugh. "Everybody, be kangaroos!"

ACKNOWLEDGMENTS

My greatest thanks to Kate Hamill at HarperCollins and Hannah Brown Gordon at Foundry Literary + Media in New York for tireless help in taming this beast back from a telephone-sized tome to something, well, people might read. Thanks to Paula Russell Szafranski for the awesome design. Ditto for the Murdoch Books/Pier 9 team of Colette Vella, Kate Fitzgerald, and Hugh Ford in Australia. Brilliant copyediting work was provided by Karen Ward in Australia and by Paula Cooper in the U.S. For their ongoing support, counsel, patience, and strangely understanding ways, I am indebted to my dad, Noel, my late mum, Wanda, and Aunty Lee, Clare's folks, Ray and Denzil, the Lane and Joyce Thompson families, David and Tina. Thanks to Chris Murray for keeping me sane with regular nights at Club Muz, to Luke Goodsell for his willingness to read and read again and still laugh, and to my dear mate, Mic Looby, who provided endless moral support while going through his own dark night of the book, and to

Rachel Carbonell, for propping us both up. Thanks also to Evil Dan Creighton for his fabulous title work on *The Bad Movie Show* (we'll get there!), to Craig Carroll for stellar design advice on the covers, to Paul and Leonie O'Farrell for reading early and with enthusiasm, to Emma Heseltine, who endured *Enter the Night* way back in the day, to Shayne, Nick, and India Jackman, for sharing that first New Year's Eve, to alternative-culture gurus Jaimie and Aspasia Leonarder and Andrew Leavold. Thanks also to the very excellent Rod Yates, Ben McEachen, Greg Bork, Sam Downs, and Tinzar Lwyn, who helped make *Empire* and *The Movie Show* doable. Cheers also big-time to Anne-Marie and David, Picko, Holder, CiBot, G-Mo, D-Mu, Timmeh, Claire, and Buge. For a good New York introduction, thanks to Sadie Chrestman and Sophie Hamley; for his help with my website, hats off to Martin Ford; for being good eggs, Mike Baard, Sharon Waxman, Lew Harris, and Stu VanAirsdale, I salute you. Thanks also to those whose work made this seem possible—Stephen King, David Sedaris, Spalding Gray, A. J. Jacobs, Carrie Fisher, Chuck Klosterman, Joel McHale, Jon Stewart, Stephen Colbert, and Ryan Bigge. This now feels too much like a bad Oscar speech, so, from the eBay and Amazon sellers who delivered on time to those directors, writers, stars, and aficionados who took the time to talk about the bad movies they made/love/hate, my deepest gratitude.